HCB

HENRI CARTIER-BRESSON: THE MAN, THE IMAGE AND THE WORLD

the man, the image

Thames & Hudson

HENRI CARTIER-BRESSON

and the world a retrospective

Text by Philippe Arbaïzar,
Jean Clair, Claude Cookman,
Robert Delpire, Peter Galassi,
Jean-Noël Jeanneney,
Jean Leymarie *and*
Serge Toubiana.

French text translated from *Henri Cartier-Bresson: de qui s'agit-il?* by Jane Brenton

First published in the United Kingdom in 2003 by Thames & Hudson Ltd,
181A High Holborn, London WC1V 7QX

www.thamesandhudson.com

First published in hardcover in the United States of America in 2003
by Thames & Hudson Inc., 500 Fifth Avenue, New York, New York 10110

thamesandhudsonusa.com

Original edition published in French by Editions Gallimard, Paris
and the Bibliothèque Nationale de France
© 2003 Fondation Henri Cartier-Bresson
Photographs © Henri Cartier-Bresson
This book was devised by Robert Delpire, assisted by Michaël Derez and Maud Moor.

British Library Cataloguing-in-Publication Data
A catalogue record for this book is available from the British Library

ISBN 0-500-54267-8

Printed and bound in Italy

Contents

Introduction
Robert Delpire *Fondation Henri Cartier-Bresson*

The question always on Henri Cartier-Bresson's lips is 'De quoi s'agit-il?' – 'What are we dealing with?' His friends have heard it so often that they teasingly say it makes no sense at all. The story is a nice one; but of greater interest to us now is the nature of the man himself: not '*What* are we dealing with?', but '*Who* are we dealing with?'

Who exactly is Henri Cartier-Bresson? – a man who has achieved mythical status in spite of himself, whose work has always been perfectly consistent, who has put his mark on an entire photographic genre through keen analytical rigour and such a perfect fit of form to content that it seems there could be no other way of recording a historical or everyday event, depicting a landscape, or conveying a subject's psychological make-up. His fame is absolute, and he is universally admired by specialists, professional photographers, and the public at large.

At the age of seventy he decided to give up travelling the world and return to his first loves: painting and drawing. They had been central concerns ever since he was a young man, so it was entirely natural for one form of activity to merge into another; before long the most prestigious galleries were exhibiting drawings as well as photographs, sometimes separately and sometimes side by side.

Over the years his personality has grown richer and more complex, and his motivations have become more difficult to discern; yet there is no inconsistency in his attitudes or contradiction in his artistic or political choices.

So now is the moment to re-examine his work as a whole. This book draws on a unique selection of material brought together for a major exhibition, including Cartier-Bresson's very earliest photographs, some never before seen; carefully identified vintage prints; a selection of the best images that constitute the core of Cartier-Bresson's photographic oeuvre; films directed

by Cartier-Bresson and about him; books, monographs, histories, portfolios – in short, every kind of publication concerned with Cartier-Bresson's work, including, for the first time, the magazines in which his photographs appeared; writings by Cartier-Bresson and those inspired by him; his drawings made in the last thirty years; and personal mementos of his childhood and family.

Looking at all the impulses and influences at work throughout his life, we hope to give an answer to the question of who Henri Cartier-Bresson is – this man who does not merely take his place in the history of photography, but is one of its most brilliant stars.

Robert Delpire is Director of the Fondation Henri Cartier-Bresson

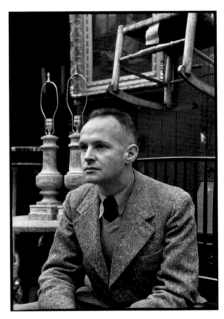

Henri Cartier-Bresson, 1946, photo David
Seymour, Magnum

'Everything that can only be said by means of silence'

Louis-René des Forêts

Seeing is Everything Jean-Noël Jeanneney *Bibliothèque Nationale de France*

A photograph of 1933, one of Henri Cartier-Bresson's few self-portraits, shows him lying stretched out on a low wall beside an Italian road, a village in the distance and a patch of undergrowth below. In this image, taken around the time he bought the Leica camera in Marseilles that has accompanied him everywhere ever since (except, sadly, during his captivity from 1940 to 1943), little can be seen of the photographer except his chest and leg and the very tip of his foot. The only visible bit of himself. A portrait of a barefoot vagrant, in short. However, with the passage of time, the image has acquired a significance its author probably never intended when he clicked the shutter. The seventy intervening years have transformed this near schoolboy's joke into a sort of manifesto. Here, photography declares itself less an art of travelling than an art of displacement (the foot counts for less than the road), a sort of simple and subtle homage to the very act of walking on two legs. It is the art of distance – physical distance covered on the road, but also the distance that results from the adoption of a humorous, and sometimes self-mocking approach to looking at yourself.

This distancing became a habit: Henri Cartier-Bresson would never take another picture of himself to discredit this one; but he did take tens of thousands of photos of the people and places of the world, accumulated in the course of his tireless journey around the planet, to Asia, to America, to all the four corners of the earth. Something of the Odysseus can be seen in him, valiantly confronting stormy seas, yet racked with a profound longing to return home. Nostalgia was at war with the urge to conquer new frontiers: it is said that in the early thirties, when he was taken ill on the Ivory Coast and believed he was about to die, he became obsessed with the idea of having his remains sent back to the family home in the Varenne valley. In fact, for Cartier-Bresson, the real return would be a journey of another order: not so much one of the foot – a geographical journey – but one of the eye – an aesthetic itinerary.

Originally, Henri Cartier-Bresson had studied drawing and painting in the atelier of the Cubist André Lhote, before succumbing to the lure of photography and occasional experiments

with the alternative eye of the cine-camera as Jean Renoir's assistant and as a documentary film-maker. Then in the 1970s, he returned for good to his homeland – drawing.

In performing this tour of his successive activities, are we then saying that drawing was his true destiny? Are we to assume photography was a mere diversion, just a stage along the way, much less important than the length of time he devoted to it, over fifty years, would suggest? In fact, it is not the linear progression of his life we should be looking at, but the pattern of emergence of the works themselves. From the outset, drawing has underpinned Henri Cartier-Bresson's photography. 'The great passion,' he says, 'is shooting photographs, *which is accelerated drawing*, a matter of intuition and recognition of a formal order, fruit of my visits to museums and art galleries, reading and an appetite for the world.'[1]. This conception of photography as the pursuit of drawing by other means suggests fascinating new parallels between the drawn line and the fixed line, the deliberate imprint of the pencil and the mechanical production of the printed scene.

A superb print provides a good illustration of this fusion of the two arts. It is a photograph of Isle-sur-la-Sorgue, a river view dating from 1988. The water is calm and, like a silvered photosensitive plate, refracts the summer light as it lies so thick and smooth on the river idling under the trees. The reflections of the trees are so intricate in appearance that they look as if they have been drawn; the image is so dense, with such intensity of values and infinite shades of grey, that it becomes hard to say if you are looking at a photograph or a drawing.

Could we say that the image of the self has changed along the way? No lingering narcissistic impulse, but perhaps the evolution of the individual consciousness into something more like the water in this photograph, which might, to borrow from the Stoics, be interpreted legitimately as a metaphor of serenity: the ability to go with the flow, to be in tune with the cosmos, to radiate an inner light. There is probably no finer spiritual self-portrait of Henri Cartier-Bresson than this landscape, which has all the beauty of Japanese calligraphy. These two photographs, taken at opposite ends of his career, frame an intervening period in which he recorded the whole spectrum of existence: portraits, events, scenes of everyday life and landscapes.

Displayed next to one another, Cartier-Bresson's pictures provide a record of *his* twentieth century. As we see the world through his eyes, it becomes ours as well. His prints are so powerful, practically absorbing their subject, they are transformed into icons. Gandhi's cremation, Matisse

wearing a turban, Giacometti with his coat over his head as he crosses the Rue d'Alésia in driving rain, Faulkner and his dog, New York transfigured, Soviet Russia slumbering in its lethargy.

Henri Cartier-Bresson's genius was often blessed with luck, allowing him on many occasions to capture the very moment when history hung in the balance. The last moments of China before Mao, the last moments of English India, and also the last moments of great political and literary figures, such as the final image of Gandhi, assassinated barely an hour after the sitting he granted Cartier-Bresson, or of Faulkner just before he disappeared.

Presumably what arouses our emotions is the sense of something being rescued in the nick of time, before a whole world vanishes for ever – although, of course, the world in question does not in fact disappear; it is still so close you can almost touch it, and you can identify with the protagonists. Look at those workers who supported the Popular Front, who enjoyed the first paid holidays, legendary figures written about in the textbooks; peremptorily elevated from their tough earthly existence, they are the stuff of modern myth. Look at the homage to the Renoirs – father and son – spending a day in the country, appropriately enough: their bodies heavy, shoulders rounded, lost in contemplation of the water that almost merges with the sky as a boat drifts by. The people who lived in the second half of the nineteenth century and in the twentieth are the first in the long history of humanity to be able to see accurate and faithful portraits of their predecessors on this earth. Ancestors are no longer only the *imagines* carried in procession at the funeral ceremonies of antiquity, no longer the painted portraits or mementoes devised by societies over the centuries as aides-mémoires. Instead they appear to us now all too horribly true to life, exact images of themselves that 'preserve the funereal presence of the dead' as never before, to quote Roland Barthes. That is probably why today a greater pathos is attached to our relationship with the departed – a development to which Henri Cartier-Bresson may well have contributed.

Never mind what Baudelaire said, photographs are not merely archives.[2] But what weight precisely do they carry? The perception of the event rather than the event itself, the shockwave that runs through the crowd rather than the initial trauma. Consider those terrified Chinese lined up outside the bank. They interest us less as a way of showing the effects of the arrival of Mao's soldiers, than as a way of encapsulating, with brilliant simplicity, the cataclysm that was the Communist Revolution in a China we foolishly believed would never change. Similarly, how better to convey the reverberations of Gandhi's death than by showing the vast crowd attending

his funeral. As the assembled hordes flood the space, lapping like a human tide around the tree in the foreground, the image is transmuted into the standard of a nation's grief.

Compared with the obsessional, breathless pursuit of news stories characteristic of the press, this is an infinitely more subtle approach, reflecting a curiosity for incidental details, and a taste for celebrating personal histories as well as the history of nations, a sort of anecdotal humanism, if you like. This fresh perspective is accompanied by a strong dose of humour and an irreverence for the evanescent hierarchies of the moment. The image of crowds gathering in Trafalgar Square for the coronation of King George VI in 1938 – part of a reportage undertaken with Paul Nizan for the magazine *Ce Soir* – is an appealing reversal of the usual scale of values. The upper half of the picture is occupied by the crowd of onlookers watching out for the arrival of the royal procession. Then, at a second glance, we see a man fast asleep at the bottom of the picture. This body shrouded in newspaper – out for the count, blind and deaf to the pageant passing by – brutally wrenches the episode into a different time frame from that of news or current affairs. The moment is fleeting, this famous event is fragile, consigned already to the big rubbish bins lining the streets.

Such a complex relationship with time is typical of photography: the shot is taken, but is not fully revealed until later in the darkroom, or later still when we come to scrutinize it in public long afterwards. Effectively, the event does not, in the full sense of the term, take place when the shutter is clicked. Rather, it *will have taken place*. The act of observation is translated into the future perfect tense; it is a temporal shift of the same order as the historian bringing his efforts to bear ad infinitum on the present at the moment it becomes fixed in the past.

So we are talking about an archive after all, but not so much of the events themselves as an anthropological archive of the different forms of observation that are brought to bear. Henri Cartier-Bresson's work tells us about the human species, a species with a variety of ways of seeing the world. Harking back to an ancient form of intuition, his work defines all of us as beings who 'see', observing the world about us, each other and ourselves. We in the West are so conscious of the opacity of our 'seeing' that – far from iconoclastic – we have invented no other god but a god conceived as the incarnation and visible revelation of the invisible. Who sees and may be seen. Timeless.

For all that, this archive of permanence does not turn away from the flow of time. An isolated image of time is recorded, a snapshot lifted out of the continuum, separated from what precedes it and what is yet to come. A moment when time and movement are suspended. Just look at the technical genealogy directly linking the film used in the Leica, the 24 × 36, with that of motion picture film.

Like Kertész, Doisneau and many others, Henri Cartier-Bresson took up photography at about the time the snapshot photo was invented. No more staged poses, but frozen scenes of the moving world. After the First World War, photojournalism offered a new avenue for exploration: a number of illustrated magazines were launched, such as *Paris Match* in 1926, and Lucien Vogel's *Vu* in 1928 (the title 'Seen' being a sort of mission statement). The daily press stimulated demand and even encouraged a new sort of voyeurism. The snapshot, with its inevitable compromises, at first ran counter to the majority taste of the day for highly polished images (the hallmark of the Studio Harcourt) or clever pieces of avant-garde art (the experimental work of Man Ray and the Surrealists). But Cartier-Bresson, fascinated as he was by Breton and the group at Place Blanche, was always very careful to follow the advice of his friend Robert Capa not to let himself be typecast as a 'Surrealist photographer'.

So, what is a snapshot? The intensification of a fracture between two classes of image: those that are man-made, like painting and drawing, and those created mechanically by imprinting light on sensitive film. Images in the first category are unique works. The rest, because they are capable of being reproduced, are judged not by their uniqueness but by the unique moment they record. Not that the artist in the second case is any less important, as he not only seeks out the image, but chooses, composes and claims it as his own. Cartier-Bresson waits in ambush for the right time to occur. Seizing that moment is a matter of instinct. Interpreting the image is for later.

In short, the snapshot stalks reality as closely as it can in order to achieve a perfect resemblance. But what resemblance? Byzantium distinguished three categories: formal resemblance (*homoiosis*); essential similarity (*homoousia*) and imitation (*mimesis*). It is neither the first nor the third that applies here, but the second, essential similarity.

On the model of Cézanne ('I owe you the truth in painting'), Henri Cartier-Bresson developed his own artistic doctrine, that of the 'decisive moment'. In the fifties he wrote a short but important book under that title. The decisive moment permits us, we are told, to catch life in the raw, 'in flagrante delicto'. 'The photographer (too bad if he's behaving badly) should take life by surprise, fresh out of bed.'[3] The unique revelation of the moment unmasks what the flow of time has hidden within its coils. The man leaping over a puddle in 1932 on the Pont de l'Europe, so often painted by Gustave Caillebotte, looks as though he is part of some strange circus of everyday life. As for the two men in Brussels, caught in the act of spying on some mysterious happening through a hole in a sheet of canvas, they are voyeurs, caught red-handed, like – who knows? – the photographer himself.

Among all these scenes captured 'in flagrante delicto', another is even more memorable. This is a picture of Dessau dating from 1944 and titled by the artist: 'In a concentration camp, a Gestapo informer is recognized by a woman she has betrayed.' The shot freezes the rictus of pain and hate contorting the victim's mouth at the moment she recognizes and hits out at her oppressor. There is also a film of this scene, directed by Henri Cartier-Bresson himself.[4] The film is moving, but only the photograph, in its perception of the imperceptible, conveys the shattering emotional impact of the moment.

In the light of the above, could it not be said that what the much celebrated 'decisive moment' does is establish an instant connection between the visible and the invisible? Consider, for example, the view of Arizona of 1947: a barren landscape in three distinct planes. Three planes, three eras. The first, which occupies the entire bottom part of the picture, shows the carcass of a thirties' car, abandoned in the flatlands – a relic of the days of the Depression. The second plane is bisected by the black line of a train that releases its black smoke into the clear sky: this is the mythological landscape of the Wild West. The third plane, comprising sky and mountains, is redolent of a sort of nostalgia for a golden age, for the America that preceded America. There before your eyes, in an instant, the whole history of the United States appears, like the sudden precipitation of a chemical solution.

Whether in literature, painting or film, the great work of art is one that transcends its own nature to become a comment on art itself. Each of Henri Cartier-Bresson's photographs, as well as observing and recording the world, also provokes a meditation on the act of observation. For him,

observation is saying yes to the world; it is an all-consuming act. 'I'm a bag of nerves waiting for the moment, and it wells up and up and it explodes, it's a physical joy, dance, time and space all combined. Yes!! Yes! Yes! like the ending of James Joyce's *Ulysses*. Seeing is everything.'[5]

Jean-Noël Jeanneney is President of the Bibliothèque Nationale de France

1. 'Conversation avec Gilles Mora', *Les cahiers de la photographie*, 1986, n° 18.
2. Baudelaire, 'Salon de 1959', in *Curiosités esthétiques*, Paris : Flammarion.
3. Henri Cartier-Bresson quoted in Yves Bourde, 'L'univers noir et blanc d'Henri Cartier-Bresson', *Photo* n° 15, 1968.
4. Pierre Assouline, *Cartier-Bresson, un œil dans le siècle*, Paris : Plon, 1999, pp. 192–3.
5. Henri Cartier-Bresson in an interview with Yves Bourde, 'Nul ne peut entrer ici s'il n'est pas géomètre', *Le Monde*, 5 September 1974.

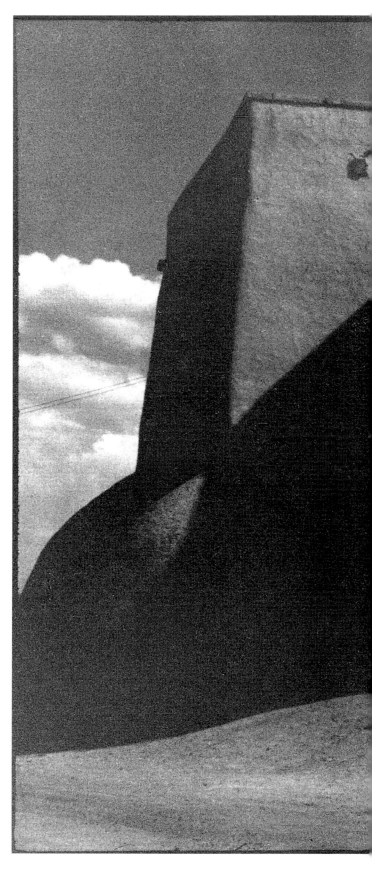

1 Taos, New Mexico, USA, 1947

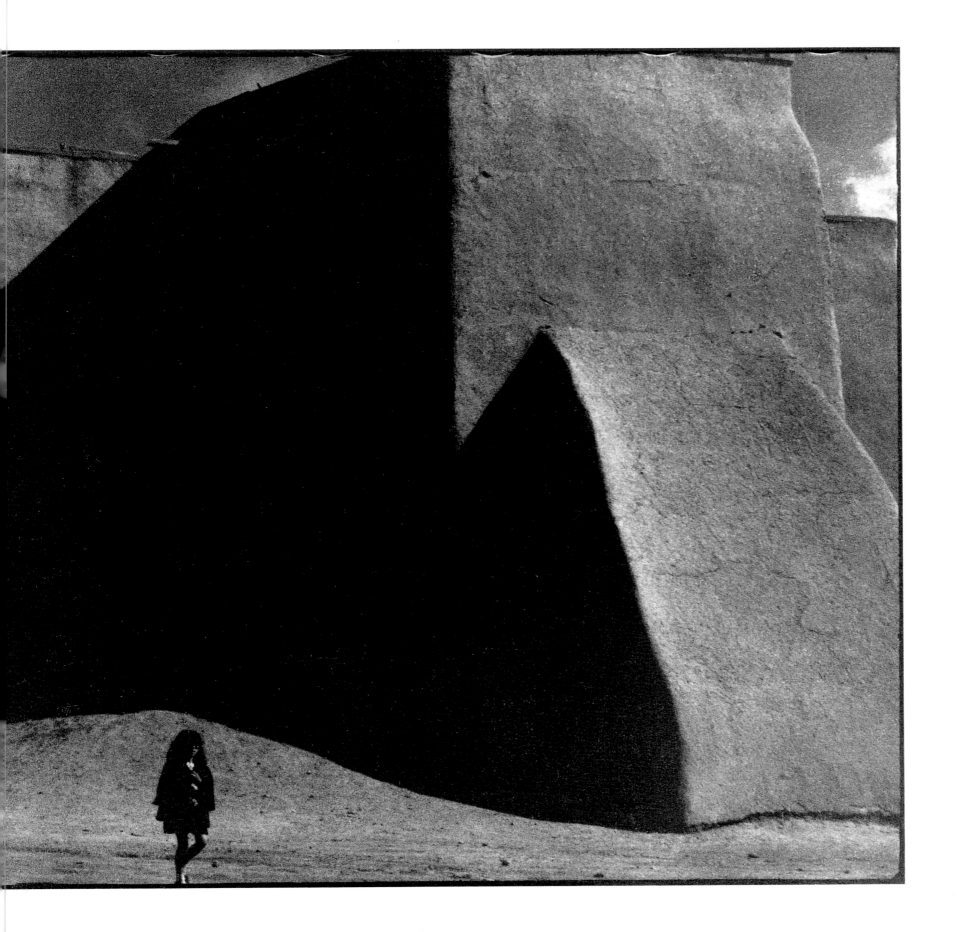

And Everything in Between Peter Galassi *Museum of Modern Art, New York*

The rise of modernist photography in the 1920s and 1930s contained the germ of many definitions of what the new art might be. Over the next half century, as obstreperous experiment deepened into sophisticated tradition, one definition proved especially fruitful: the photograph is a picture grasped from the over-abundant world of visual experience. The link between picture and experience is unbreakable but infinitely flexible. The art of photography lies in mastering that flexibility, not merely in one picture but in many, which together speak in one voice. This may sound obvious now. In 1930, as a deliberate exploit performed by one artist in full view of others, it was a new thing under the sun.

From 1932 to 1934, Henri Cartier-Bresson did as much as any other to shape that definition and its prospects. In a white streak of invention, he proved that a photographer can handle the world as freely as a sculptor handles clay, all the while pretending that he (or she) has touched nothing. A child playing ball before a weather-beaten wall becomes a figure of rapture isolated in the cosmos (pp. 92–3). A woman squinting in puzzlement at the photographer brings her younger self to life in the defaced poster behind her (p. 104). Who could have imagined that photography was capable of such alchemy? After the early work of Cartier-Bresson, who could deny it?

The momentum of those few extraordinary years was deflected in the second half of the thirties by Cartier-Bresson's detour into film-making and by his deepening engagement with the ever more alarming turmoil of Europe. From 1940 through 1943 he made no photographs at all, for doing so would have inconvenienced his German captors. He returned to photography in 1944 and over the next three decades created a body of work that remains unique in its scope.

Fifteen years ago I argued that there is a crucial difference between Cartier-Bresson's stunning innovation of the early thirties and the much richer achievement that came later.[1] In the earlier work, the decisive moment is a scalpel that cuts a fragment of perception from its context, displacing it into the realm of imagination. In the later work, the decisive moment is a net that

gathers 'the significance of an event'[2] into the still frame, suggesting the absent context. True enough, I still believe. But this was hardly intended as the last word on the matter. Permit me, then, to contradict myself.

To begin: that second definition of the decisive moment could not exist without the first. For there is no such thing as 'the significance of an event', at least not in the way we may speak of the weight of a stone. Most of the time there was hardly an event at all before Cartier-Bresson saw it for us in his picture.

In the early thirties, he had discovered that photography possessed the power to reinvent experience so radically that it could transform child's play into cosmic rapture. After the war, he used that very same power to strip experience of its *Rashomon* multiplicity of potential meanings, to isolate and reveal the one that he felt. The realist transparency of the post-war work is a fiction no less artful than the Surrealist fantasy of the thirties.

The brilliance of this creative performance has been dulled by the massive output of countless self-elected followers who have misconstrued Cartier-Bresson's style as a pictorial game. The 'precise organization of forms' (to quote again from *The Decisive Moment*) is merely the precondition of an articulate picture. The picture must then have something to say – about something. On that score, too, Cartier-Bresson's work is rich in continuities.

'You must understand', he once explained, 'that the thirties were still the nineteenth century.' I understood him to mean that modern technology and commerce had not then penetrated our lives as they have so deeply since. It took me much longer to see how often, and in what ways, Cartier-Bresson's post-war world resembles his world of the early thirties.

In the opening plate of *The Europeans* (1955), smokestacks rise ominously behind ancient Greek stones.[3] But the next picture – a Greek farmer guiding a horse-drawn plough in an olive grove – might have been made in the fifteenth century, had photography (and Cartier-Bresson) then existed. It is instructive to consider how nearly true this is of a great many photographs made throughout Cartier-Bresson's career.

The Decisive Moment (1952) shows us some skyscrapers, a highway, an oilfield, and the urban ugliness of an elevated metro. But these unsettling intrusions belong to the New World; they're all American. Otherwise, in a book that ranges throughout Europe, Mexico, and Asia, evoking the great upheavals of the globe at mid-century, the only sure evidence of mechanized modernity is a bicycle here and there and half a dozen vehicles powered by combustion engines, all of them half hidden in the background of a single photograph made in Rangoon.

Unencumbered by any assignment in his first years of photography, Cartier-Bresson had followed his nose to the neighbourhoods of the common people. The spirit of the pictures suggests that he found more vitality among the poor than among the proper. But there were plenty of poor who worked the machines of industry even in the thirties, and we do not see them, at least not at work. It was the unmodern poor who caught Cartier-Bresson's eye.

Even as the social scope of his work broadened dramatically after the war, Cartier-Bresson never relinquished his affectionate curiosity for the timeless patterns of human behaviour and their endlessly unique incarnations.[4] That first plate of *The Europeans* announces the conflict between ancient and modern as a salient theme of the post-war work, and so it is. But it shares our attention with many other themes, all of which existed long before the automobile: man and woman, young and old, rich and poor, the powerful and the weak, the individual and the group, the group and the crowd. Good and evil are there too, of course, but Cartier-Bresson usually lets us sort them out for ourselves.

★ ★ ★

'Through living we discover ourselves, at the same time as we discover the external world.'[5] Doubtless Cartier-Bresson meant 'external world' metaphorically, to denote everything that is not ourselves. But in his case the external world meant literally the whole world, or nearly so. His legacy is not merely a very large collection of very compelling pictures. It amounts to a personal history of the twentieth century.[6]

In photography – especially hand-camera photography, above all the photography of people – intellect must express itself through instinct. There is no time to think. That is why most photographers are best at home, where meaning – of an accent, a gesture, a glance, a gathering – is grasped in an instant. Only Cartier-Bresson has been at home everywhere.

It is remarkable enough that he was so often in the right place at the right time: in India when Gandhi died, in China when Mao triumphed, in Khrushchev's Russia before anyone else. More remarkable still is what he did. To photograph the news, being there is nine tenths of the battle. To photograph history as it is lived in the street is something else altogether.

The challenge of history was new to Cartier-Bresson, and the sobering experience of the war goes a long way toward explaining why he took it on. His eagerness to know history as it happened prompted him to go where and when he did, and it inspired him to write long captions every evening to accompany the pictures he had made earlier in the day. These captions – an overlooked dimension of his work, now ripe for recovery – were not merely part of his job. He recalls that he put as much passion into them as he put into his photographs. That passion – not just to see but to communicate – is what suited this fiercely independent artist to adopt the guise (and the discipline) of the journalist.

But the challenge of the street was familiar. For all of its pretensions to reinvent life, Surrealism had been an art of the studio and the salon. It was Cartier-Bresson who had taken it into the street, and then into the world.[7] In purely stylistic terms, he could have spun his magic of the early thirties without ever leaving Paris. But he did leave Paris, and France, and Europe. His eager curiosity to discover himself by greeting the world was the driving force behind his photography from the very beginning. The challenge of history may have been new, but the way he defined and mastered it was rooted in the adventures of his youth.

★　★　★

'I have never been interested in photography.' When Cartier-Bresson says this, as he often does, people who have given their lives to photography take it as a provocation, which it is. As a result, few seem to consider that he might mean it, which I believe he does.

Some of his admirers were also provoked when he gave up photography in the 1970s, and so they failed to see how that ending explained the beginning, and everything in between. For us, the picture is what matters. It's all we have. For Cartier-Bresson, what mattered most took place before and after he released the shutter. Photography wasn't just a way of making sense of experience. It was a way of having experience, of being himself by being among others – any and all others. He sustained this radically expansive definition of experience for nearly half a century.

When (inevitably) he began to withdraw from the fray of ceaseless travel and fresh encounters, photography (inevitably) lost its central place in his life. The occasional photographs he has continued to make – portraits drawn from his large circle of intimates and vast circle of acquaintances; piquant observations snatched in passing here and there – only reinforce the point.

It is the mystery and splendour of photography that the essence of the art has little to do with photography itself. The making of the picture – especially Cartier-Bresson's kind of picture – is simple and quick. The hard part is everything else: the whole of the photographer's relationship to the world.

Peter Galassi is Chief Curator of the Department of Photography,
Museum of Modern Art, New York

1. *Henri Cartier-Bresson: The Early Work*, exhibition catalogue, New York: Museum of Modern Art, 1987.

2. Henri Cartier Bresson, *The Decisive Moment*, New York: Simon and Schuster, 1952, n.p.

3. Henri Cartier-Bresson, *The Europeans*, New York: Simon and Schuster, 1955. Cartier-Bresson's caption points out that 'the smoke-stacks are in the style of the late nineteenth century,' adding that 'the middle of the twentieth century contributed its own touch, invisible in the picture, but clearly audible at the time when it was made: the noise of jets at the neighboring airfield.' To my knowledge, however, he did not photograph the airfield.

4. It was not until 1969 – thanks to a commission from IBM, no less – that Cartier-Bresson would produce *Man and Machine*. The prevailing tone of comic irony echoes the note that Chaplin had struck in 1936, as if man were condemned to perpetual embarrassment in the face of his contraptions.

5. Also from the introduction to *The Decisive Moment* but here translated anew from the French (*Images à la Sauvette*, Paris: Editions Verve, 1952, n.p): 'C'est en vivant que nous nous découvrons, en même temps que nous découvrons le monde extérieur.'

6. I owe this observation to Lee Friedlander, and I thank him for it.

7. It would be fair to object that Louis Aragon's *Le Paysan de Paris* (1926) and André Breton's *Nadja* (1928) had taken Surrealism into the street, and both novels did help to shape Cartier-Bresson's aesthetic of the early thirties. The point stands nonetheless, especially in realm of the visual arts.

'From now on, there won't be a gesture, nor a blink of the eye which doesn't commit me irrevocably, which doesn't change the course of my life.'

Louis Aragon

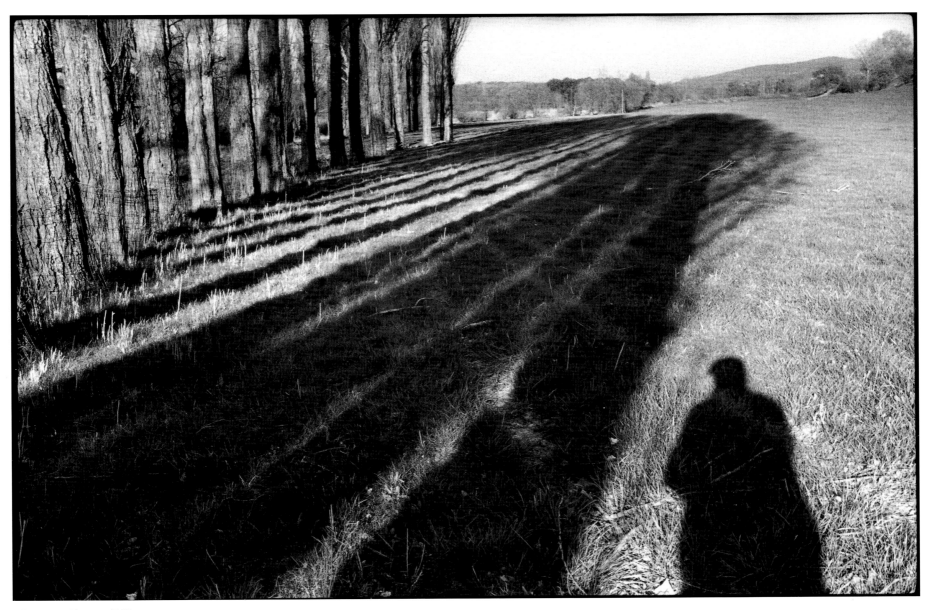

2 Provence, France, 1999

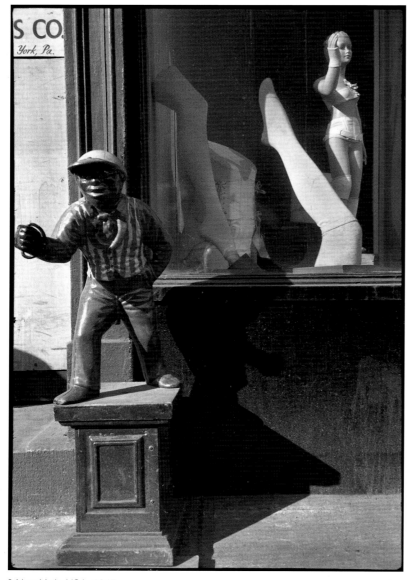

3 New York, USA, 1947

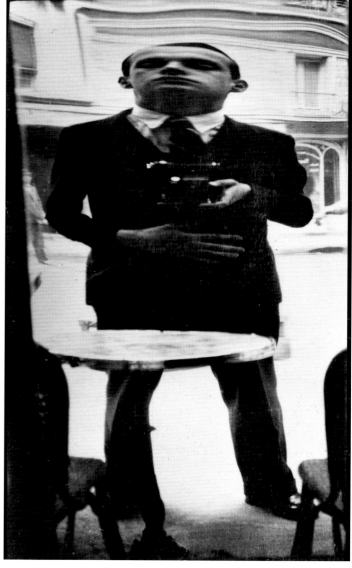

4 Henri Cartier-Bresson, Self-portrait, c. 1932

5 New York, USA, 1947

6 Poland, 1931

7 New York, USA, 1947

8 Warsaw, Poland, 1931

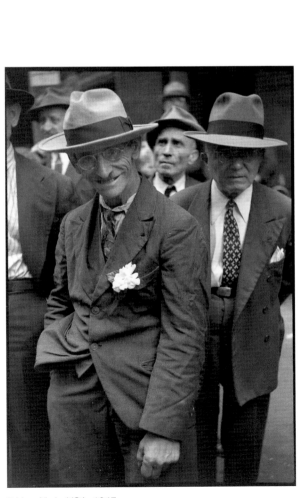

9 New York, USA, 1947

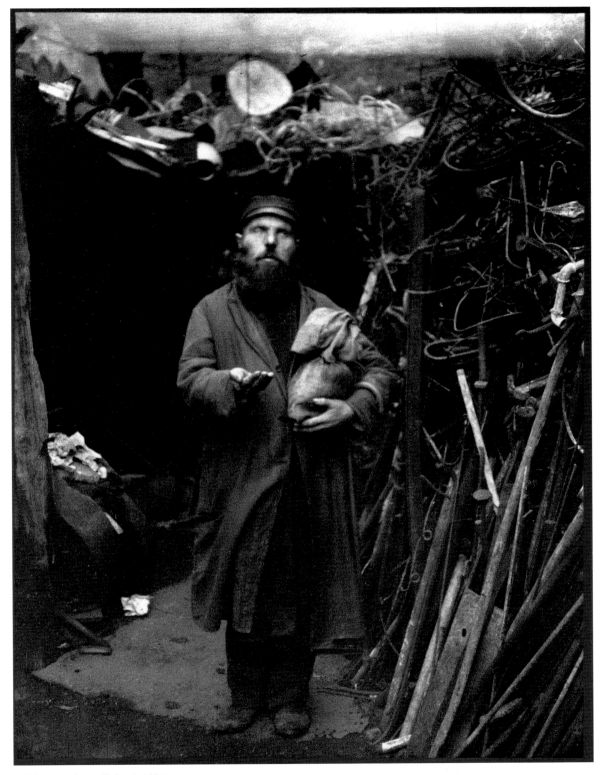

10 Warsaw ghetto, Poland, 1931

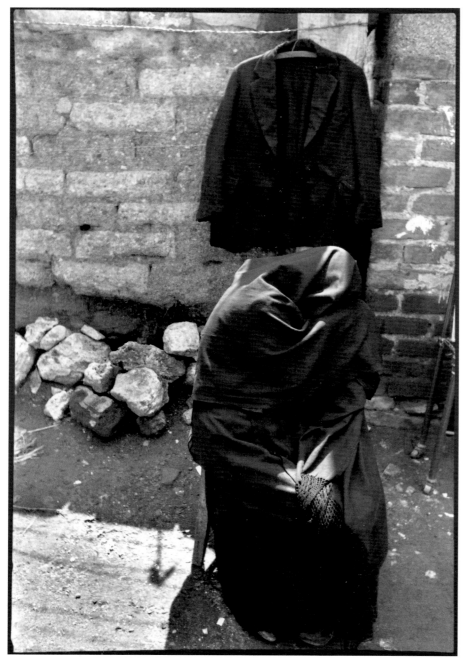

11 Mexico, 1934

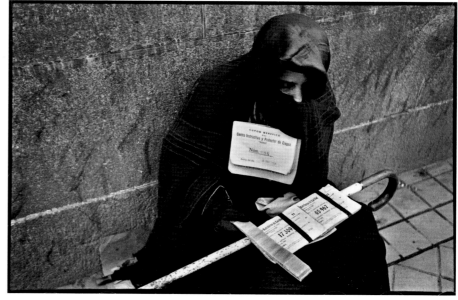

12 Madrid, Spain, 1933

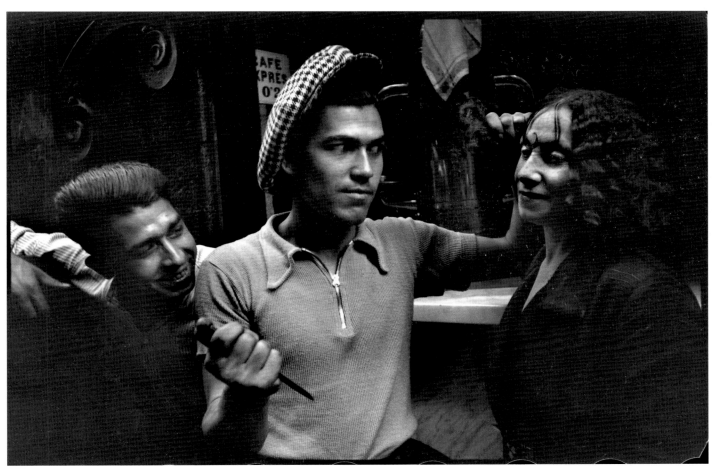

14 Barrio Chino, Barcelona, Spain, 1932

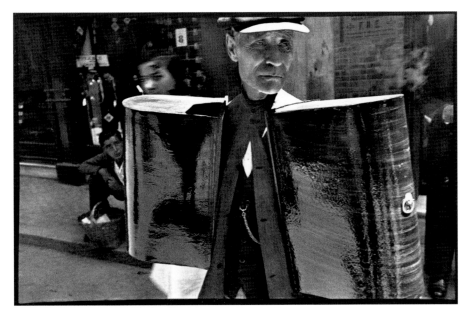

13 Madrid, Spain, 1933

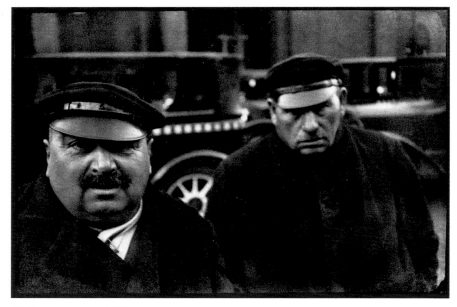

15 Berlin, Germany, 1932

Captions for book and magazine covers shown in this book can be found on page 429.

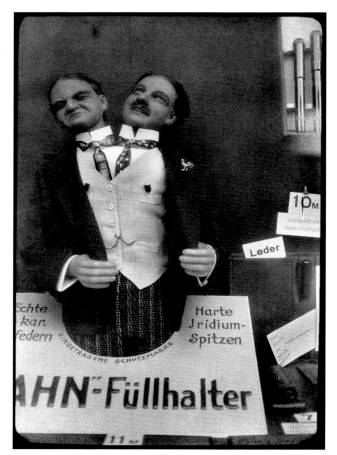

16 Berlin, Germany, 1931

17 Cracow, Poland, 1931

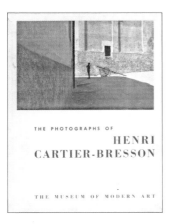

THE PHOTOGRAPHS OF
HENRI
CARTIER-BRESSON

THE MUSEUM OF MODERN ART

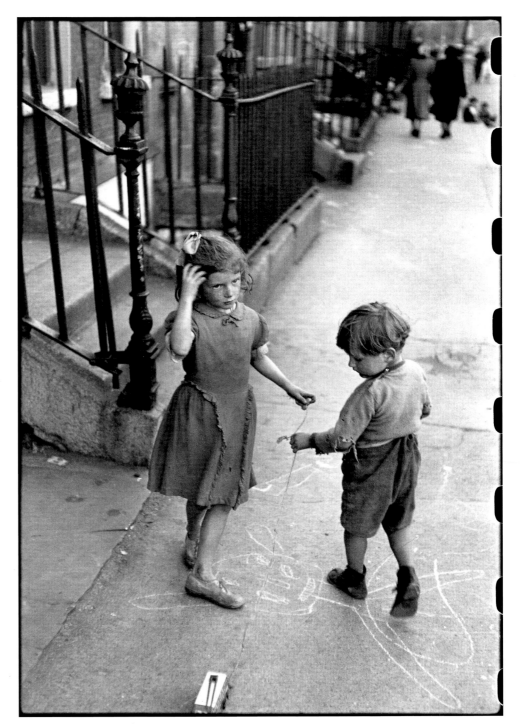

19 Dublin, Ireland, 1952

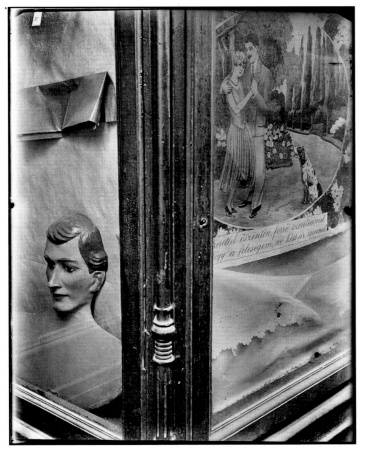

18 Hungary, 1931

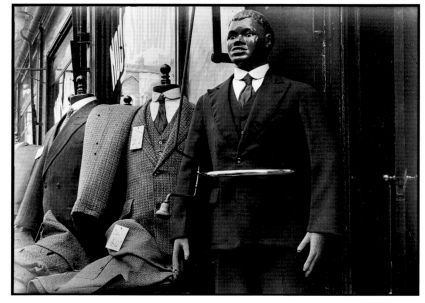

21 Rouen, France, 1929

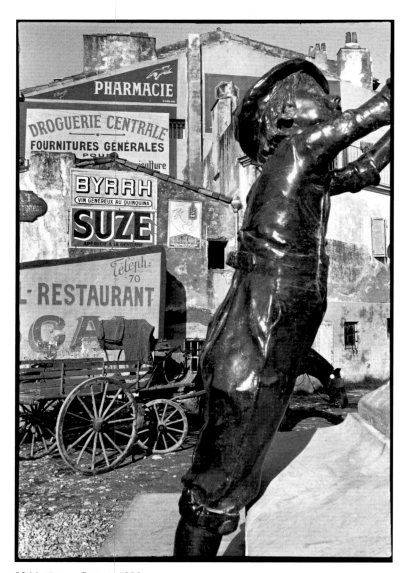

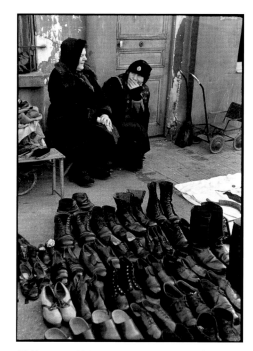

22 France, 1936

20 Martigues, France, 1932

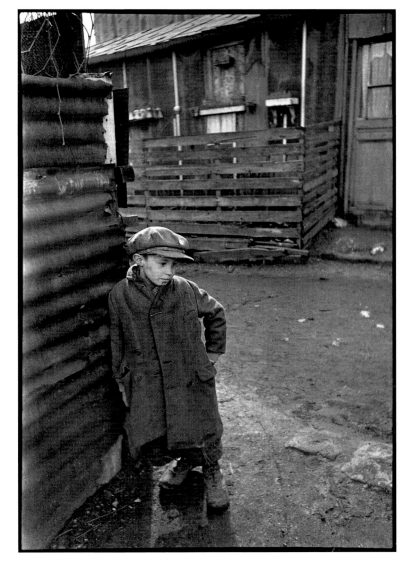

24 Aubervilliers, France, 1932

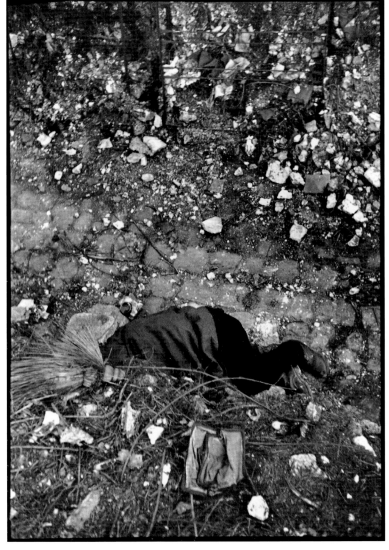

23 Marseilles, France, 1932

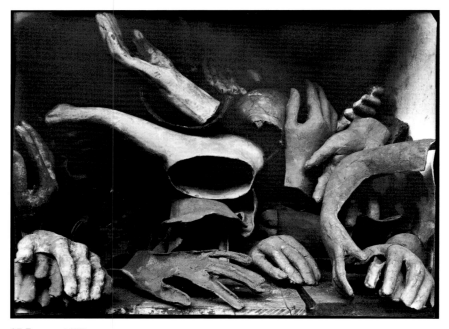

25 France, 1929

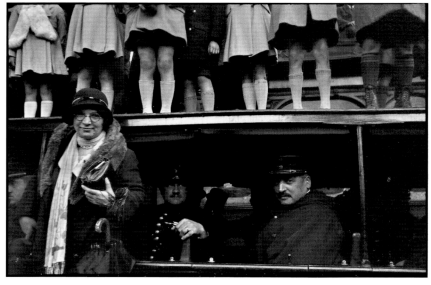

26 14 July, Paris, France, c. 1936

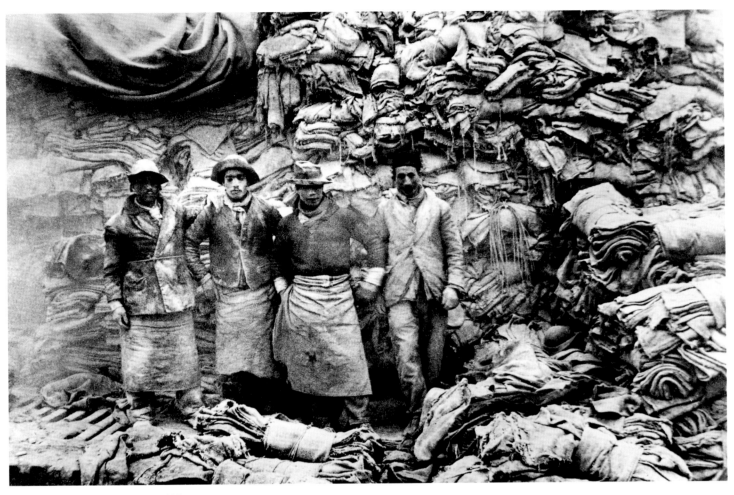

28 Quai de Javel, Paris, France, 1932

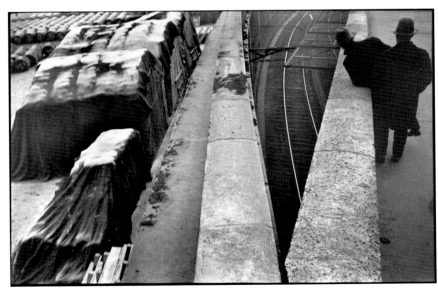

27 Quai Saint-Bernard, Paris, France, 1932

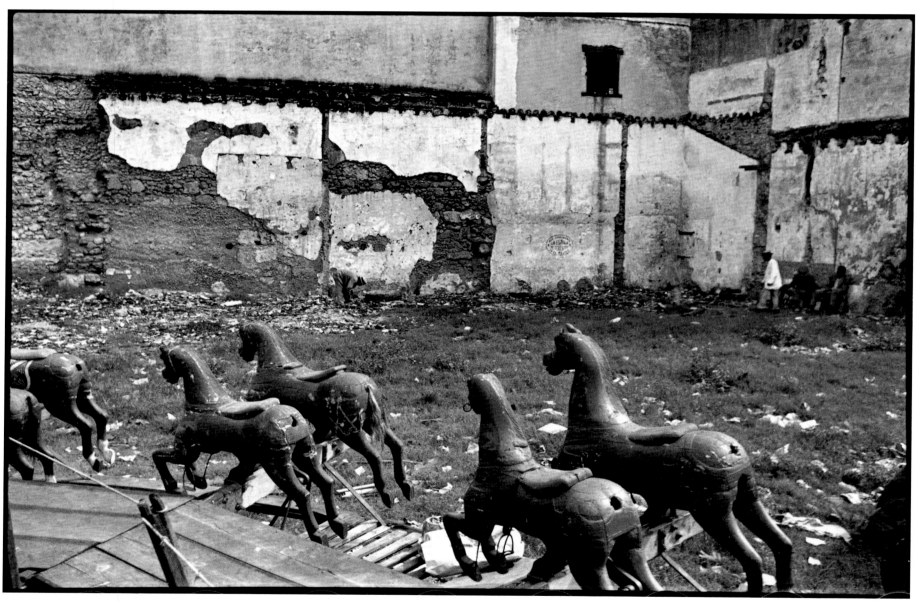

29 Havana, Cuba, 1934

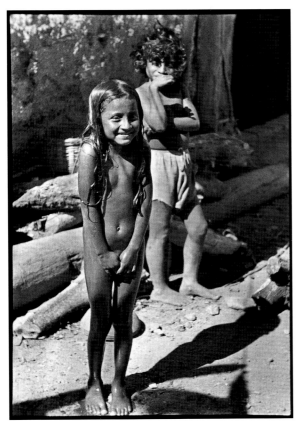

30 Mexico, 1934

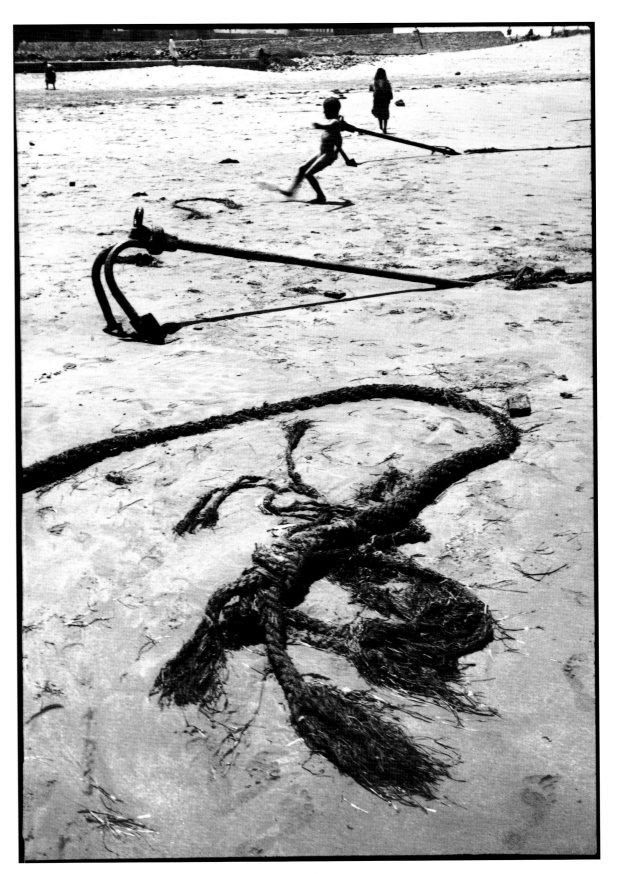

31 Asilah, Morocco, 1933

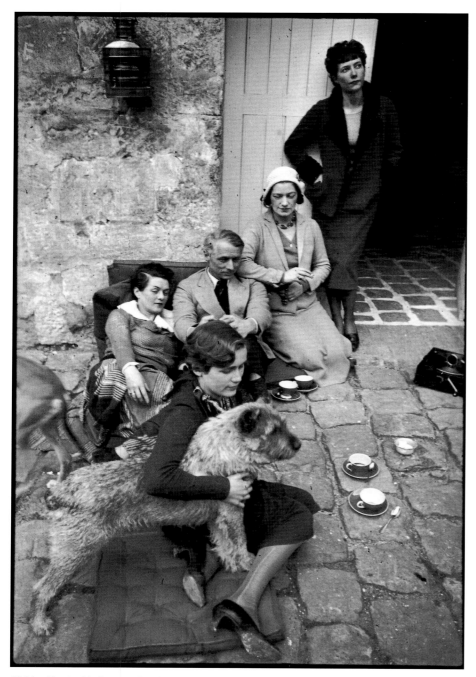

32 Max Ernst with Caresse Crosby on his left, Ermenonville, France, 1929

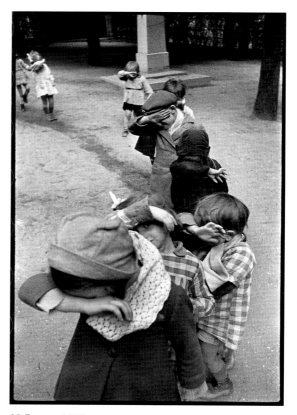

33 France, 1938

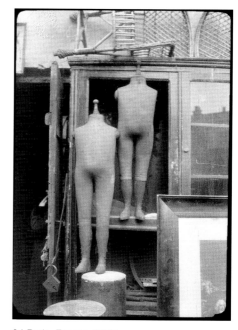

34 Paris, France, 1932

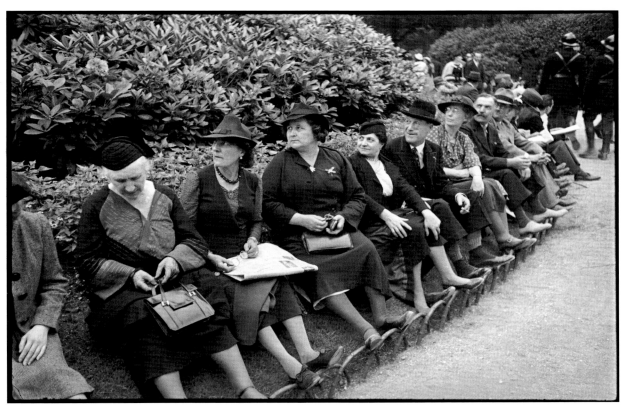

36 Visit of George VI, Versailles, France, 1938

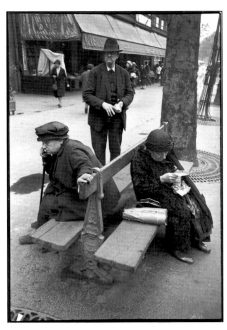

35 Paris, France, 1932

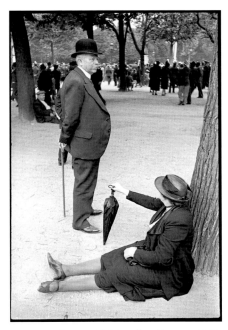

37 Visit of George VI, Versailles, France, 1938

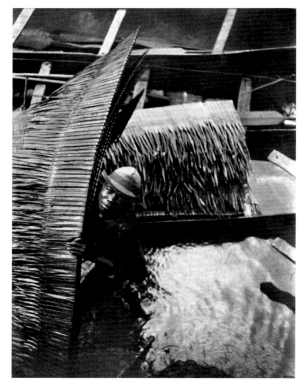

38 Ivory Coast, 1931

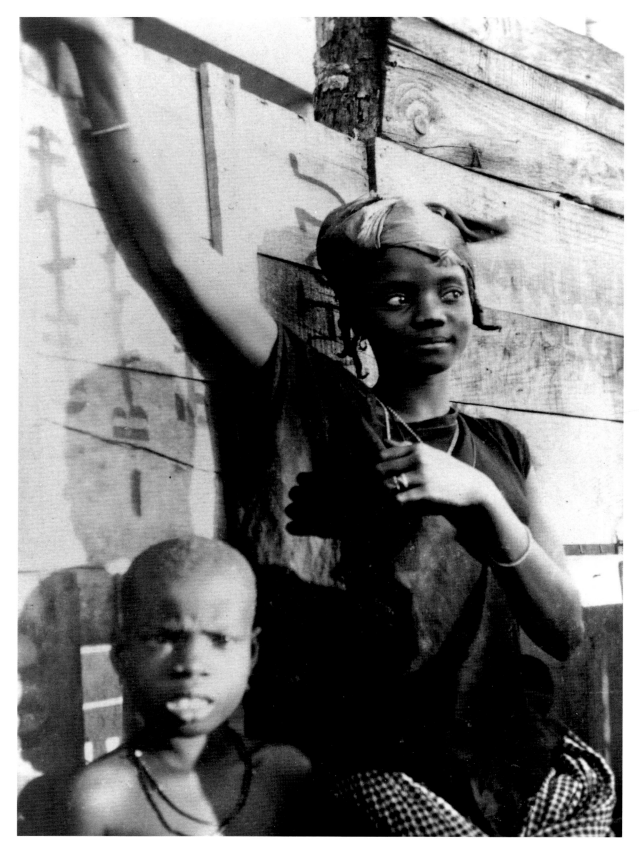

39 Ivory Coast, 1931

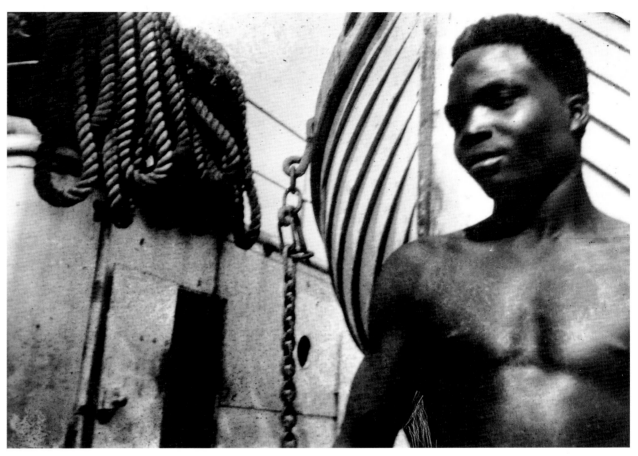

41 Ivory Coast, 1931

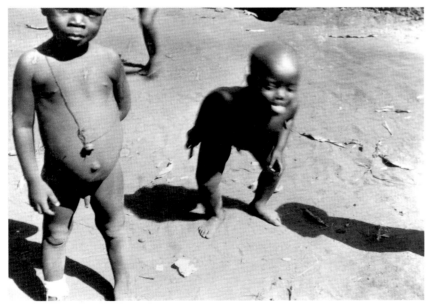

40 Ivory Coast, 1931

43

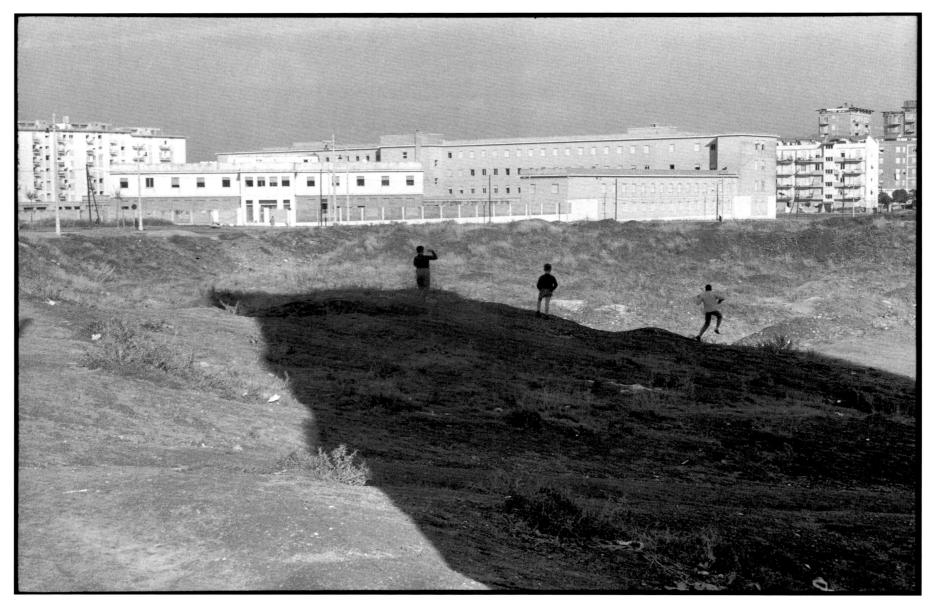

42 Rome, Italy, 1959

'The wise man is astonished by everything.'
André Gide

Rem tibi quam nosces aptam dimittere noli;
Fronte capillata, post est occasio calva.
Disticha Catonis, II, 26

'There is nothing in this world that does not have its decisive moment'
Cardinal de Retz

Kairos : The Idea of the Decisive Moment in the Work of Cartier-Bresson Jean Clair *Musée Picasso, Paris*

What the ancient Greeks meant by the word *kairos* was what we today would probably call something like 'the right time'[1]. It was a way of describing the opportune moment, the appropriate opportunity, the right occasion; a point, therefore, on a temporal scale, coming to mean 'time' itself in modern Greek.

Back in the archaic period, however, it was used to refer to a place, a critical position in space rather than time. In Homer, for example, *kairos* meant a nerve centre in the body, a crucial point, a vulnerable spot that could sometimes spell the difference between life and death.

In the many battle songs of the *Iliad*, there are several passages in which Athena, goddess of reason, intervenes on the hero's behalf by deflecting the path of the dart, arrow or spear that threatens him at the very last moment. She diverts it – in space – away from the critical spot, vulnerable place or *kairos* of the body, the chink in the armour that allows death to enter.

The original spatial definition of *kairos* relates to the eye's ability, back in a period of antiquity still governed by empiricism and largely ignorant of the art of measurement, to discriminate intuitively, to make a correct choice, to pierce exactly the right spot.

This ability, the clear-sightedness of a person who 'has a good eye', we might describe as *perspicacity* (to borrow from the Latin *perspicere*). Such a power of visual discrimination, such an ability to distinguish a particular point, anticipates what would later, with the development of modern geometry in the fourteenth century, become the art of perspective, a particular method of organizing space around a chosen point. A person with a 'good eye' possesses the ability to find the critical point around which the world organizes itself.

But this power of discrimination may be other things as well: it may be the doctor's power to discover, by means of palpation, the precise spot in the body, the lesion, weakness, or fissure, at which sickness entered. The doctor's skill resides in his ability to discern whether the wound is serious or not. *Kairos*, then, within the organism, is the essential and precise position of the wound, the body's vulnerable spot. Similarly, for the hunter, this power of discrimination lies in his skill at shooting an arrow accurately amid a tangle of undergrowth so that it hits its mark. For the helmsman, it is the art of detecting the way through a hazardous channel. And so on.

How did the change from one meaning to another occur, from the spatial to the temporal scale? How did the sense shift from describing the act of isolating the single infinitesimal point that may perhaps decide an individual's fate, to isolating the moment in time – equally decisive – that is capable of influencing events and thereby imposing a meaning on them? *Kairos* is to be understood in this context as the seizing of an opportunity that ought to be seized, a moment that is not to be missed, a decision that needs to be taken.

In one sense *kairos* is the opposite of *logos*: it is the decisive moment that marks a break in the continuity and logical progression of things, an intervention in the rhetoric of the world, an invasion, an incursion timed to occur at precisely the right moment to interrupt its flow.

Key to an understanding of how the sense shifted from the spatial to the temporal sphere is the example of the hunter, the image of the archer skilled with his bow. In Aeschylus's *Agamemnon*, it is said of Zeus that: 'He long kept his bow bent against Alexander until his bolt would neither fall short of the mark [*kairos*] nor, flying beyond the stars, be launched in vain.'

Here the notion of choosing an appropriate location in space, or a decisive spot on the body, is precisely superimposed onto the idea of choosing the right moment in time for the decision, the ability to decide which moment is the decisive one, or in other words, *kairos*. In this instance the notion of *kairos* oscillates between a particular apprehension of space and a specific understanding of time. The doctor too, who, as we have seen, exercises an understanding of *kairos* in space, also exercises an understanding of *kairos* in time when he decides at what moment he should intervene, by leaving the sickness to gestate, to reach its crisis or critical point, before he makes his intervention.

The most interesting aspect of this enlargement of the primary sense of *kairos*, initially relating to space and then tied specifically to the moment, is that it occurred during the period when Greece was experiencing the growth of *technai*, what we would call art or fine art. For the Greeks, however, art was not a spontaneous outpouring of genius, as we like to think of it today. It was a whole body of knowledge that was passed on through teaching, and that, little by little, placed the eye at the service of the mind; it was the exercise of a practice in which technical mastery, that is, knowledge, was indissolubly combined with intuition, the mental acuity and speed of thought rooted purely in sensibility – or art, in the modern sense of the word. *Technè* is the art of the painter, the sculptor and the architect, but it is also the art of the archer, who fires his arrows with skill; *technè* is the art of the orator who similarly launches shafts (of wisdom), who knows how to find just the right word, who achieves the perfect expression of his thoughts; *technè* is the art of the doctor, when the knowledge of the practitioner is allied with the intuition of the healer in tracing

the body's vulnerable spot; and it is also the art of the potter, his fingers skilled at probing the right form within the clay.

At the moment when Greek culture reached its apogee, when astronomy, mathematics, music, medicine, tragedy and architecture were at their height, the rare and complex phenomenon of *kairos* became both much more common and more specific.

A boundless wealth of knowledge was generated by the rapid growth of the sciences and the arts, of medicine, rhetoric, strategy, politics, the art of building and the art of healing, the art of convincing and the art of persuading. The new spirit made a science of everything. The extraordinary complexity of knowledge reflected the complexity of the world itself. This overflowing, chaotic cornucopia, this embarrassment of riches, this prolixity and profusion, was called *poïkilia*. To master it, to make sense of it, to 'see clearly' in the new confusion of knowledge, to preserve the eye's power to discriminate and continue to make sense of the multiplicity of events, it was necessary to demonstrate a new wisdom and a new precision. That power, the capacity to discriminate, to judge and to choose, was called *acribie*. Faced with the infinite diversity of factors governing any action, and having to consider on each and every occasion what the circumstances might demand, it became more necessary than ever, in the absence of any fixed and immutable rule (which would be supplied eventually by a science then still in its infancy), to master the superior apprehension of time and place that is *kairos*.

The enhanced role of *kairos*, implying as it did the ability to choose the opportune occasion, the critical or decisive moment, was even given a religious sanction. At the end of the classical period, Kairos became a god, Zeus's youngest son.

From these modest attempts to summarize this complex idea, it will already be apparent how much photography, science and art in general, and the art of Henri Cartier-Bresson in particular, owe to the *kairos* of antiquity.

It may initially seem strange to discuss an art form that is rooted in modern technology and still so new – only a little over a century old – in terms of concepts that go back to the very beginnings of Western thought. And yet, one can see how precisely relevant they still are. The advance of technology, the growth of knowledge, they are neither here nor there, for as the centuries roll by, it is exactly the same action that is being repeated, and precisely the same energies that are mobilized.

Lining up a shot through a viewfinder and clicking the shutter to capture a particular configuration of the world, the expression of a face or the unfolding of a landscape, may seem a simple matter; yet that trivial and apparently mechanical act in fact presupposes a whole philosophy,

ethical framework and body of knowledge that are those of the ancient world. Implicit in the act is one of the most fertile and illuminating concepts of ancient philosophy. Its performance brings into play intellectual frameworks without which neither Greek tragedy, nor Plato, nor the Parthenon would ever have seen the light of day.

It seems that the photographer, armed with his small Leica, is none other than a reincarnation of the thinker at the dawn of our culture who established the very foundations of Western thought armed simply with a tablet and a stylus and guided very often by nothing more than his own sensibility and a few rare ideas of algebra and aesthetics.

When Henri Cartier-Bresson writes that a photograph, for him, is 'the simultaneous recognition in a fraction of a second of the significance of an event as well as of a precise organization of forms,' he is actually spelling out a rule of etiquette. To discover the 'decisive moment' is effectively the same thing as to arrive 'at precisely the correct time', neither too early nor too late; in other words, a rule of ethical and social behaviour on which an exact consensus can be reached with contemporaries. It is a question of being in tune with the times (and of being better at it than anyone else) like tuning an instrument before playing. By inference, it is also a rule of aesthetics, incorporating concepts of beauty, the measure or equilibrium of things and the *kairos* capable of apprehending them in an instant. Cartier-Bresson is saying the same thing as Plutarch in his *Moralia*: 'In all works of art, beauty is, so to speak, the product of a large quantity of numbers that achieve a single *kairos* by means of a system of proportion and harmony.'

Kairos exists in the blink of the photographer's eye, it is the phenomenon of hitting the mark in space and of hitting it at precisely the right time. Up it pops, at the exact dazzling moment when the screen of the world seems to open up, tear apart, yawn or gape before you, only to close up again immediately afterwards. It is, to introduce a semi-religious concept, the *propitious* moment, the moment when the gods smile upon you. It is seizing chance on the wing. It is the unreflecting gesture that lands exactly where it is supposed to – the winged gesture. In Homer there are many references to 'winged words'. The comparison is with arrows: *mots justes* are words that carry, words that are accurately aimed. The photographer anticipates just such a successful flight when he asks you to 'watch the birdie'. In the blink of his eye he unleashes something like one of Homer's winged words, something that hits the mark, something light, quick and insubstantial. Almost like a shaft of wit. It is, if you like, Henri Cartier-Bresson at play, a sort of subversive Scarlet Pimpernel underneath his disguise as the perfect gentleman, the sober reporter of twentieth-century life. You can see what it was in him that made him brush with the Surrealists, admiring as he did their taste for the bizarre, for strange juxtapositions and the fantastic.

At the same time, it is what distinguishes him from them. If *kairos* is the opposite of *logos*, in that it interrupts the smooth logical flow, it is also the opposite of *tuchè*. *Tuchè* is chance, and *kairos* is the opposite of chance. *Kairos* is a correct decision, one that has its effect where it should and when it should. It is on the side of necessity, not contingency, and that is why it was classed in ancient Greece along with *kallos*, 'beauty', and *summetria*, 'harmony', which for the ancients meant the harmony of the parts in relation to each other and of the parts within the whole. *Kairos*, the decisive point, is a point of equilibrium. It has nothing to do with the sudden intervention of chance, disrupting the phenomenological order.

That is the fundamental difference between Cartier-Bresson and his Surrealist friends. It has often been claimed that in his early work he was heavily influenced by Surrealism, and the so-called 'objective' magic of chance. Another friend of the Surrealists, the eminent psychoanalyst Jacques Lacan, developed a world view very similar to theirs. He made *tuchè*, or chance, one of the cornerstones of his clinical practice, viewing it as the *encounter with reality*, evidence of the return, re-emergence and persistence of signs under the pleasure principle.[2] But that, we should be in no doubt about, was because he was influenced by André Breton, and not because he believed in any sort of primitive magic. Cartier-Bresson is a different case altogether. He never, in my belief, left things to chance. As an artist, he is in control of phenomena – sunshine and shade, brightness, the movement of leaves or crowds – just as he is also in control of events, to the extent at least that he is able to predict them. *Kairos* is that control.

Thus the photographer is someone who remains always on the alert, without ever succumbing to *acedia*, or 'nonchalance', even though he is surrounded by the constant confusions of the visual world, the unceasing and unpredictable bustle of events.

'Nonchalance' was the word Cartier-Bresson used to accuse people whose attitude was 'what does it matter to me?' or, in modern parlance, 'it's not my problem': that routine expression of generalized indifference so common among our own contemporaries. For the photographer, the world does matter, it matters at every moment, he never lets his eyes stray from it. He is not unlike like those holy men in the Far East who ensure the prayer wheels are kept turning. If they were ever to stop, the world would come to an end. The photographer is the guardian of the visible world, and the roll of film in his camera is his prayer wheel. He is the physician of the visible world. He preserves it and keeps it safe. It is because there are images of the world that it continues to exist before our eyes.

For he has the capacity to capture the precise moment when events make sense within the order of the logical universe, at the same time that they arrange themselves harmoniously within

the order of the physical universe. When *logos* and *cosmos* come together, that instant in which the order of the world releases a meaning, like a poem in celebration of the event, that is *kairos*.

That brief and intense moment when the world, so to say, reveals itself, before the waters roll back and chaos returns, when light and shade are perfectly in balance before they merge, in which form emerges from amid a confusion of forms – that moment the photographer, the patient observer of the world, is there to capture.

'Our eye should constantly measure, evaluate. We modify perspectives with a gentle flexing of the knees, we make lines meet simply by moving the head a fraction of a millimetre, but that can only be done with the speed of a reflex, so that it prevents us from trying to make Art.'

The photographer manoeuvring his camera, lining up his view of the world and determining the moment for his shot, is no more reliant on a science of photography than the hunter, the physician, the orator or the potter were reliant in their art, their *technè*, on the abstract rules of a universal science (destined one day to materialize as the rules of scientific perspective, for example, or dictates on colours from the French Academy). No, the photographer goes with the flow, he lets himself drift, while remaining always on the watch for the slightest thing that might happen.

In the *Republic*, Plato was the first to identify this inability of the human mind to apprehend, not the incidental, but the universal amid the endless confusions of the real world: 'The differences of men and their actions, and the endless irregular movements of human things, do not admit any universal and simple rule. And no art whatsoever can lay down a rule which will last for all time.'

Faced with the fleeting nature of the visible world, and unable to draw his inspiration from the canons of any 'Art', the photographer, who deals with the relative and not the absolute, with incident and not substance, resorts to a sort of pre-scientific approach. This form of subliminal recognition has 'the speed of a reflex', as Henri Cartier-Bresson puts it, which, if directed towards the currents of the real world – borne along like a barque on the waters – is the same as that associated with the *kairos* of antiquity.

This type of mercurial, or perhaps hermetic, intelligence is effectively of the same order as the archer's skill with his bow, his ability to fire his arrow without reflection, with all his being mobilized and directed towards his goal. It permits self adaptation to the constantly shifting and unstable nature of things by a necessary and continuous flexibility. In this way it is able to operate in an infinite variety of circumstances.

The type of interruption discussed above, that leap of the sensibility associated with *kairos* as it breaks through the prevailing *logos*, is exactly the same as what Cartier-Bresson – that

light-footed Hermes (god not only of commerce but of robbers) – so clearly equates with crime and violation: 'I walked the whole day on tenterhooks, searching the streets in order to snatch photos, as it were, in flagrante delicto.'

But even in his criminality, that thief of reality, the photographer, is also its judge. It is because he is faced with the problem of a reality that cannot be reduced to a universal rule of understanding (or because no universal body of knowledge can be congruent with the real world), that the man of the real world par excellence that is the photographer, and even more so the reporter, relies instead on that infinitely subtle understanding deployed not only by entomologists, but by all those who practise hunting, war or navigation: not rational cognition, not wise *logos*, but the instinctive recognition of the decisive moment that is *kairos*. The photographer, the potter, the helmsman, the cab driver – all possess a singular flair, a cunning intelligence, that *métis*, or hybrid form, that Jean-Pierre Vernant, not without justification, equates with *kairos*, susceptible neither to logic nor to academic art, and capable only of being applied to the multiple and protean realities of the world.

The photographer's eye, like the physician's or the hunter's, is capable of singling out from the infinite variety of shifting circumstances of the world one specific sequence of risks and opportunities. The photographer deals with the particular case, extrapolating from no law or universal concept. Among all the possible factors of reality, he recognizes the decisive moment, or *kairos*, when a particular image makes sense amid the chaos. *Kairos* is the art of predicting and particularizing, of prognosis and of cure. Like any great artist, the photographer cures us of real life, he helps us bear it and even love its burdens, because he isolates the point at which two timescales meet: the point of intersection between the maturation of the past and the burgeoning of a crisis in the making. He effects his intervention in the flow of time with infinite tact and accuracy. He clicks the shutter, dividing time into two, with all the precision of the beam lying level on its balance.

His camera is his balance. Like a judge, he weighs up the world, in the image of Vermeer's woman with her scales, weighing the motes of light that are her pearls. At times he is also a seer, predicting in a millisecond what is about to happen next – which may be the murder of a member of the government. 'The condensed form of thought that is the language of photography', as Cartier-Bresson puts it so acutely, 'has a great power [which is] that of a making a judgment on what we see, and that implies great responsibility.'

Human time is not homogenous time. It has its ups and downs. It speeds up and slows down. It is a time of ripening and of decay. And sometimes, rarely, a time of immobility, or a time

of catastrophe. Time is living. It is not the same as the time of machines, which is a time of repetition, that produces identical objects. Human time waits, hopes and finds. It is the time associated with the work of art, not the production line. *Kairos*, in this context, relates to man's intimate understanding of time, more to do with Mnemosyne, sweet memory, than with Chronos and his terrible scythe. It is because he remembers that he can predict, it is because he has seen that he can anticipate. A doctor should never forget that he is dealing with time when he attends a patient who is, as we say, 'chronically' ill. Nothing repeats itself. The photographer, the artist, they are the proof of it. The photographer never stands still, because he remembers. His mastery is not academic but 'chronic', or 'temporal', he is the master of time. Hence that meteoric sensibility of Cartier-Bresson. It is bringing the temporal back to the spatial sphere: pinning down the *kairos* of a moment, the weather at a particular moment of the day, in a particular place. Some of Cartier-Bresson's finest photos are studies of weather conditions, cloud lifting in India, evening shadows in Flanders. I understand why he was so fond of Bonnard.

Anyone who knows him, anyone who has ever seen him walking, light, airy, on the tips of his toes, anyone who has seen him taking photographs, his camera concealed in his palm, silent, invisible, will not be too surprised to discover in him a resemblance to the famous statue of Kairos by Lysippus, described in an epigram by Posidippus in the third century BC in which the following dialogue takes place between Kairos and a passer-by:

> You, who are you?
> I am Kairos, the master of the World!
> Why do you run on tiptoe?
> I am always moving on.
> Why do you have winged feet?
> Because I fly like the wind.
> Why do you hold a blade in your right hand?
> To remind men that I, Kairos, am sharper and swifter than anything.

Jean Clair is Director of the Musée Picasso, Paris

1. For the following account of *kairos*, we are indebted to Monique Trédé's *Kairos. L'à-propos et l'occasion*, Paris : Klincksieck, 1992. Also recommended to any reader wishing to learn more about the subject are: Henri Ellenberger, 'La notion du *kairos* en psychothérapie', in *Médecines de l'âme*, Paris : Fayard, 1995, and the entry on '*Le moment opportun*', in *Les Présocratiques*, La Pléiade, Gallimard, 1988, p. 1521.

2. Jacques Lacan, *Le Séminaire*, book XI, Paris, 1973, p. 53 onwards.

'I saw him, understand, I saw him, saw him with my own eyes,
what I did is described as seeing.'

Molière

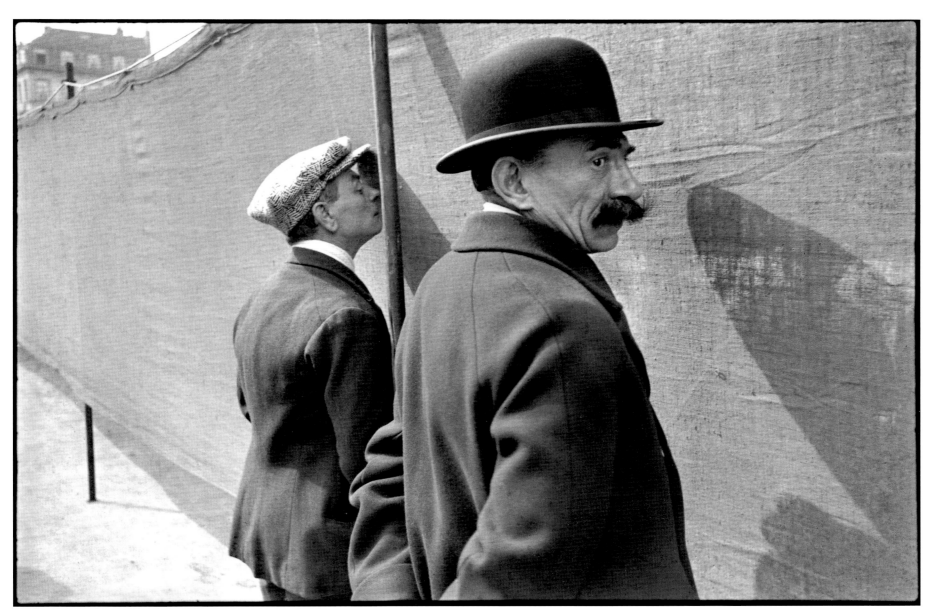

43 Brussels, Belgium, 1932

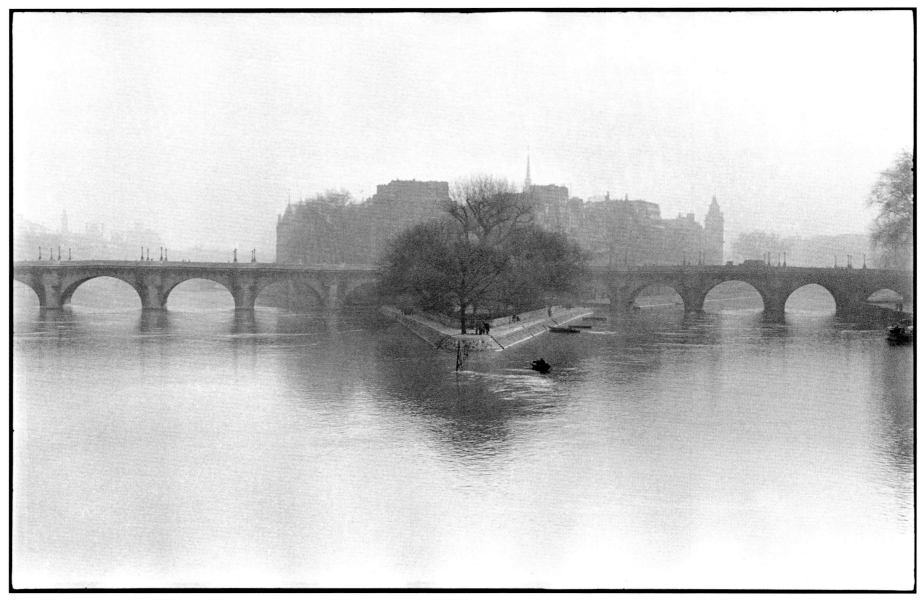

44 Ile de la Cité, Paris, 1951

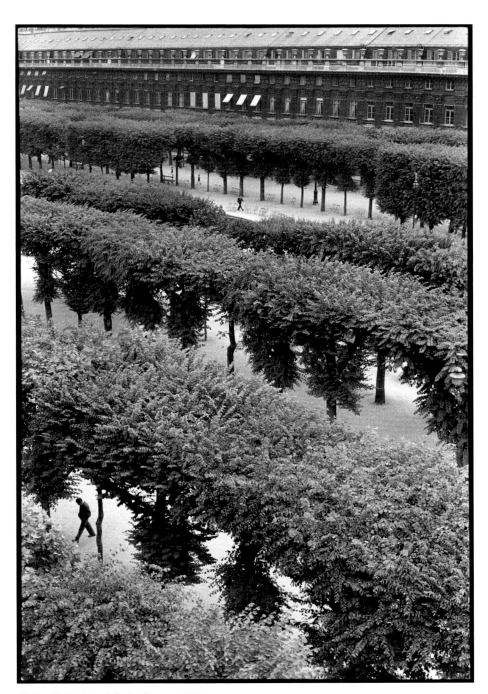

46 The Palais-Royal, Paris, France, 1959

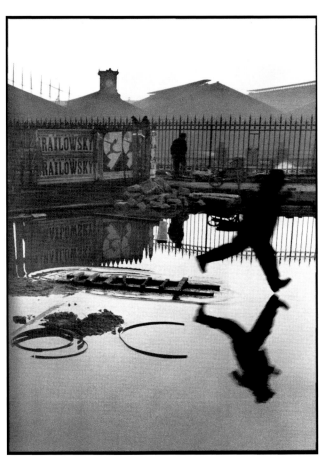

45 Behind the Gare Saint-Lazare, Paris, France, 1932

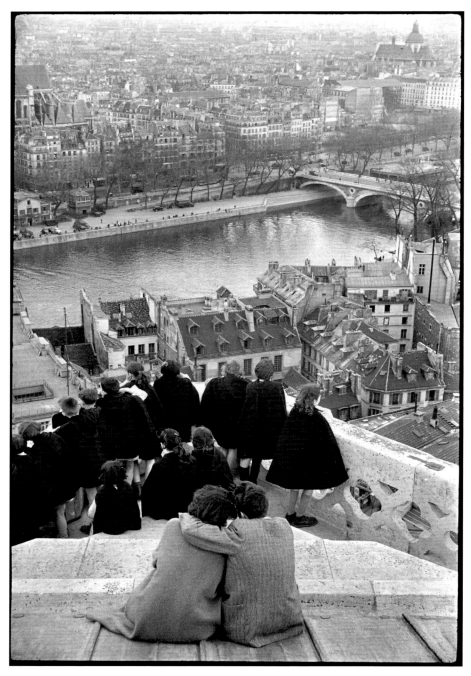

47 Paris, France, 1953

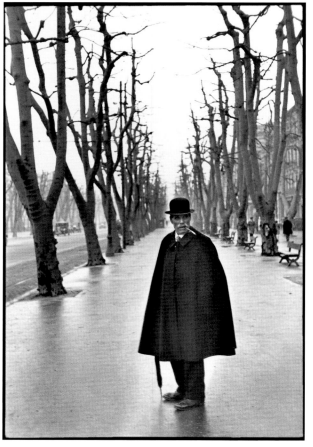

48 Allées du Prado, Marseilles, France, 1932

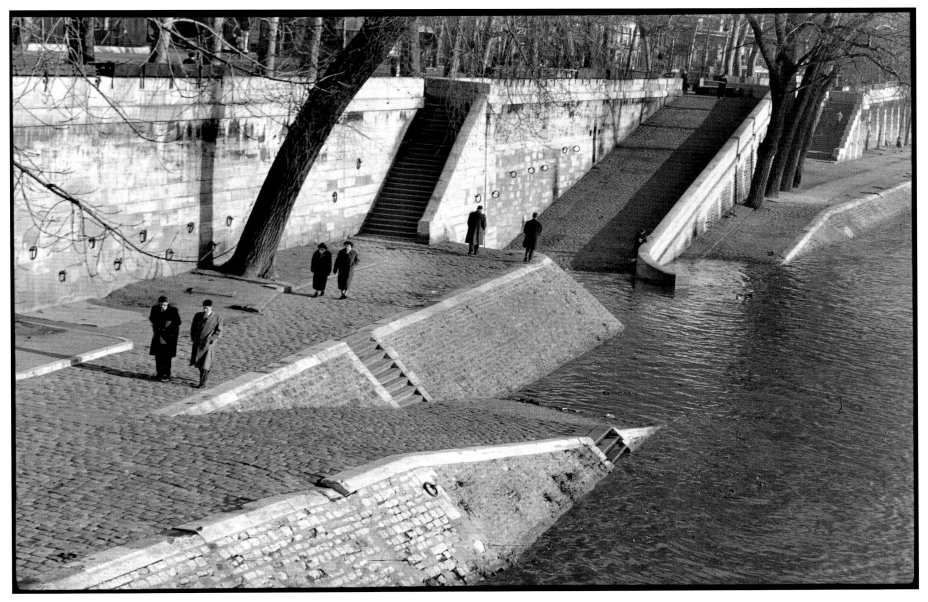

49 Paris, France, 1956

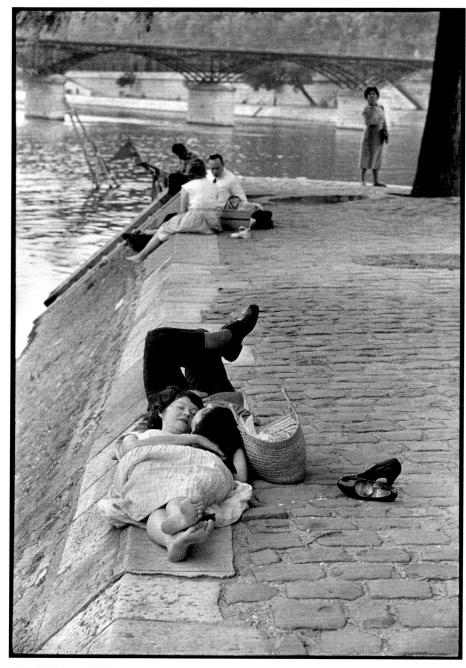

50 Paris, France, 1955

HENRI CARTIER-BRESSON

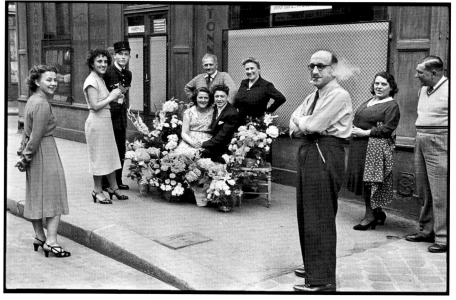

51 Paris, France, 1951

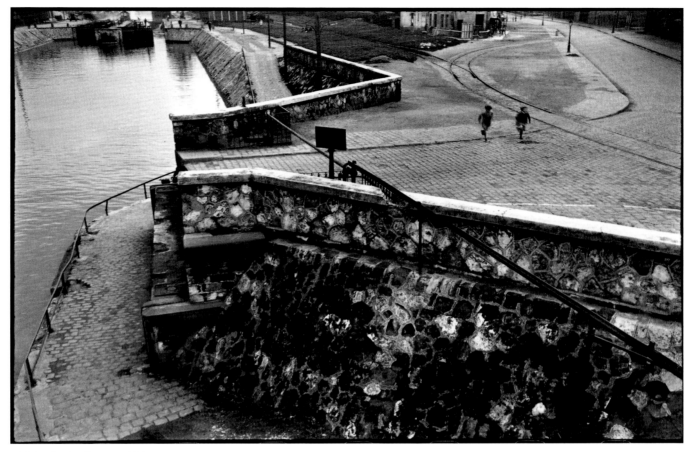

53 Saint-Denis, France, 1932

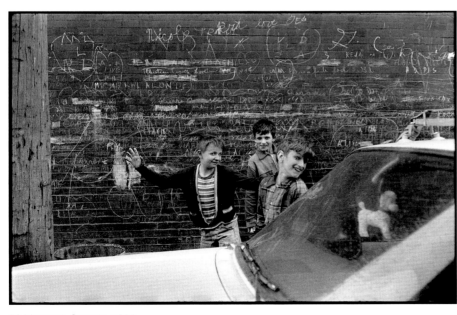

52 Montreal, Canada, 1965

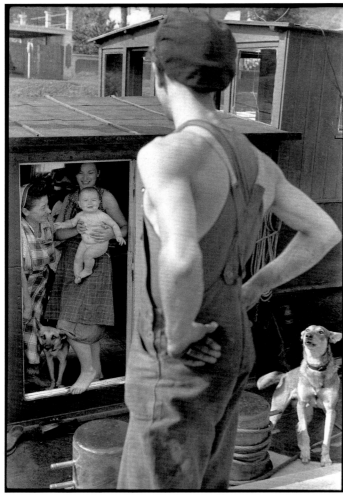

54 Locks at Bougival, France, 1955

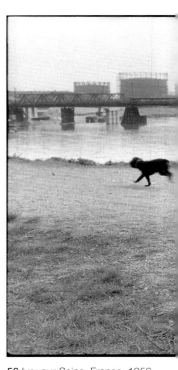

56 Ivry-sur-Seine, France, 1956

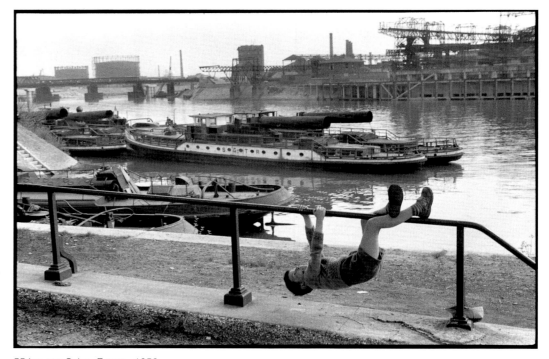

55 Ivry-sur-Seine, France, 1956

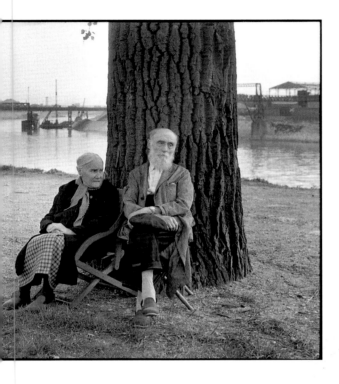

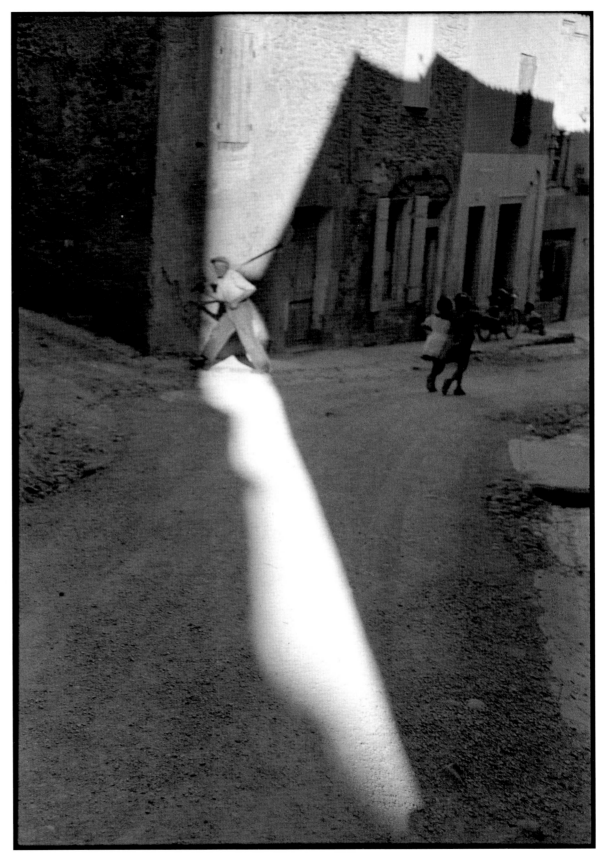

57 Tarascon, France, 1959

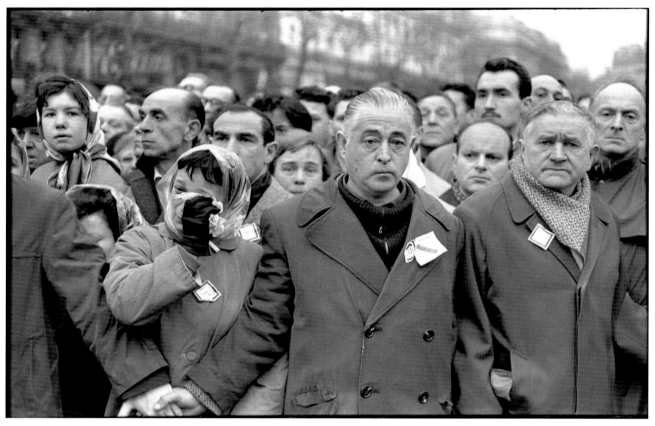

58 Funeral of the Charonne victims, Paris, France, 1962

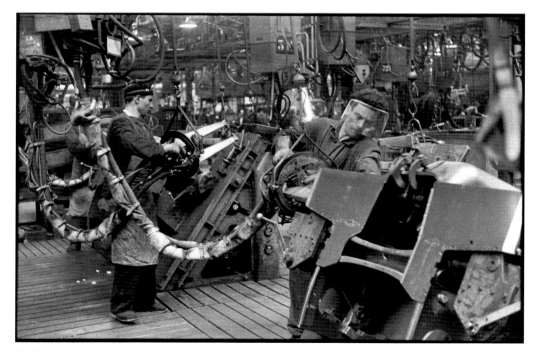

59 Citroën factory, Paris, France, 1959

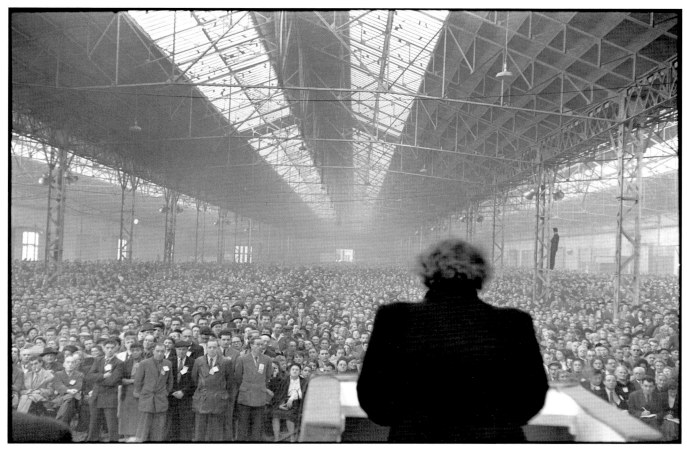

60 Political rally, Parc des Expositions, Paris, France, 1953

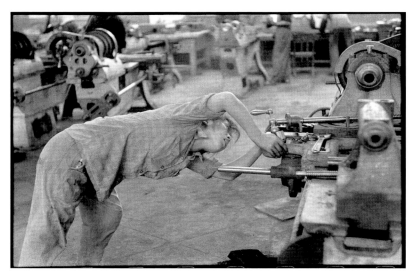

61 The Great Leap Forward, China, 1958

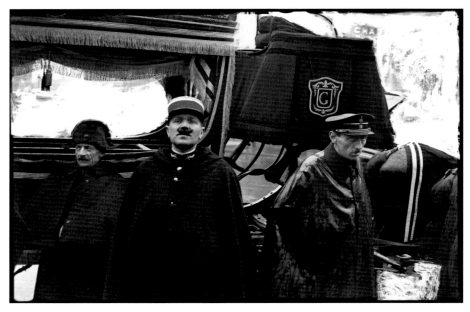

62 Funeral of the comic actor Gallipeaux, Paris, France, 1932

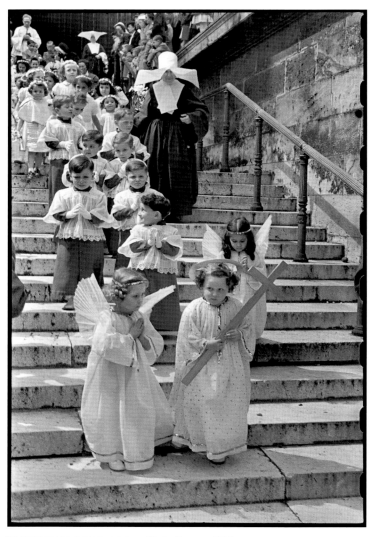

63 Corpus Christi procession, Paris, France, 1951

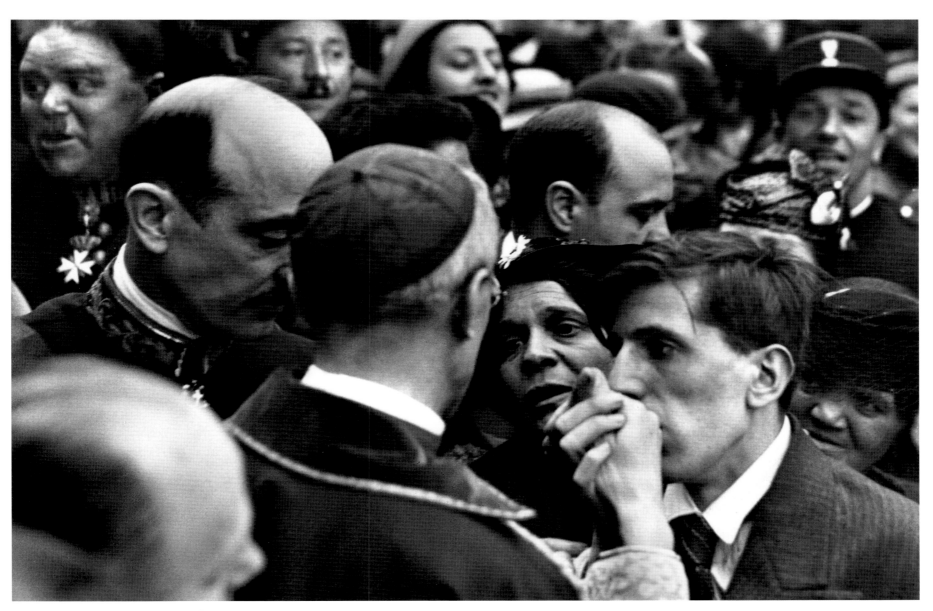

64 Cardinal Pacelli in Montmartre, Paris, France, 1938

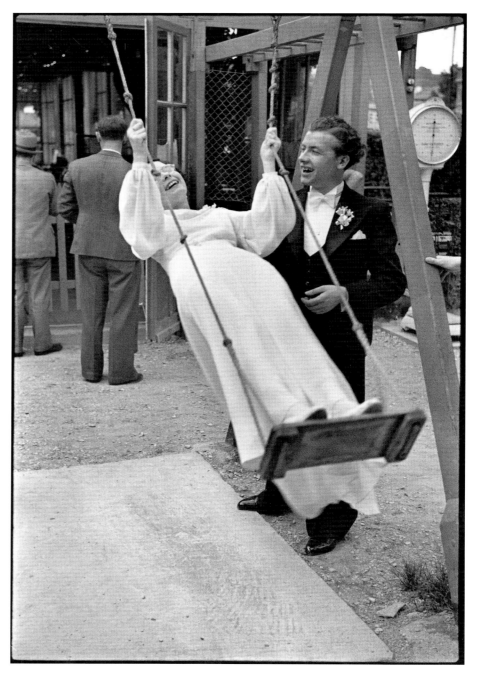

66 Joinville-le-Pont, France, 1938

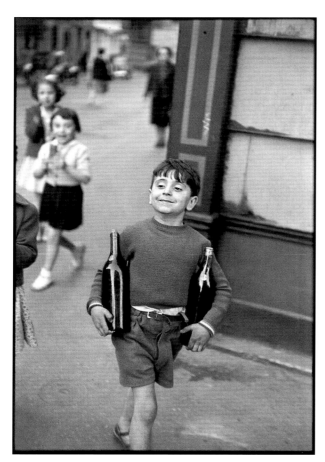

65 Rue Mouffetard, Paris, France, 1952

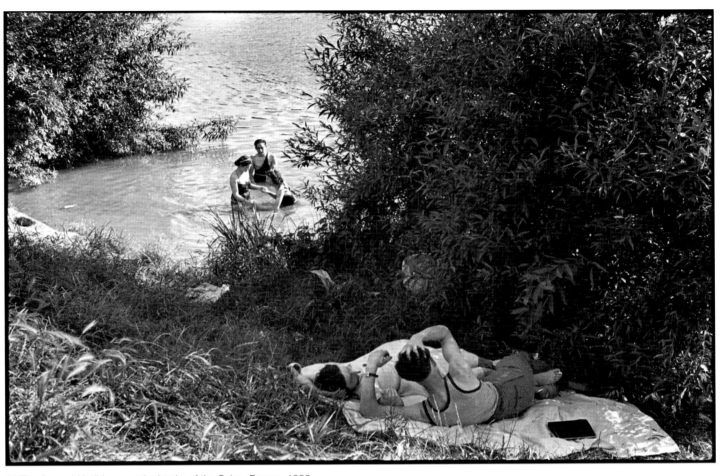

68 The first paid holidays, on the banks of the Seine, France, 1936

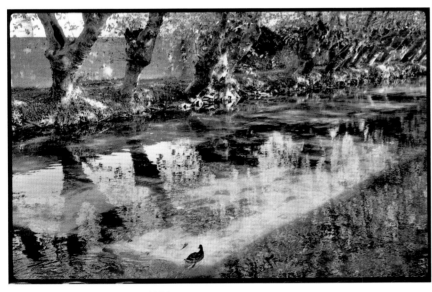

67 Isle-sur-la Sorgue, France, 1988

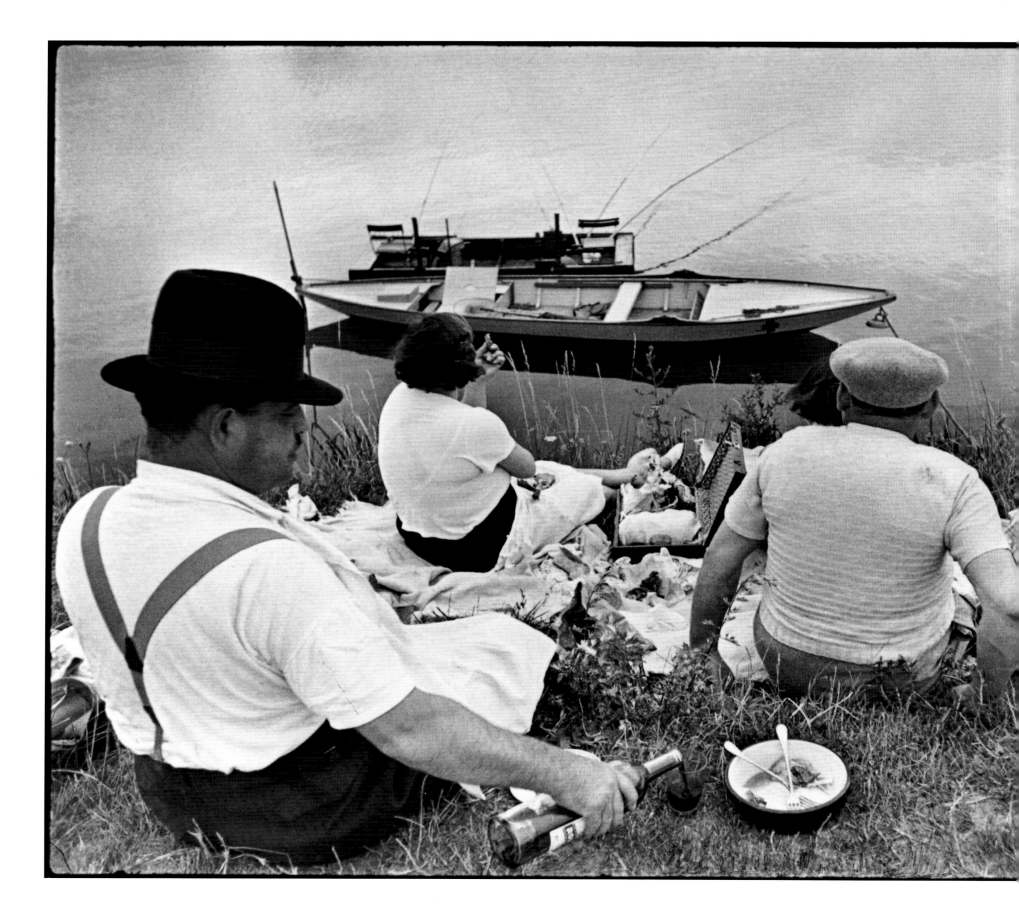

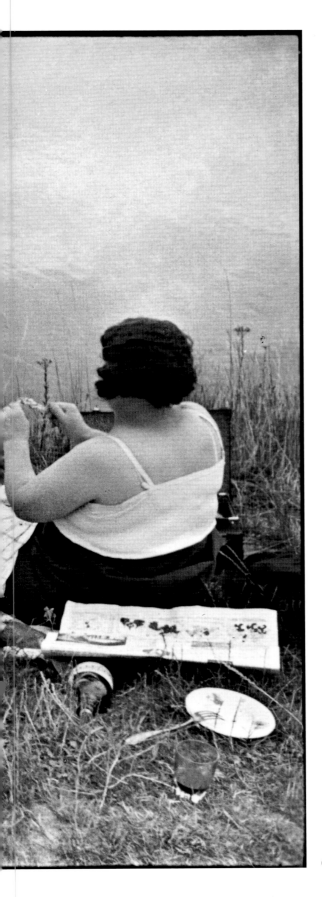

69 On the banks of the Marne, France, 1938

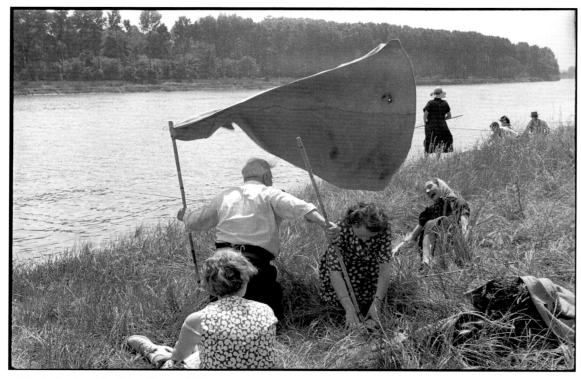

70 On the banks of the Seine, France, 1955

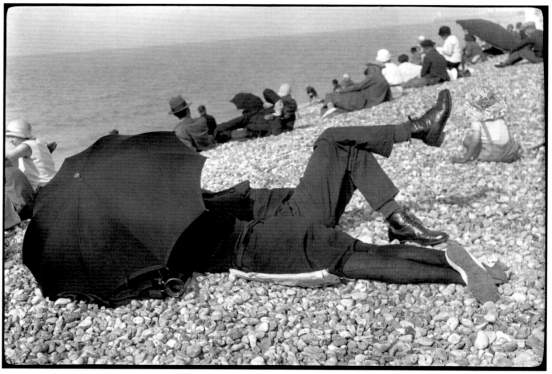

71 Dieppe, France, 1926

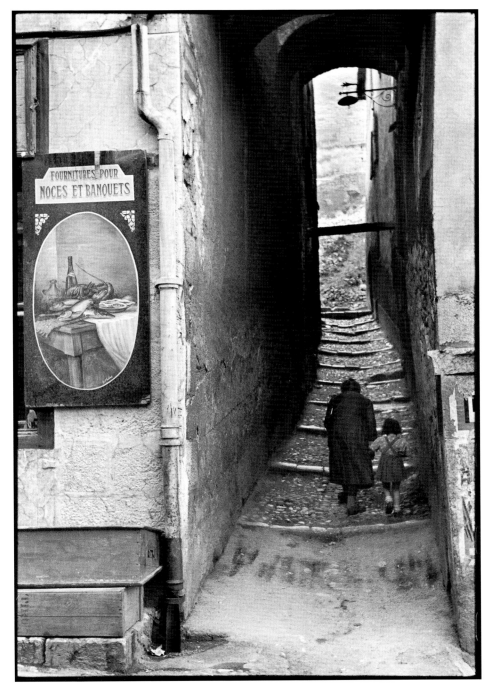

72 Briançon, France, 1951

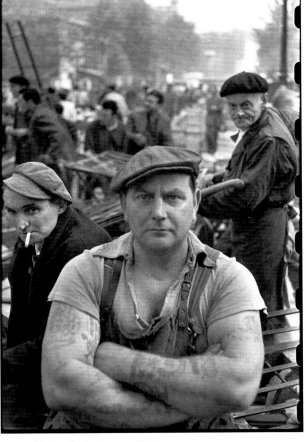

73 Les Halles, Paris, France, 1952

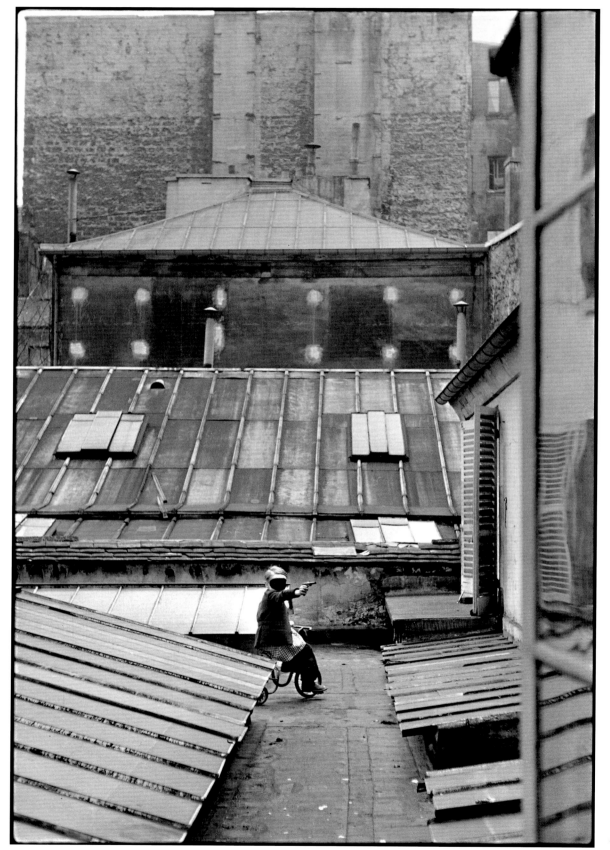

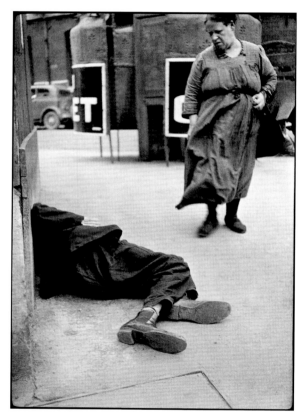

75 La Villette, Paris, France, 1929

74 Paris, France, 1953

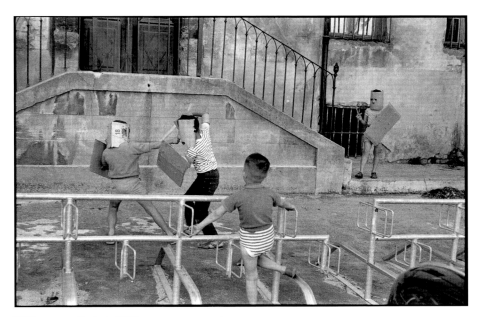

77 Tarascon, France, 1959

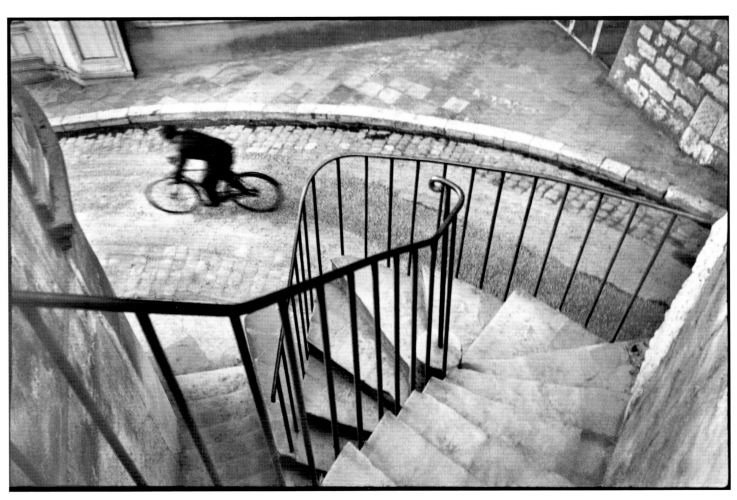

76 Hyères, France, 1932

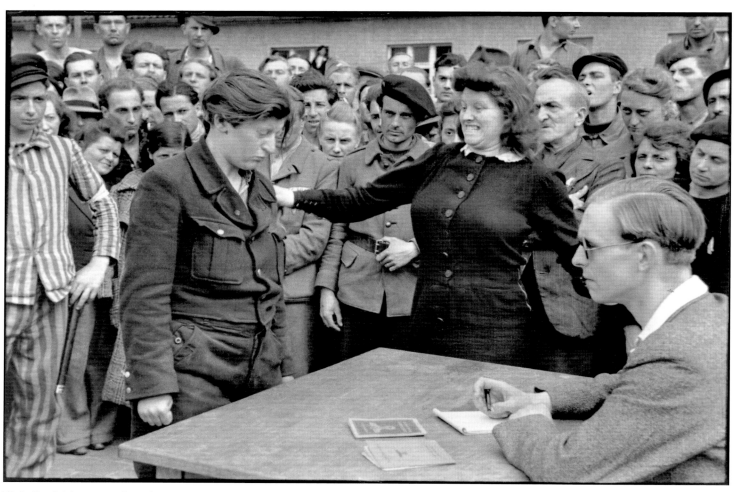

79 As the detainees are released, a woman prisoner in a concentration camp recognizes the Gestapo informer who betrayed her, Dessau, Germany, 1945

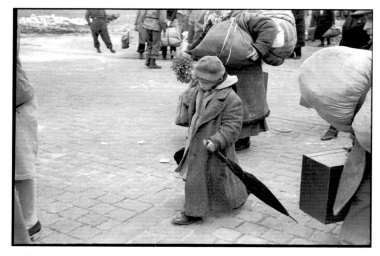

78 Russian child released from a concentration camp, Dessau, Germany, 1945

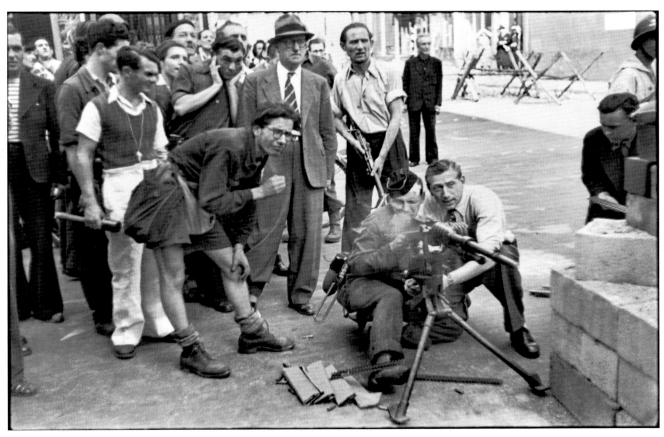

81 Liberation of Paris, France, 1944

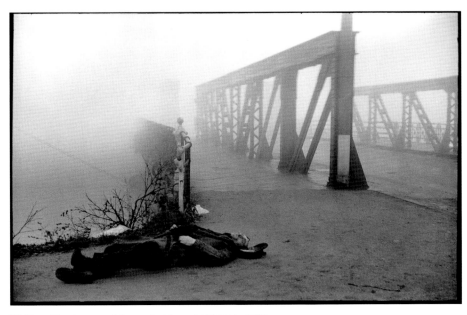

80 Near Strasbourg, at the end of the war, France, 1944

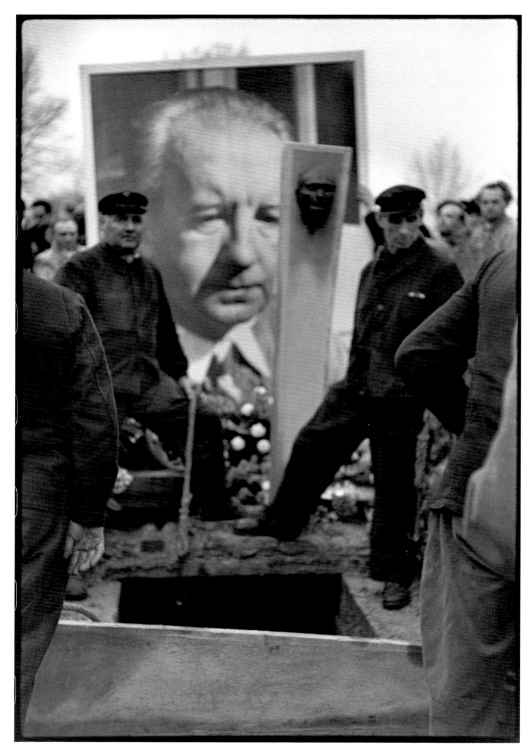

82 Funeral of Paul Eluard, Paris, France, 1953

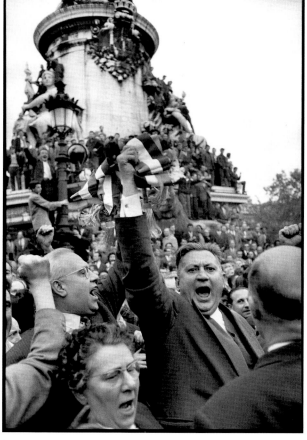

83 Demonstration, Paris, France, 1958

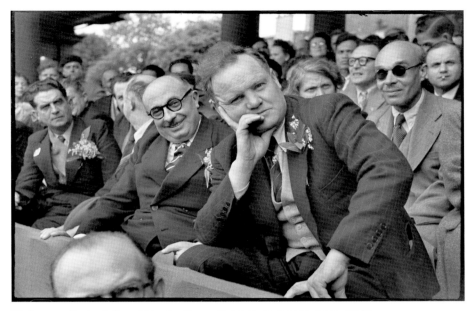

85 Jacques Duclos (left) and Maurice Thorez (right), Paris, France, 1 May 1946

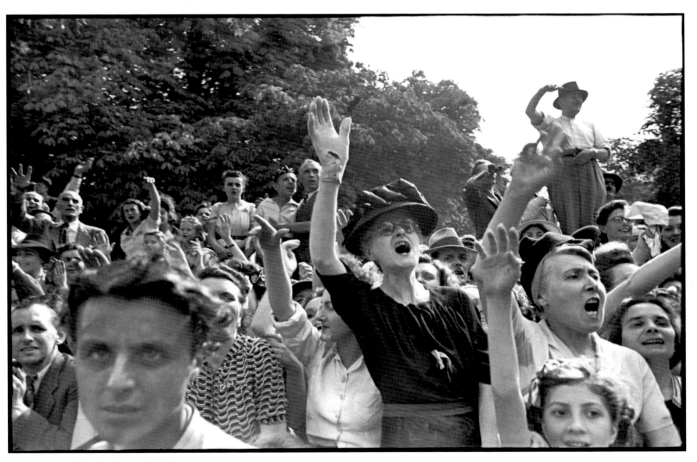

84 Liberation of Paris, France, 1944

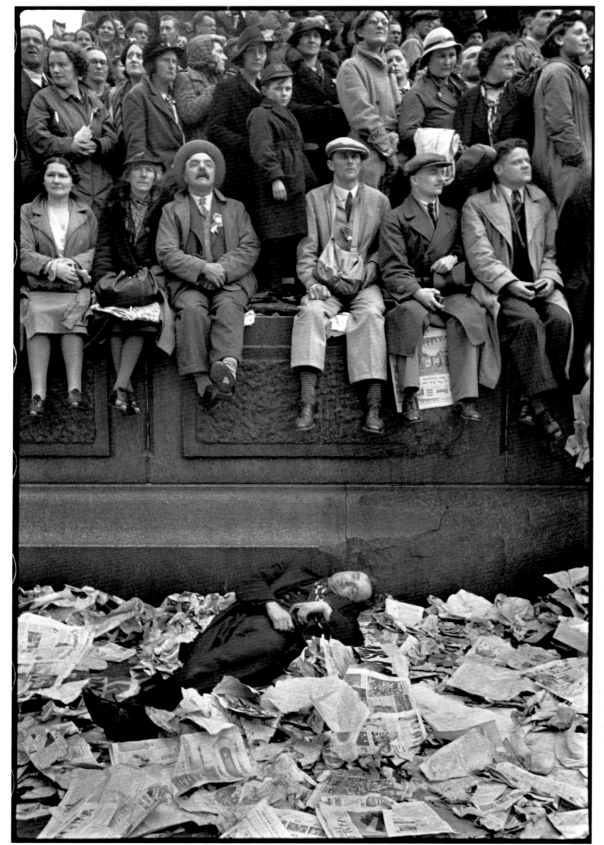

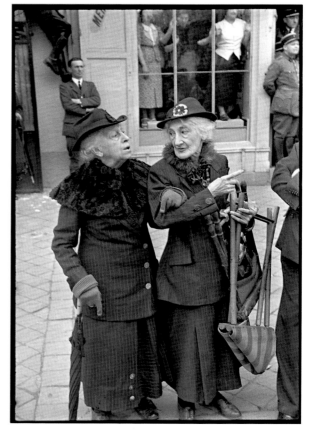

87 George VI's visit to Versailles, France, 1938

86 Trafalgar Square on the day of the coronation of George VI, London, Great Britain, 1937

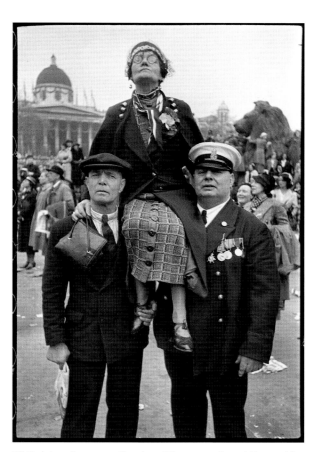

88 Trafalgar Square on the day of the coronation of George VI, London, Great Britain, 1937

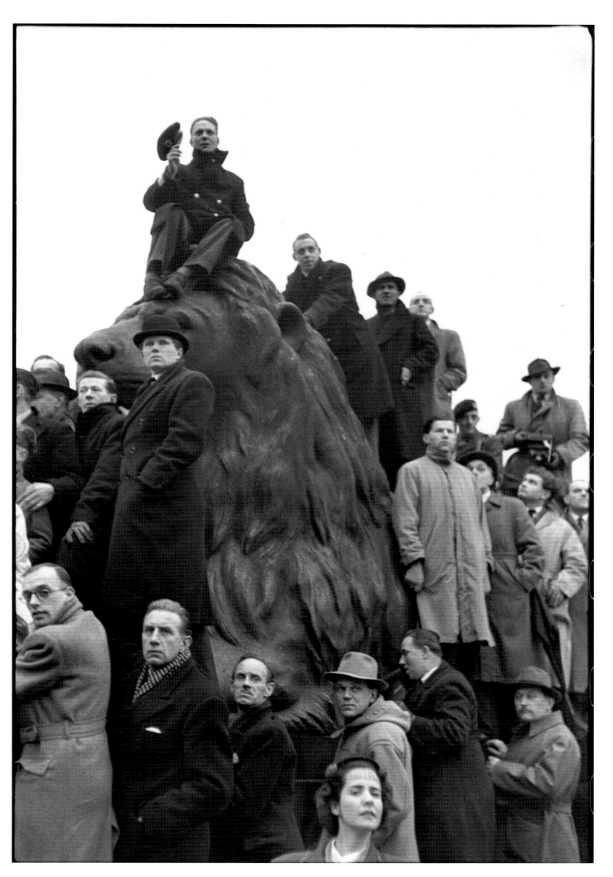

89 Funeral of George VI, Trafalgar Square, London, Great Britain, 1952

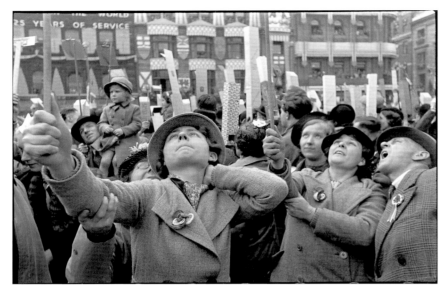

90 Coronation of George VI, London, Great Britain, 1937

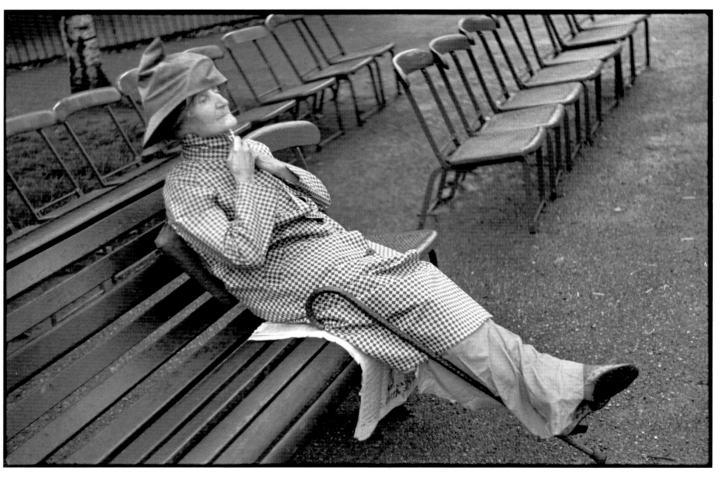

91 Hyde Park, London, Great Britain, 1937

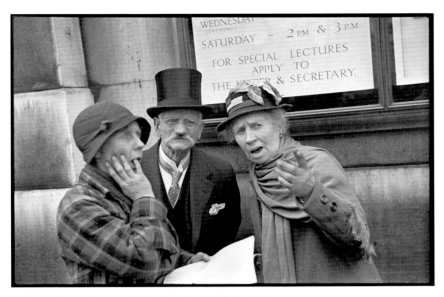

92 Coronation of George VI, London, Great Britain, 1937

93 Ireland, 1962

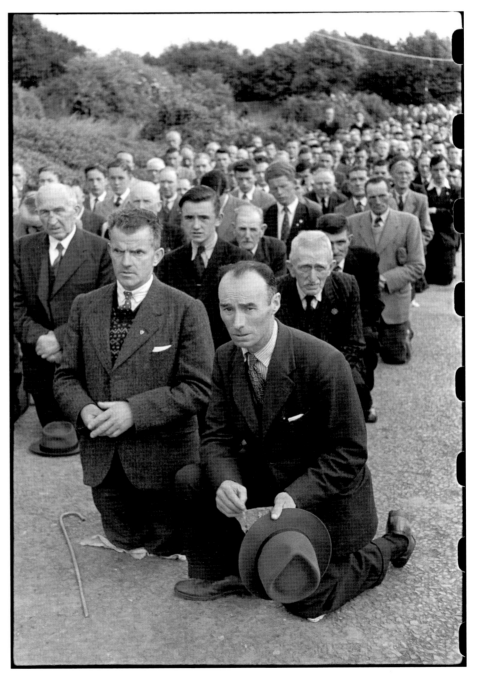

94 Dublin, Ireland, 1952

85

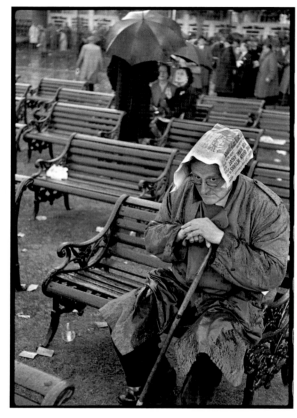

95 Ascot, Great Britain, 1953

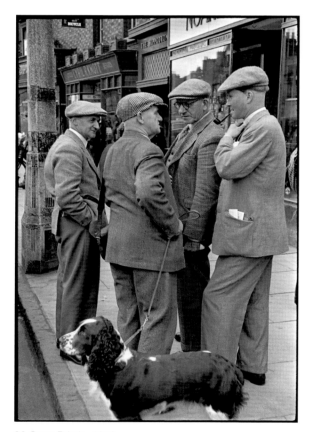

96 Great Britain, 1953

97 London, Great Britain, 1951

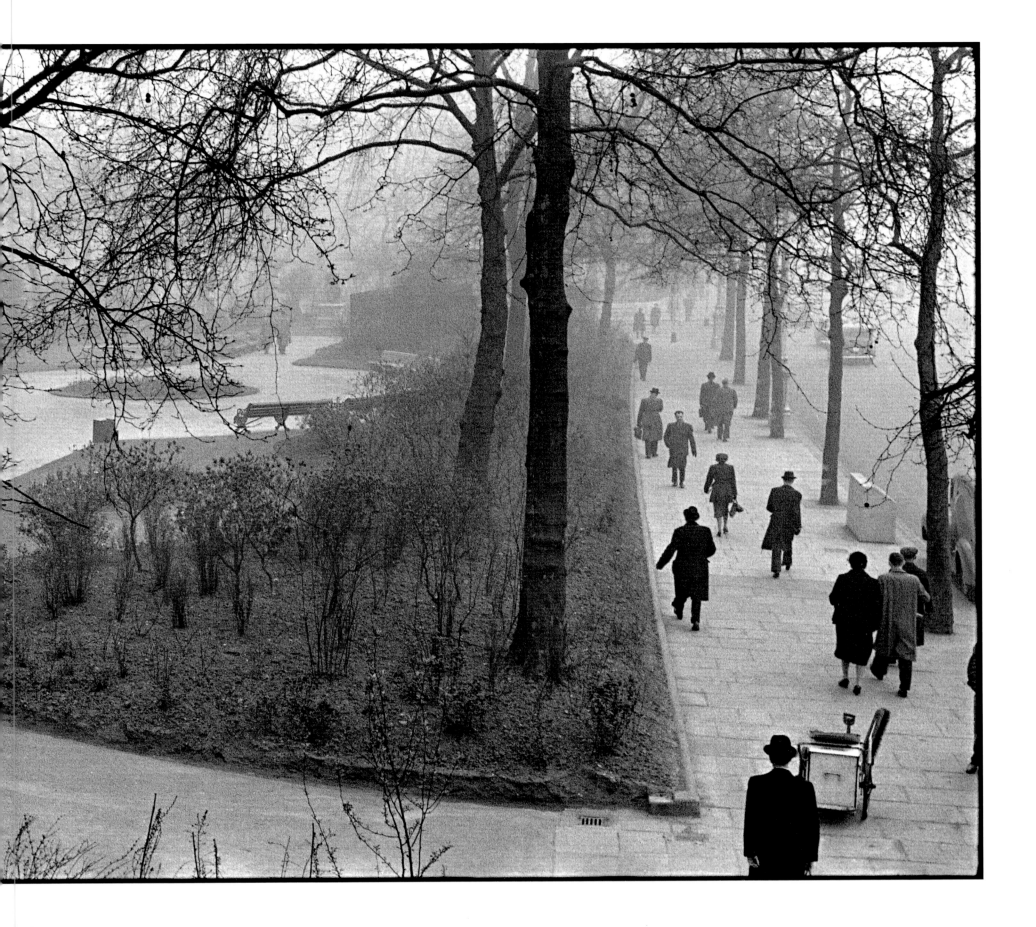

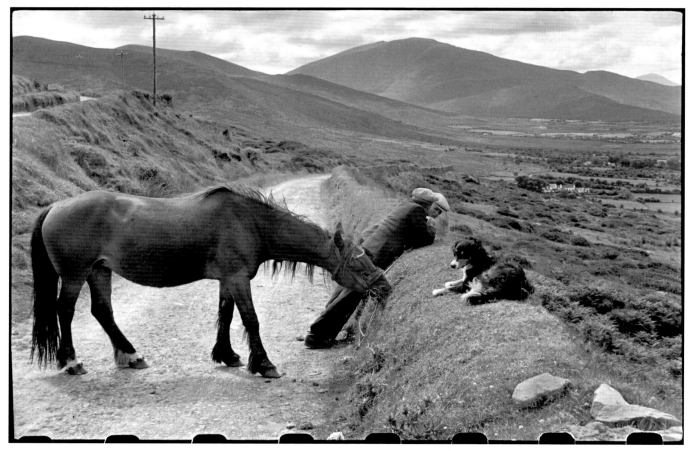

98 Ireland, 1952

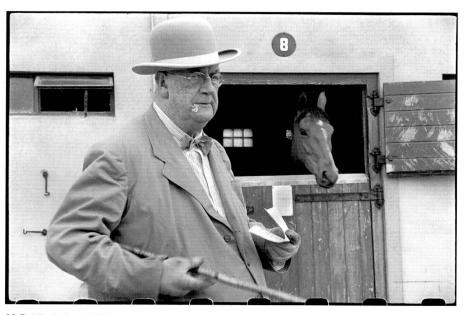

99 Dublin, Ireland, 1952

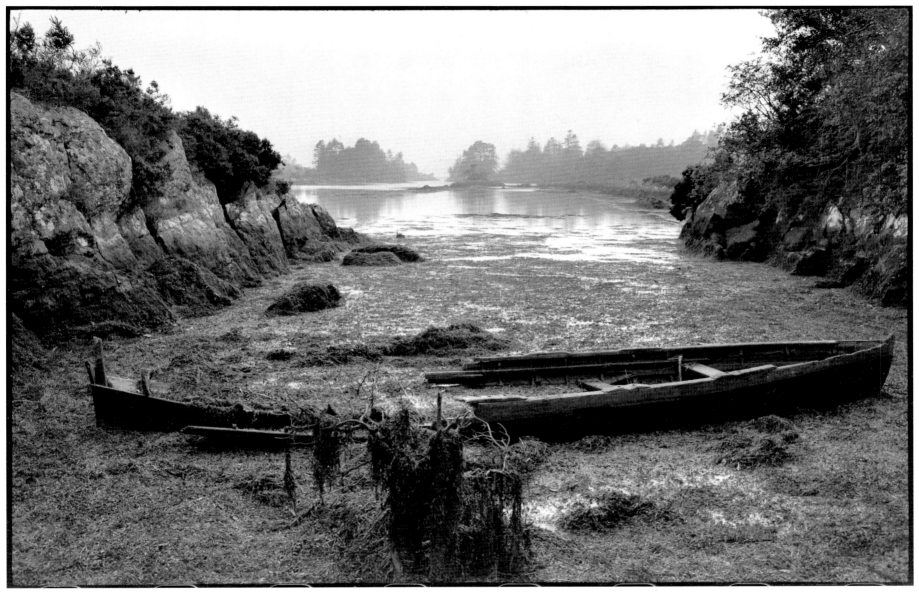

100 Ireland, 1962

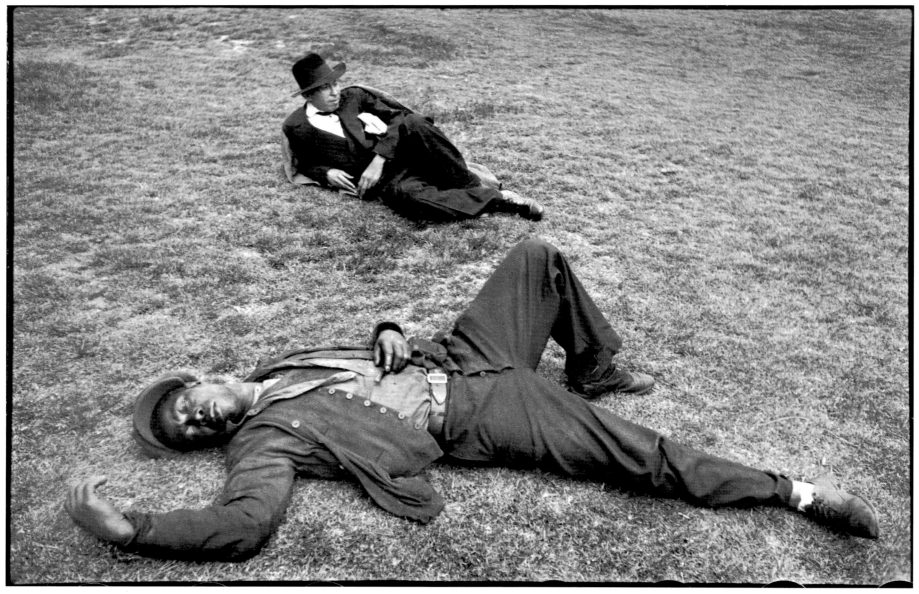

101 Marseilles, France, 1932

'We reject all humanist mythology that speaks of an abstract man and ignores the real state of his life.'

Paul Nizan

102 Valencia, Spain, 1933

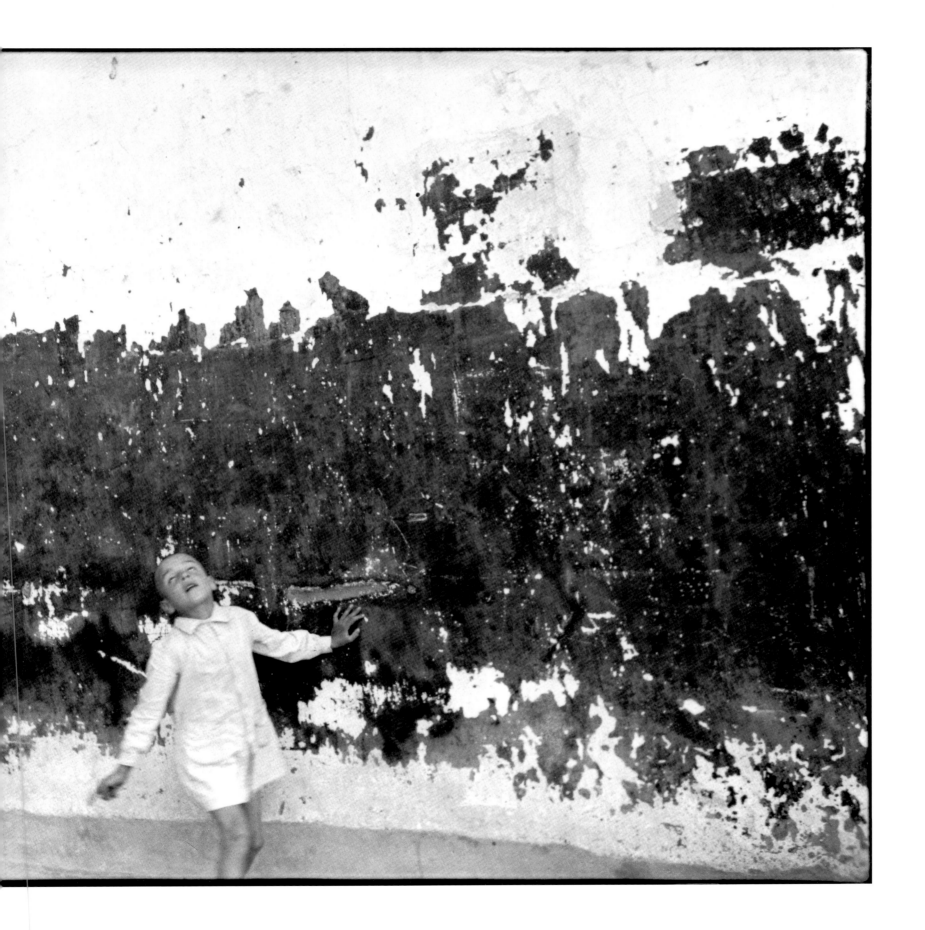

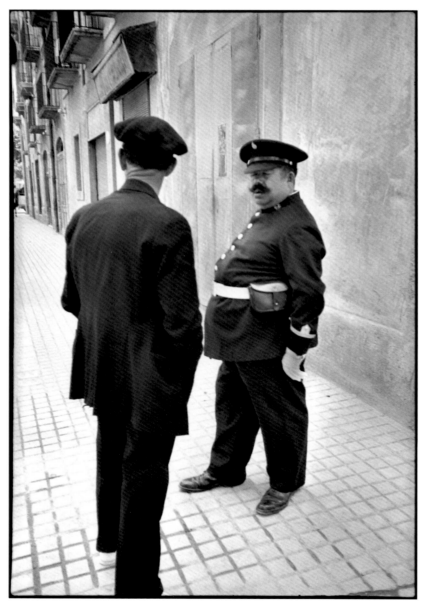

103 Spain, 1932

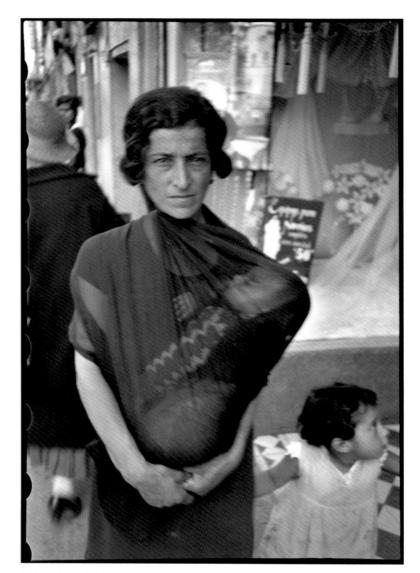

104 Mexico, 1934

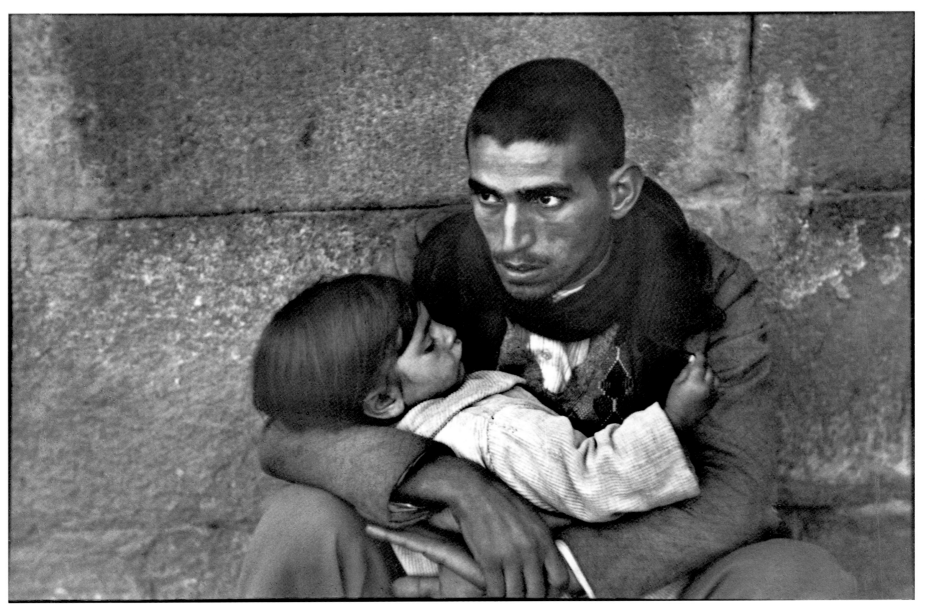

105 Madrid, Spain, 1933

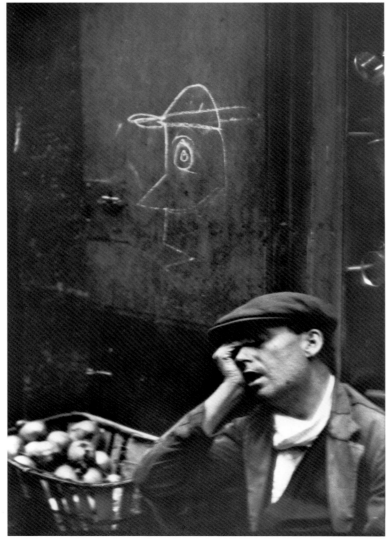

106 Barrio Chino, Barcelona, Spain, 1933

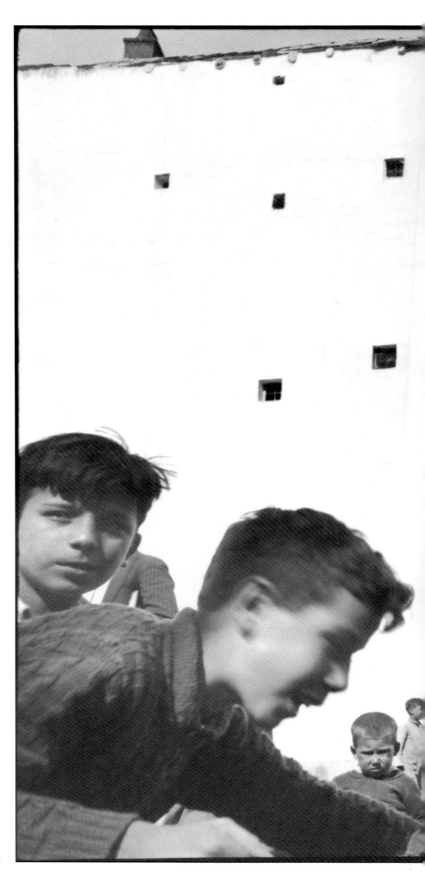

107 Madrid, Spain, 1933

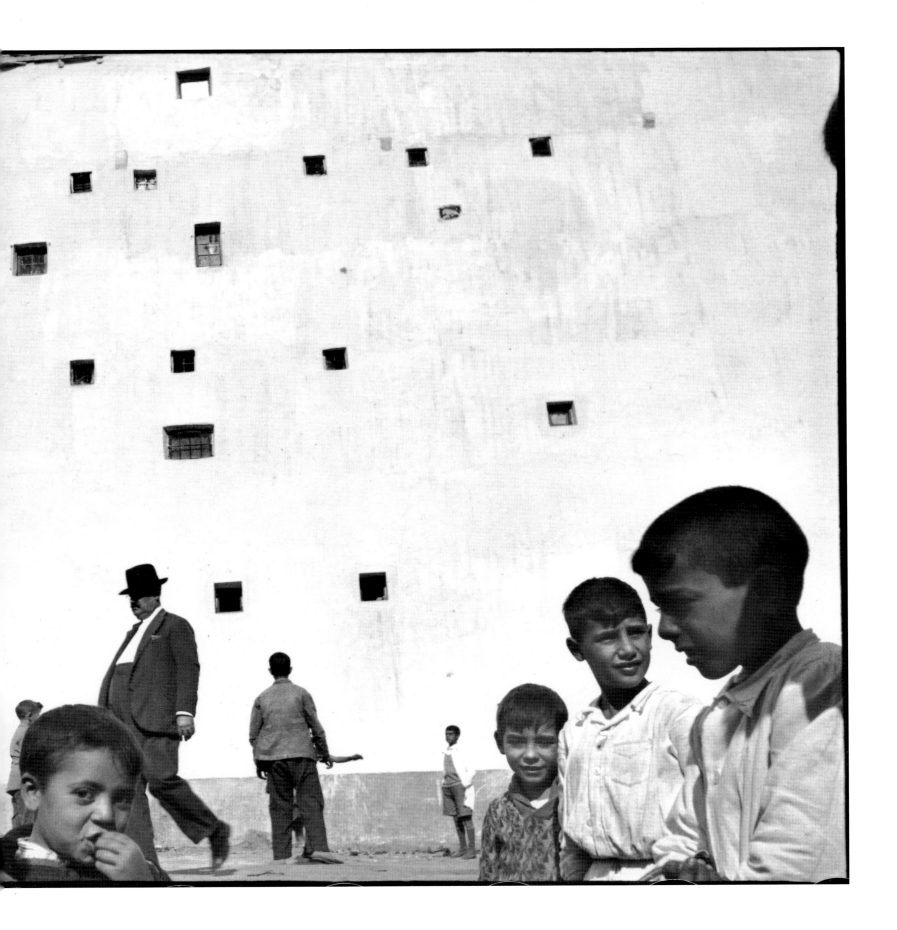

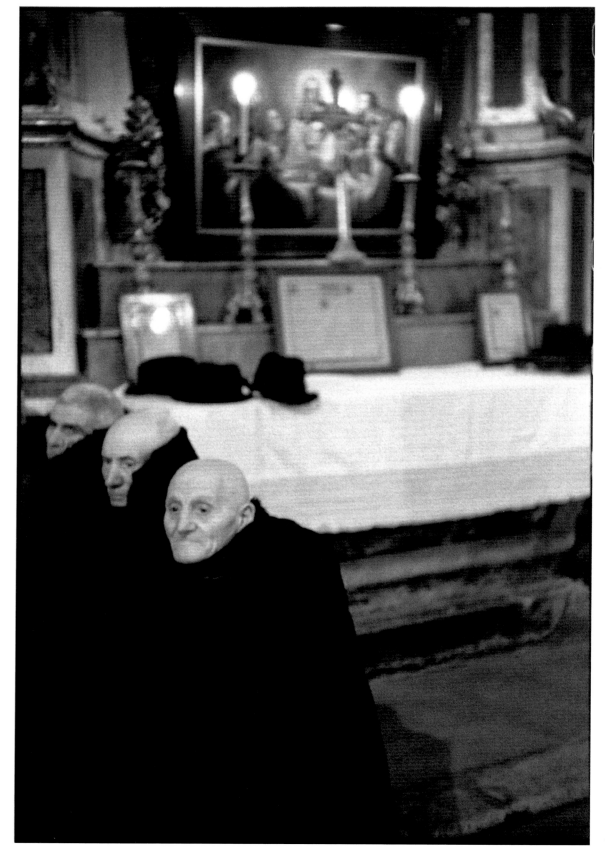

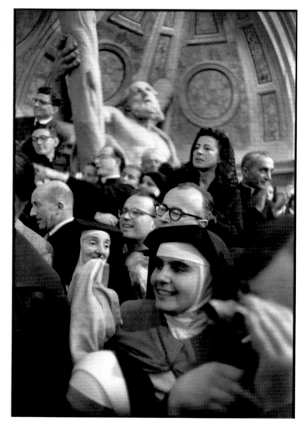

109 The Vatican, Rome, Italy, 1958

108 Midnight mass, Scanno, Abruzzo, Italy, 1953

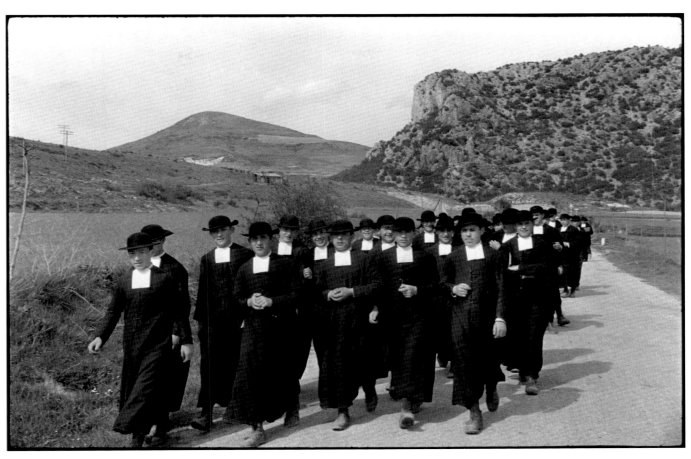

111 Castile, Spain, 1955

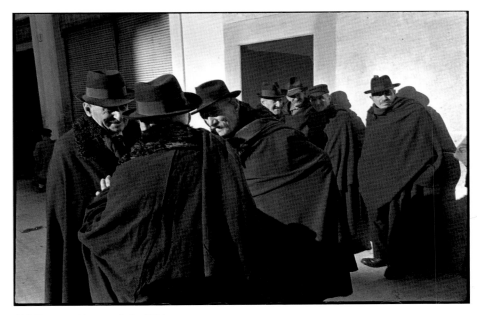

110 Scanno, Abruzzo, Italy, 1951

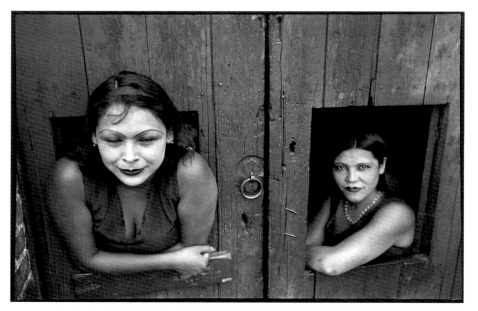

112 Calle Cuauhtemocztin, Mexico, 1934

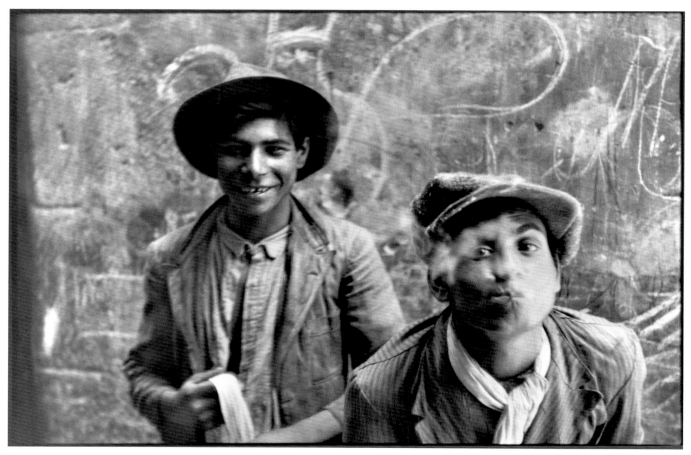

113 Grenada, Spain, 1933

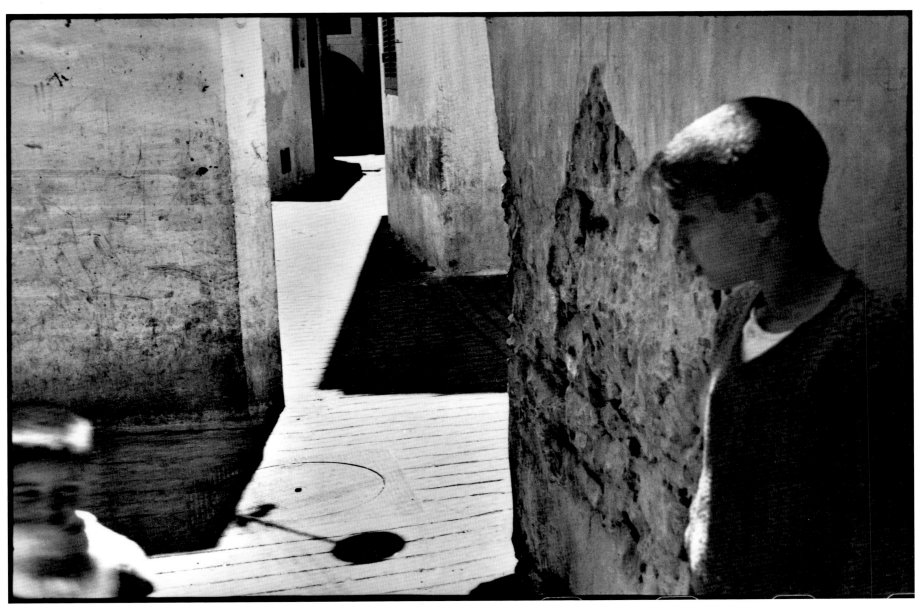

114 Seville, Spain, 1933

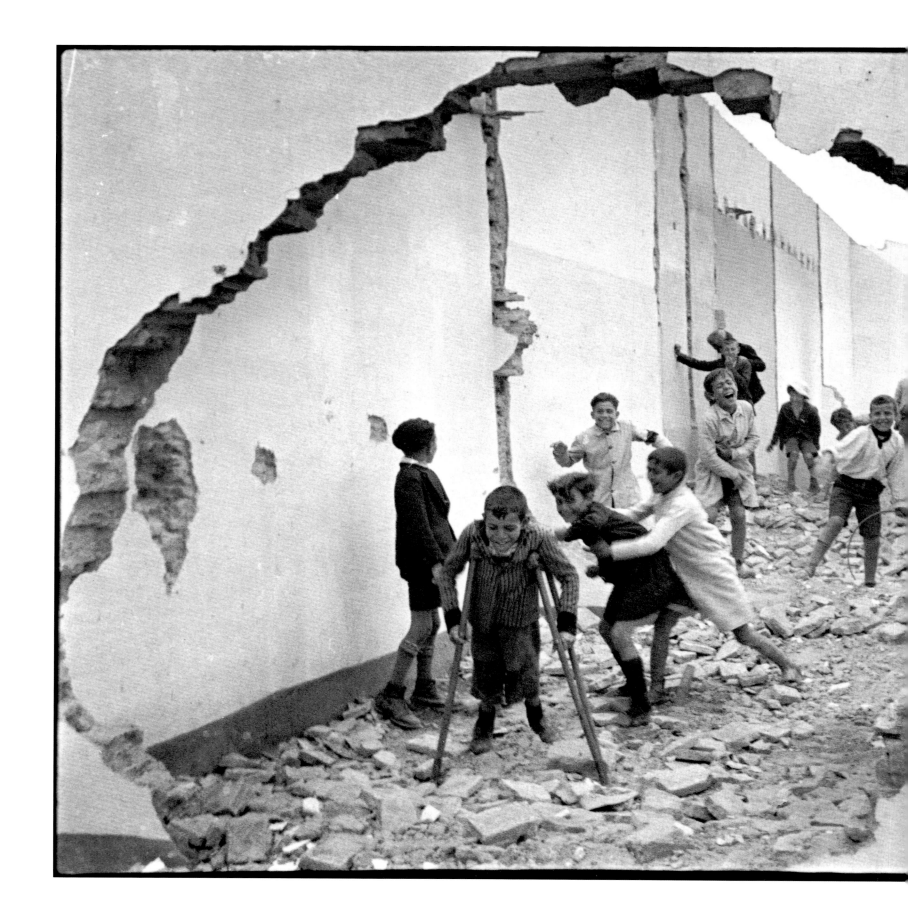

116 Mexico, 1934

115 Seville, Spain, 1933

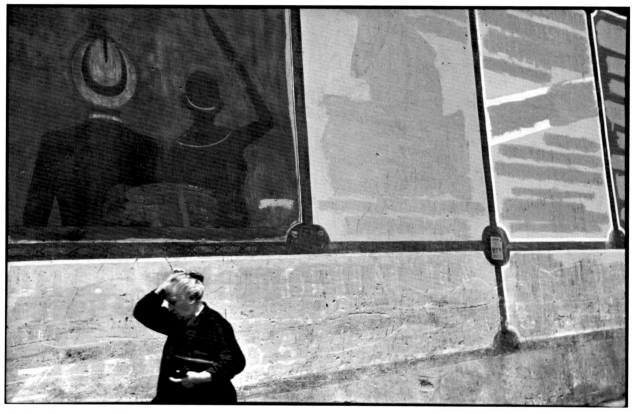

117 Barcelona, Spain, 1933

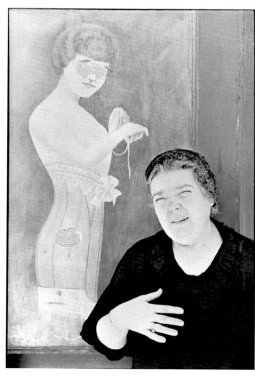

118 Cordoba, Spain, 1933

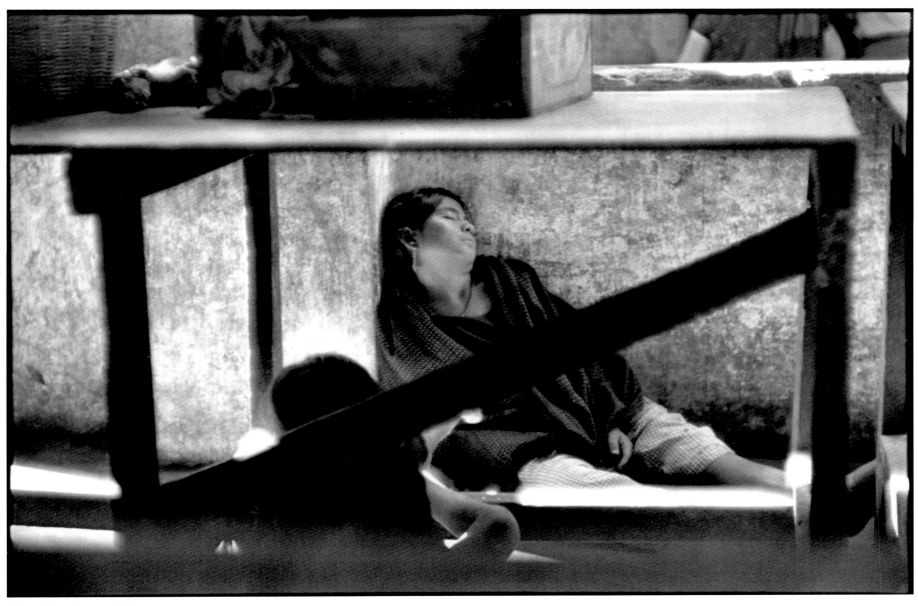

119 Juchitan, Mexico, 1934

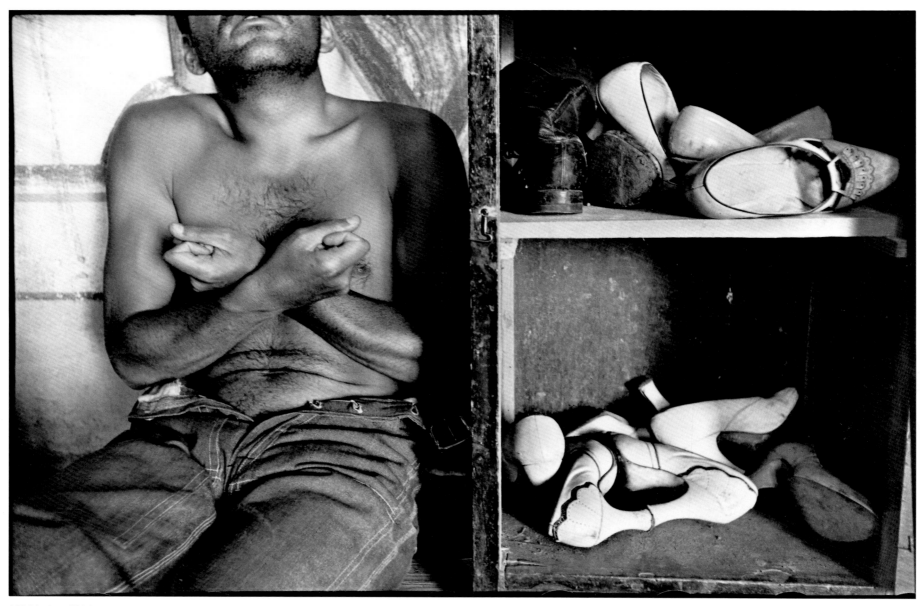

120 Mexico, 1934

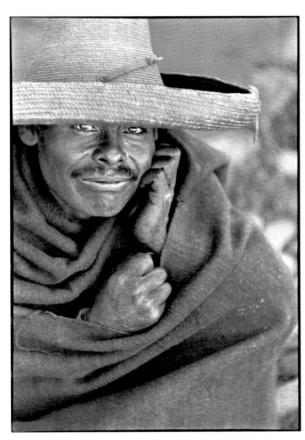

121 Mexico, 1934

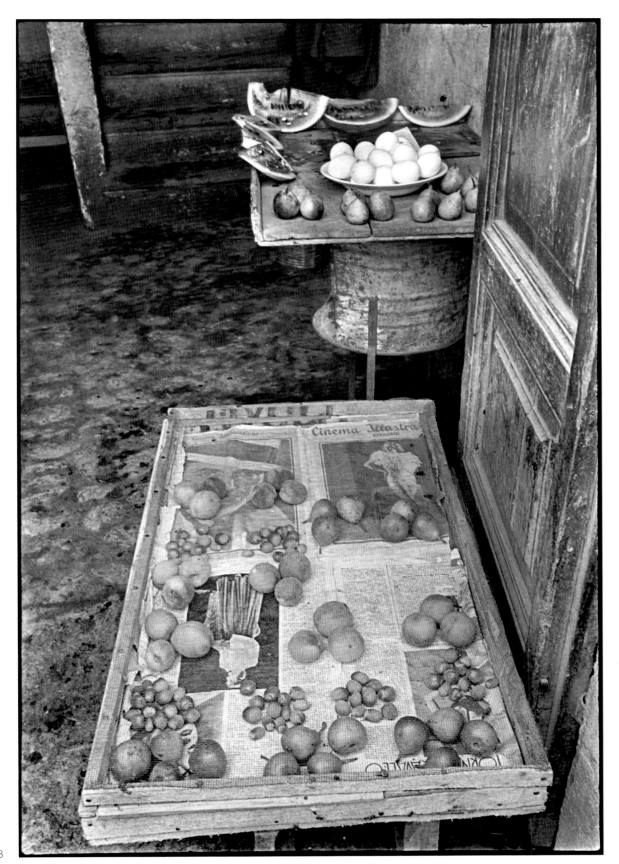

122 Tivoli, Italy, 1933

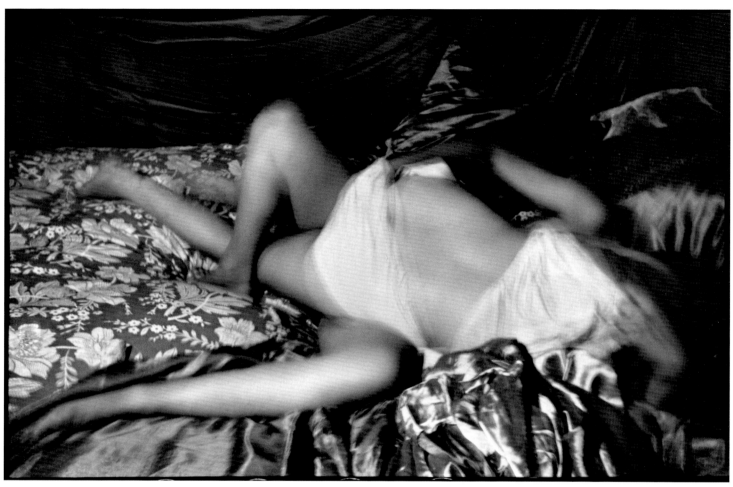

123 Mexico, 1934

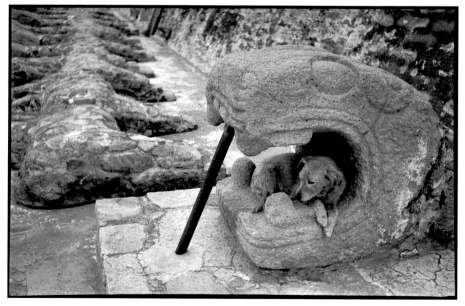

124 Tehuantepec, Mexico, 1934

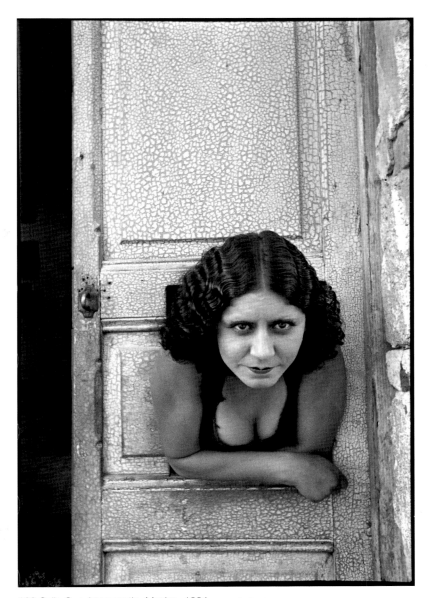

126 Calle Cuauhtemocztin, Mexico, 1934

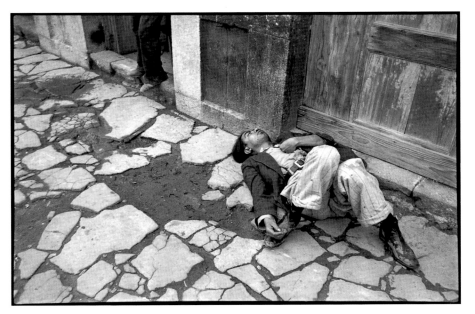

125 Mexico, 1934

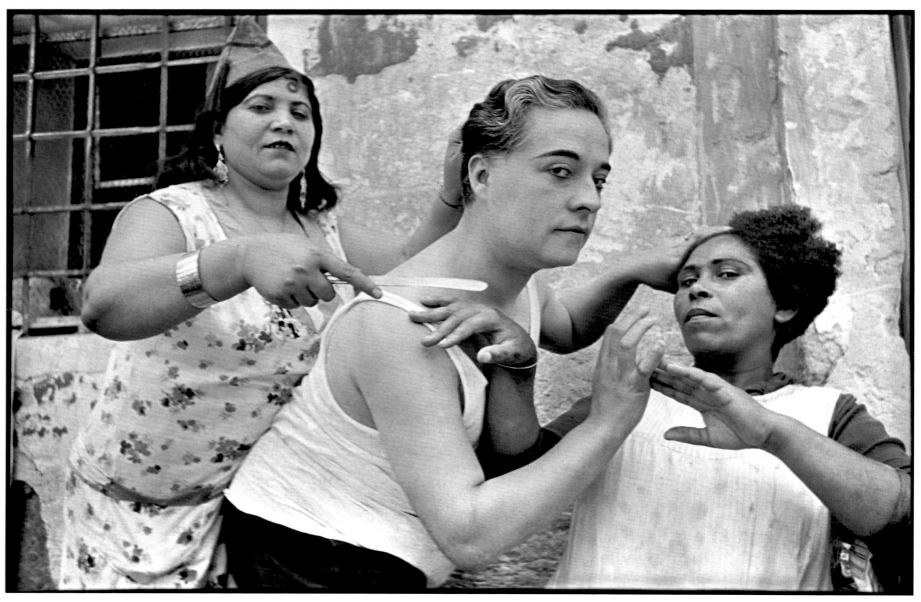

127 Alicante, Spain, 1933

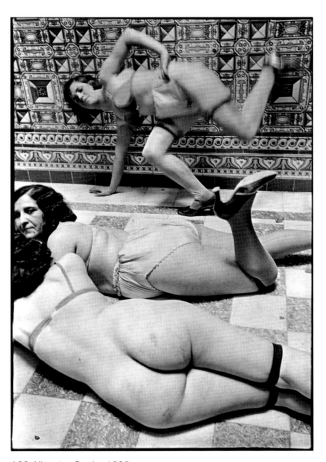

128 Alicante, Spain, 1933

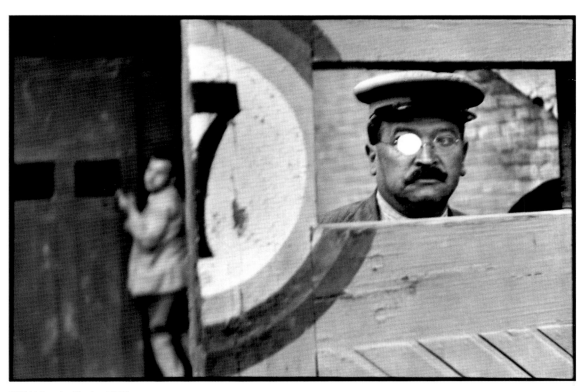

129 Valencia, Spain, 1933

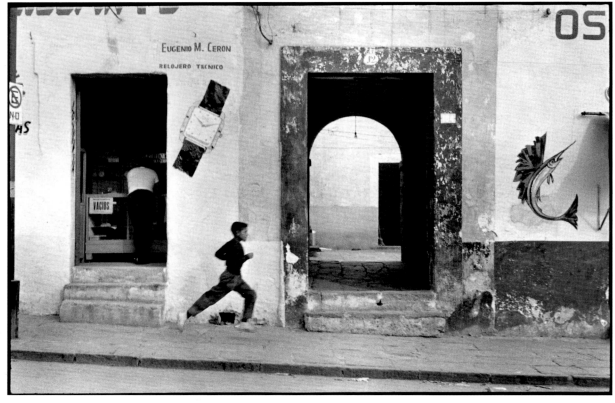

130 Mexico, 1964

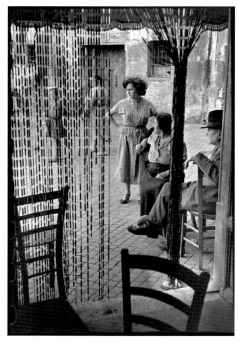

131 Rome, Italy, 1952

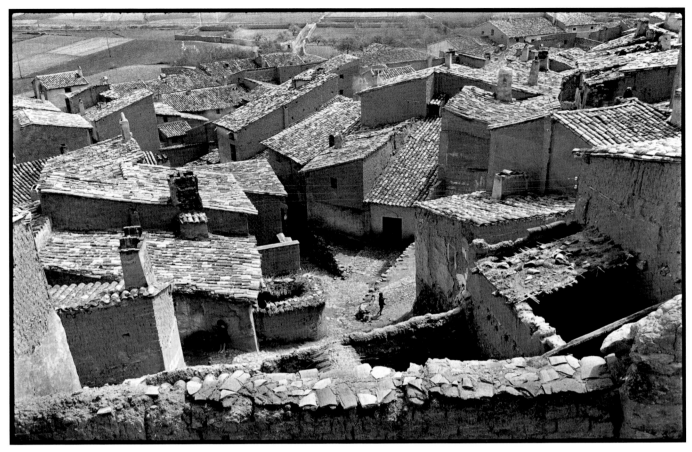

133 Ariza, Spain, 1953

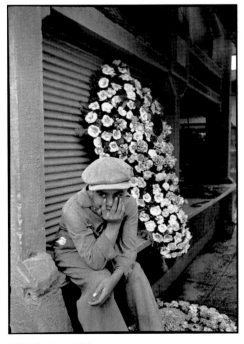

132 Mexico, 1934

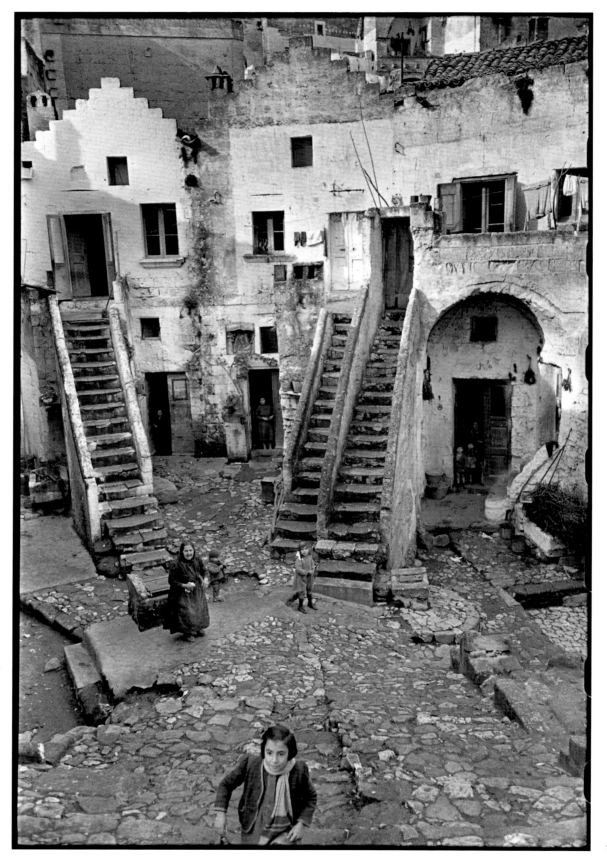

134 Matera, Basilicata, Italy, 1951

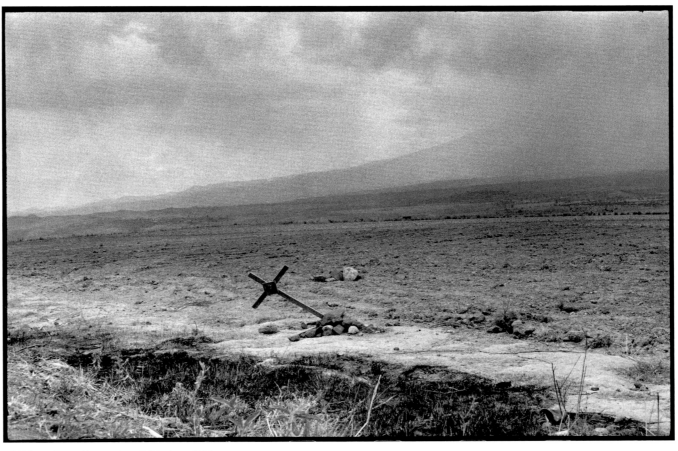

136 The volcano Popocatepetl, Mexico, 1963

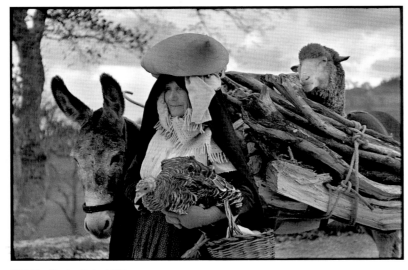

135 Basilicata, Italy, 1951

115

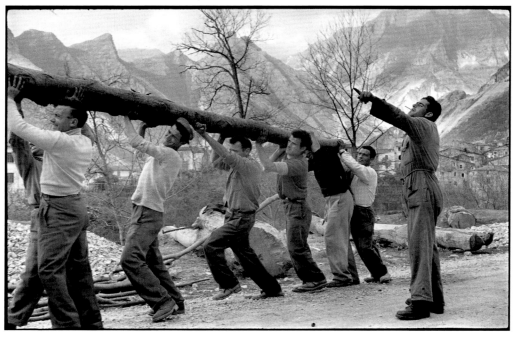

137 Carrara, Italy, 1953

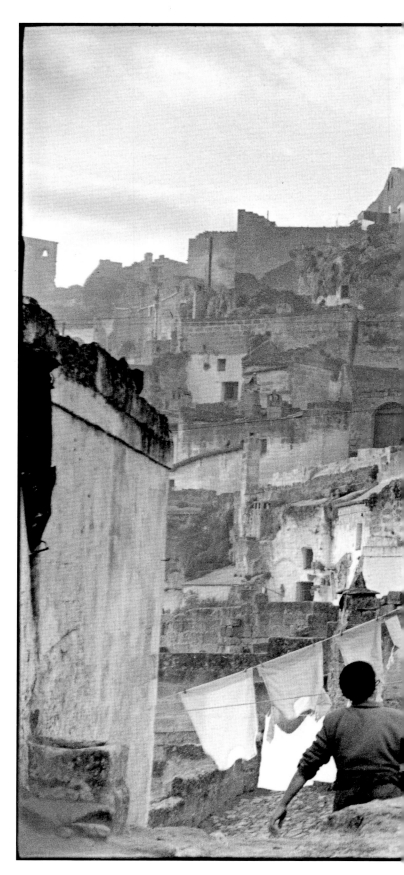

138 Matera, Basilicata, Italy, 1951

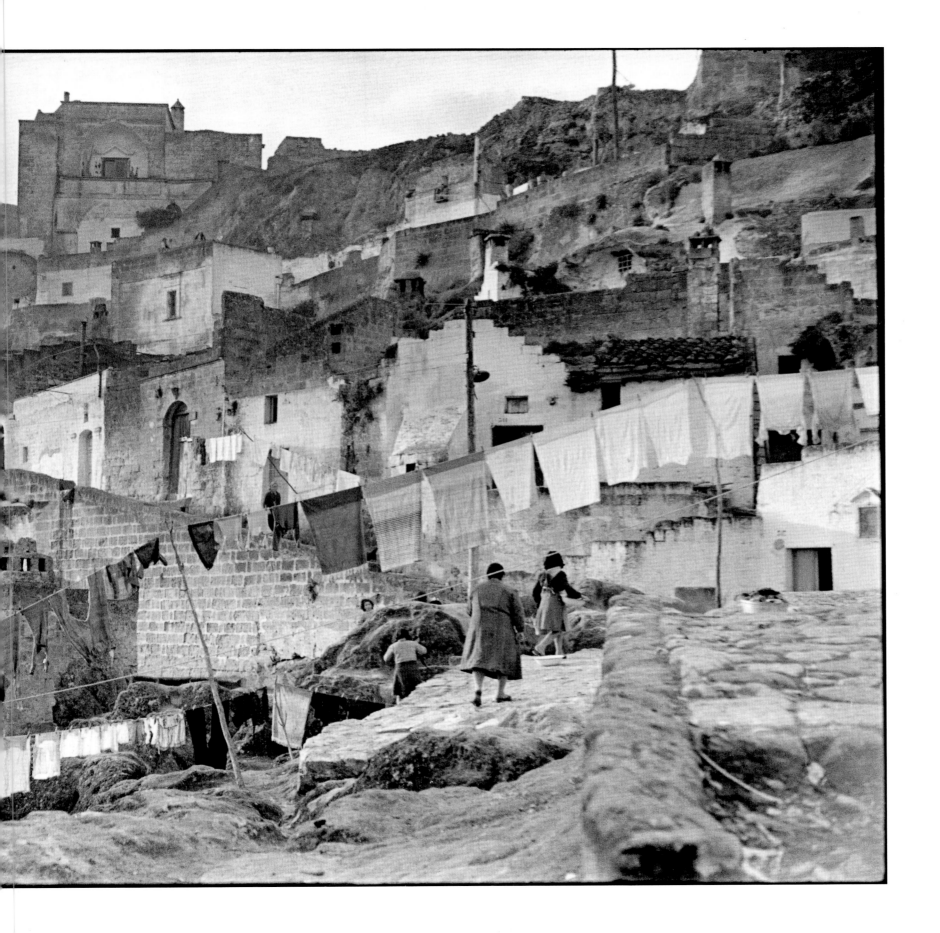

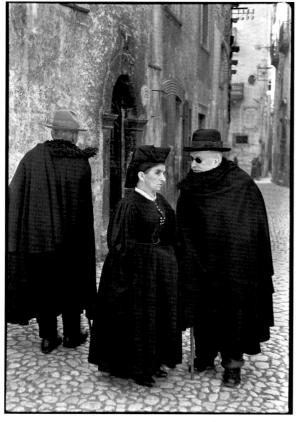

139 Scanno, Abruzzo, Italy, 1951

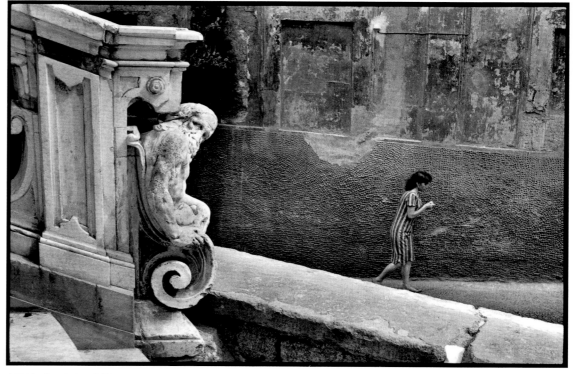

140 Naples, Italy, 1960

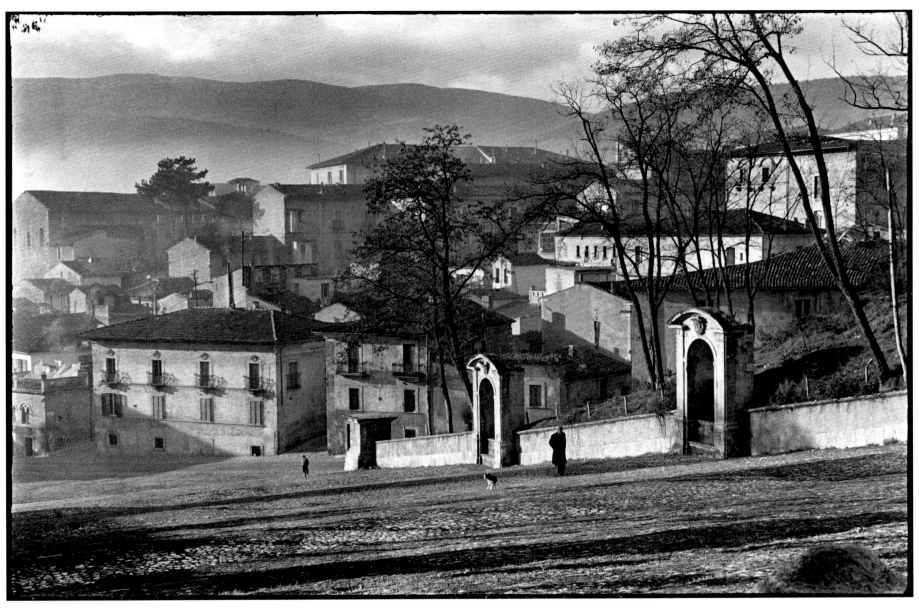

141 L'Aquila, Italy, 1951

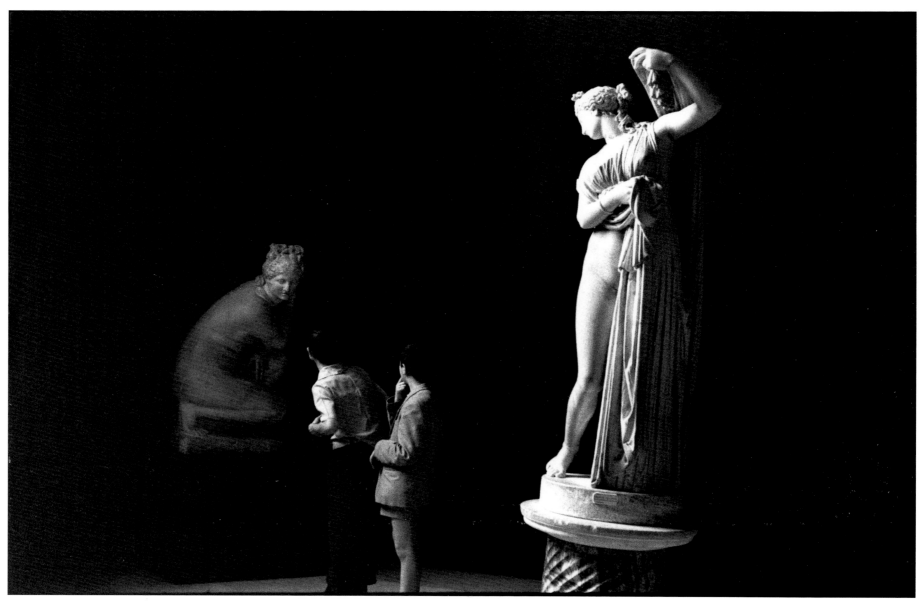

142 Naples, Italy, 1960

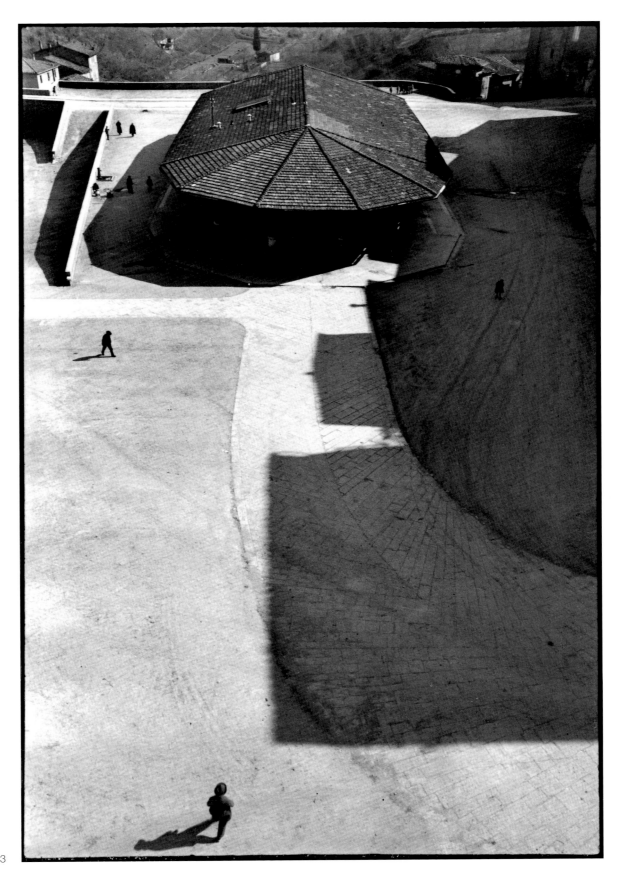

143 Siena, Italy, 1933

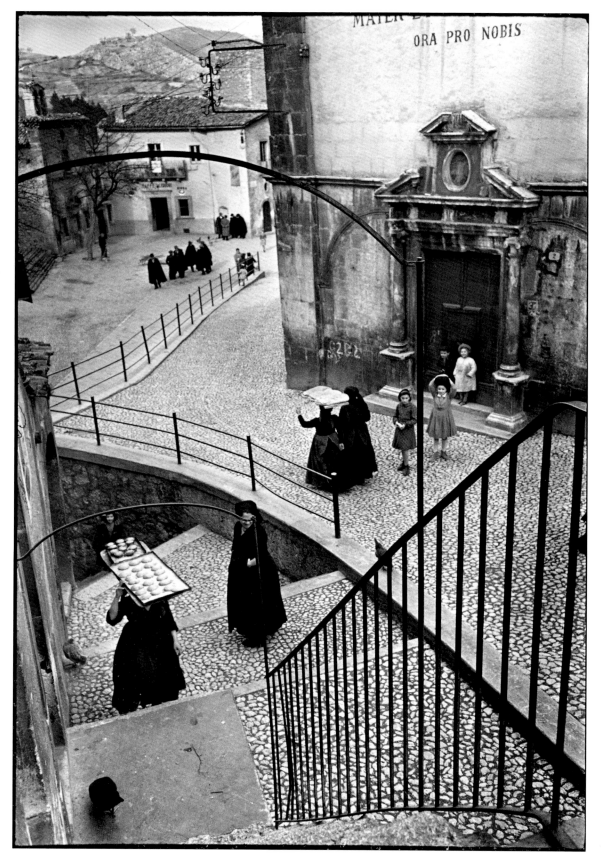

ORA PRO NOBIS

144 L'Aquila, Abruzzo, Italy, 1951

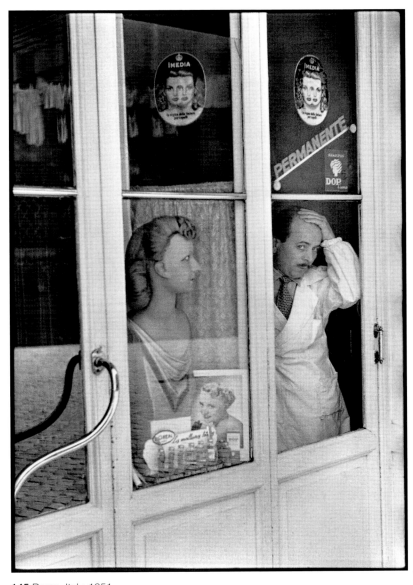

145 Rome, Italy, 1951

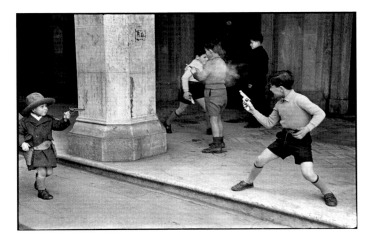

146 Rome, Italy, 1951

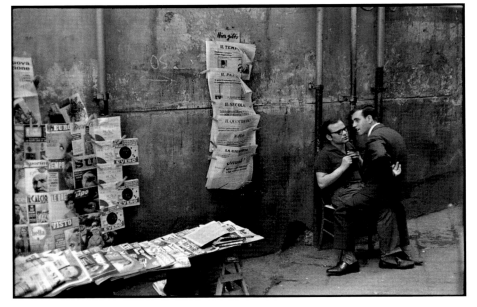

147 Naples, Italy, 1960

123

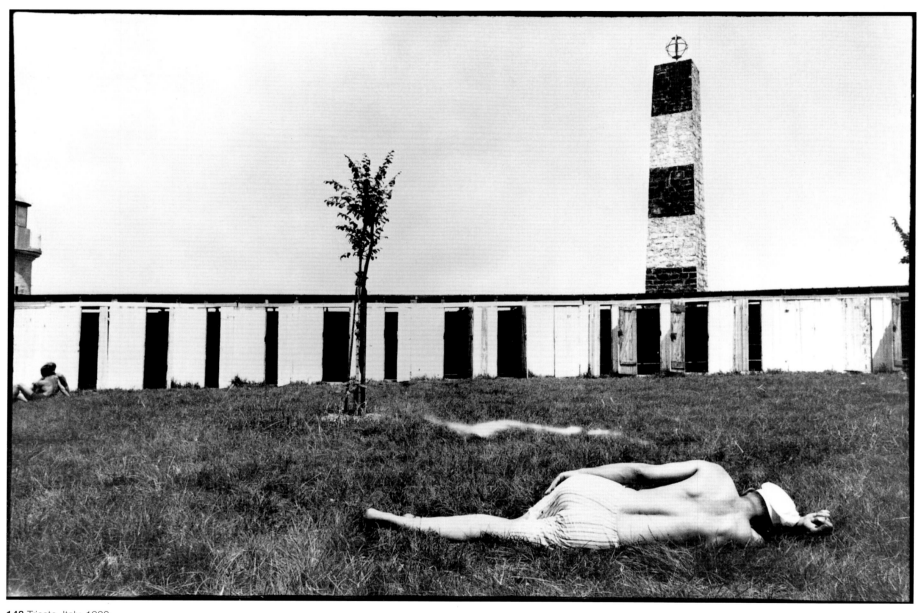

148 Trieste, Italy, 1933

124

149 Florence, Italy, 1933

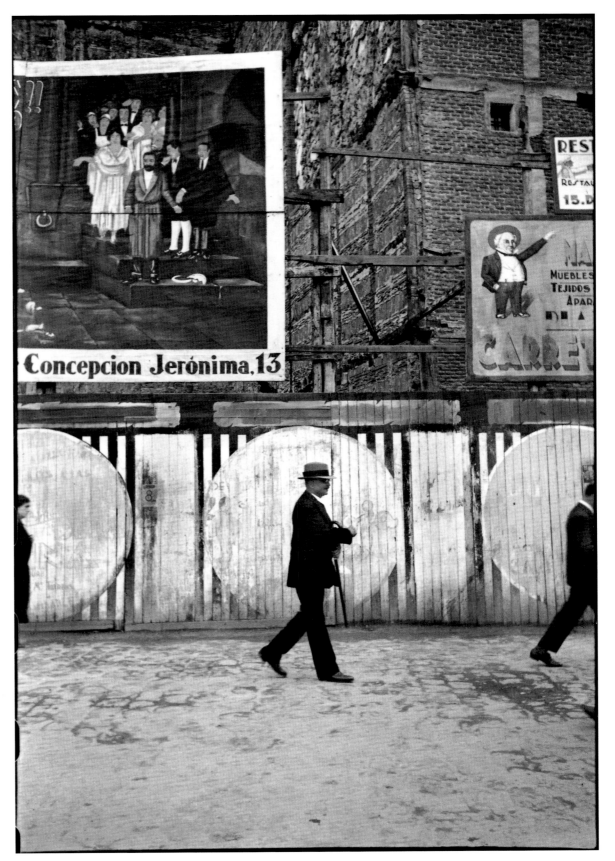

150 Madrid, Spain, 1933

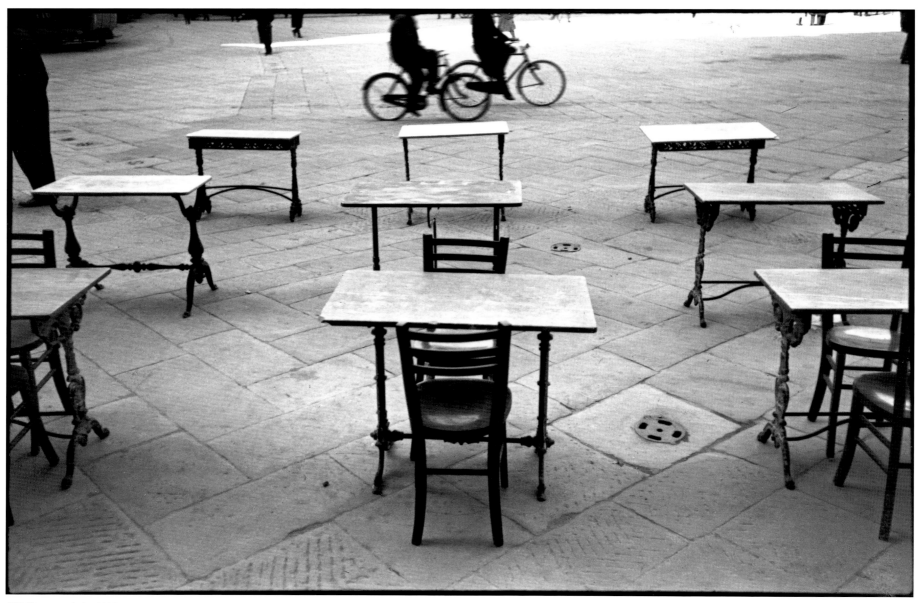

151 Florence, Italy, 1933

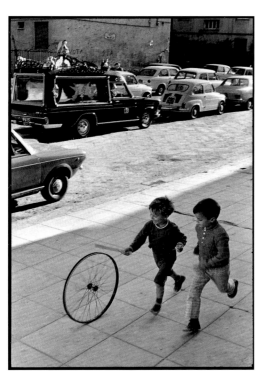

152 Palermo, Italy, 1971

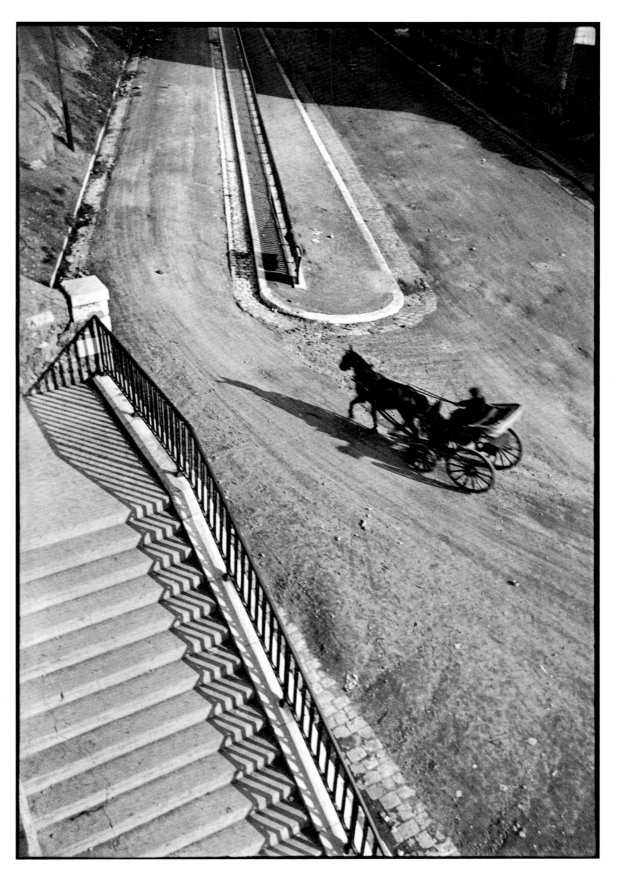

153 Marseilles, France, 1932

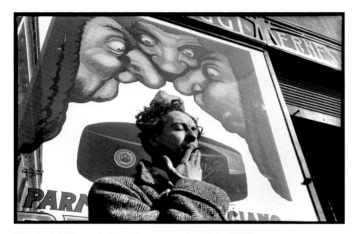

154 André Pieyre de Mandiargues, writer, Italy, 1933

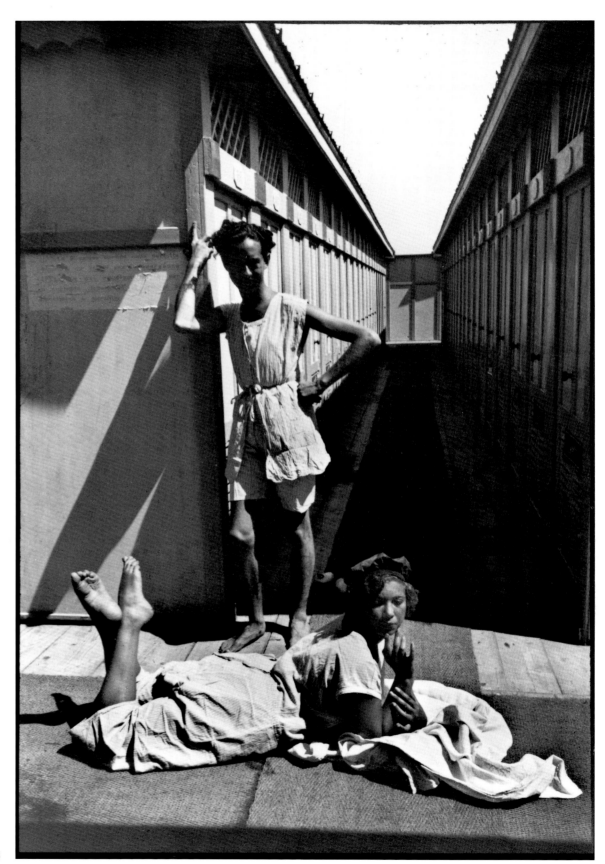

155 André Pieyre de Mandiargues and Leonor Fini, painter, Italy, 1933

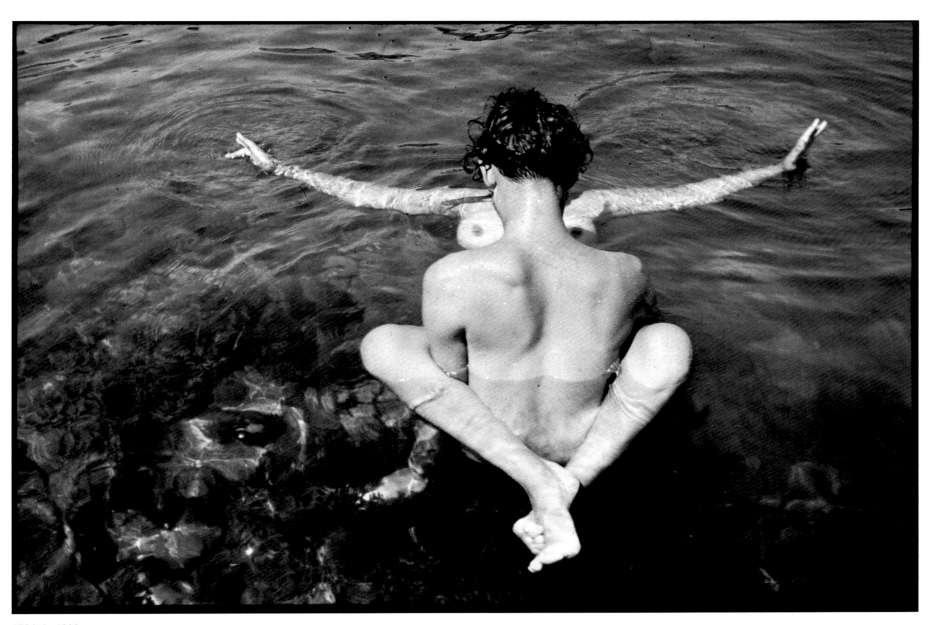

156 Italy, 1933

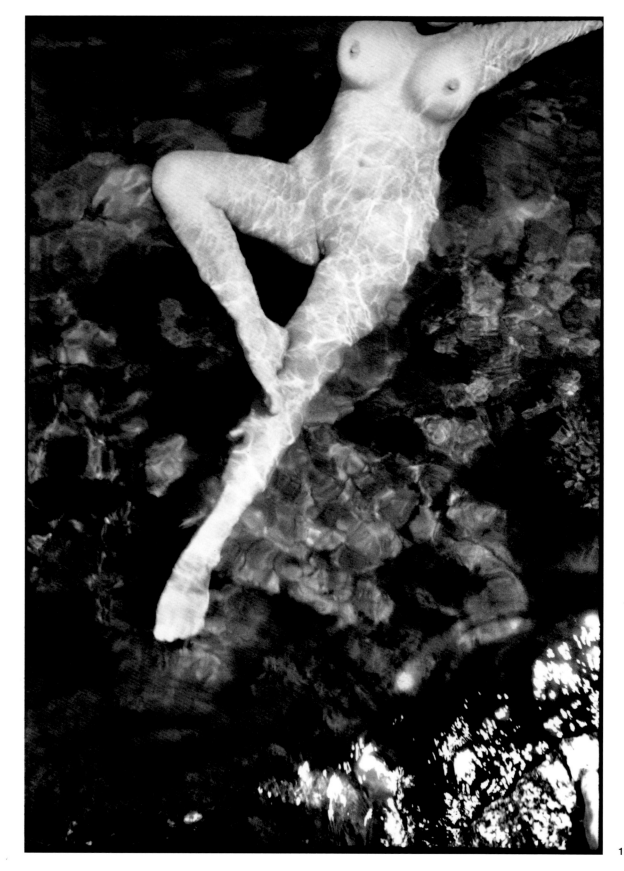

Portfolio

BIBLIOTHEK DER ✹ FOTOGRAFIE Nº 13

Henri Cartier-Bresson
Landschaften Landscapes

02440 ✳

130

157 Italy, 1933

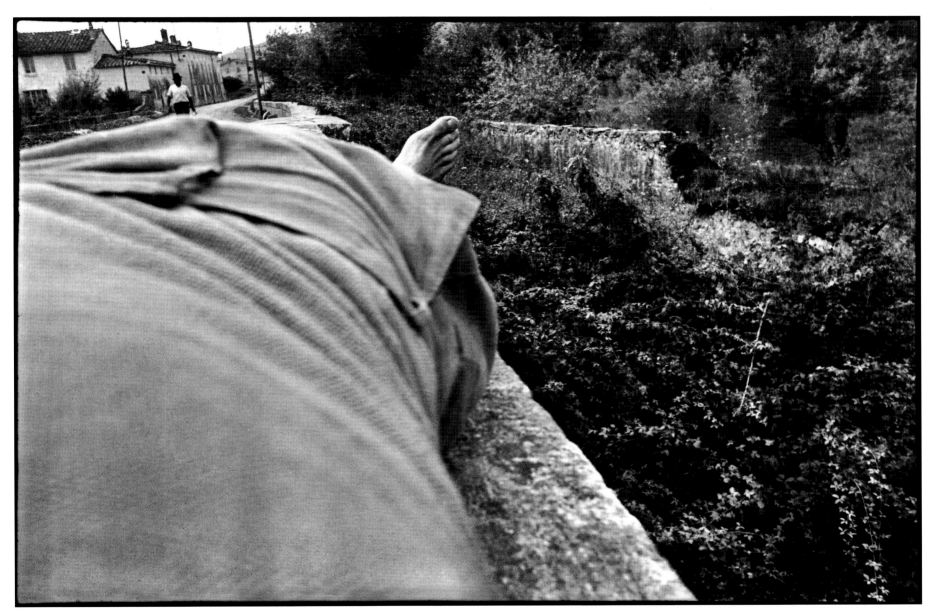

158 Italy, 1933

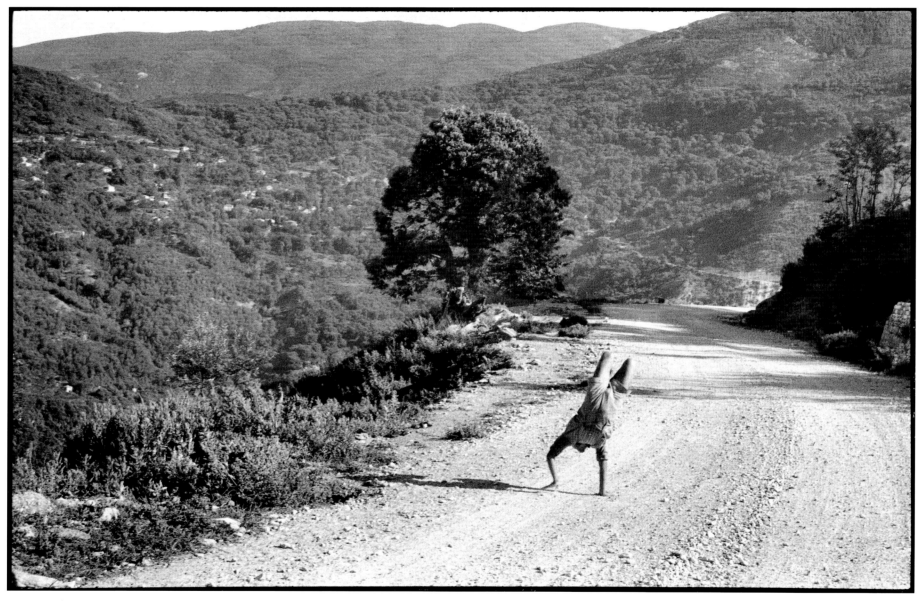

159 Ipiros, Greece, 1961

'Because I didn't study at all, I learned a lot.'
Anatole France

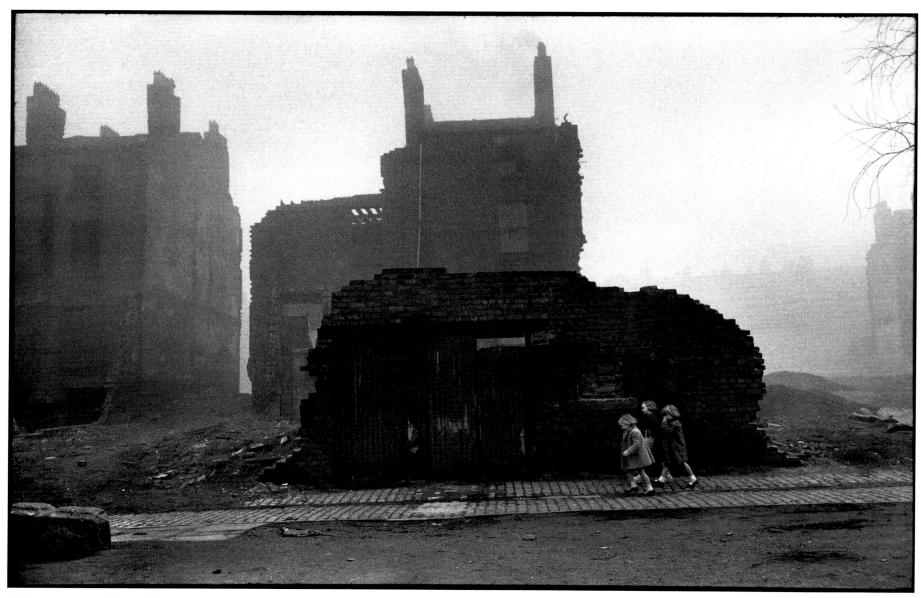

160 Liverpool, Great Britain, 1962

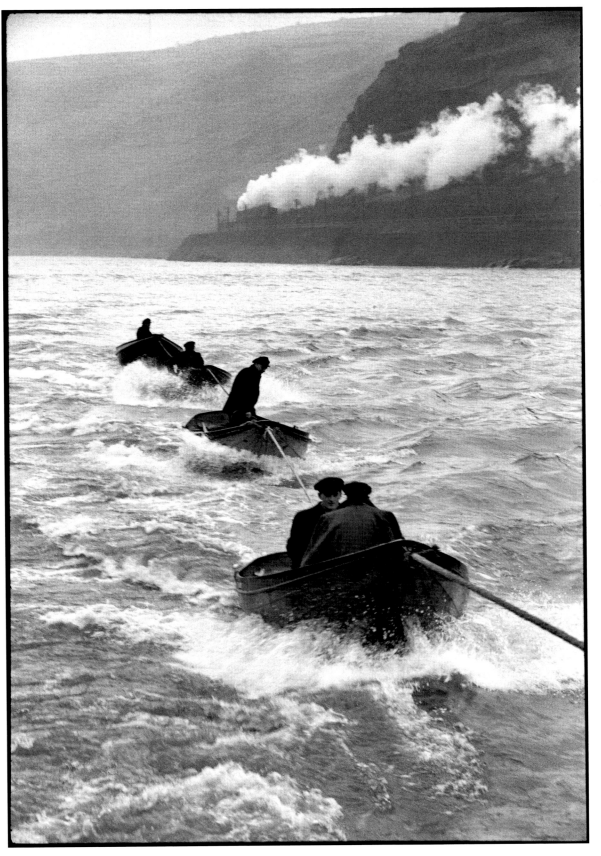

161 On the Rhine,
Germany, 1956

162 Poland, 1931

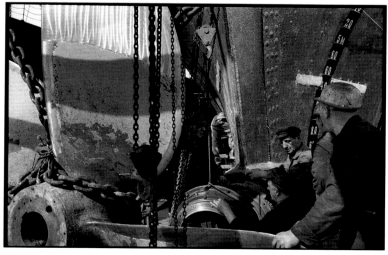

163 Naval shipyard, Bremen, West Germany, 1962

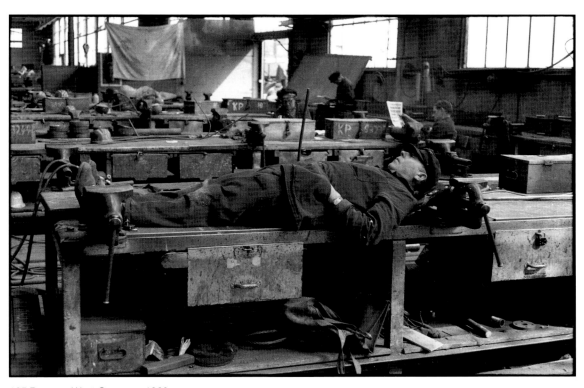

165 Bremen, West Germany, 1962

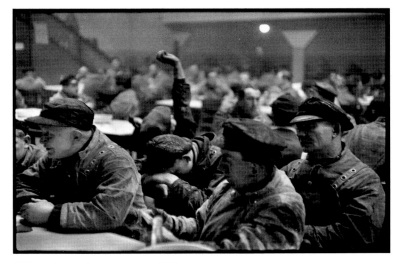

164 Hamburg, West Germany, 1952

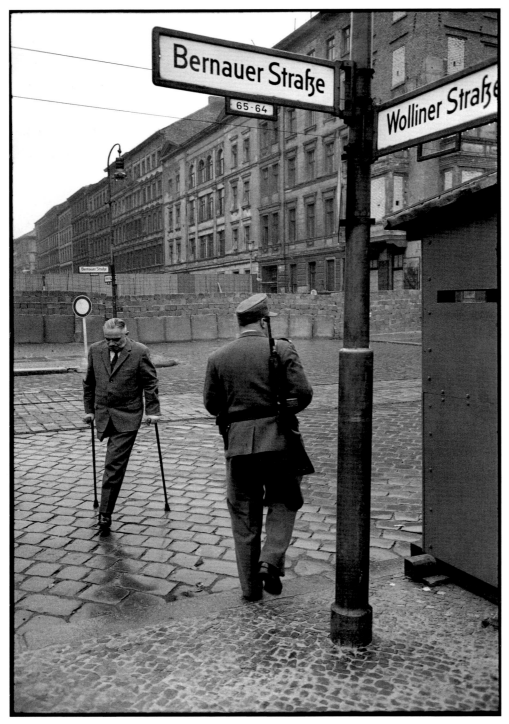

166 Berlin, West Germany, 1962

167 Romania, 1975

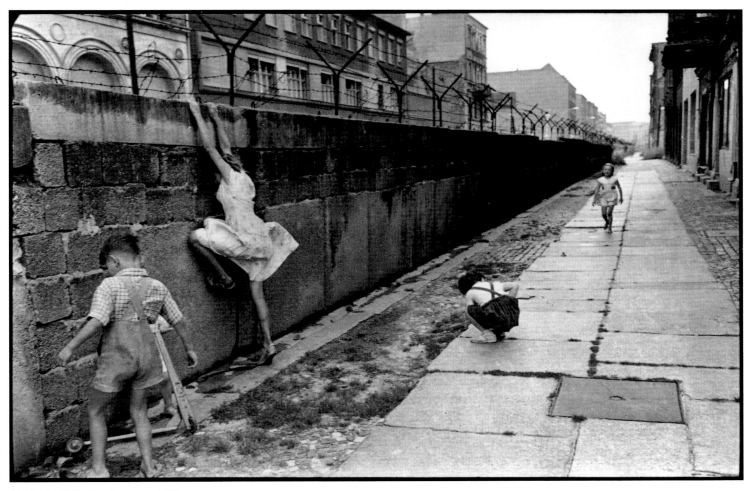

169 Berlin Wall, West Germany, 1962

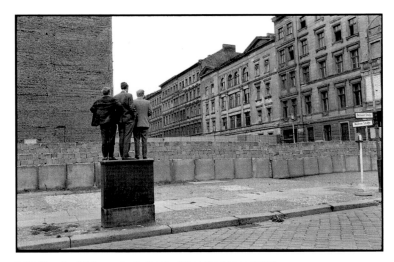

168 After the Wall was built, Berlin, West Germany, 1962

'Every human endeavour, however singular it seems,
involves the whole human race.'

Jean-Paul Sartre

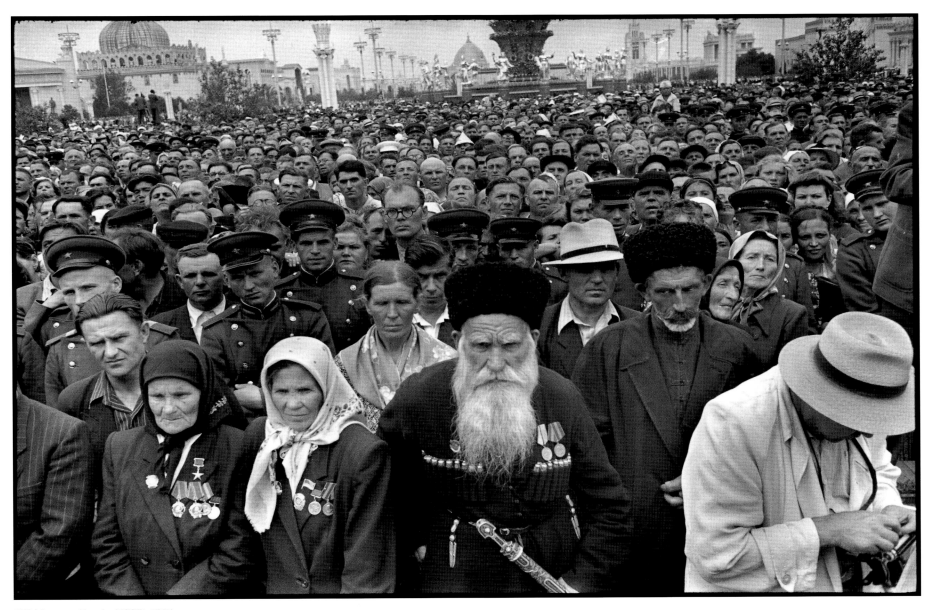

170 Moscow, Russia, USSR, 1954

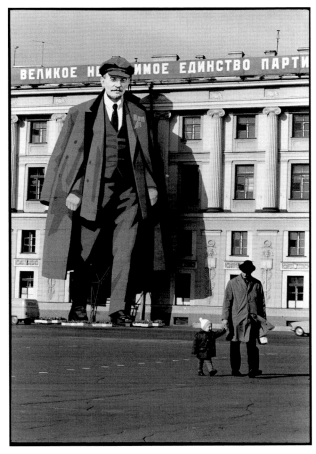

172 Leningrad, Russia, USSR, 1973

171 Moscow, Russia, USSR, 1954

143

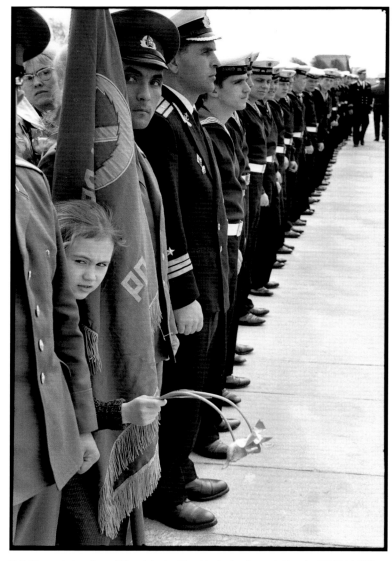

174 Commemoration of the defeat of the Nazis, Leningrad, Russia, USSR, 1973

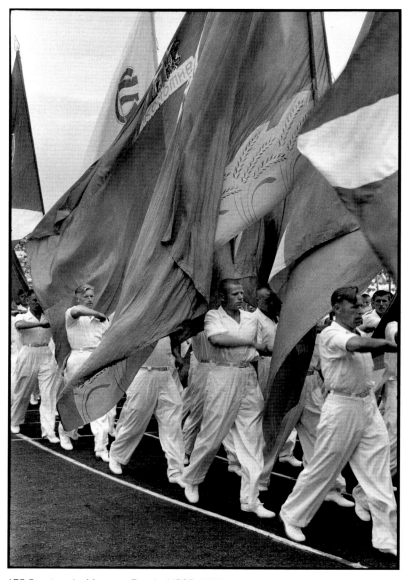

175 Sports gala, Moscow, Russia, USSR, 1954

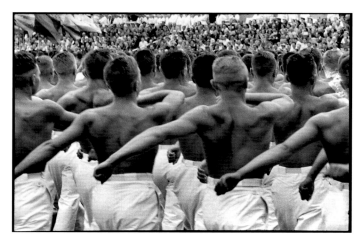

173 Sports gala, Moscow, Russia, USSR, 1954

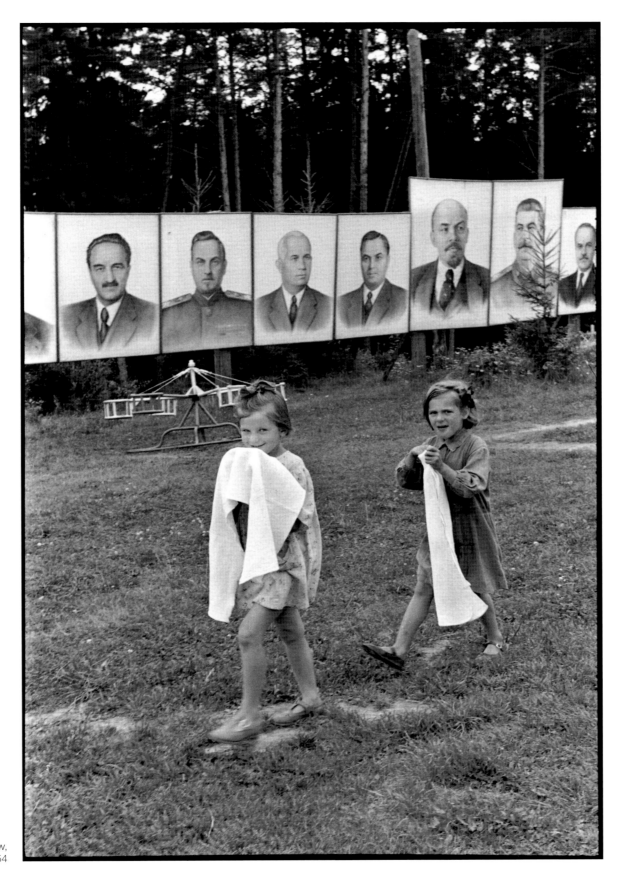

176 Pioneer camp, outside Moscow, Russia, USSR, 1954

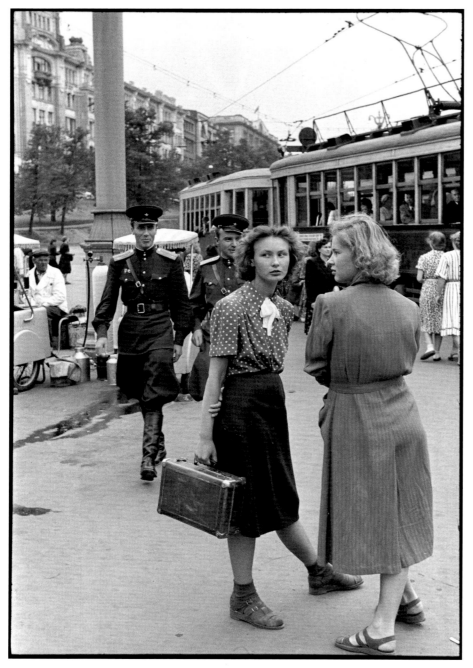

177 Moscow, Russia, USSR, 1954

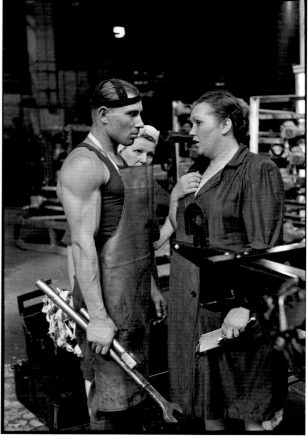

178 Moscow, Russia, USSR, 1954

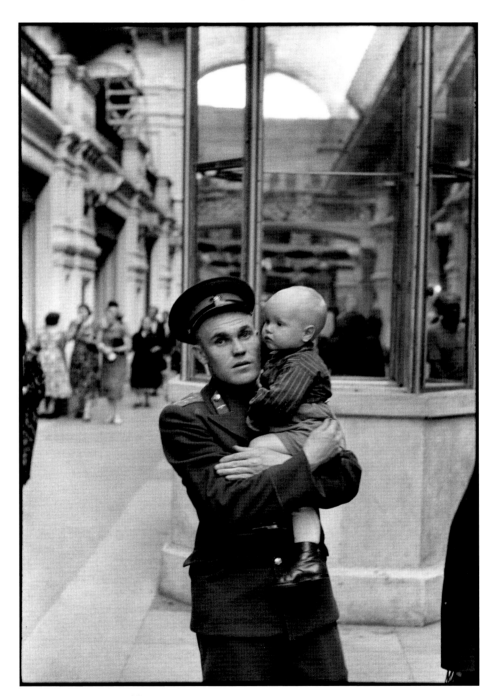

180 Moscow, Russia, USSR, 1954

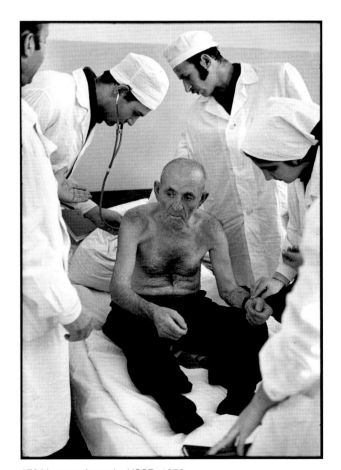

179 Yerevan, Armenia, USSR, 1972

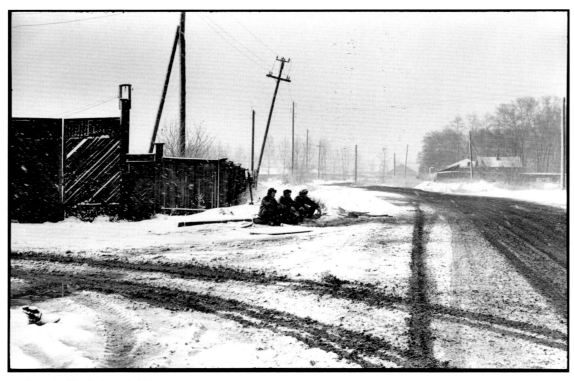

181 Irkutsk, Siberia, USSR, 1972

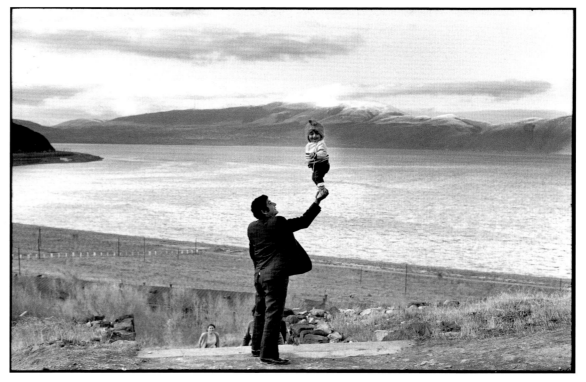

182 Armenia, USSR, 1972

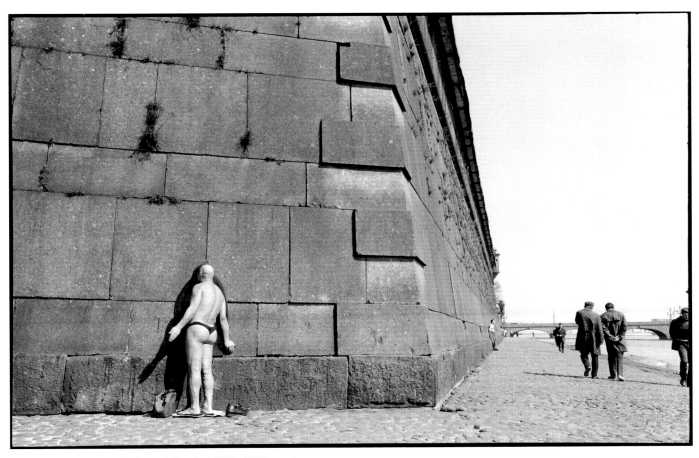

184 Peter Paul fortress, Leningrad, Russia, USSR, 1973

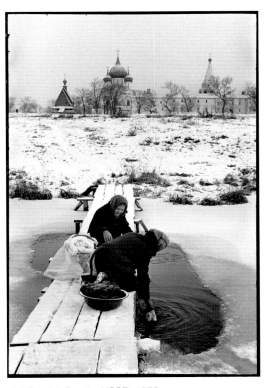

183 Suzdal, Russia, USSR, 1972

149

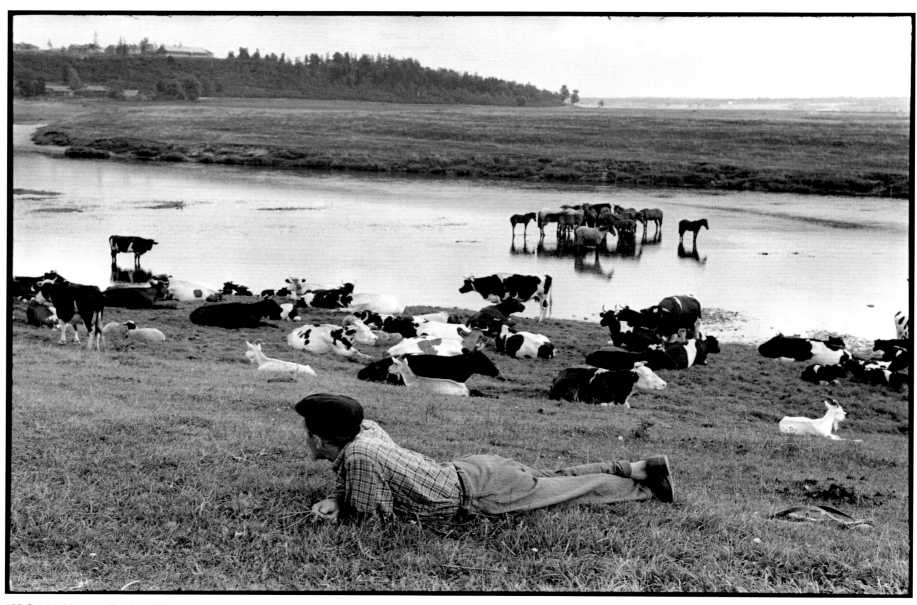

185 Outside Moscow, Russia, USSR, 1954

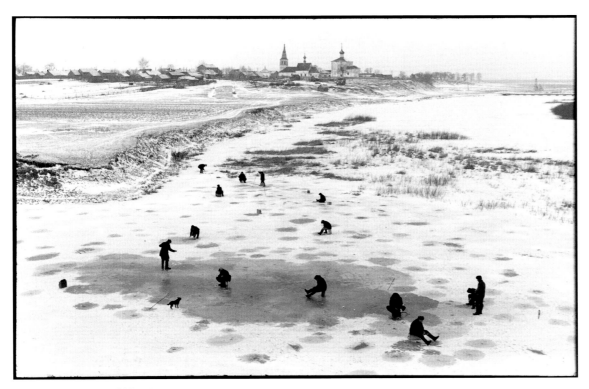

186 Suzdal, Russia, USSR, 1972

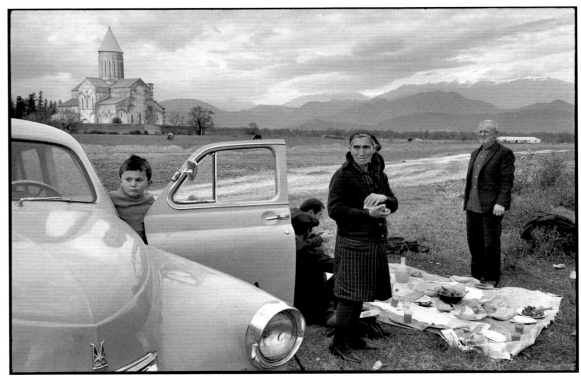

187 Georgia, USSR, 1972

151

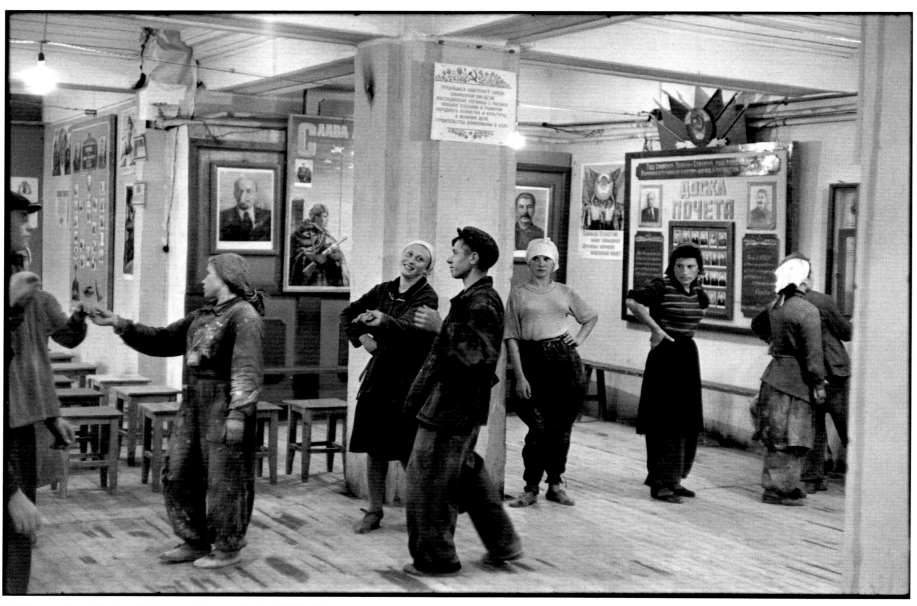

188 Construction of the Hotel Metropole, Moscow, Russia, USSR, 1954

152

'You have seen because you have believed.'
Charles de Gaulle to Henri Cartier-Bresson

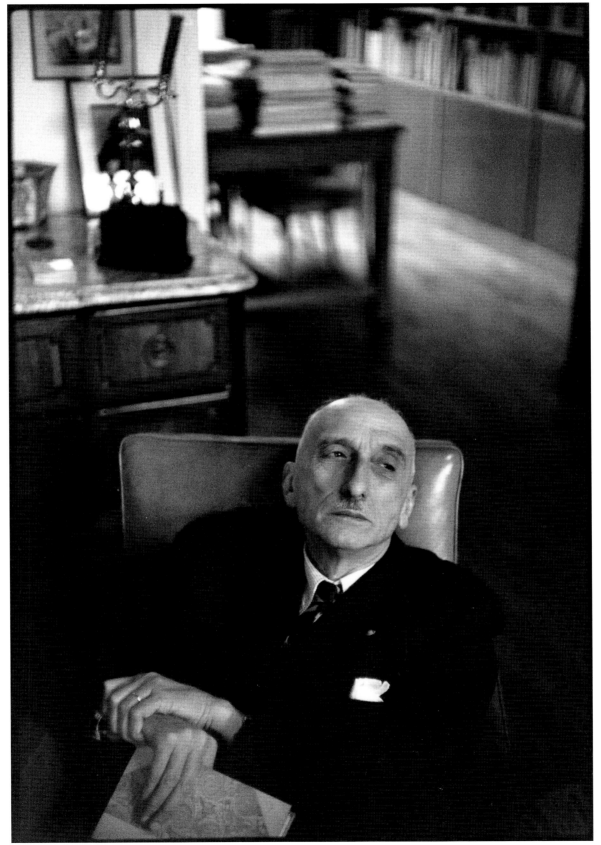

189 François Mauriac,
writer, 1952

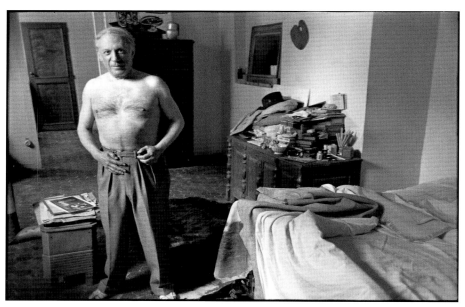

191 Pablo Picasso, painter, Paris, France, 1944

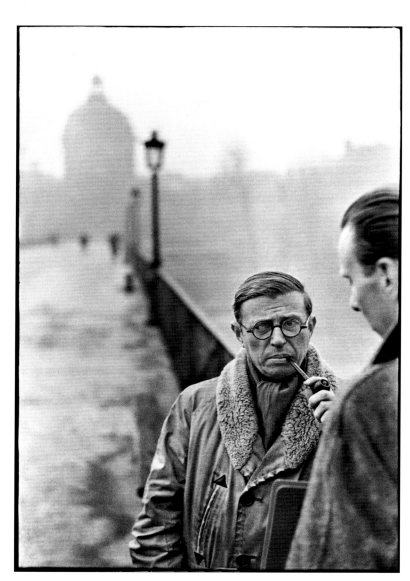

190 Jean-Paul Sartre, writer, Paris, France, 1946

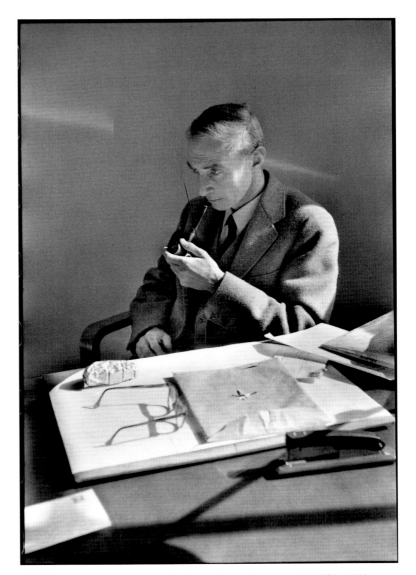

193 Robert Oppenheimer, scientist, Cambridge, Massachusetts, USA, 1958

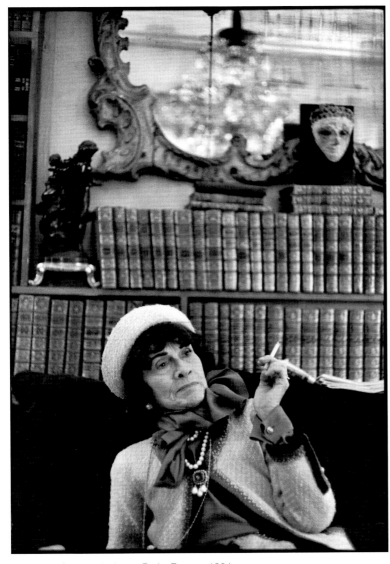

192 Coco Chanel, designer, Paris, France, 1964

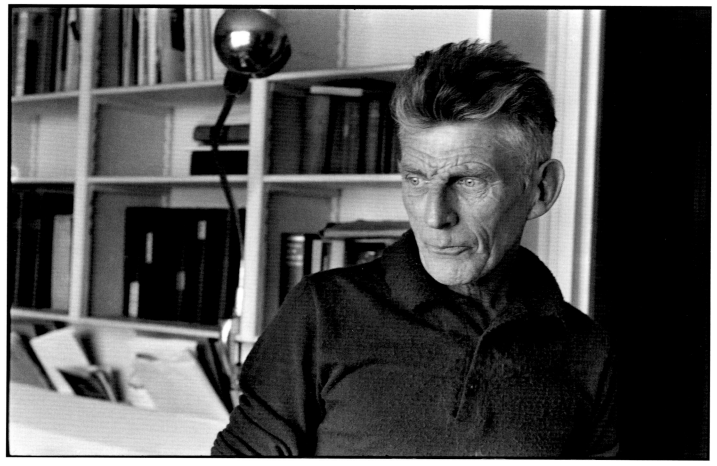

194 Samuel Beckett, writer, Paris, France, 1964

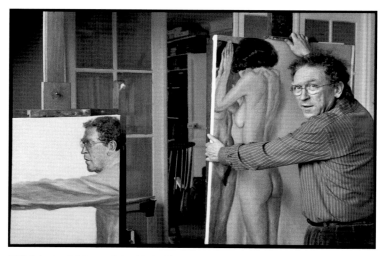

195 Avigdor Arikha, painter, Paris, France, 1985

198 Barbara Hepworth, sculptor, Great Britain, 1971

197 Georg Eisler, painter, Vienna, Austria, 1993

196 Violette Leduc, writer, Paris, France, 1964

199 Max Ernst and Dorothea
Tanning, painters, Huismes,
France, 1955

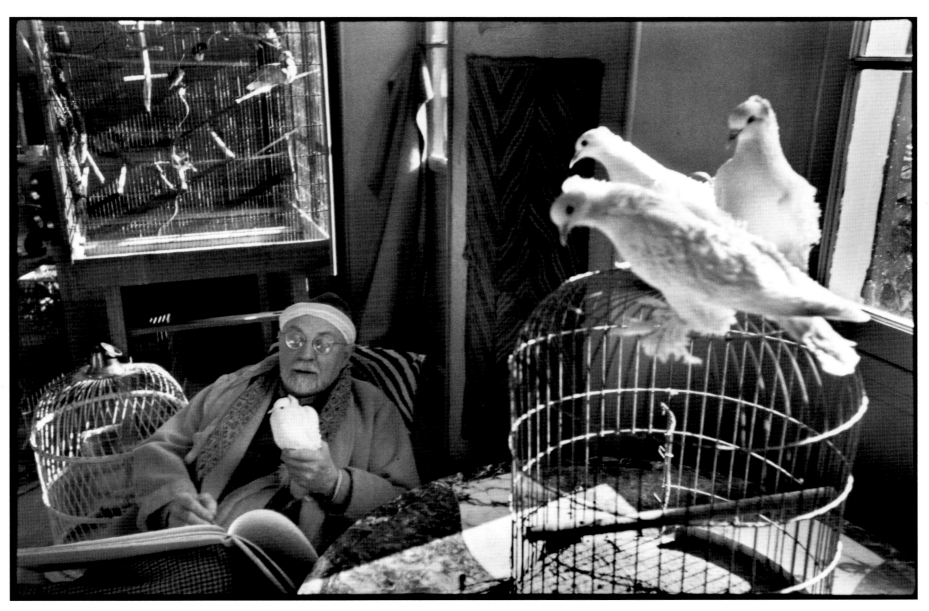

200 Henri Matisse, painter, Vence, France, 1944

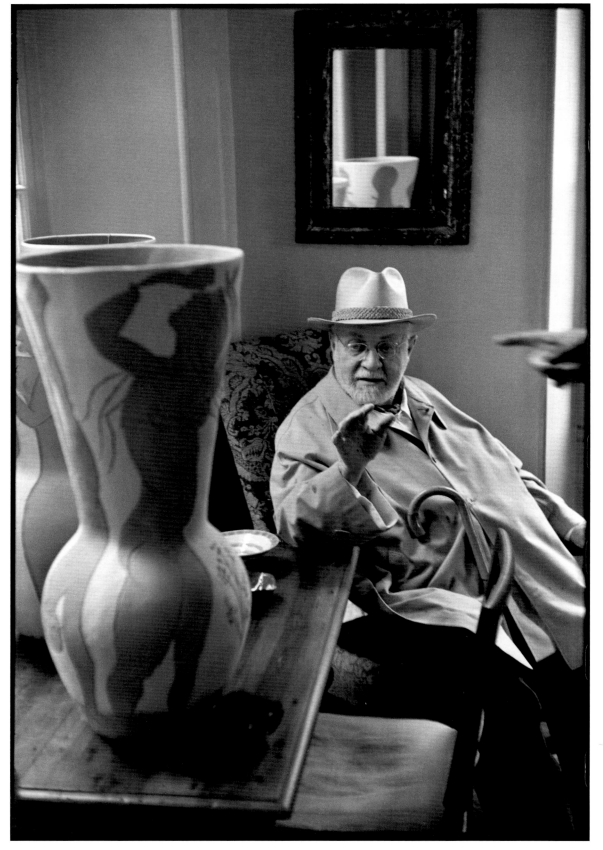

201 Henri Matisse at Tériade's,
Saint-Jean-Cap-Ferrat, France, 1951

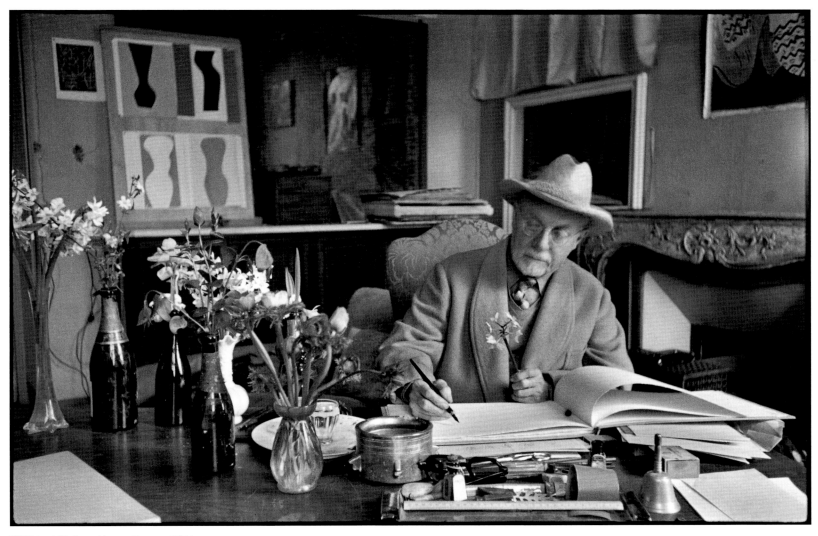

202 Henri Matisse, Vence, France, 1944

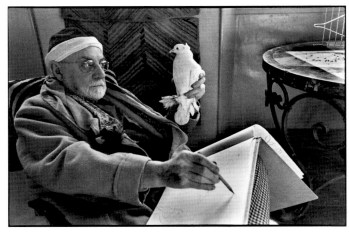

203 Henri Matisse, Vence, France, 1944

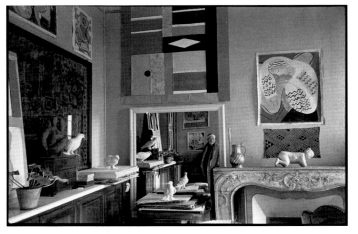

204 Henri Matisse, Vence, France, 1944

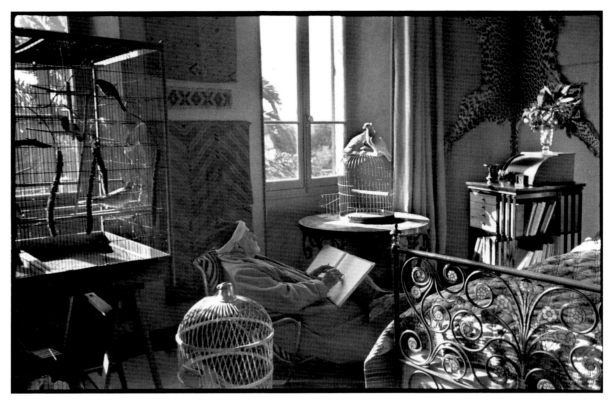

205 Henri Matisse, Vence, France, 1944

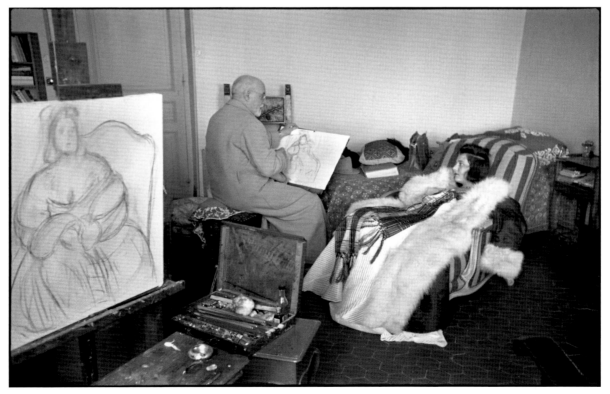

206 Henri Matisse and his model Michaela Avogrado, Vence, France, 1944

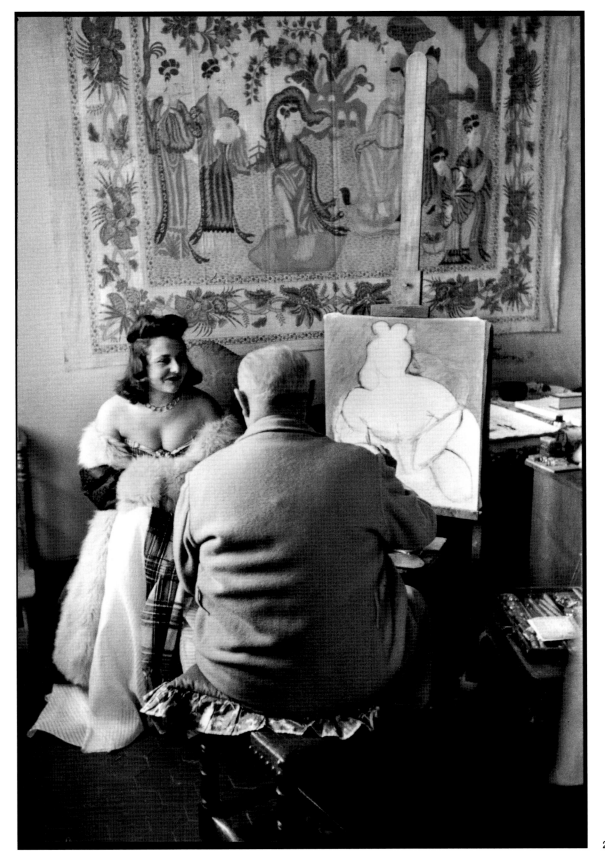

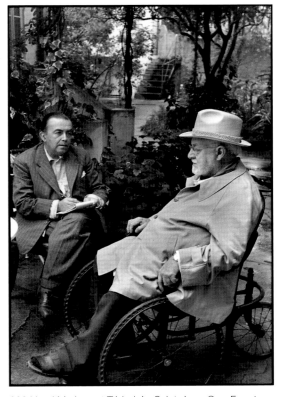

208 Henri Matisse at Tériade's, Saint-Jean-Cap-Ferrat, France, 1951

207 Henri Matisse and his model, Vence, France, 1944

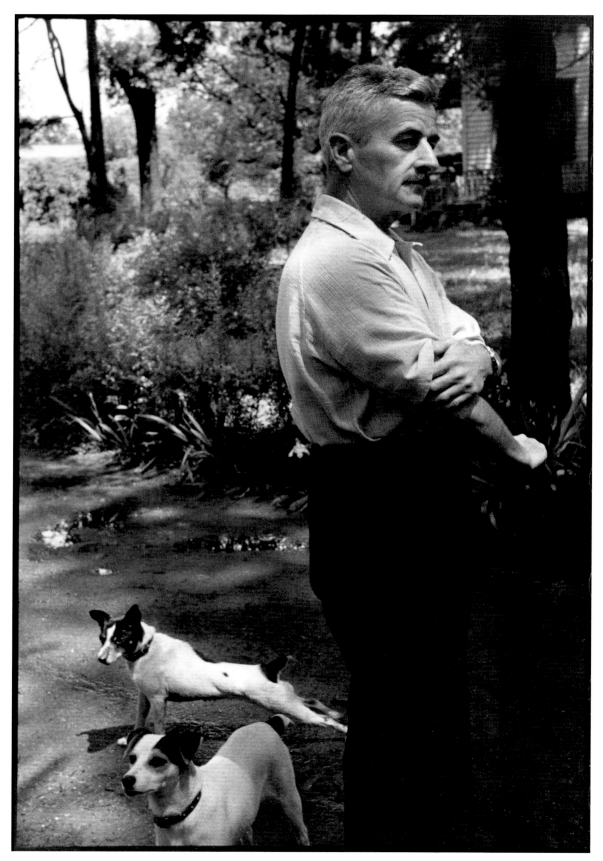

209 William Faulkner, writer, Oxford, Mississippi, USA, 1947

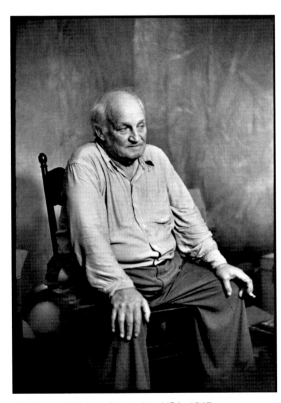

210 Robert Flaherty, film-maker, USA, 1947

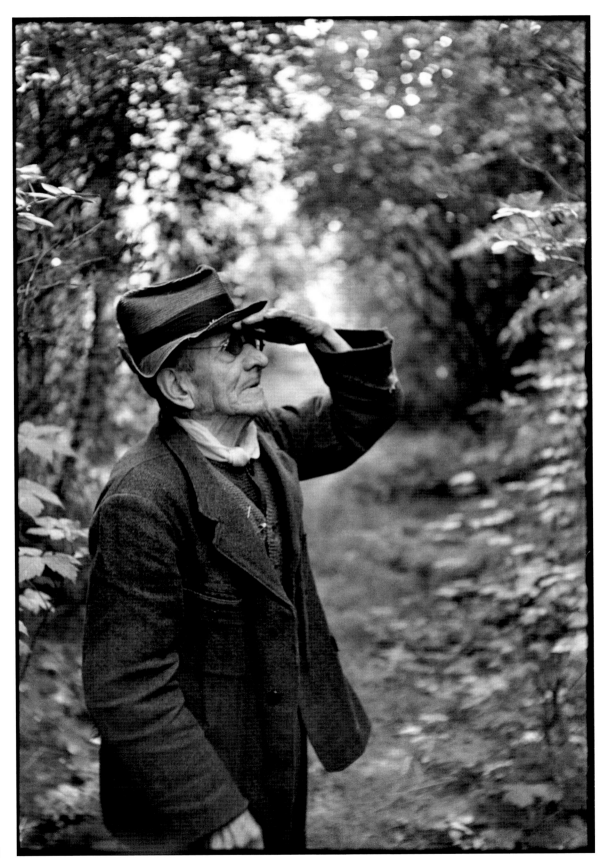

211 Paul Léautaud, writer, Fontenay-aux-Roses, France, 1952

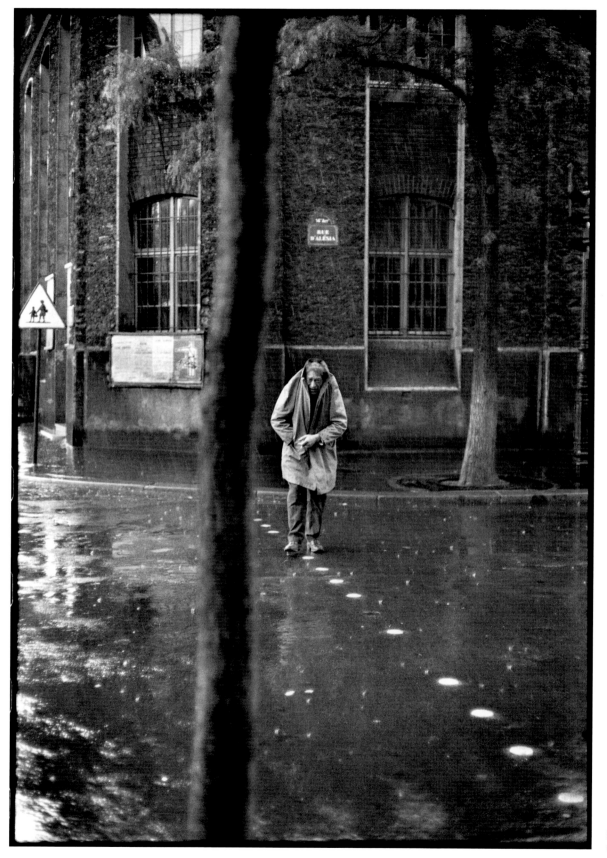

212 Alberto Giacometti, painter and sculptor, Paris, France, 1961

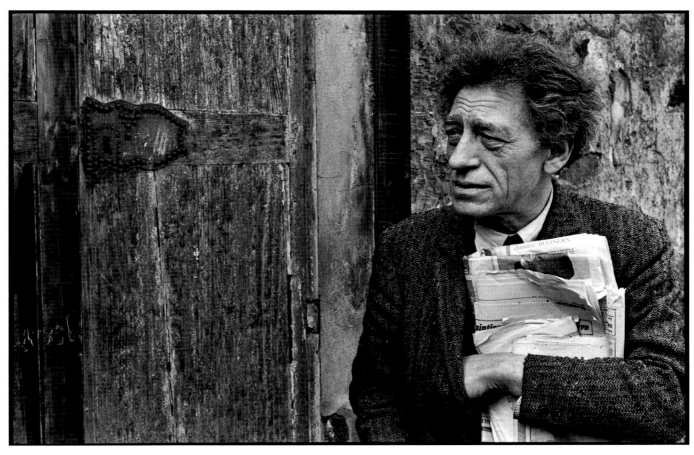

214 Alberto Giacometti, Paris, France, 1961

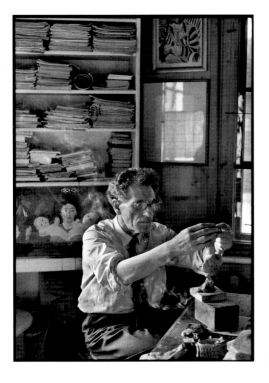

213 Alberto Giacometti, Stampa, Switzerland, 1961

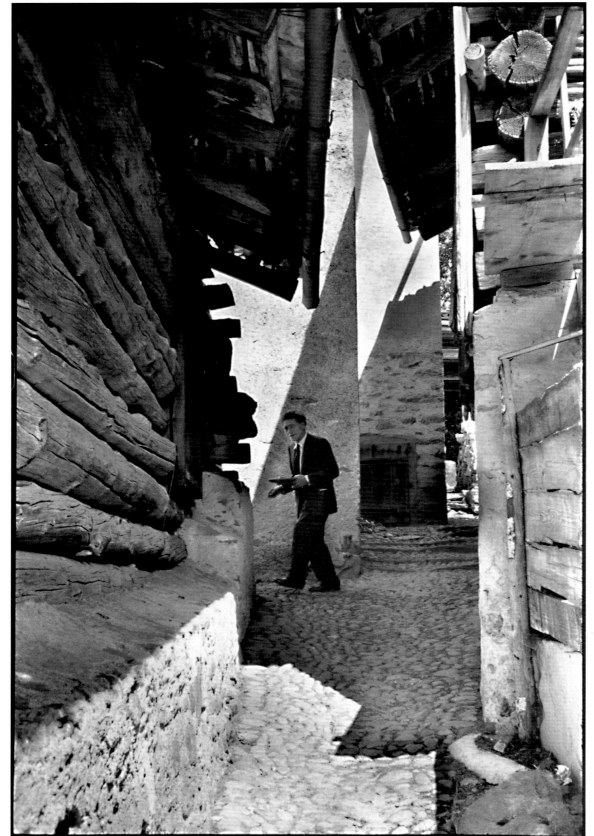

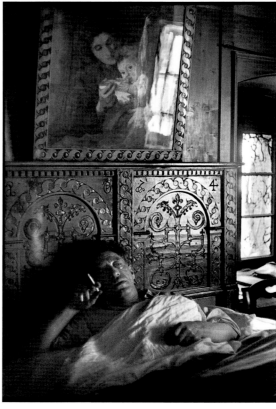

216 Alberto Giacometti, Stampa, Switzerland, 1961

215 Alberto Giacometti, Stampa, Switzerland, 1961

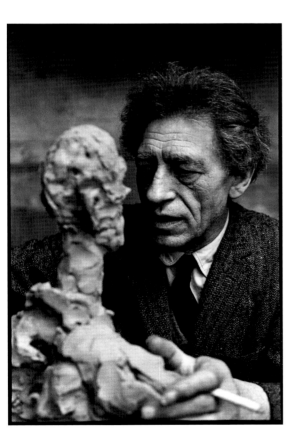

217 Alberto Giacometti, Paris, France, 1961

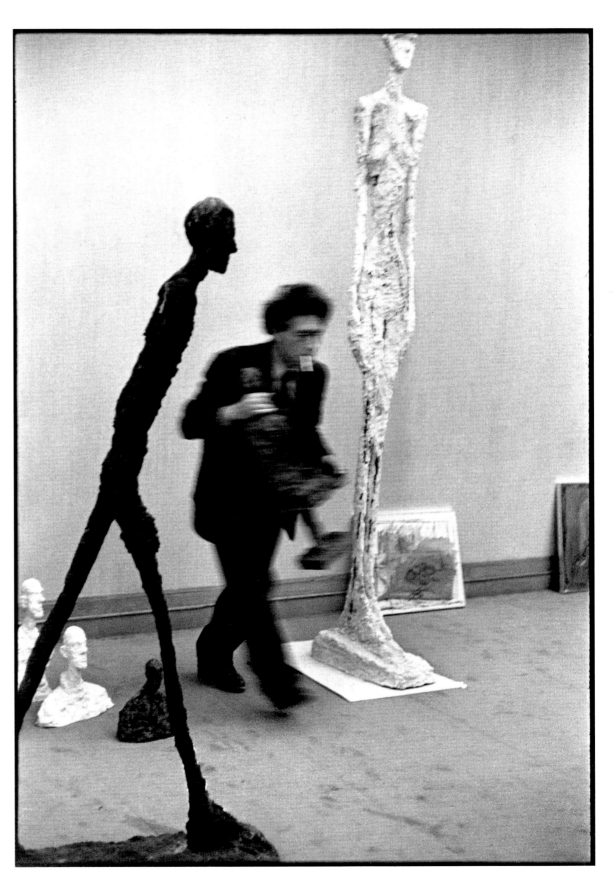

218 Alberto Giacometti, Paris, France, 1961

219 Colette, writer, and her lady companion, Paris, France, 1952

221 Louis Pons, painter, France, 1963

220 André Lhote, painter, and his students,
Paris, France, 1944

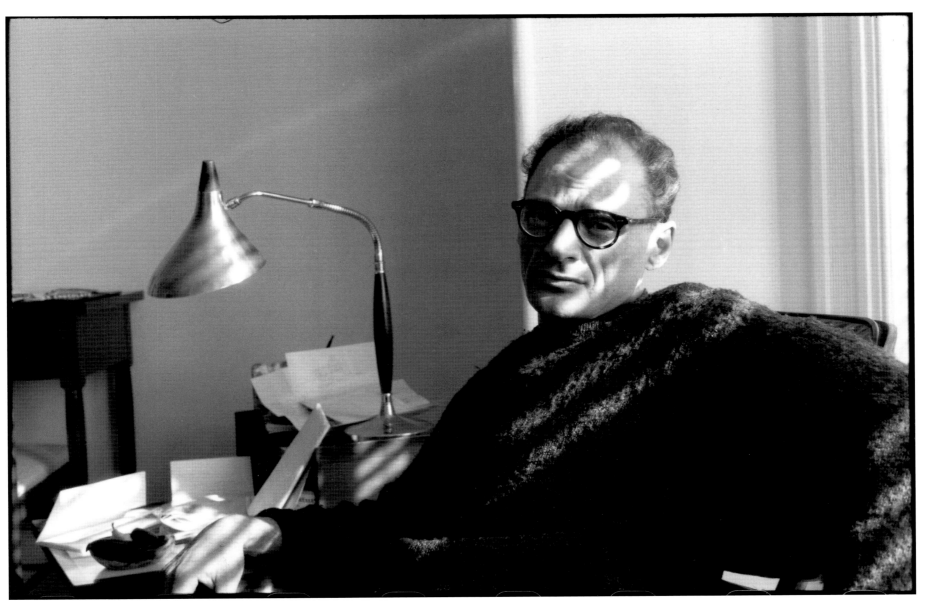

222 Arthur Miller, writer, Roxbury, Connecticut, USA, 1961

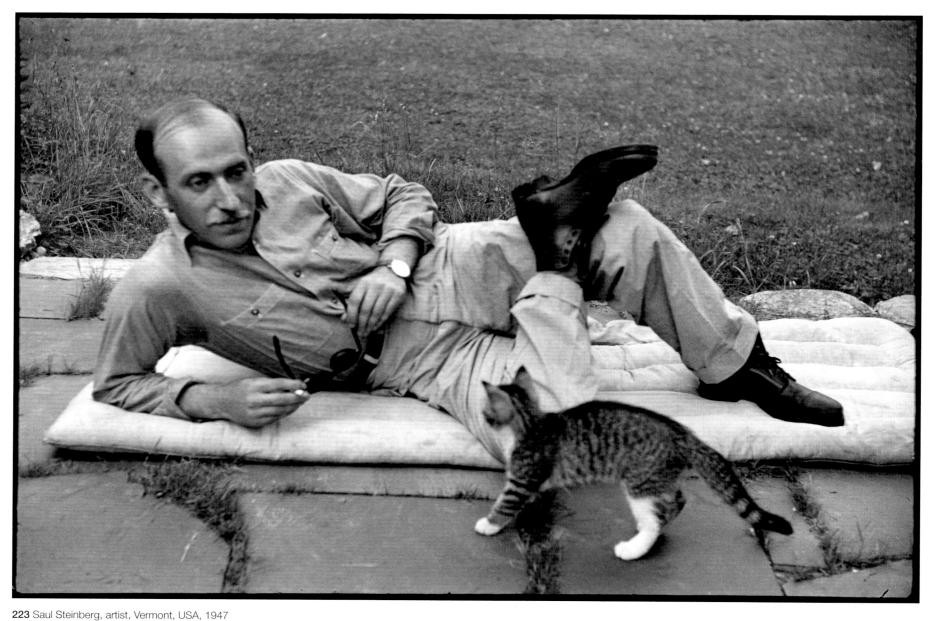

223 Saul Steinberg, artist, Vermont, USA, 1947

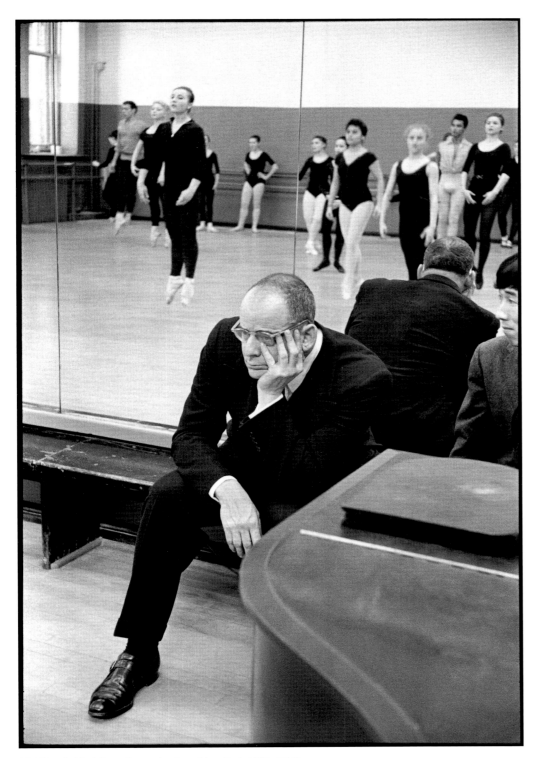

224 Lincoln Kirstein, writer and patron, New York, USA, 1959

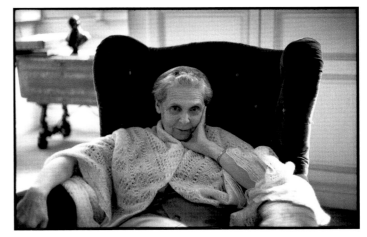

225 Elsa Triolet, writer, Paris, France, 1963

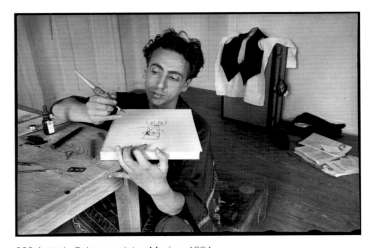

226 Antonio Salazar, painter, Mexico, 1934

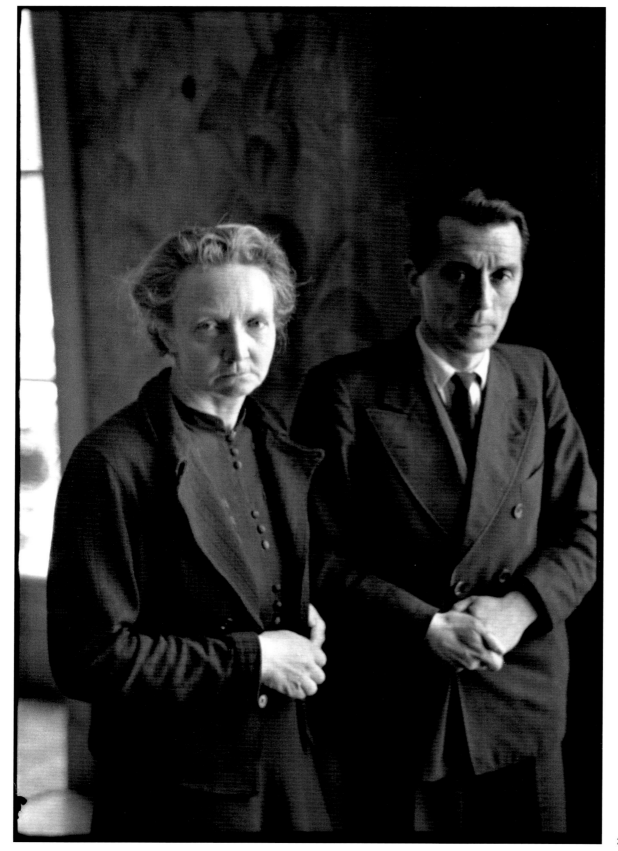

228 Sylvia Beach, publisher, Paris, France, 1959

227 Irène and Frédéric Joliot-Curie, scientists, Paris, France, 1944

230 Gjon Mili, photographer, New York, USA, 1958

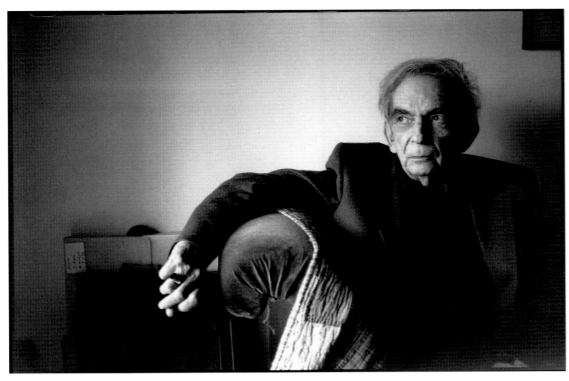

229 Louis-René des Forêts, writer, Paris, France, 1985

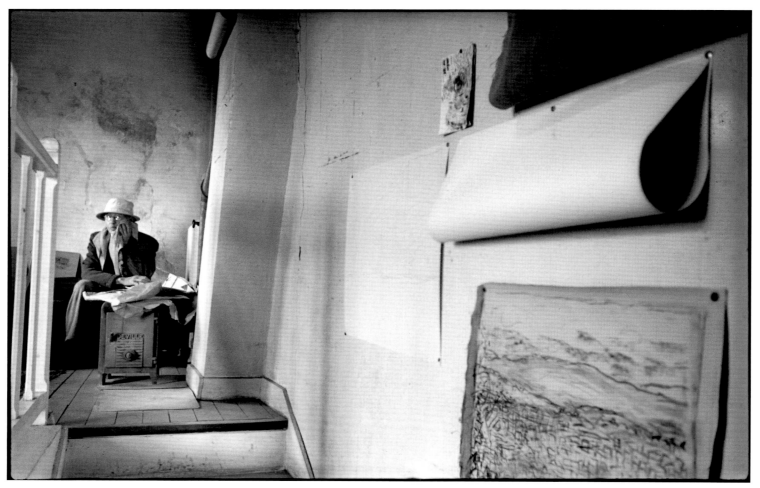

231 Pierre Bonnard, painter, Le Cannet, France, 1944

232 Pierre Bonnard, Le Cannet, France, 1944

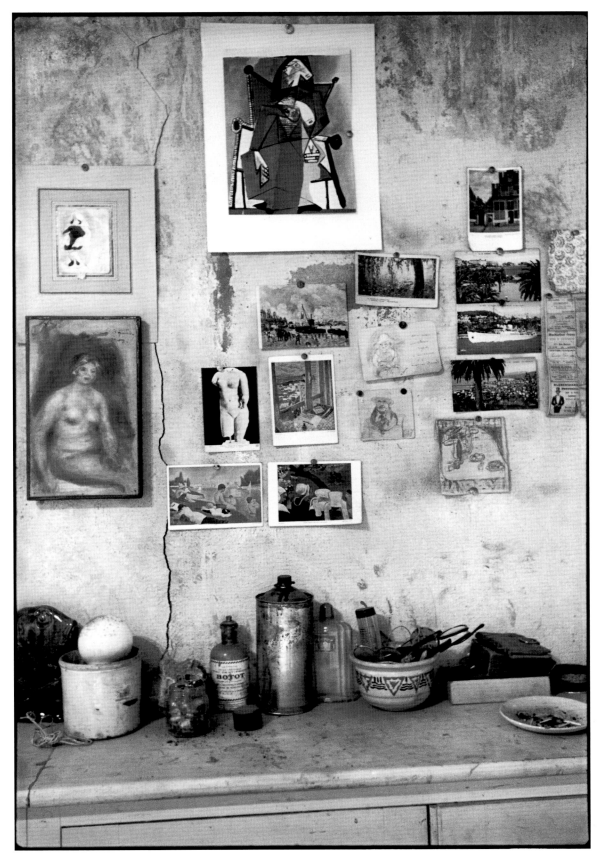

233 Pierre Bonnard's studio,
Le Cannet, France, 1944

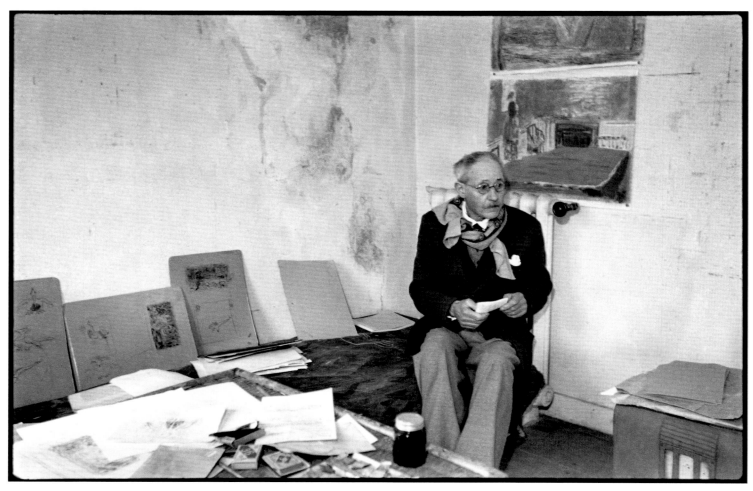

234 Pierre Bonnard, Le Cannet, France, 1944

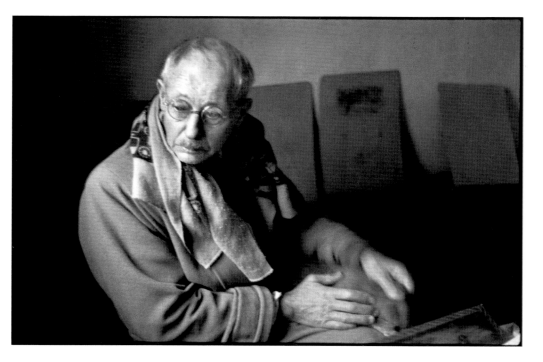

235 Pierre Bonnard, Le Cannet, France, 1944

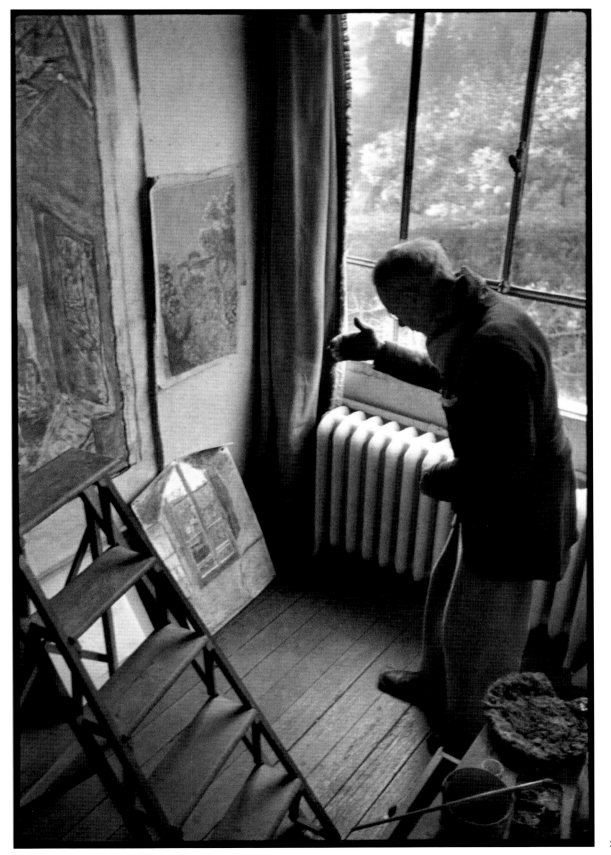

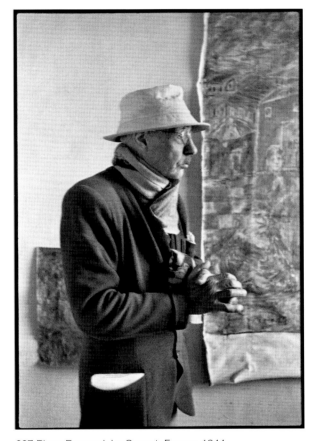

237 Pierre Bonnard, Le Cannet, France, 1944

236 Pierre Bonnard, Le Cannet, France, 1944

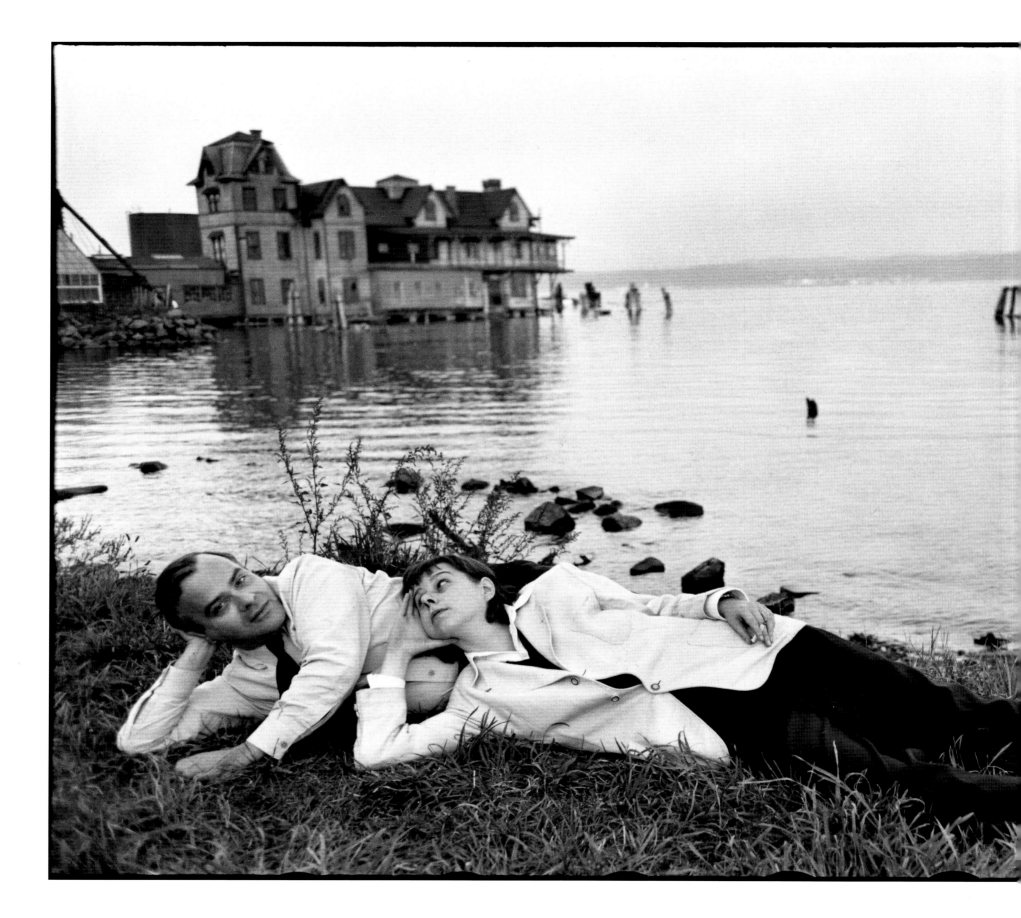

239 Francis Bacon, painter, London, 1971

240 Richard Avedon, photographer, Carmel Snow and Marie-Louise Bousquet, fashion editors, Paris, France, 1951

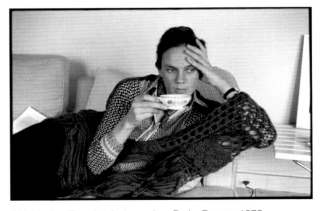

241 Martine Franck, photographer, Paris, France, 1975

238 George Davis and Carson McCullers, writers, Long Island, New York, USA, 1947

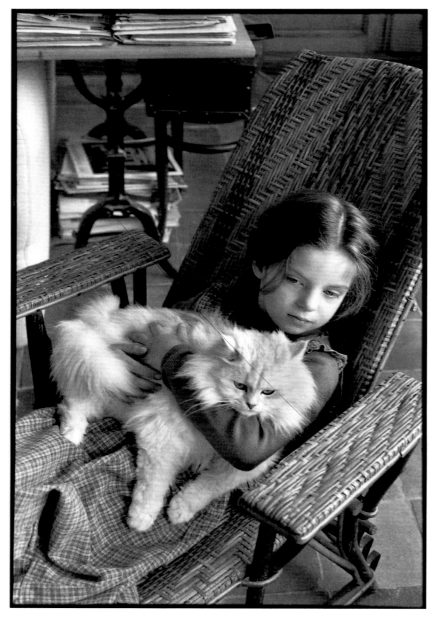

242 Mélanie Cartier-Bresson at Folon's, Burcy, France, 1978

243 In Henri Cartier-Bresson's studio, Paris, France, 1962

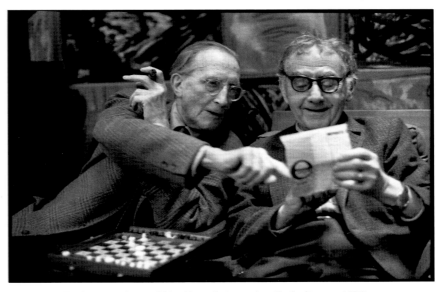

245 Marcel Duchamp, artist, and Man Ray, photographer, Paris, France, 1968

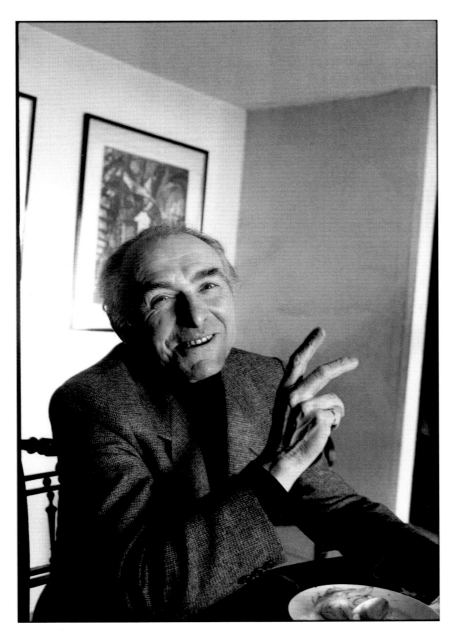

244 Robert Doisneau, photographer, Paris, France, 1982

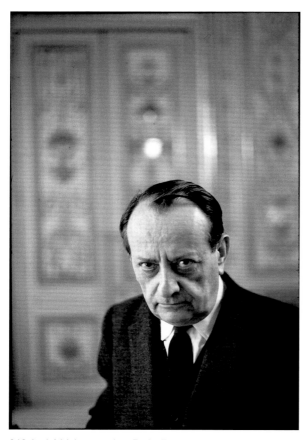

246 André Malraux, writer, Paris, France, 1968

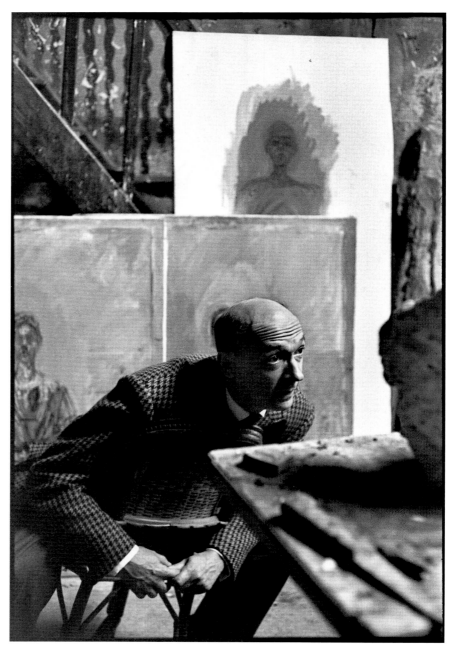

247 Pierre Josse, sculptor, in Alberto Giacometti's studio, Paris, France, 1961

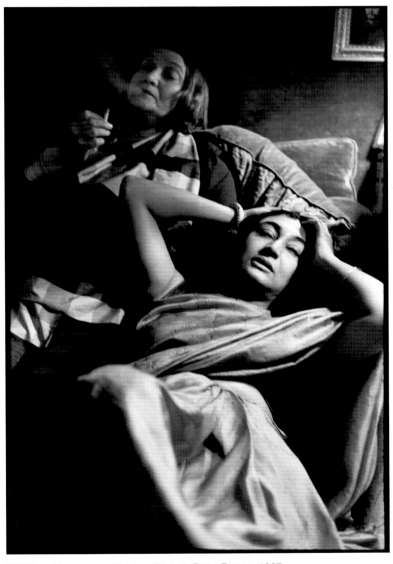

248 Mary Meerson and Krishna Riboud, Paris, France, 1967

249 Eugène Ionesco, writer, Paris, France, 1971

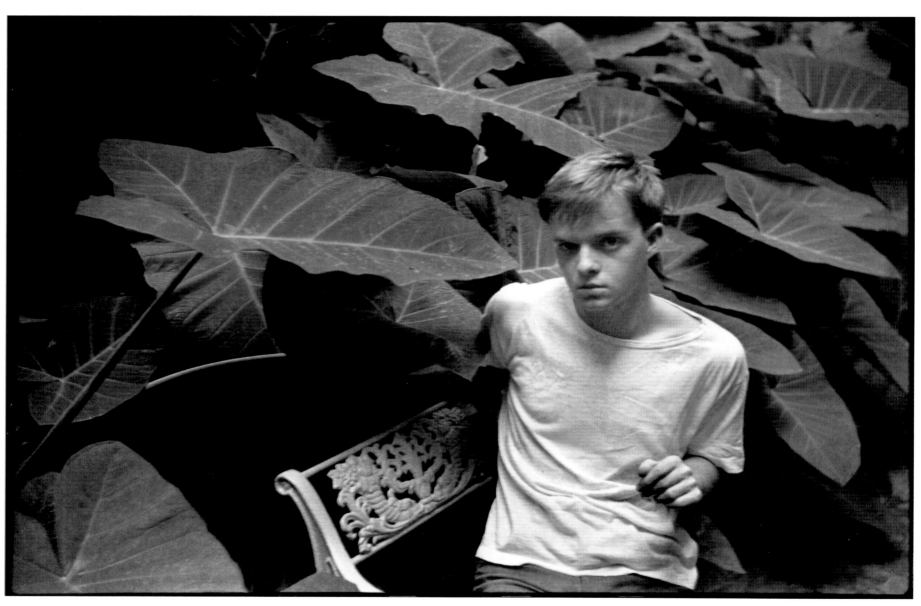

250 Truman Capote, writer, New Orleans, Louisiana, USA, 1947

252 Alfred Stieglitz, photographer, New York, USA, 1946

251 Pierre Jean Jouve, writer, Paris, France, 1964

253 Georges Rouault, painter, Paris, France, 1944

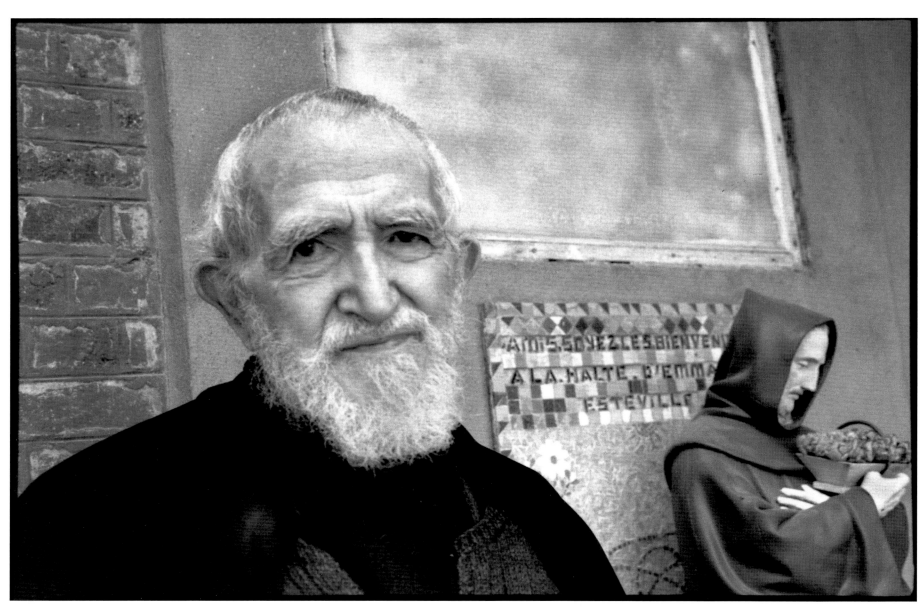

254 Abbé Pierre, Esteville, France, 1994

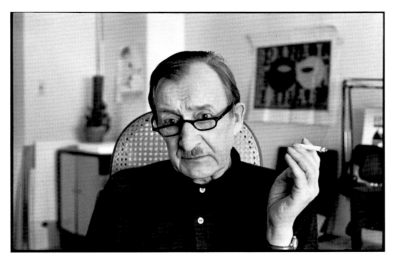

255 Alexey Brodovitch, graphic artist, New York, USA, 1962

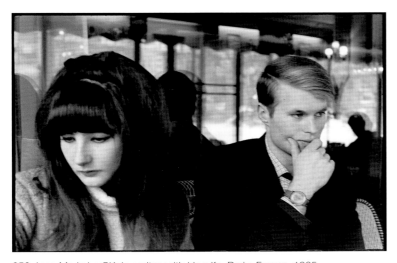

256 Jean-Marie Le Clézio, writer, with his wife, Paris, France, 1965

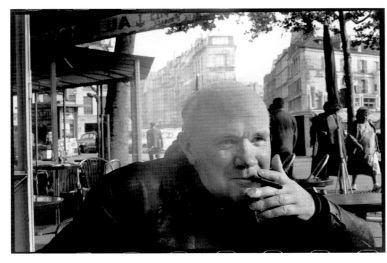

257 Jean Genet, writer, Paris, France, 1963

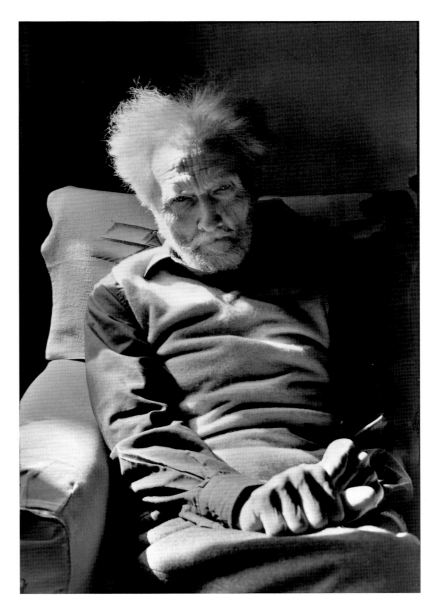

258 Ezra Pound, writer, Venice, Italy, 1971

191

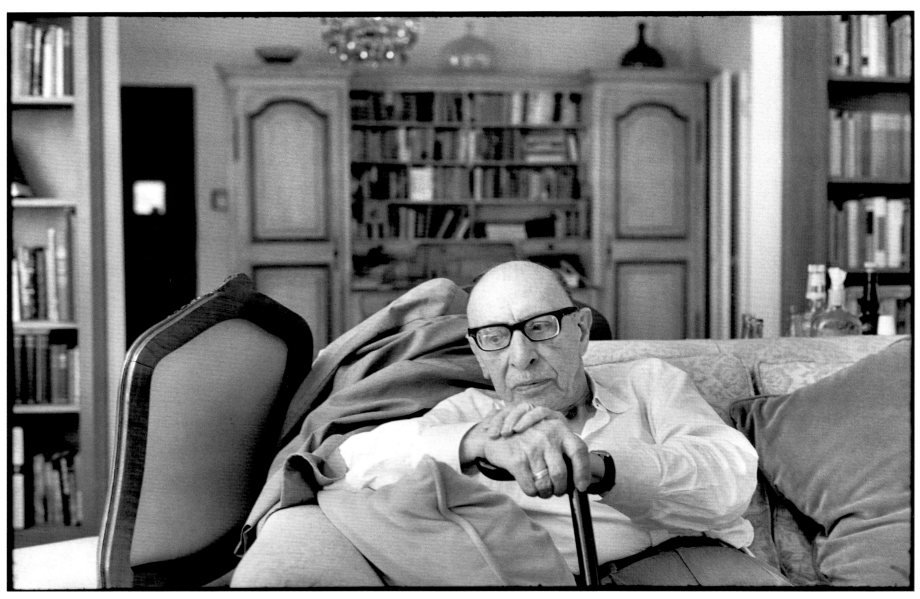

259 Igor Stravinsky, composer, New York, USA, 1967

'To say that he was only a mathematician. He had faith in geometry. Do you think that doesn't seem very much? With mathematics and geometry you can explain almost everything. Almost everything.'

Morandi on Pascal
Quoted by Philippe Jaccottet

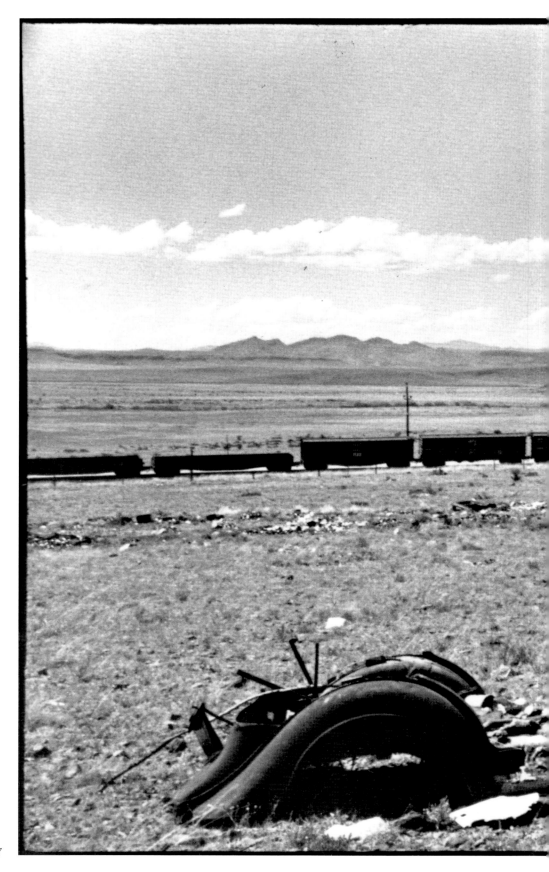

260 Arizona, USA, 1947

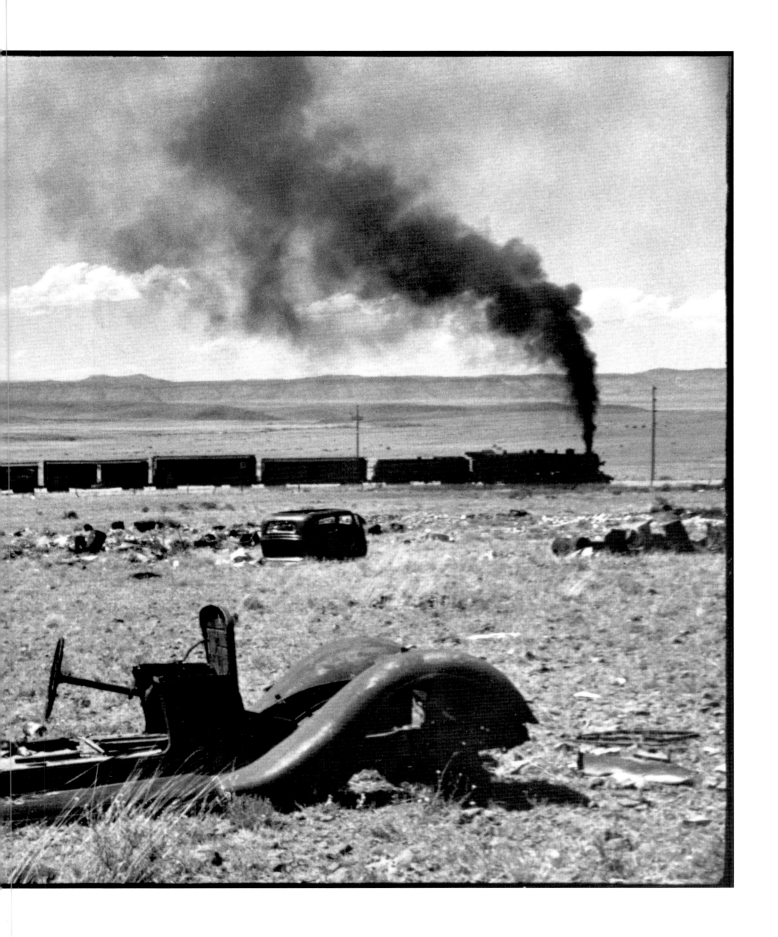

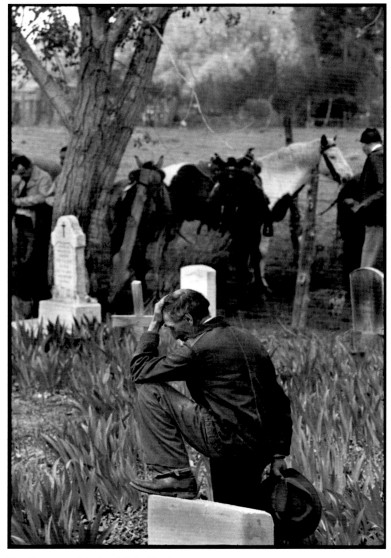

261 Taos, New Mexico, USA, 1947

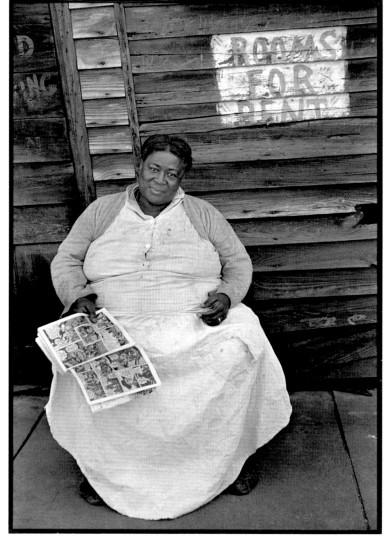

262 Vicksburg, Mississippi, USA, 1947

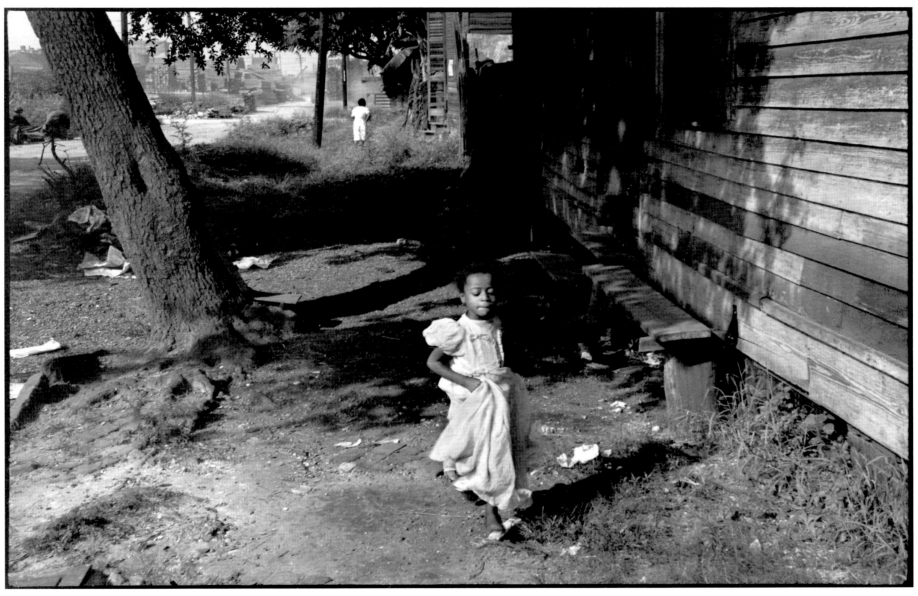

263 New Orleans, Louisiana, USA, 1947

264 Texas, USA, 1947

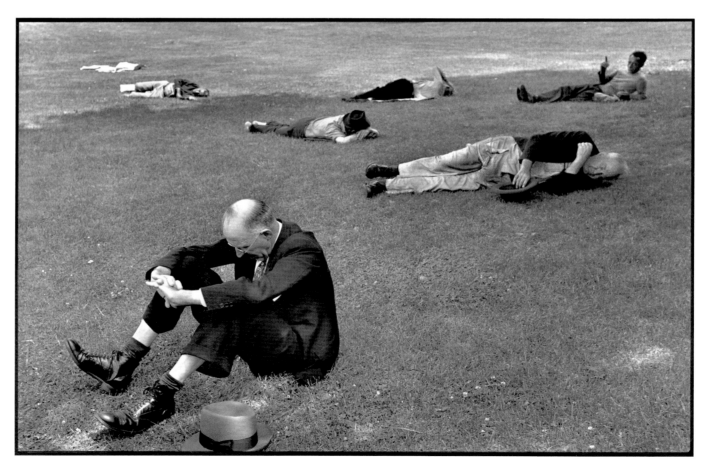

265 Boston, Massachusetts,
USA, 1947

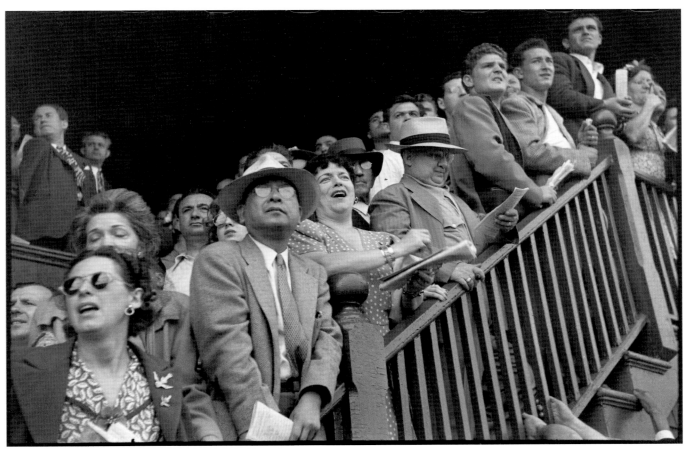

267 Saratoga, New York State, USA, 1947

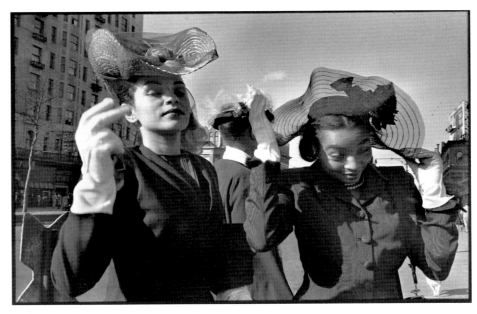

266 Harlem, New York, USA, 1947

199

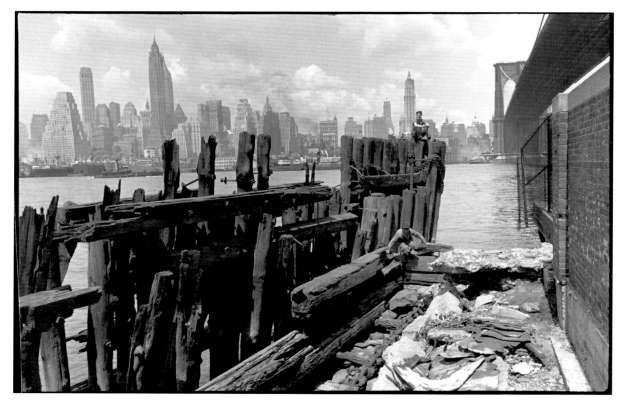

268 New York, USA, 1947

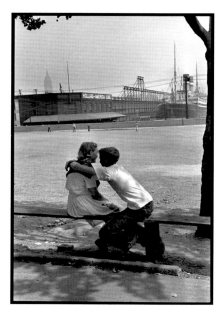

270 New Jersey, USA, 1947

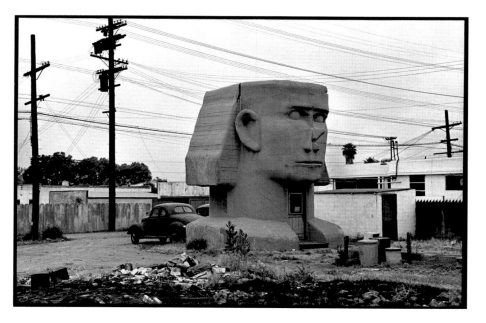

269 California, USA, 1947

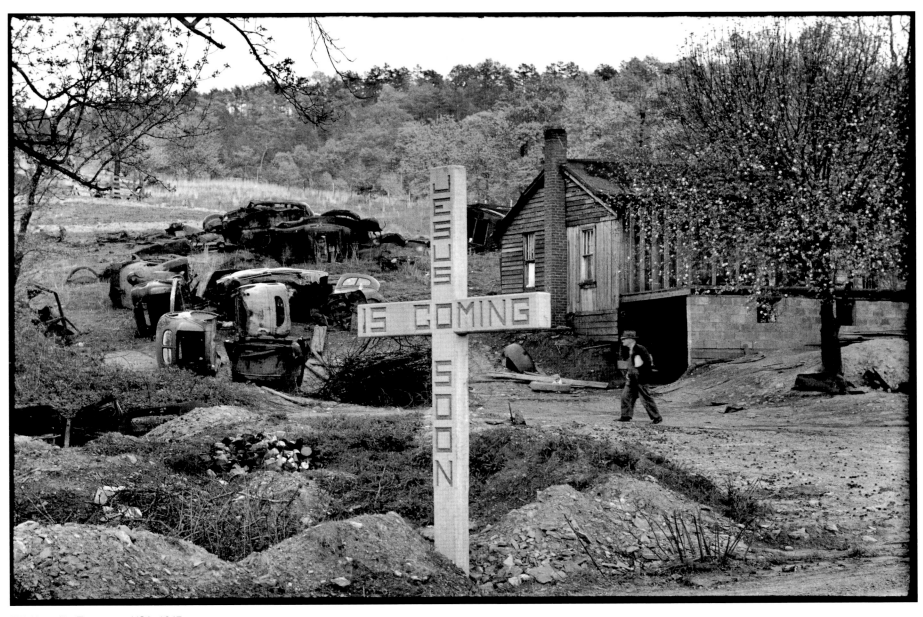

271 Knoxville, Tennessee, USA, 1947

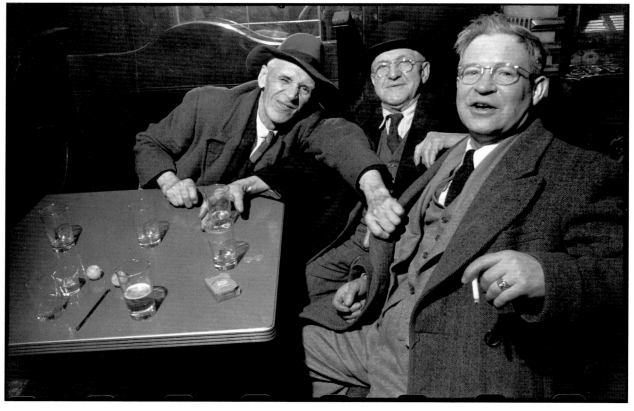

273 Detroit, Michigan, USA, 1947

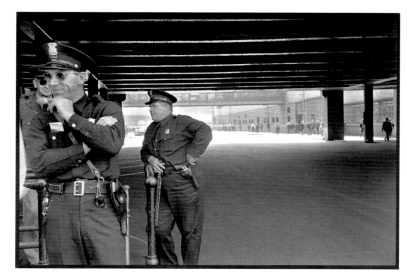

272 New York, USA, 1947

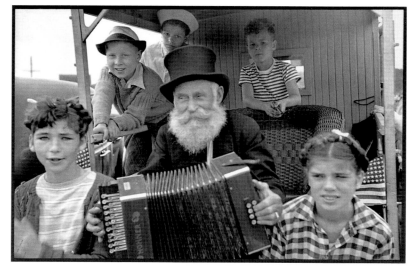

274 Cape Cod, Massachusetts, USA, 1947

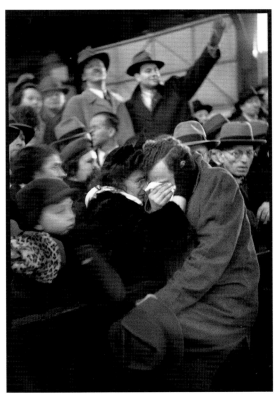

276 Arrival of a boatload of refugees in Manhattan,
New York, USA, 1935

277 New York, USA, 1947

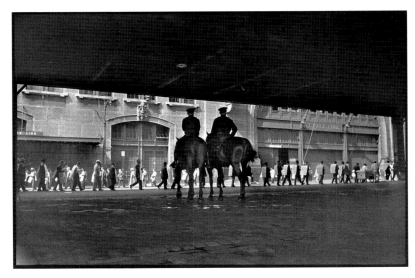

275 New York, USA, 1947

279 Manhattan, New York, USA, 1935

278 Chicago, Illinois, USA, 1947

280 Lynchburg, Virginia, USA, 1947

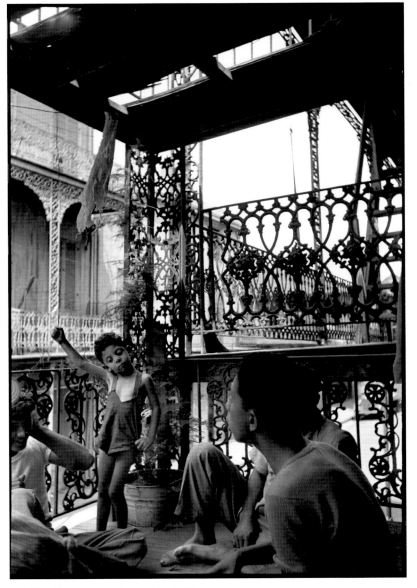

281 New Orleans, Louisiana, USA, 1947

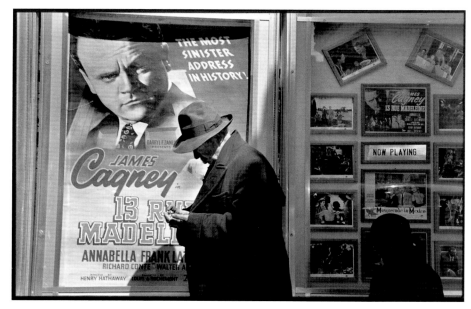

283 New York, USA, 1947

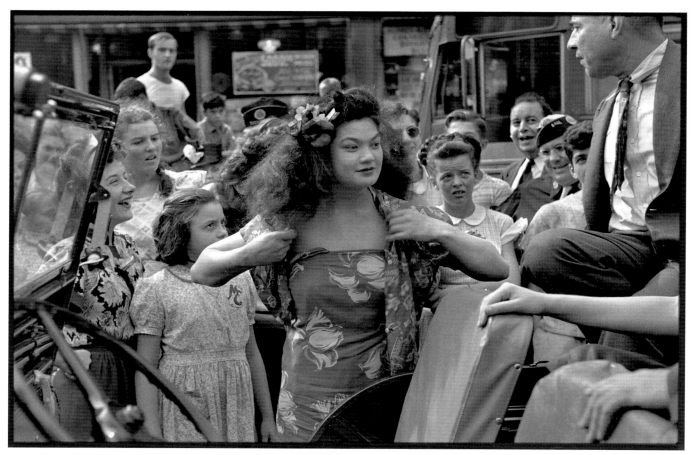

282 Manhattan, New York, USA, 1947

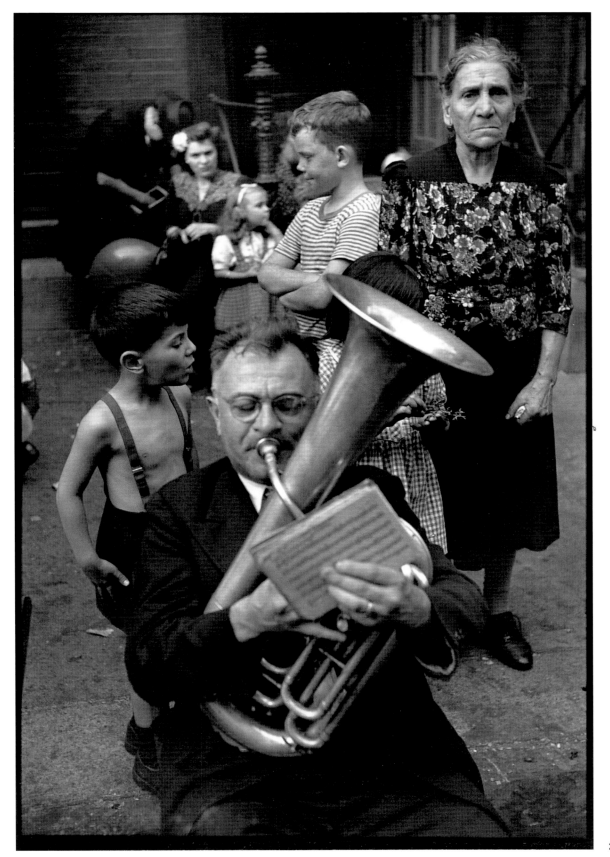

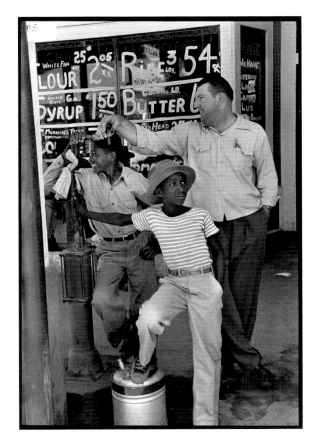

285 St Francisville, Louisiana, USA, 1947

284 Manhattan, New York, USA, 1947

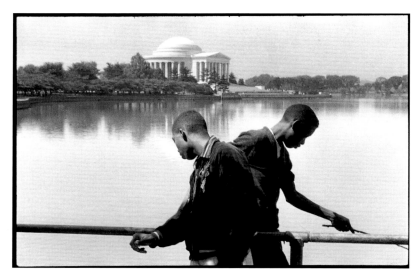

286 The Capitol, Washington DC, USA, 1957

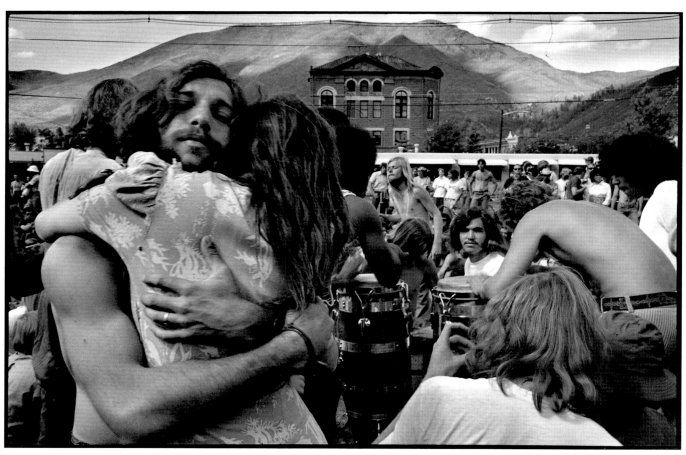

287 Aspen, Colorado, USA, 1971

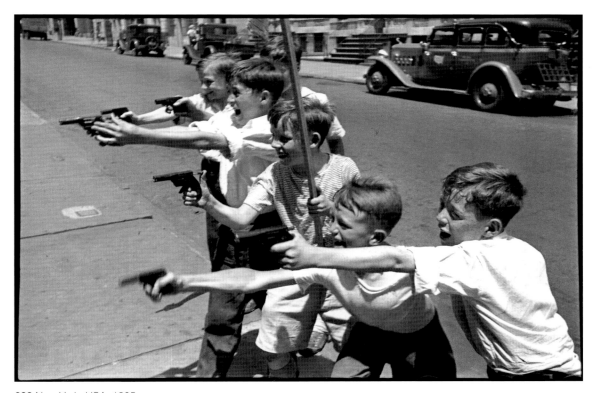

288 New York, USA, 1935

289 United States, 1947

290 Chicago, Illinois, USA, 1947

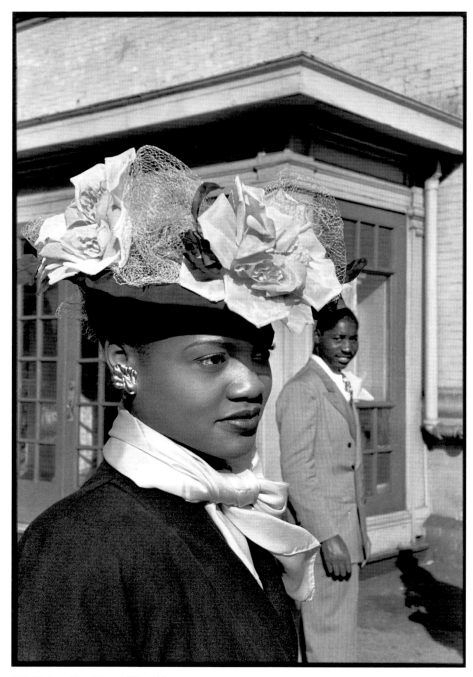

291 Harlem, New York, USA, 1947

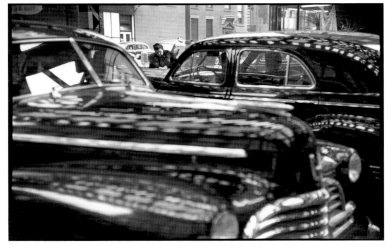

293 New York, USA, 1947

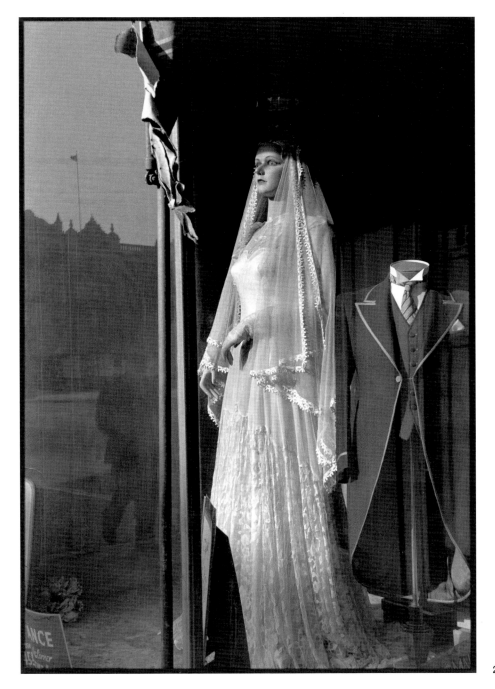

292 Manhattan, New York, USA, 1935

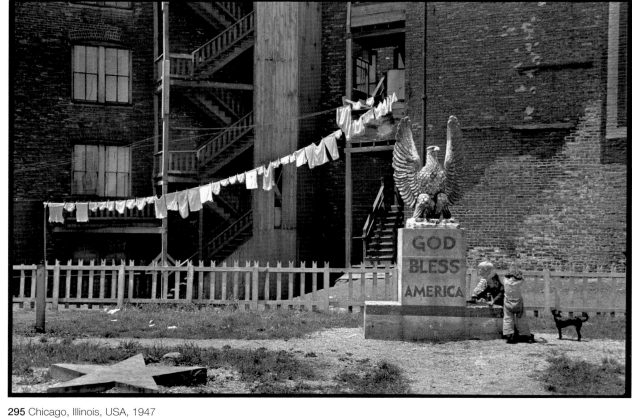

295 Chicago, Illinois, USA, 1947

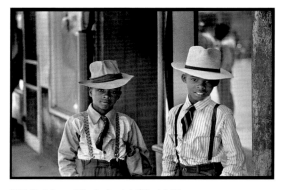

294 Natchez, Mississippi, USA, 1947

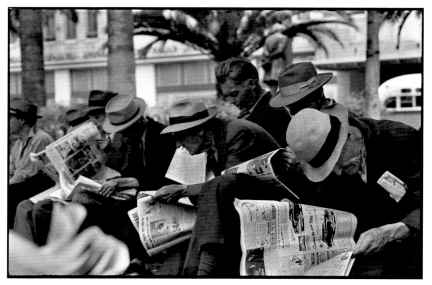

296 Los Angeles, California, USA, 1947

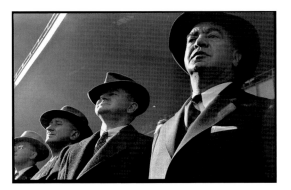

297 New York, USA, 1947

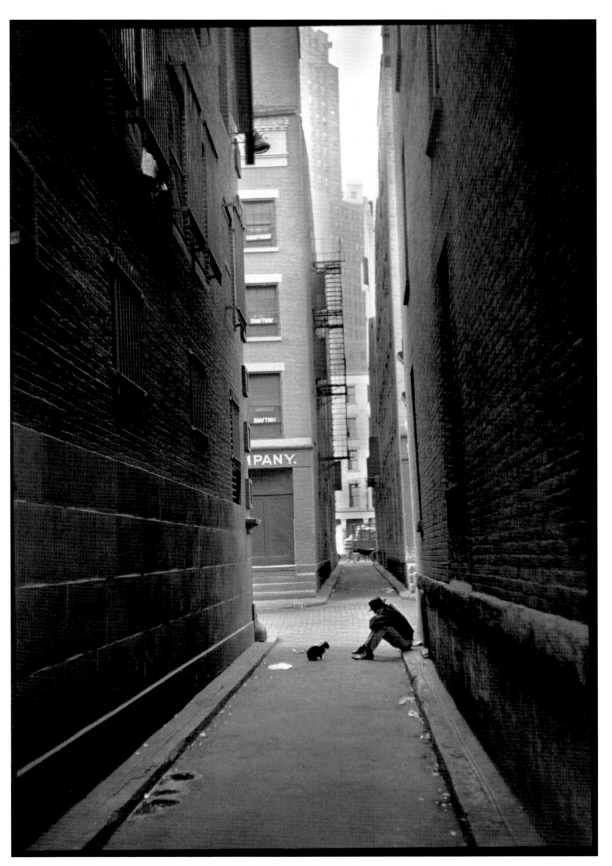

298 Manhattan, New York, USA, 1947

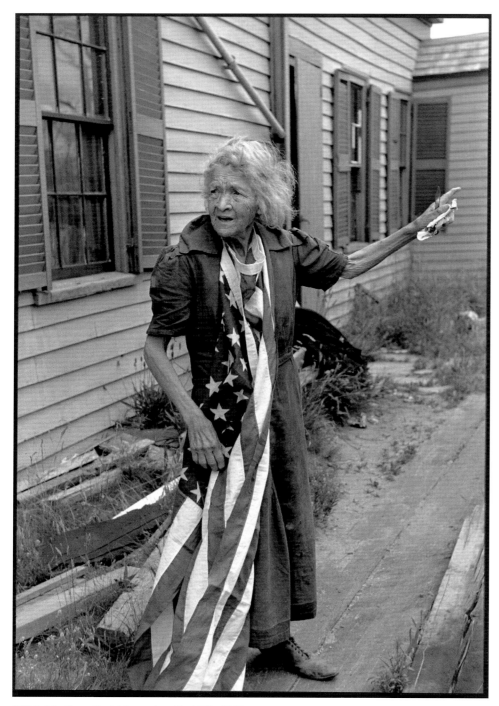
299 4 July, Cape Cod, Massachusetts, USA, 1947

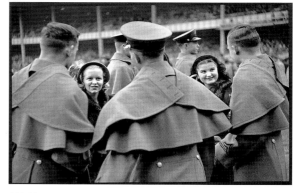
300 New York, USA, 1947

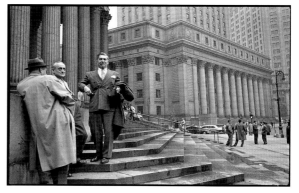
301 Manhattan, New York, USA, 1947

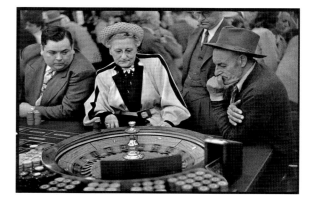
302 Las Vegas, Nevada, USA, 1947

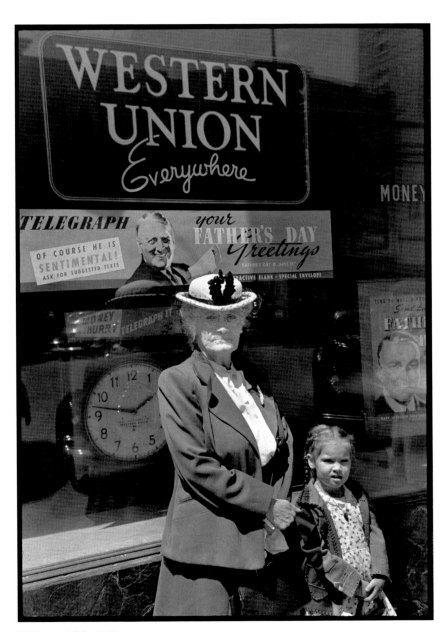

303 Iowa, USA, 1947

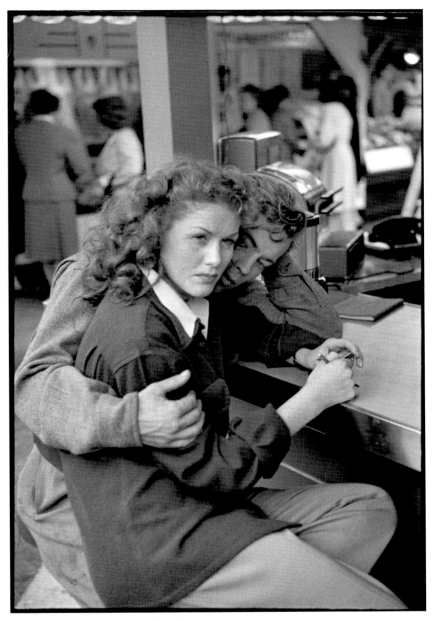

304 Los Angeles, California, USA, 1947

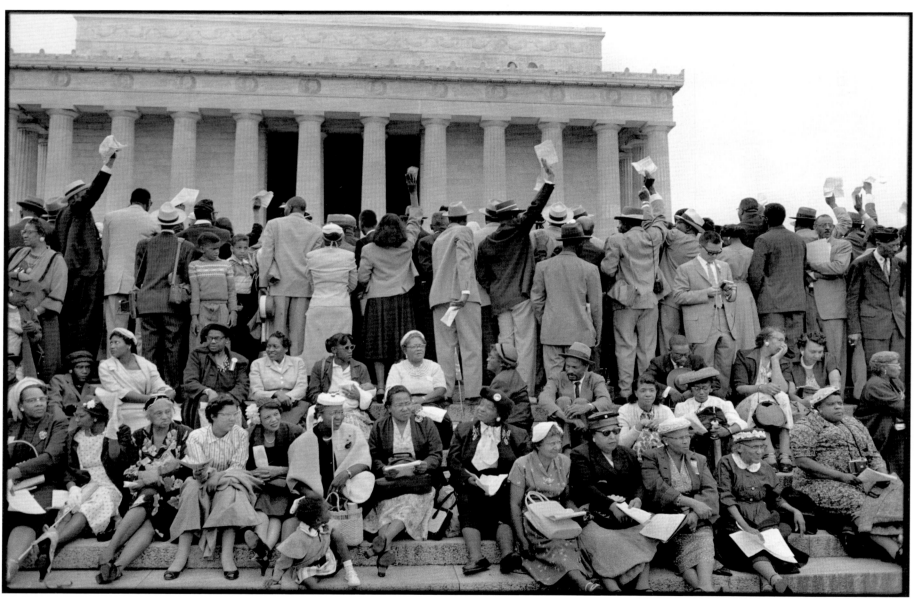

305 Washington DC, USA, 1957

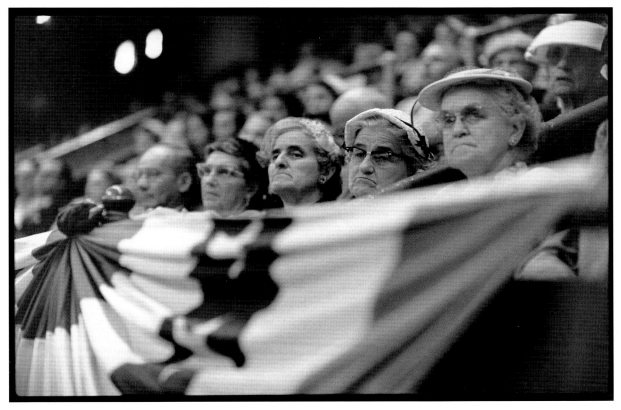

306 Harlem, New York, USA, 1947

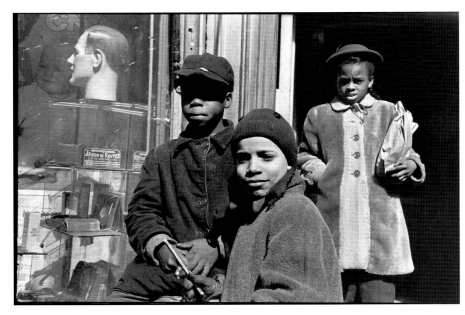

307 New York, USA, 1957

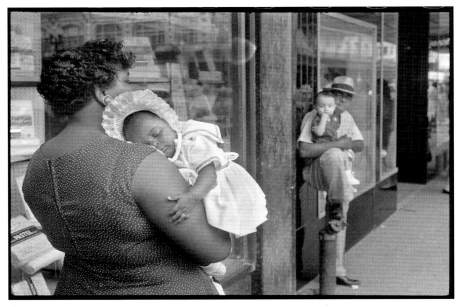

308 Texas, USA, 1957

217

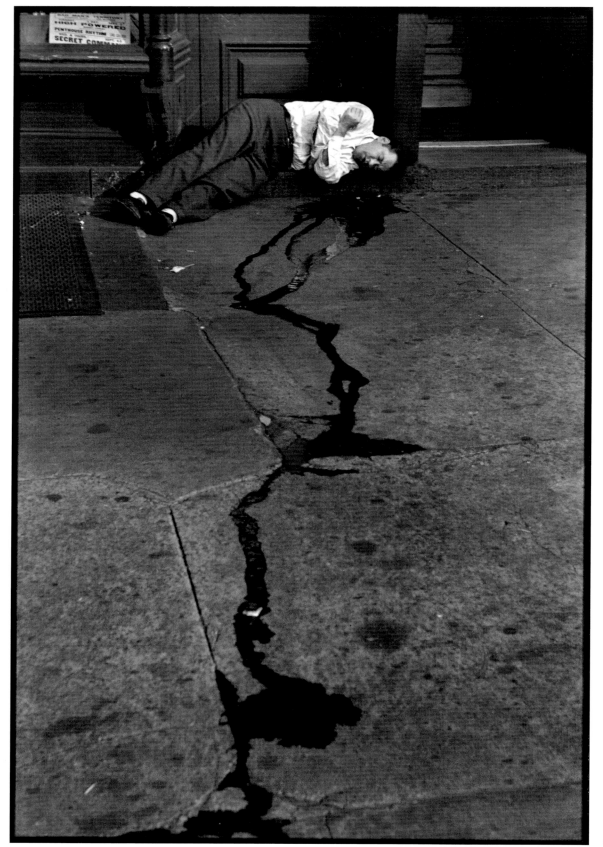

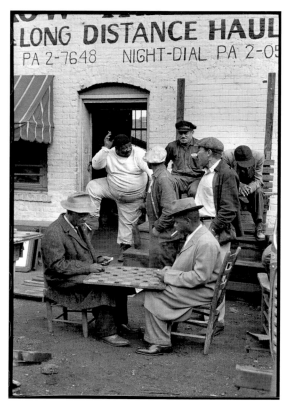

310 Raleigh, North Carolina, USA, 1960

309 Manhattan, New York, USA, 1947

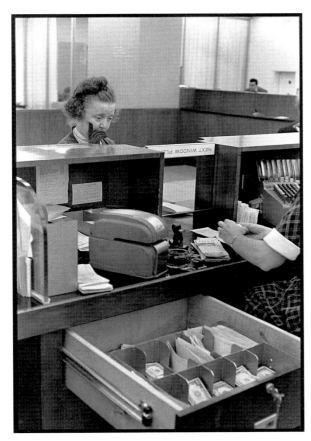

311 Manhattan, New York, USA, 1960

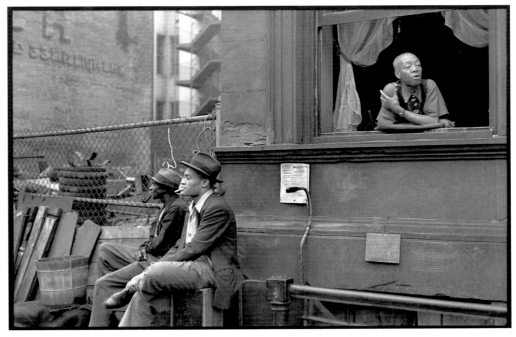

312 Harlem, New York, USA, 1947

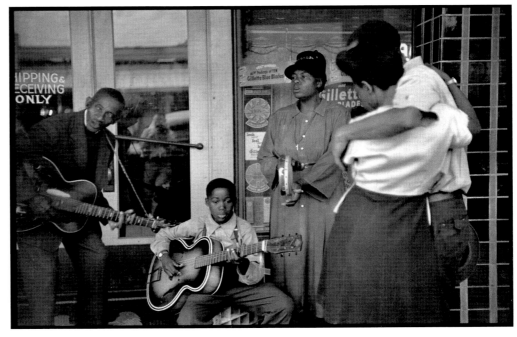

313 San Antonio, Texas, USA, 1947

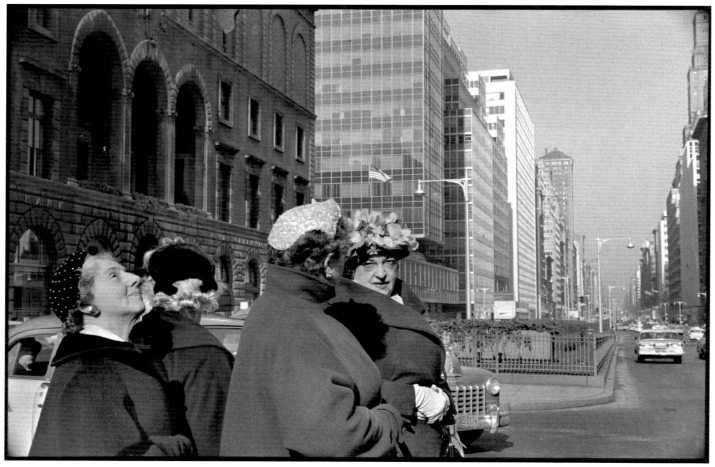

314 Park Avenue, Manhattan, New York, USA, 1959

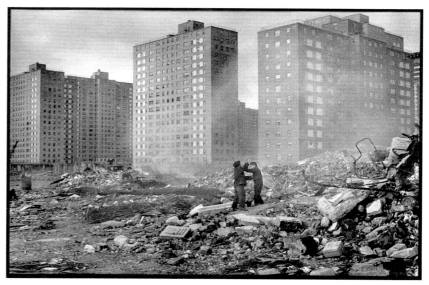

315 Manhattan, New York, USA, 1959

316 Manhattan, New York, USA, 1960

317 Virginia, Richmond, USA, 1960

318 The Capitol, Washington DC, USA, 1957

319 Los Angeles, California, USA, 1960

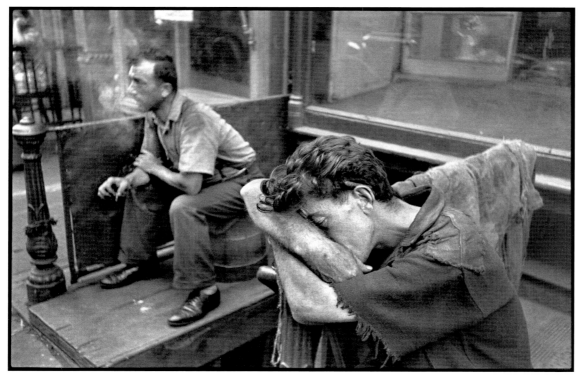

320 Manhattan, New York, USA, 1939

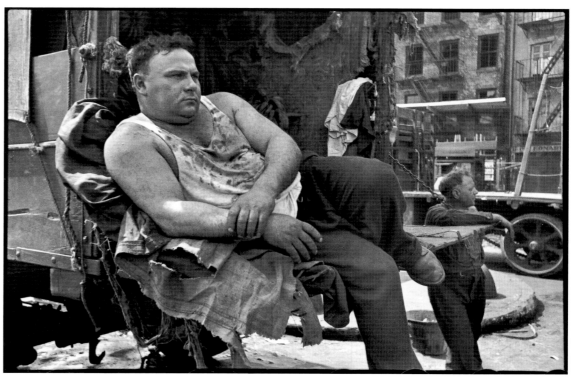

321 Manhattan, New York, USA, 1947

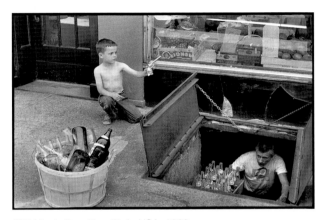

323 Manhattan, New York, USA, 1963

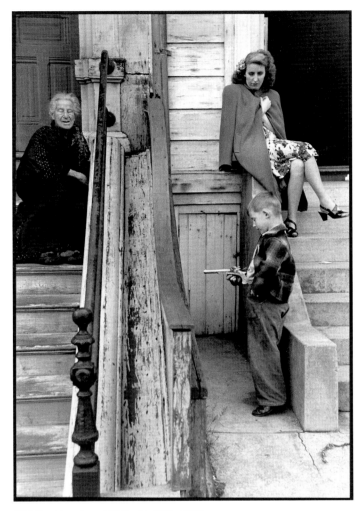

324 San Francisco, California, USA, 1946

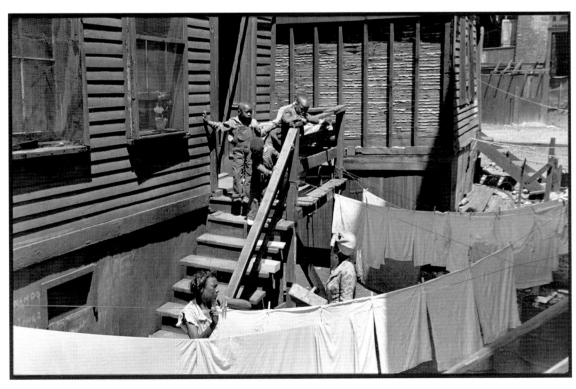

322 Chicago, Illinois, USA, 1947

325 Arrival of Fidel Castro at the United Nations building, Manhattan, New York, USA, 1960

327 Texas, USA, 1960

326 Ottawa, Illinois, USA, 1960

328 Michigan, USA, 1960

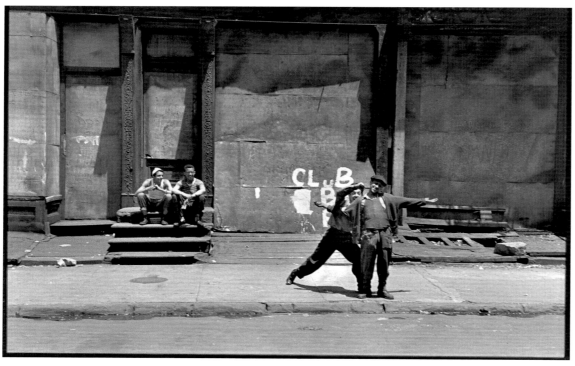

329 Harlem, New York, USA, 1947

330 New York, USA, 1947

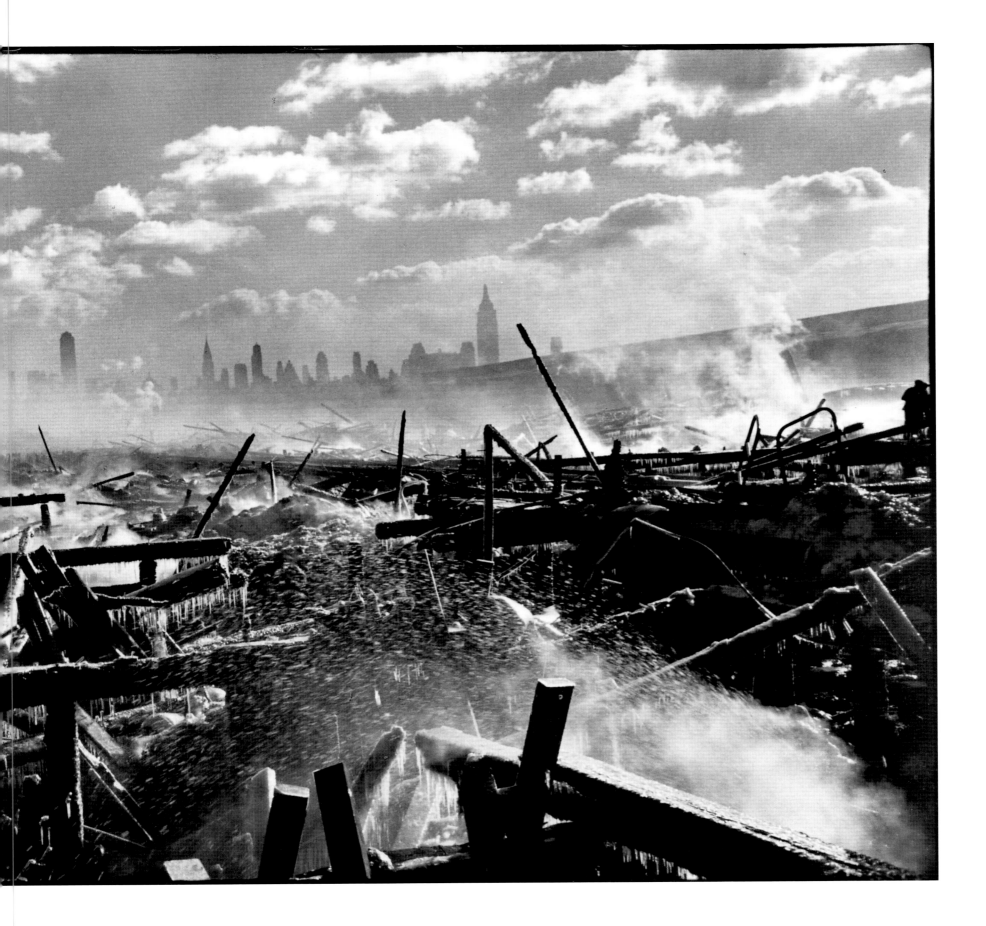

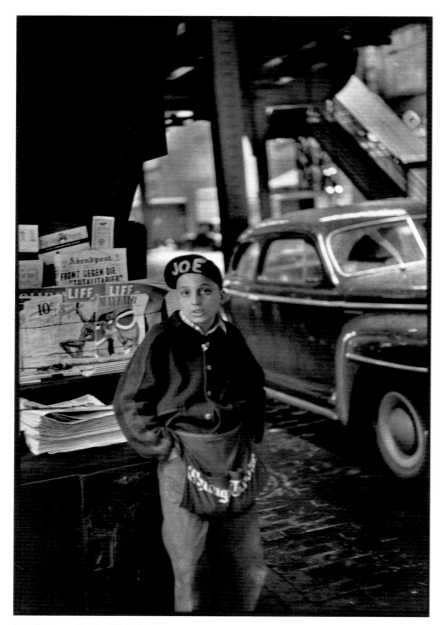

331 Chicago, Illinois, USA, 1947

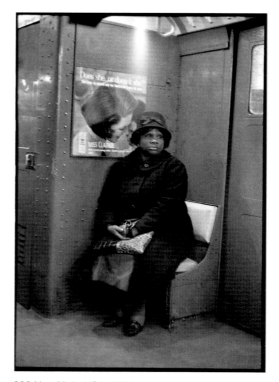

332 New York, USA, 1964

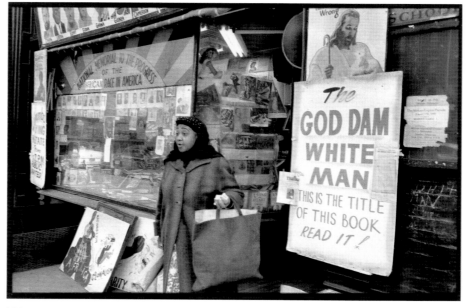

333 Harlem, New York, USA, 1961

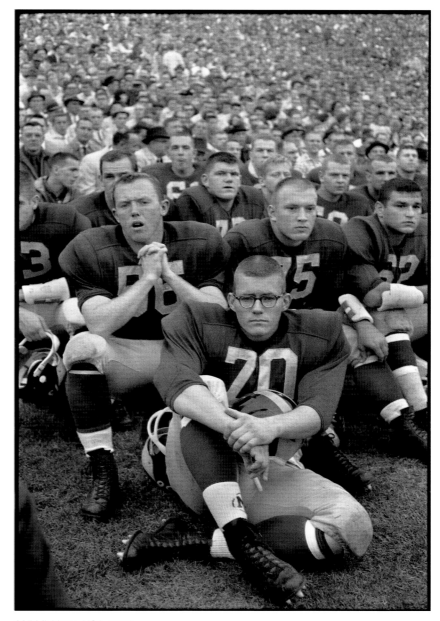

335 Michigan, USA, 1960

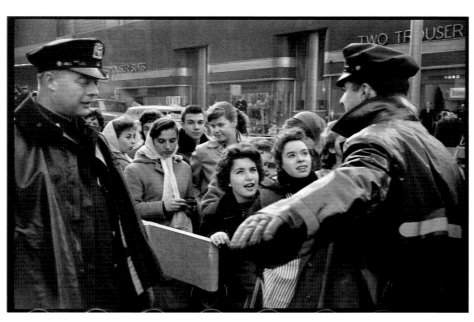

334 Manhattan, New York, USA, 1959

336 Cape Kennedy, Florida, USA, 1967

337 Lincoln, Nebraska, USA, 1957

338 Milwaukee, Wisconsin, USA, 1957

339 Berkeley, California, USA, 1967

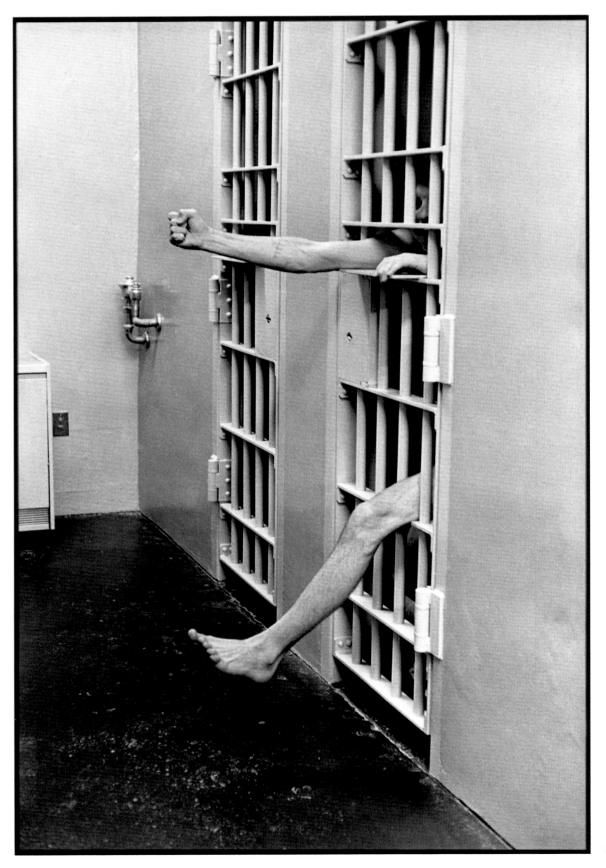

340 New Jersey, USA, 1975

'Remember that the only constant in life is change.'

Buddha

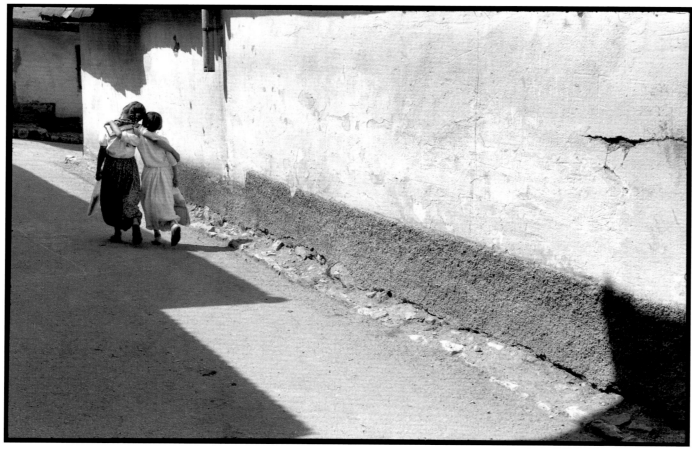

341 Sarajevo, Yugoslavia, 1965

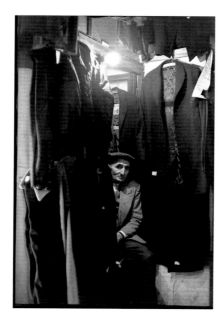

342 Istanbul, Turkey, 1964

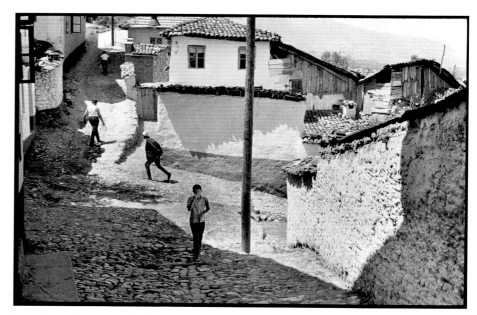

343 Prinzen, Yugoslavia, 1965

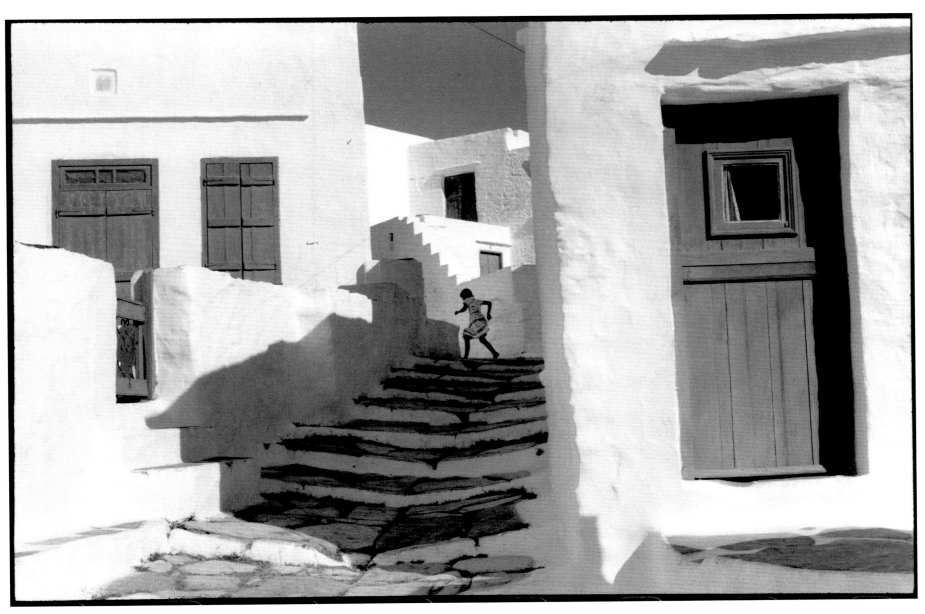

344 Sifnos, Greece, 1961

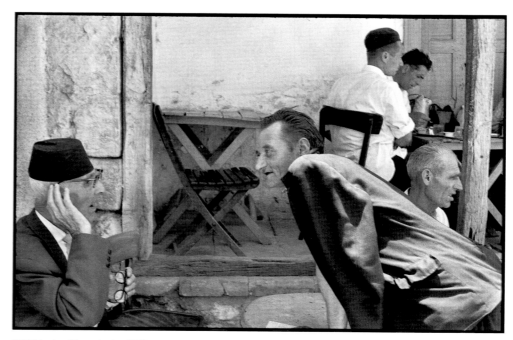

346 Mostar, Yugoslavia, 1965

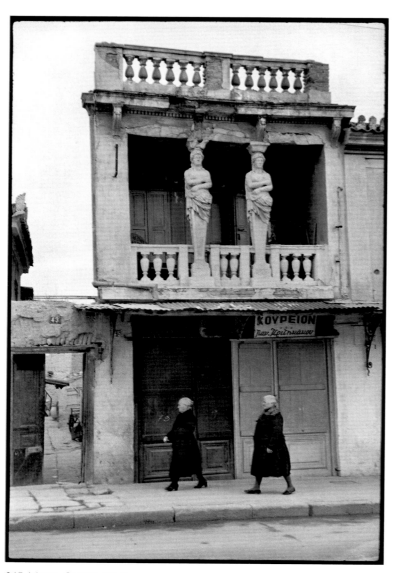

345 Athens, Greece, 1953

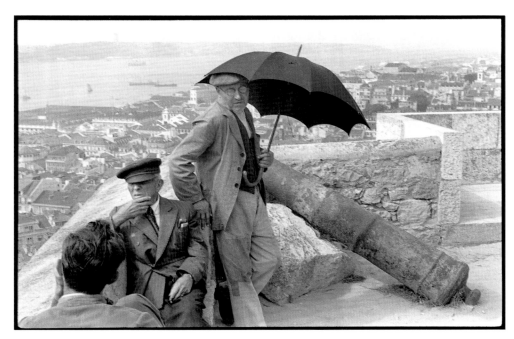

348 Castel San Jorge, Lisbon, Portugal, 1955

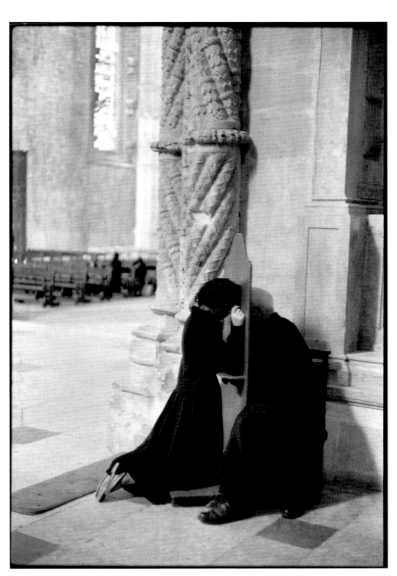

347 Lisbon, Portugal, 1955

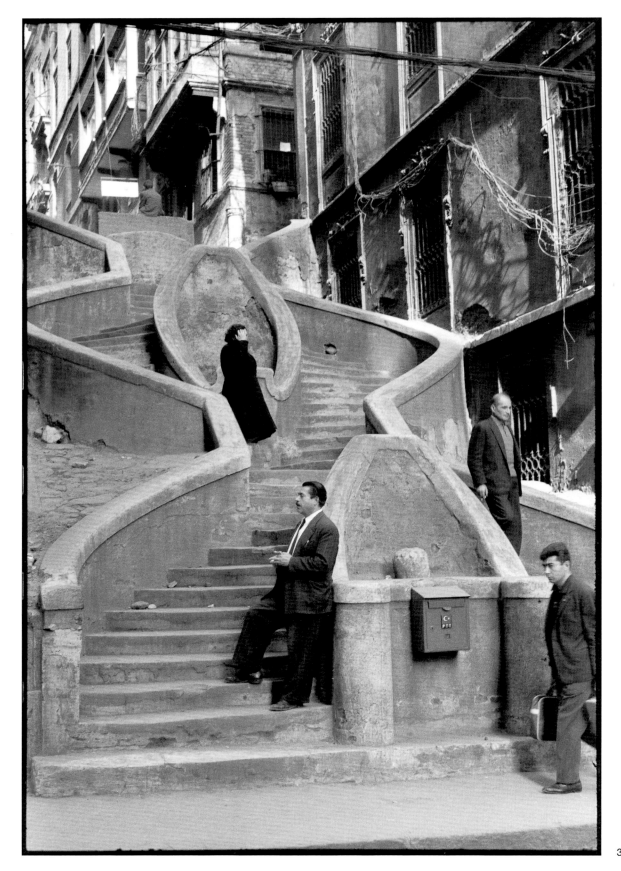

349 Istanbul, Turkey, 1964

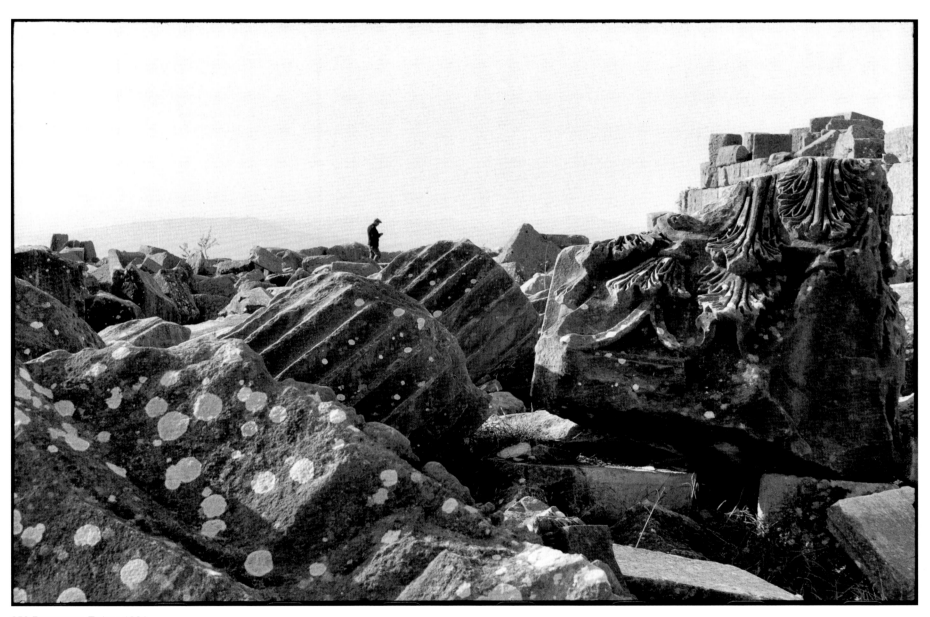

350 Pergamum, Turkey, 1964

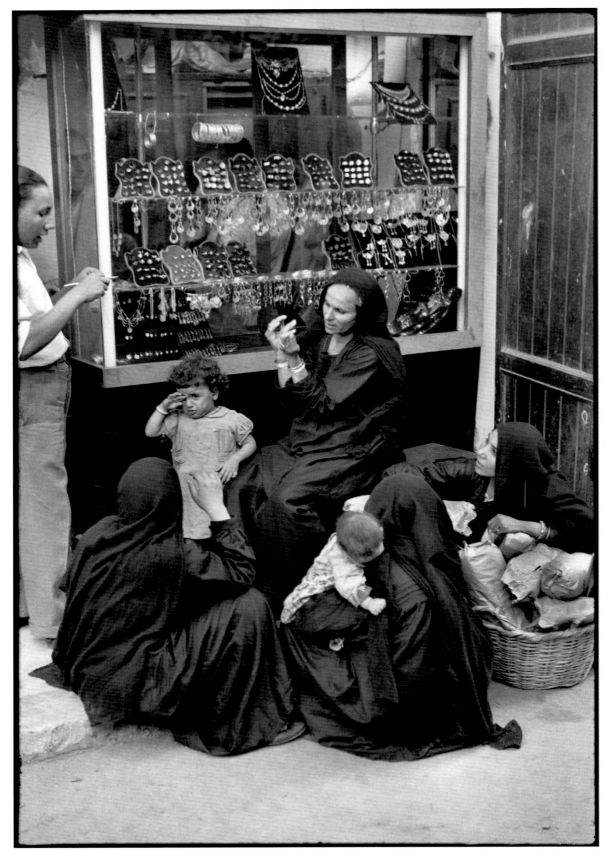

352 Cairo, Egypt, 1950

351 Cairo, Egypt, 1950

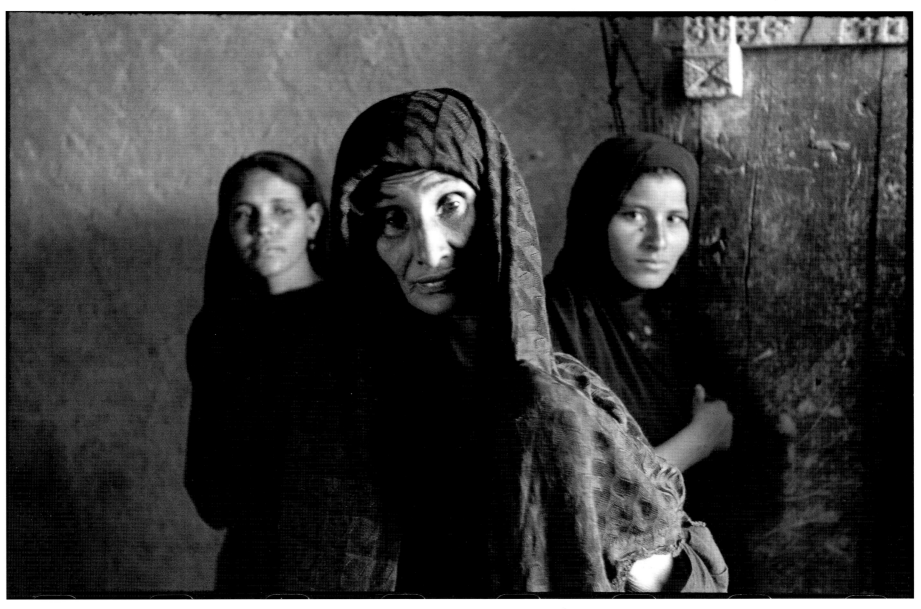

353 Egypt, 1950

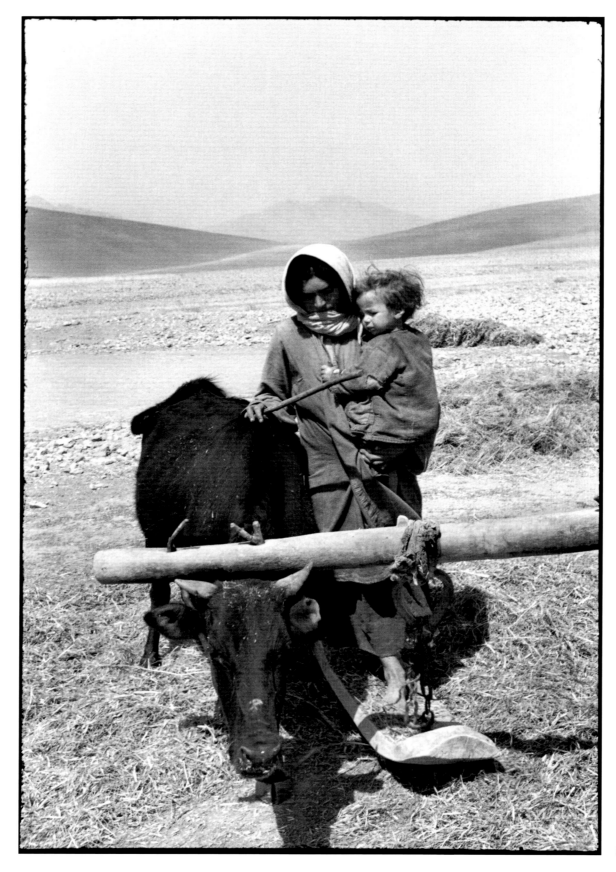

354 Akore, Iran, 1950

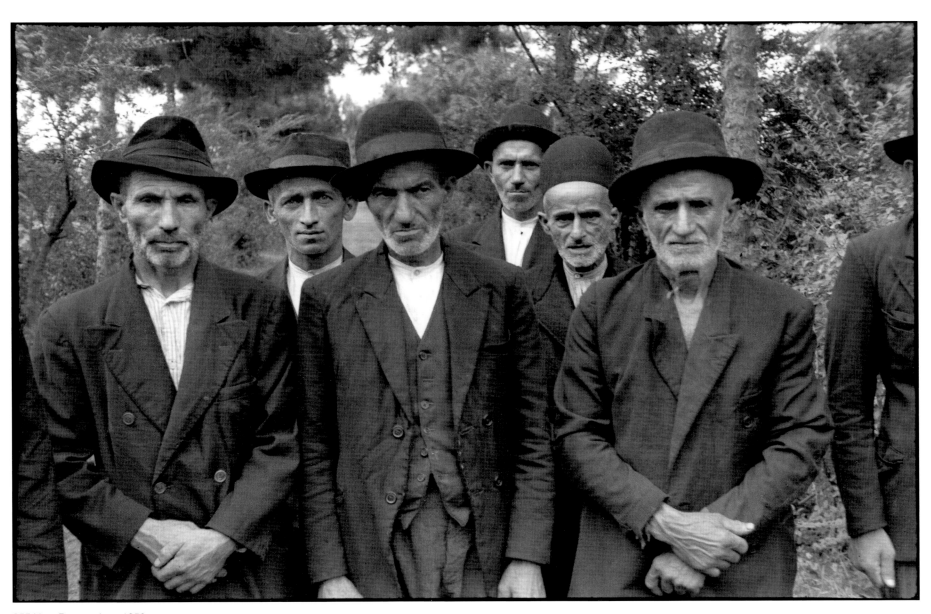

355 Near Ramsar, Iran, 1950

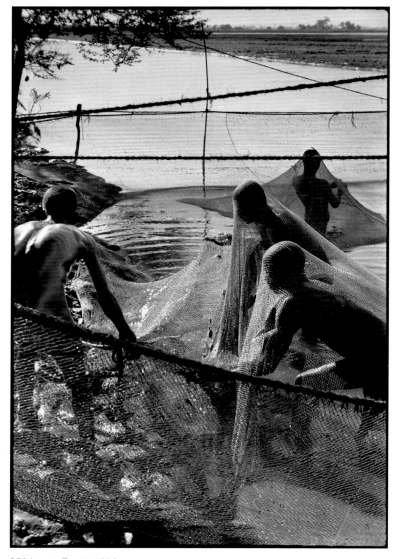

356 Luxor, Egypt, 1950

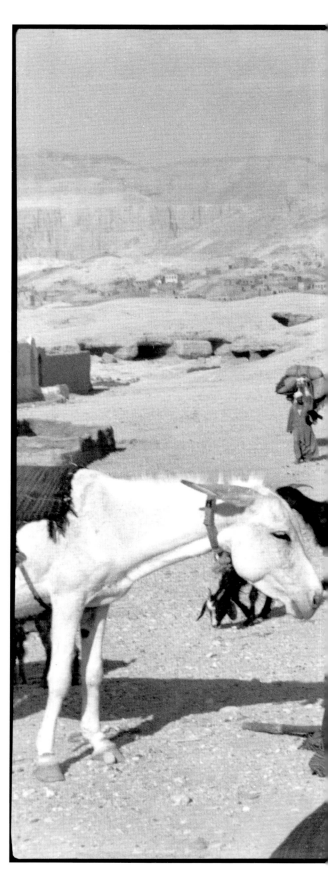

357 Beside the Nile, Egypt, 1950

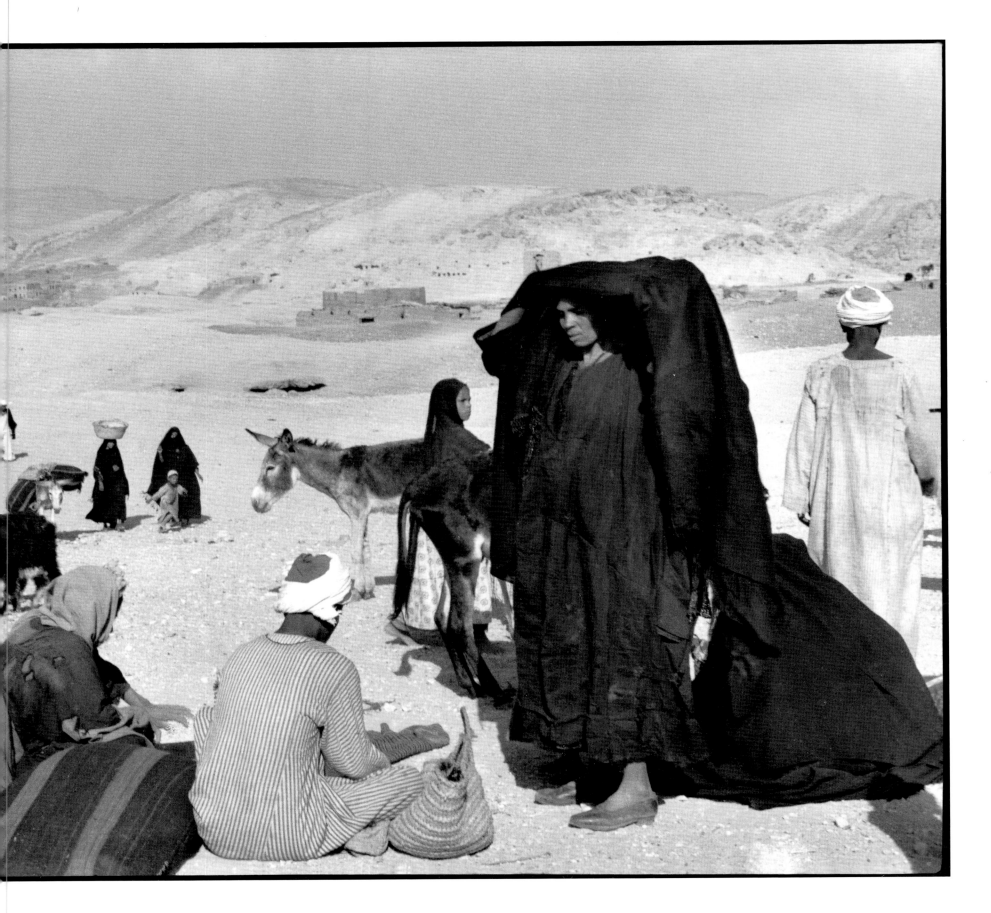

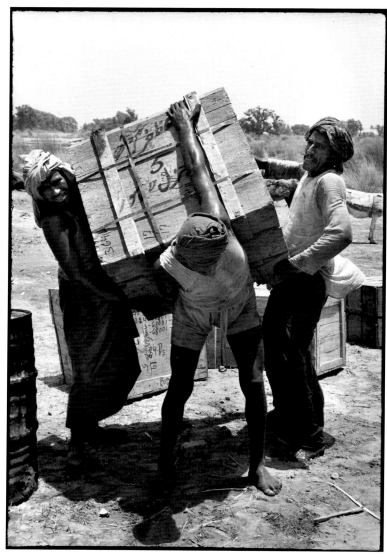

358 Pakistan, 1950

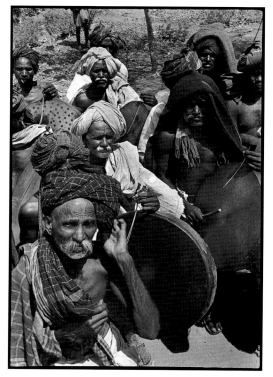

360 Hyderabad, India, 1947–1948

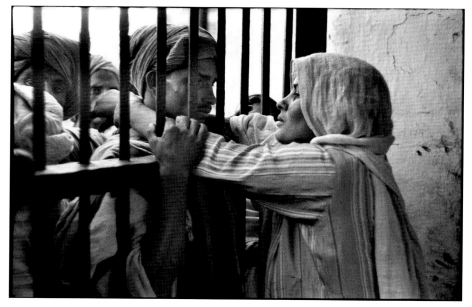

359 Lahore, Pakistan, 1948

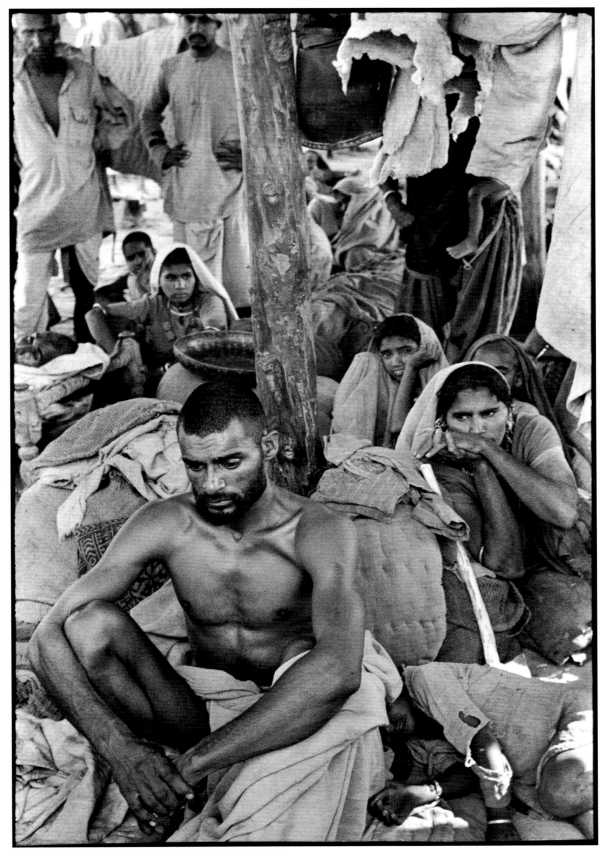

361 Lahore, Pakistan, 1948

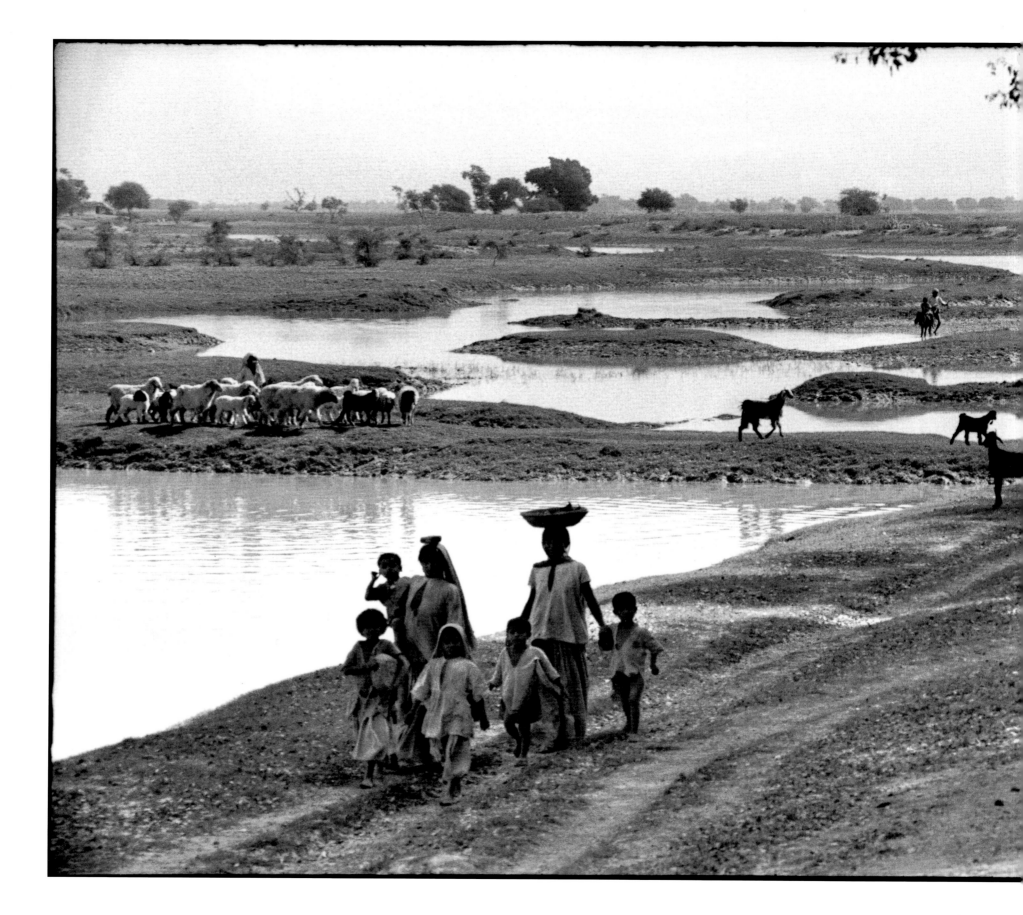

362 Punjab, India, 1947

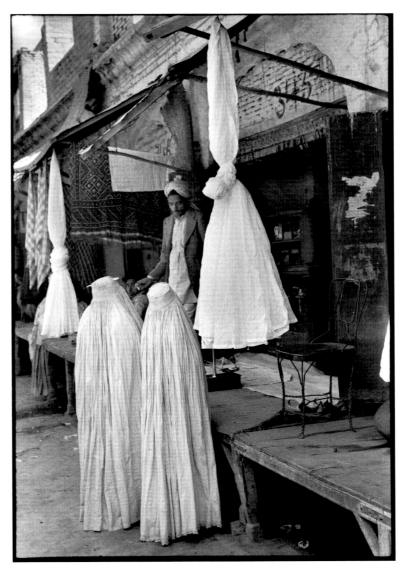

363 Pakistan, 1948

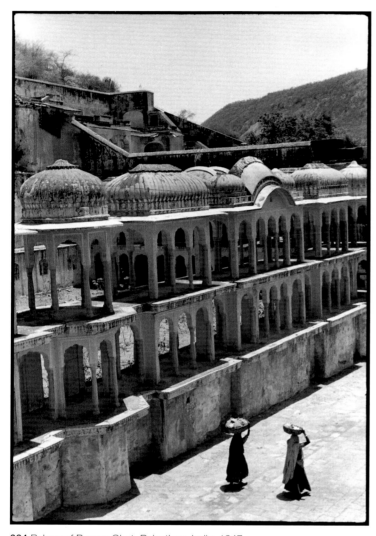

364 Palace of Purana Ghat, Rajasthan, India, 1947

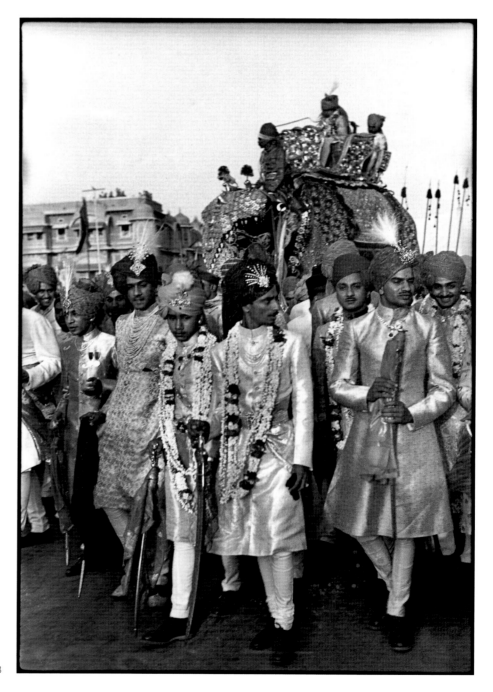

365 Wedding of the daughter of the Maharaja of Jaipur, Rajasthan, India, 1948

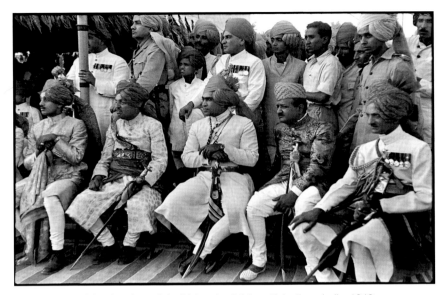

367 Wedding of the daughter of the Maharaja of Jaipur, Rajasthan, India, 1948

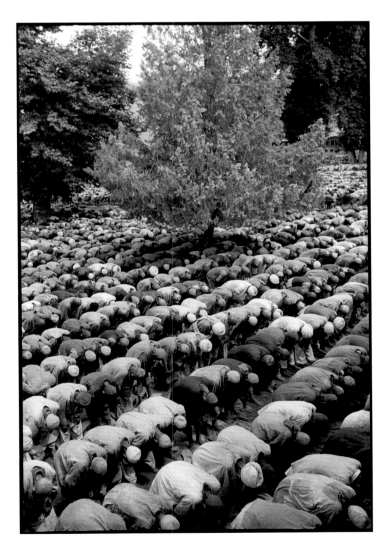

366 Hazrat Bal mosque, Srinagar, Kashmir, 1948

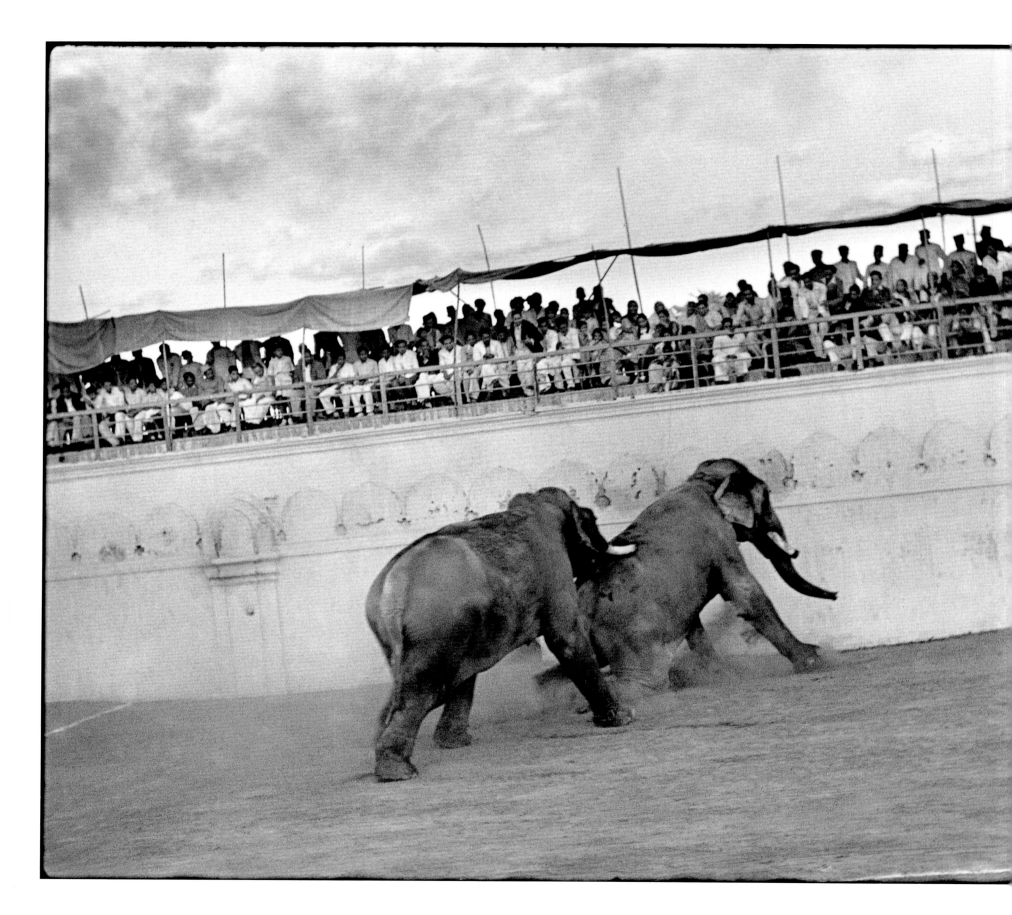

368 Baroda, India, 1948

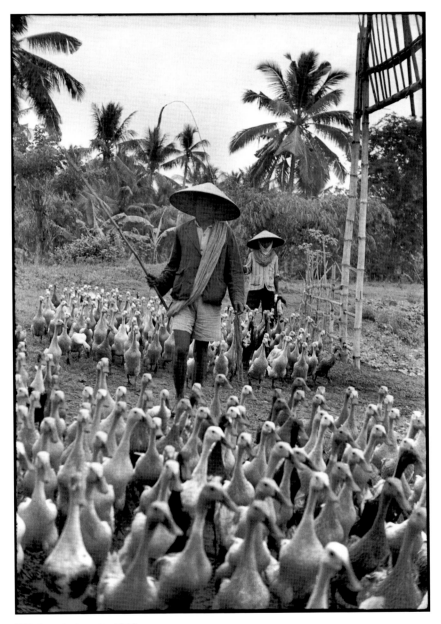

369 Java, Indonesia, 1948

253

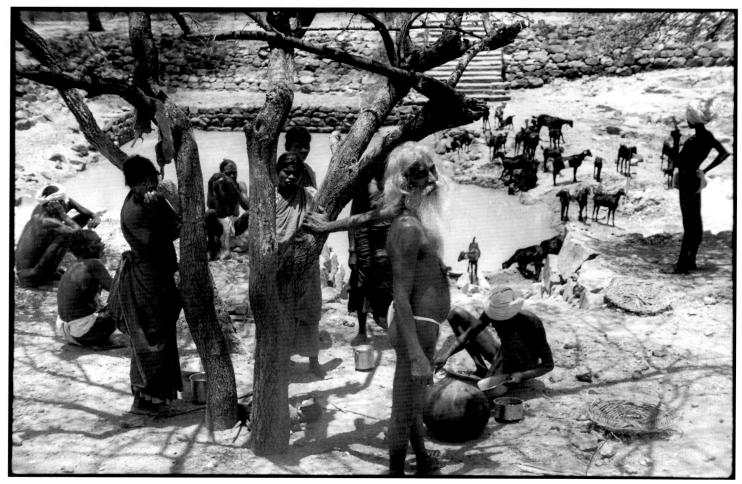

370 Tiruvannamalai, Tamil Nadu, India, 1950

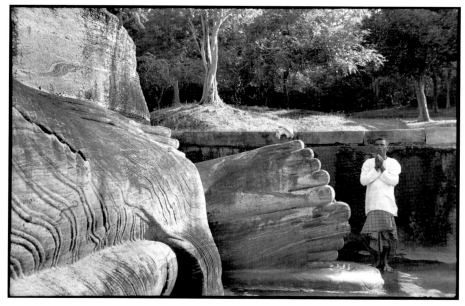

371 Polonnaruwa, Ceylon, 1950

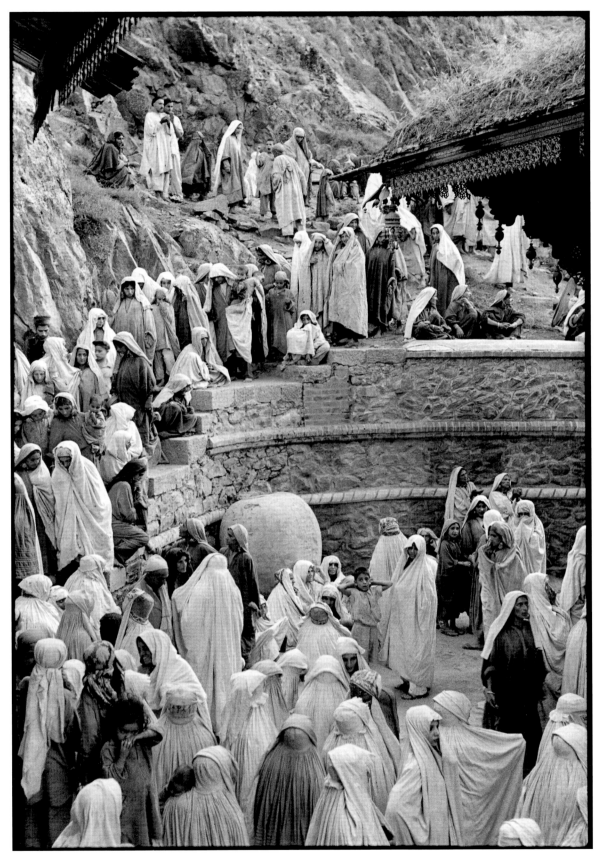

372 Fort Hari Prabat, Srinagar,
Kashmir, 1948

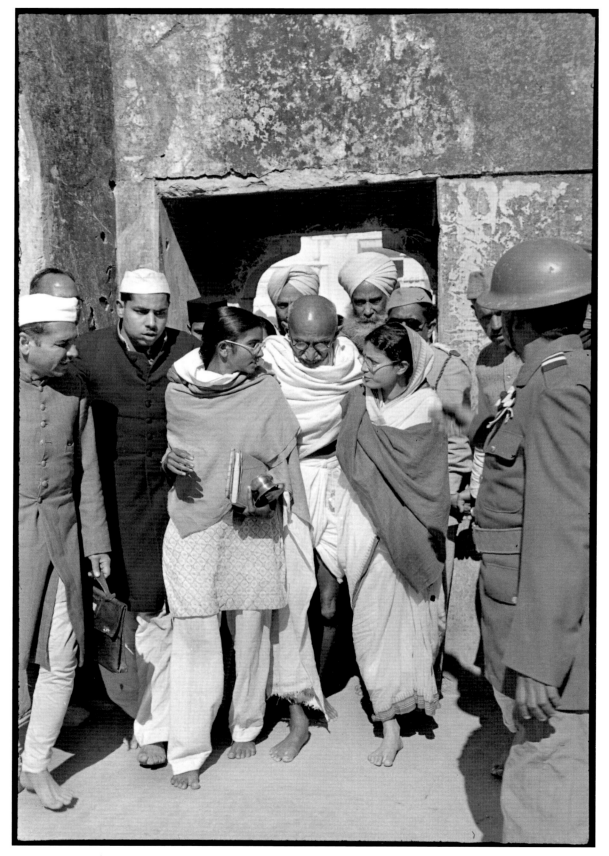

373 Gandhi, Delhi, India, 1948

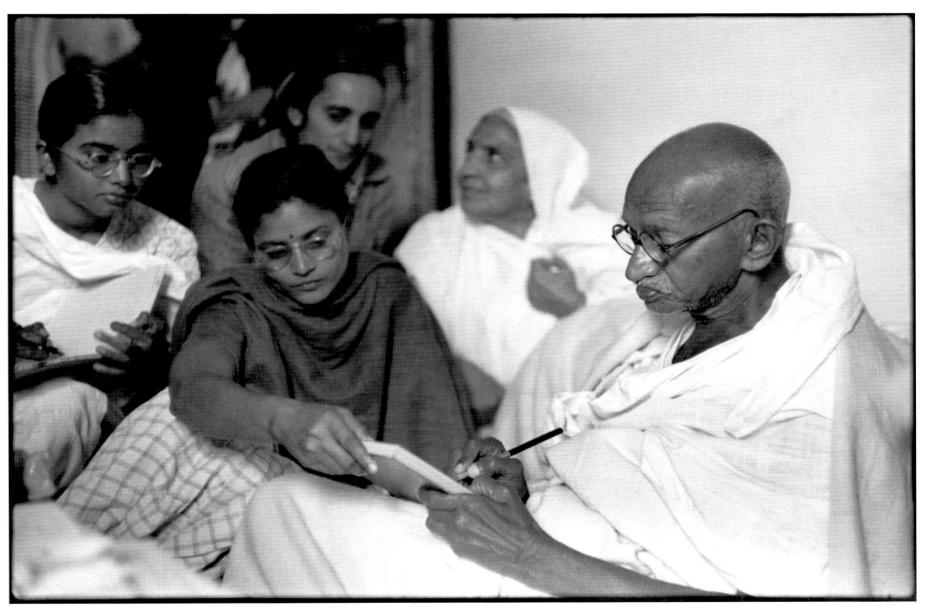

374 Gandhi, before breaking his fast, Delhi, India, 1948

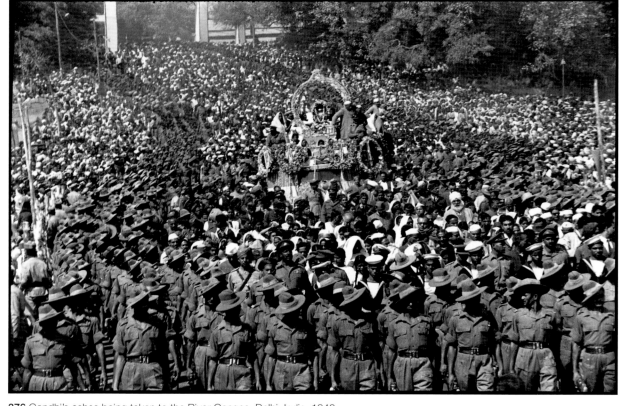

376 Gandhi's ashes being taken to the River Ganges, Delhi, India, 1948

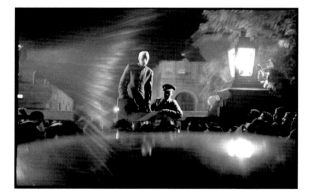

375 Nehru announces Gandhi's assassination,
Delhi, India, 1948

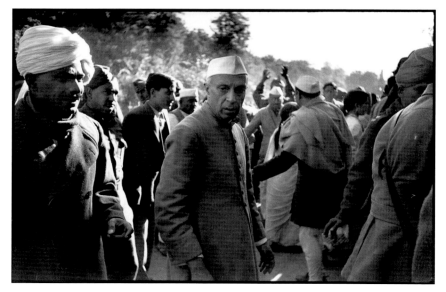

377 Nehru, Delhi, India, 1948

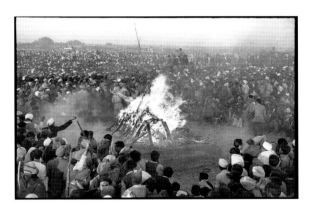

378 Gandhi's cremation, Delhi, India, 1948

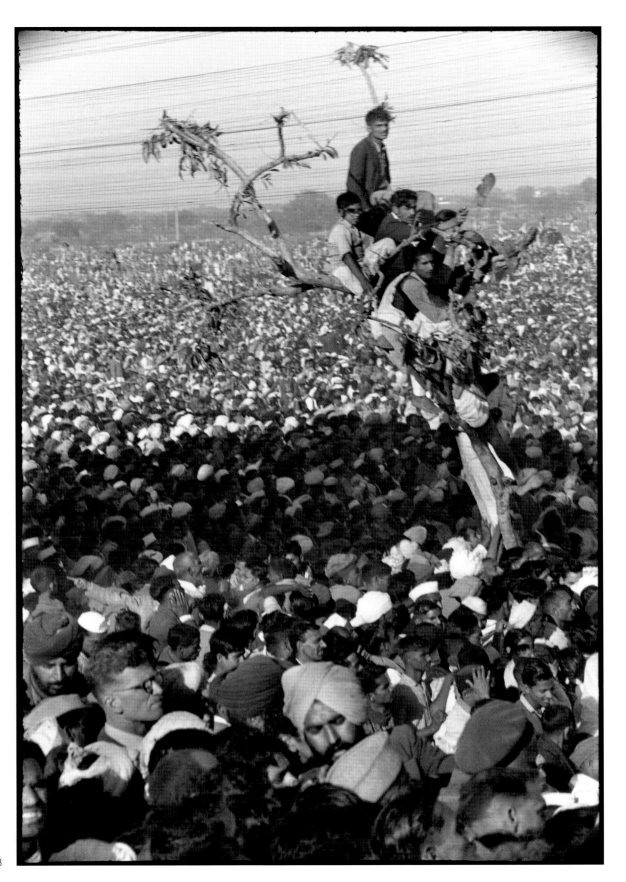

379 Gandhi's funeral, Delhi, India, 1948

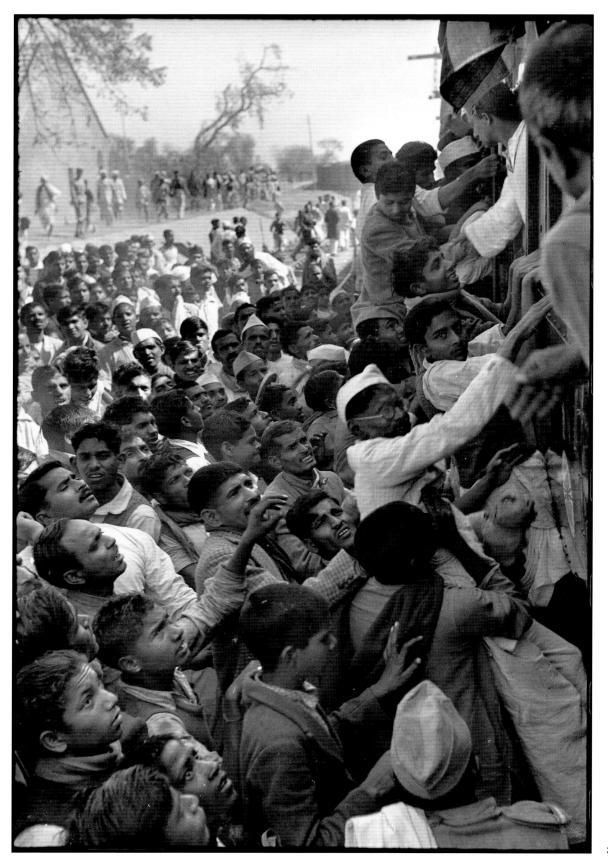

380 Delhi, India, 1948

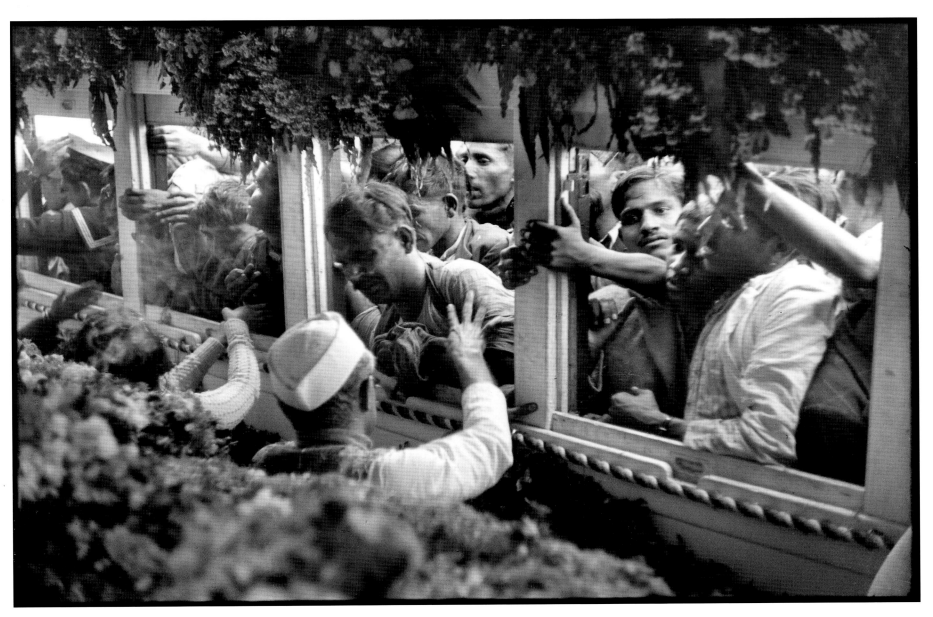

381 The train carrying Gandhi's ashes to the River Ganges, Delhi, India, 1948

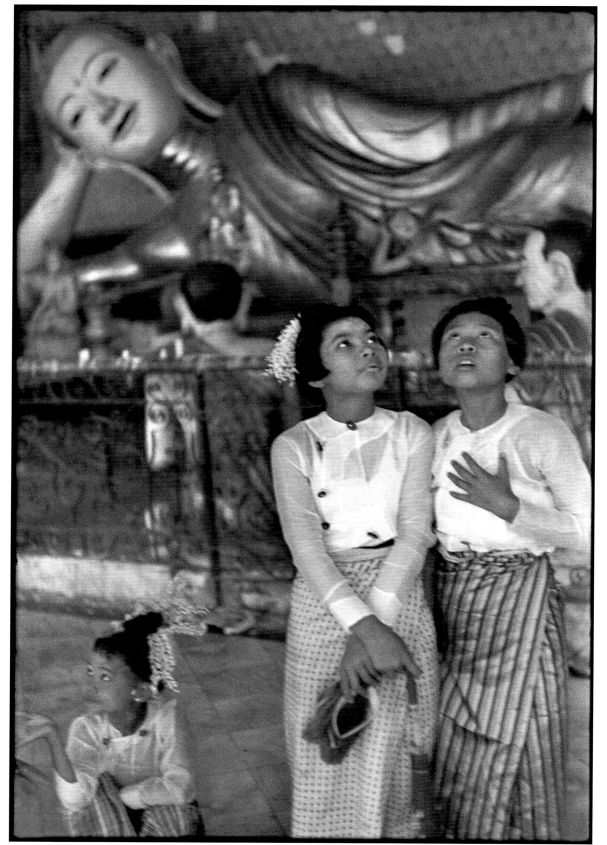

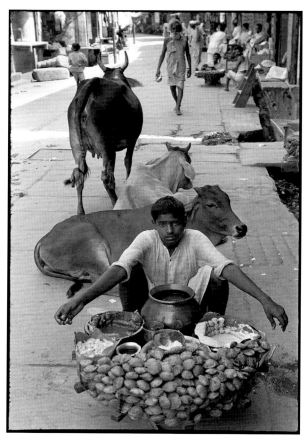

383 Tamil Nadu, India, 1950

382 Rangoon, Burma, 1948

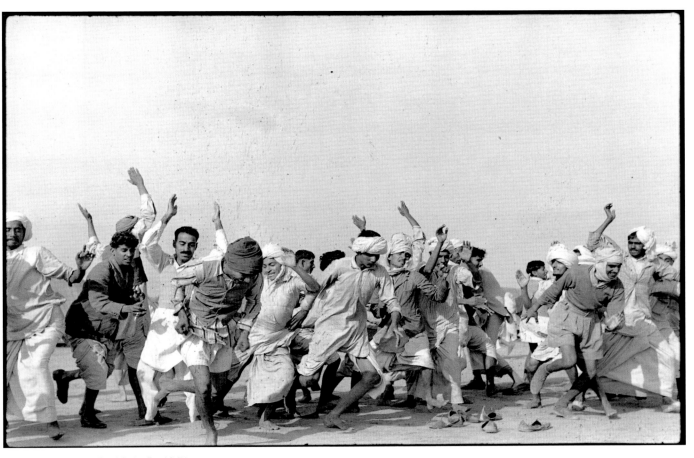

385 Refugee camp, Punjab, India, 1947

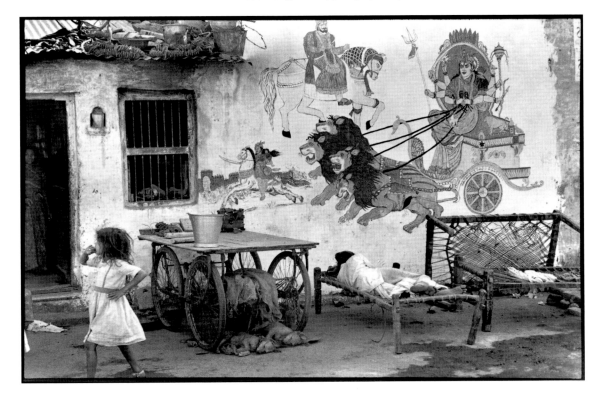

384 Ahmadabad, Gujarat, India, 1966

263

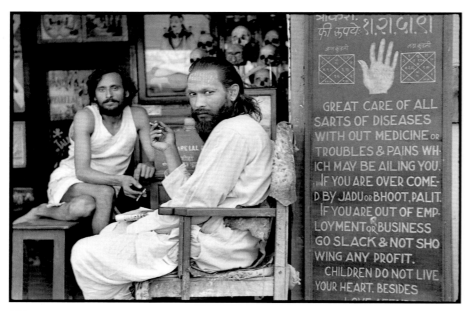

386 Astrologer, Bombay, India, 1947

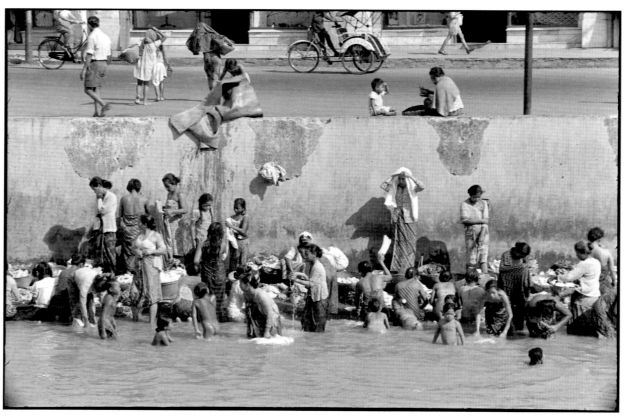

387 Jakarta, Java, Indonesia, 1949

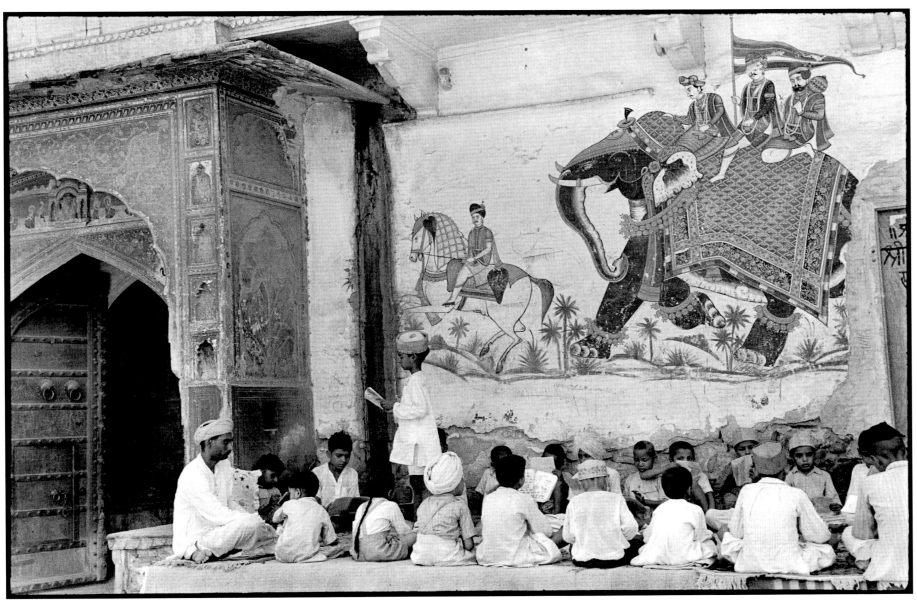

388 Jaipur, Rajasthan, India, 1947

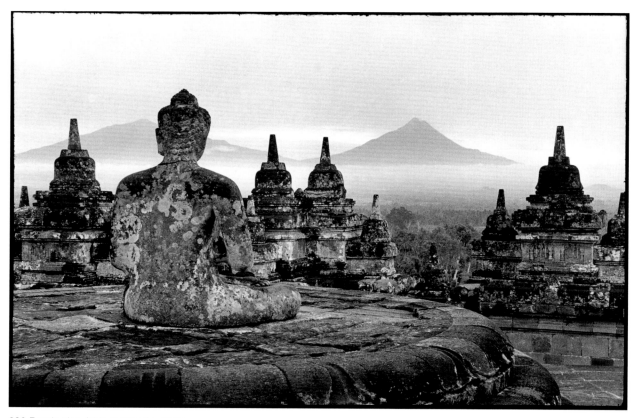

389 Borobudur, Java, Indonesia, 1950

390 Borobudur, Java, Indonesia, 1950

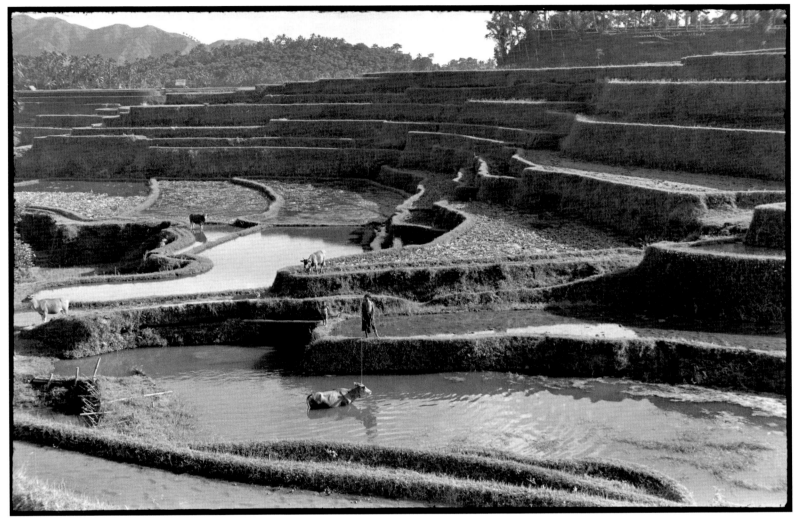

392 Bali, Indonesia, 1949

391 Borobudur, Java, Indonesia, 1950

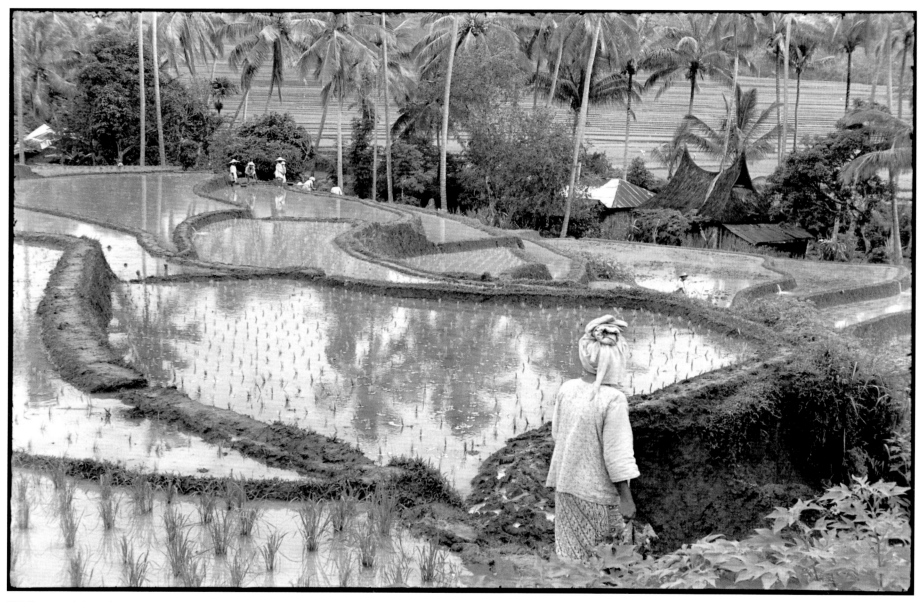

393 Sumatra, Indonesia, 1950

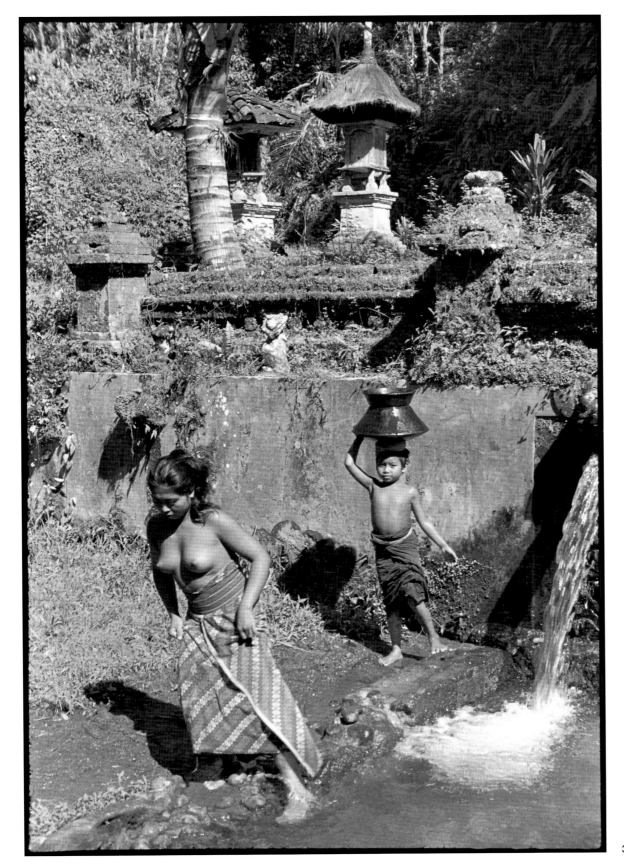

394 Bali, Indonesia, 1949

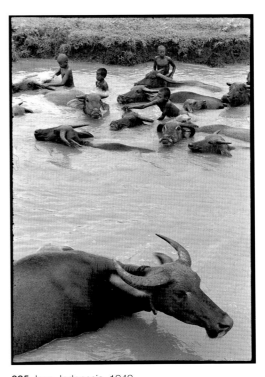

395 Java, Indonesia, 1949

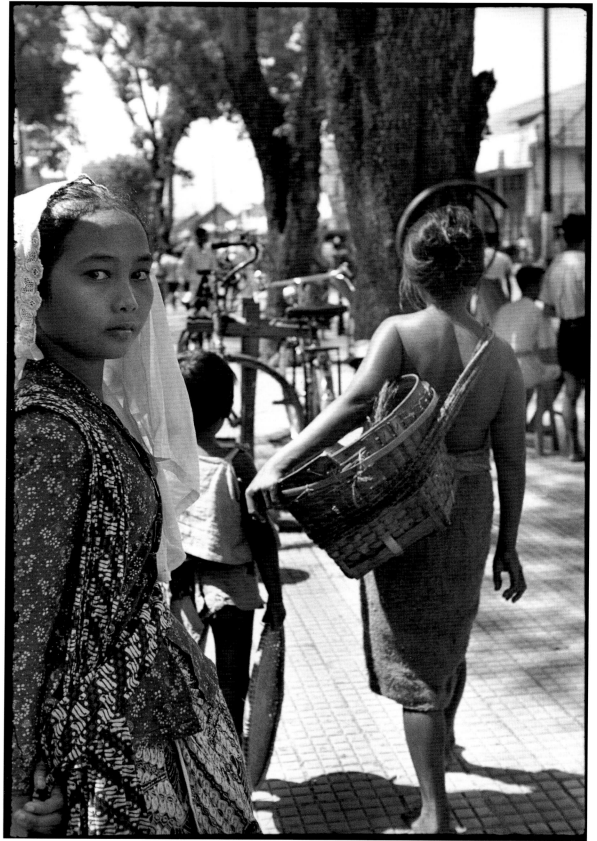

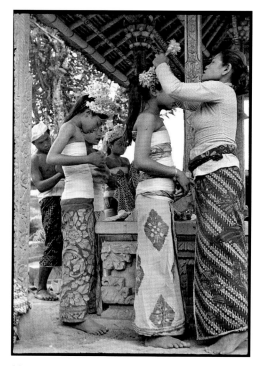

397 Preparations for the Baris dance, Bali, Indonesia, 1949

396 Java, Indonesia, 1949

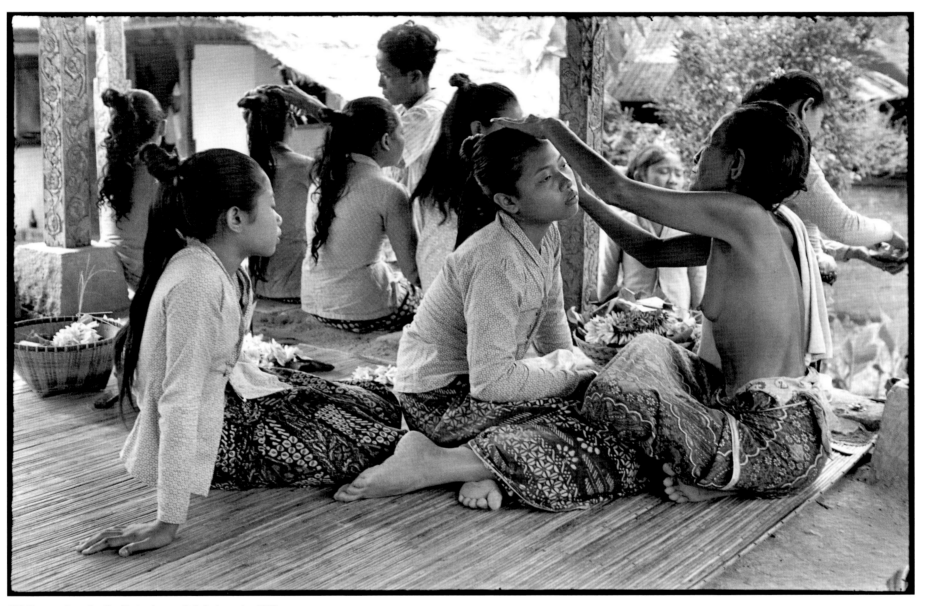

398 Preparations for the Baris dance, Bali, Indonesia, 1949

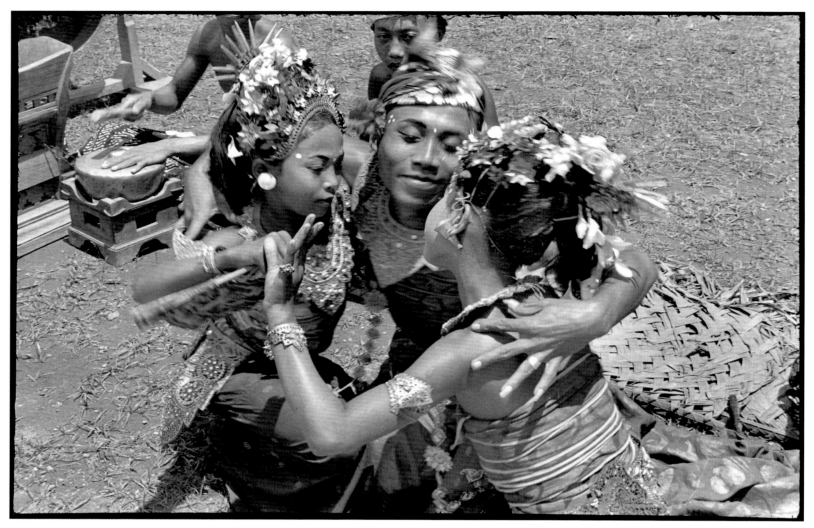

399 Alloen Kotjok dance, Sajan, Bali, Indonesia, 1949

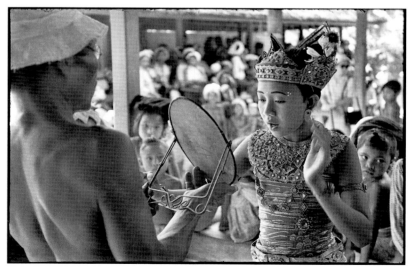

400 Preparations for the Legong dance, Bali, Indonesia, 1949

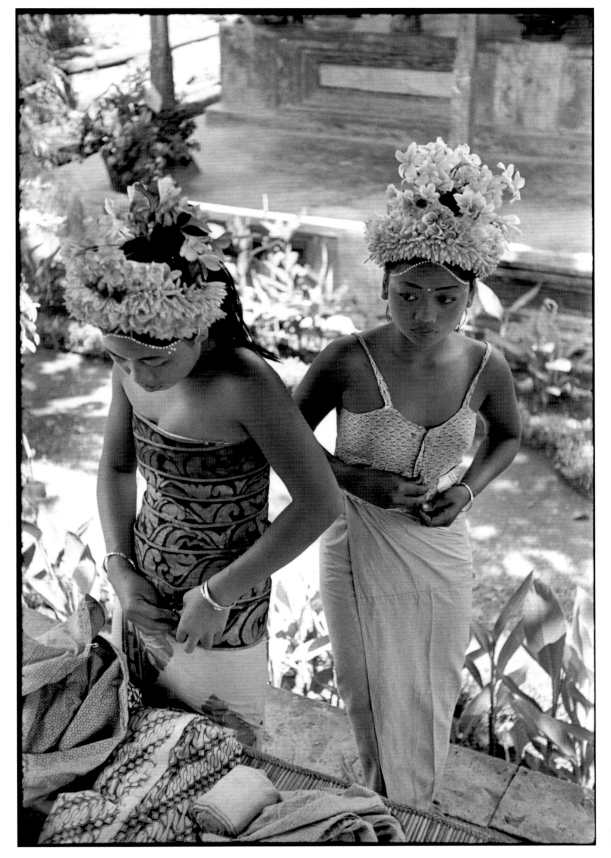

401 Preparations for the Baris dance, Ubud, Bali, Indonesia, 1949

273

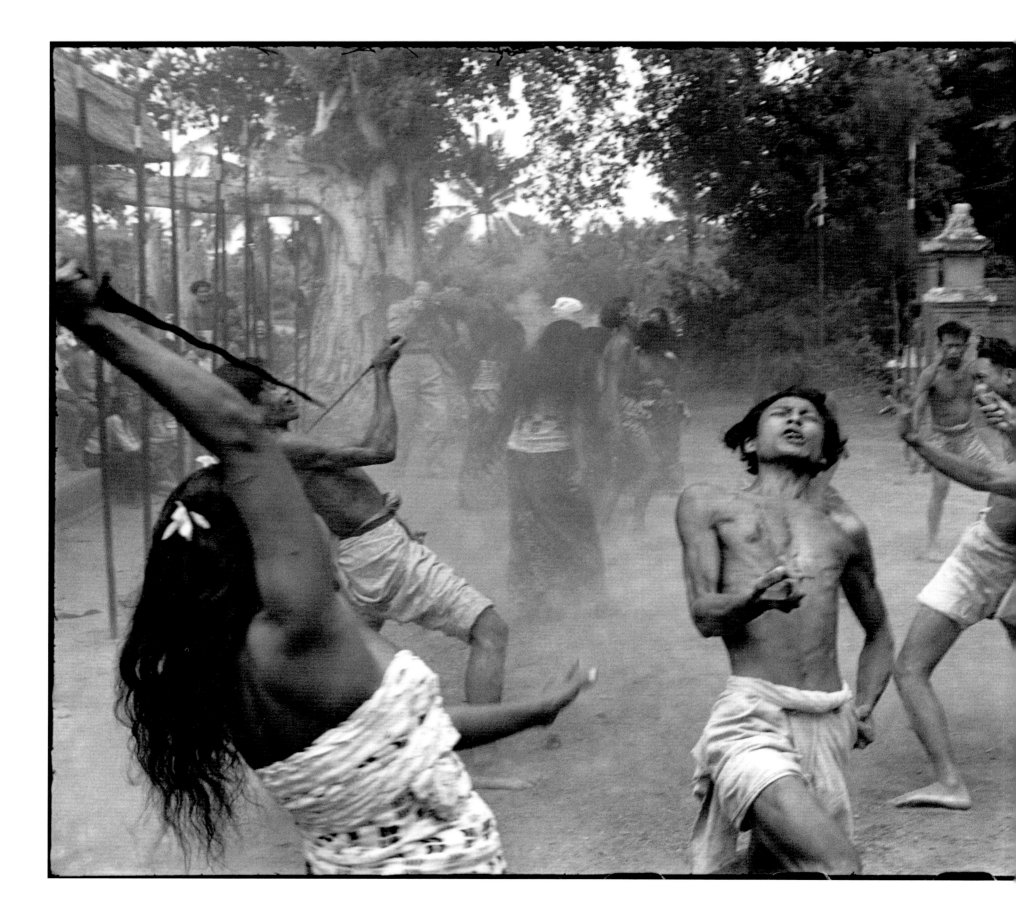

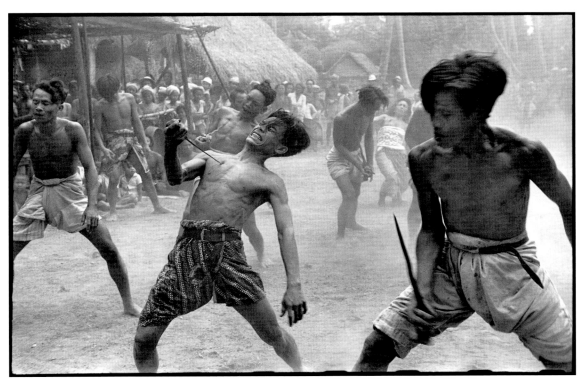

403 Kriss dancers in a trance, Batubulan, Bali, Indonesia, 1949

402 Kriss dancers in a trance, Batubulan, Bali, Indonesia, 1949

275

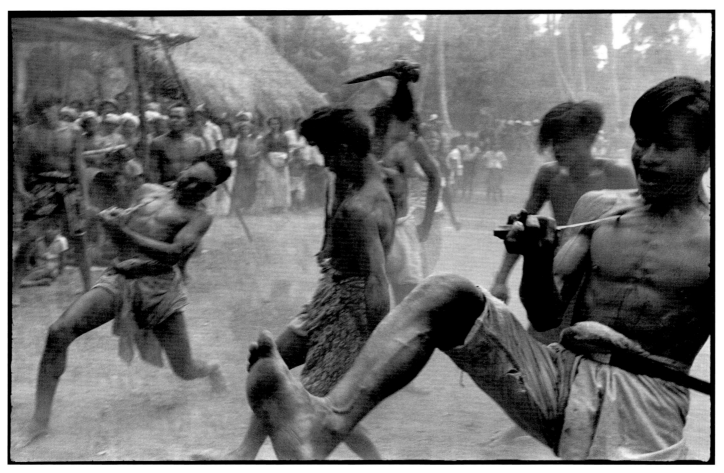

404 Kriss dancers in a trance, Batubulan, Bali, Indonesia, 1949

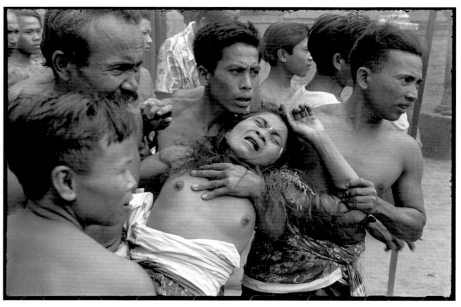

405 Kriss dancers in a trance, Batubulan, Bali, Indonesia, 1949

406 The Baris dance, Ubud, Bali, Indonesia, 1949

407 Srinagar, Kashmir, 1948

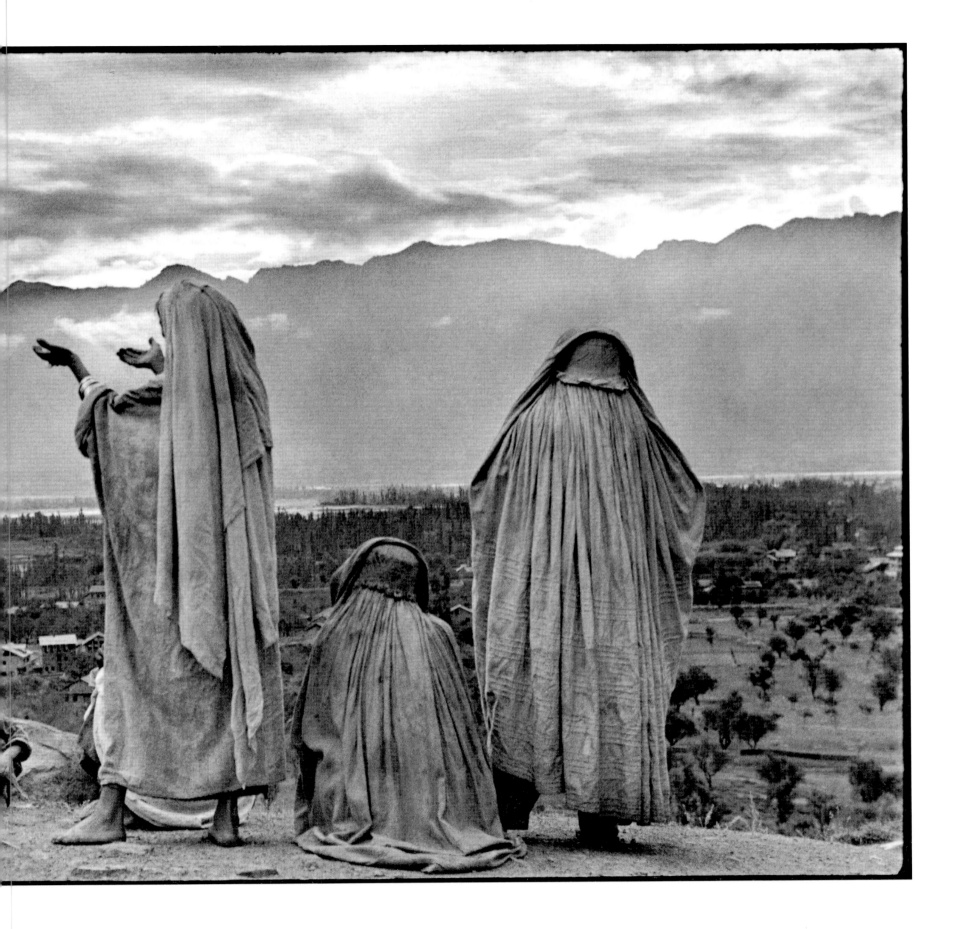

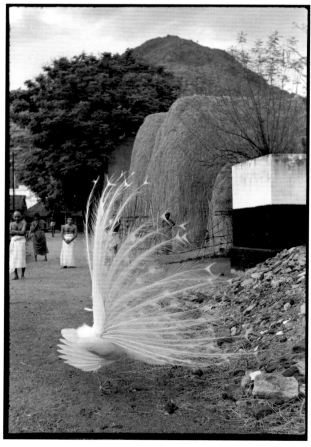

408 Tamil Nadu, India, 1950

409 Fatehpur Sikri, Uttar Pradesh, India, 1966

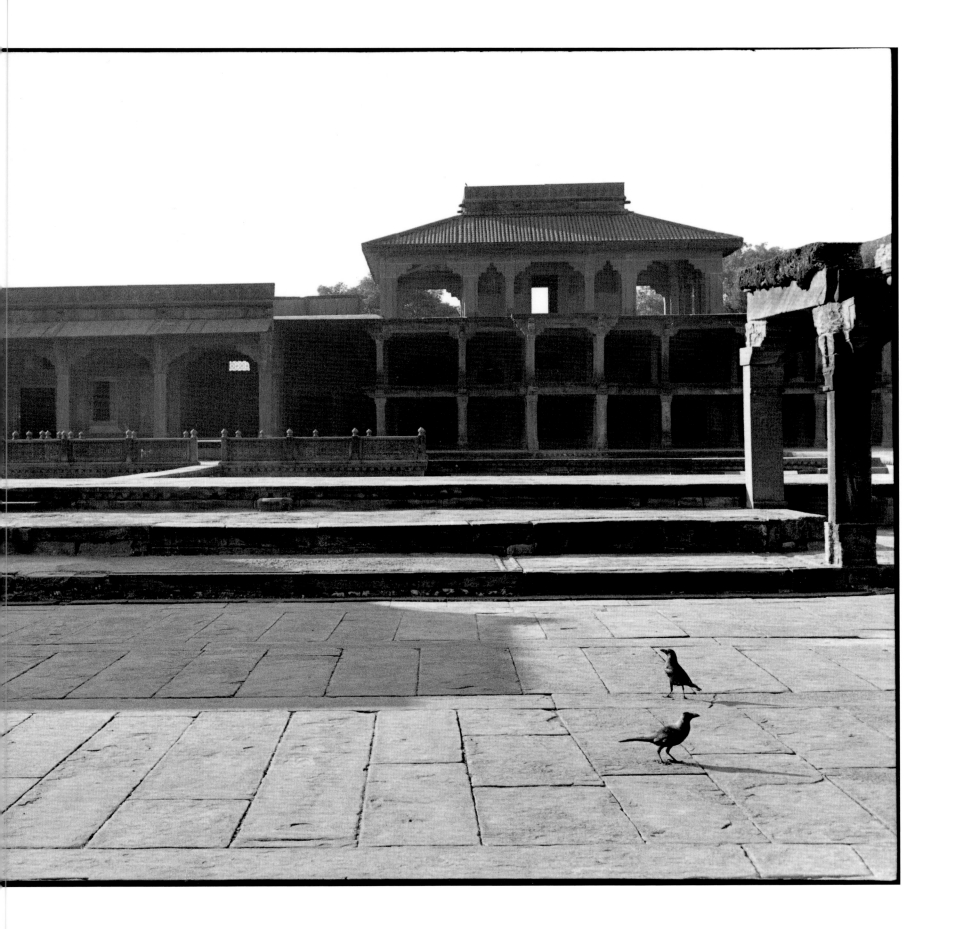

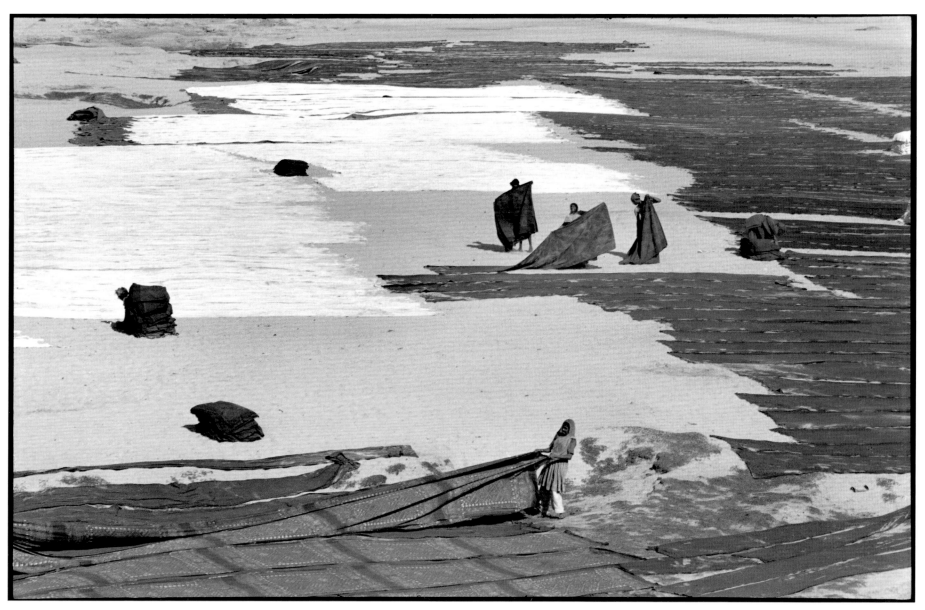

410 Ahmadabad, Gujarat, India, 1966

'It may be said that geometry is to the plastic arts what grammar is to the art of the writer.'

Guillaume Apollinaire

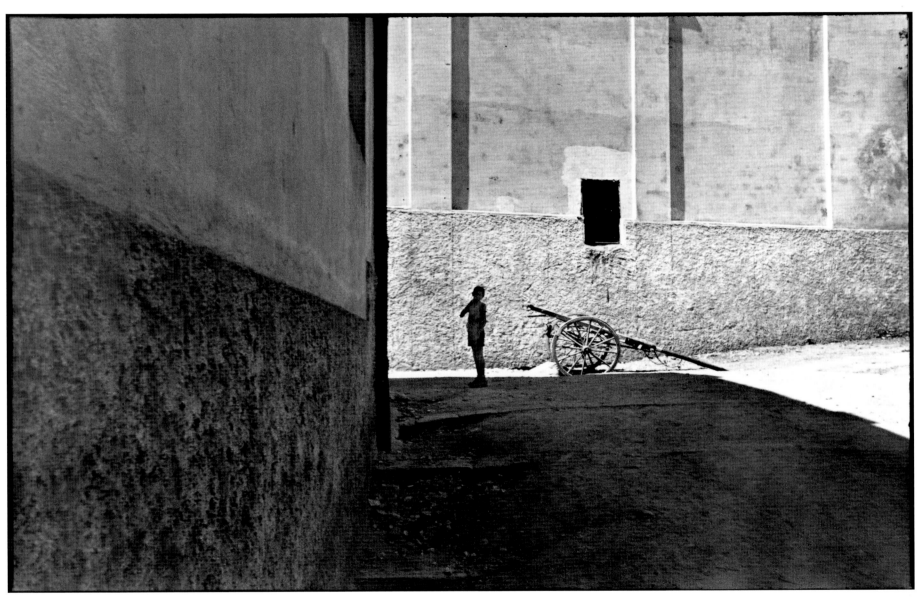

411 Salerno, Italy, 1933

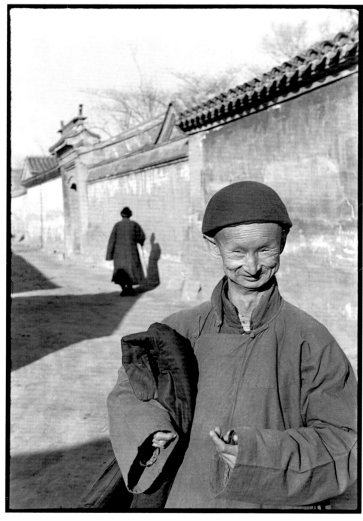

412 Eunuch of the Imperial Court, Peking, China, 1948

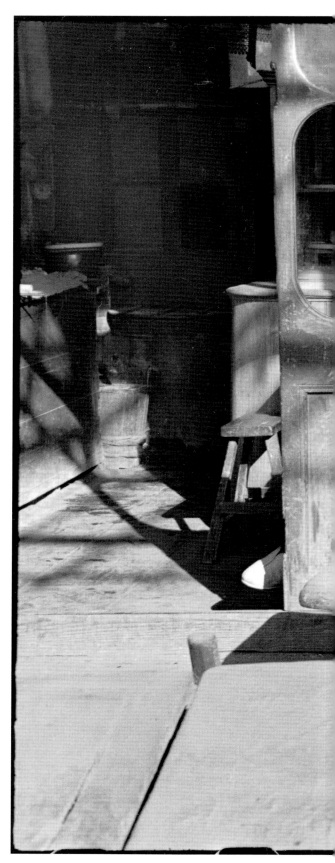

413 Peking, China, 1948

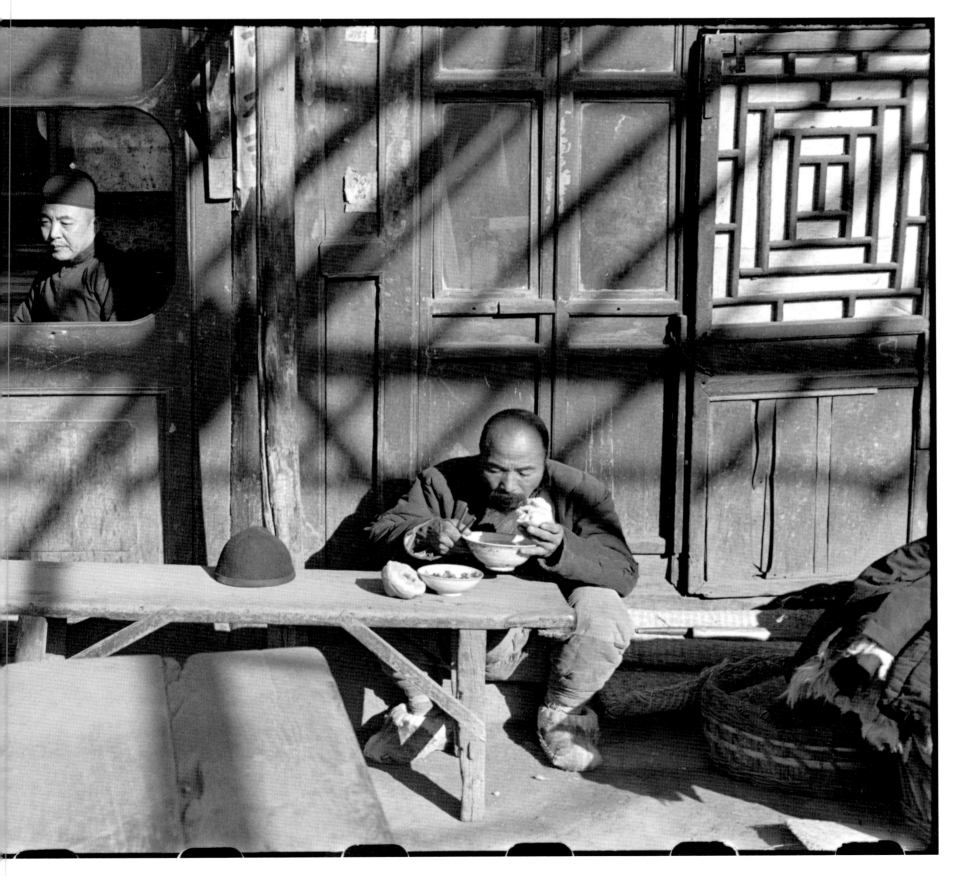

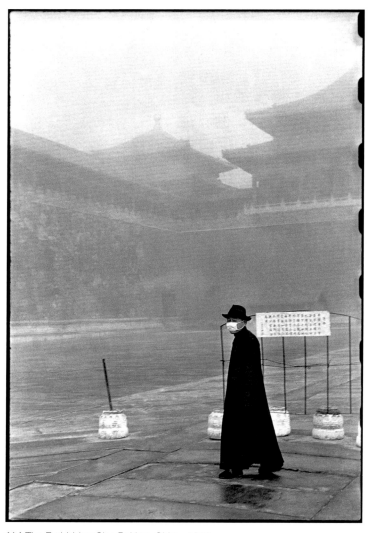

414 The Forbidden City, Peking, China, 1948

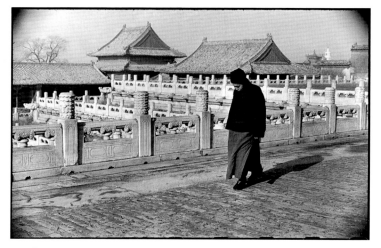

416 The Forbidden City, Peking, China, 1948

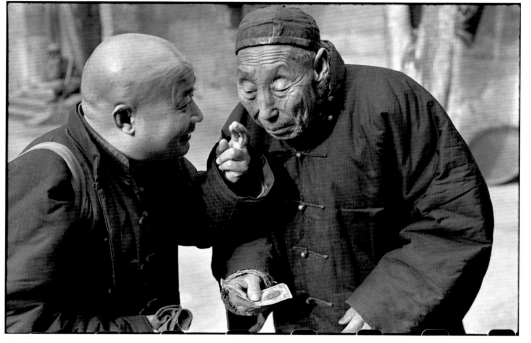

415 Peking, China, 1948

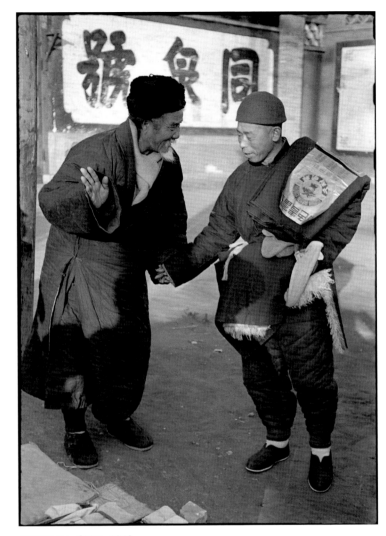

418 Peking, China, 1948

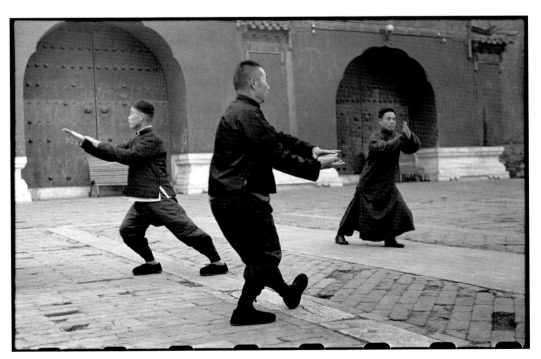

417 Peking, China, 1948

289

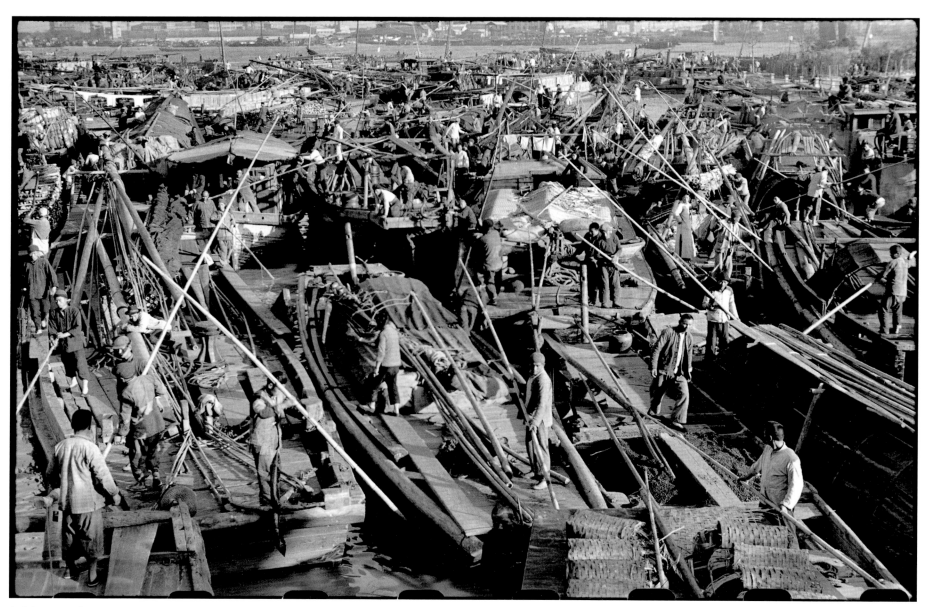

419 Soochow Creek, Shanghai, China, 1948

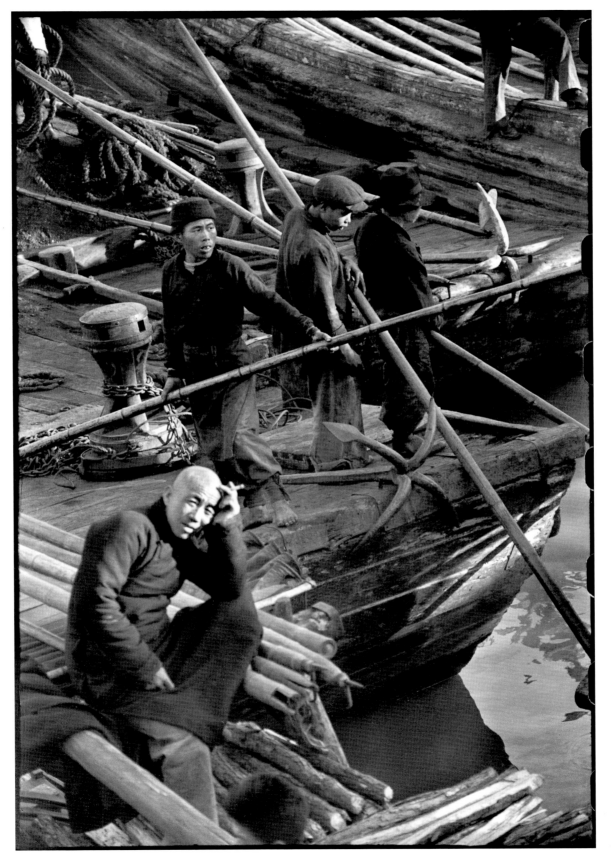

420 Shanghai, China, 1948

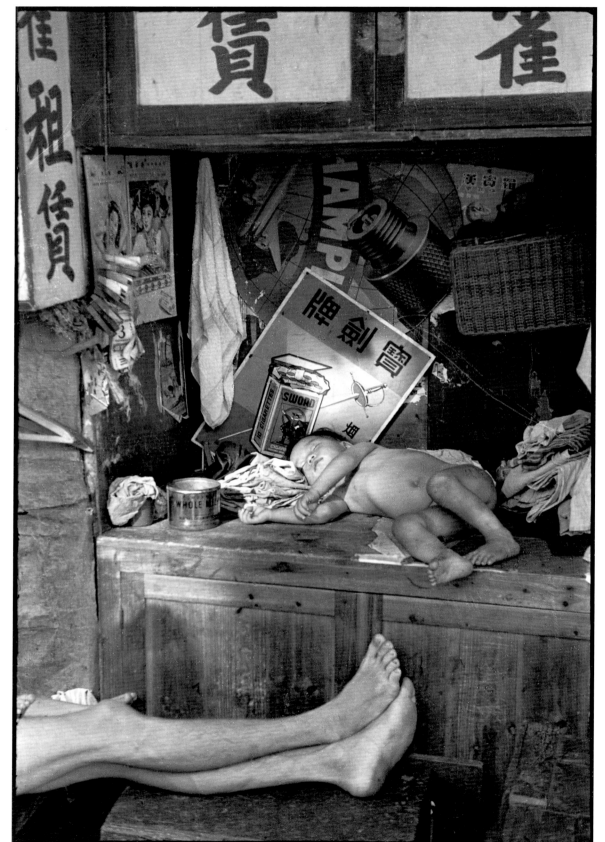

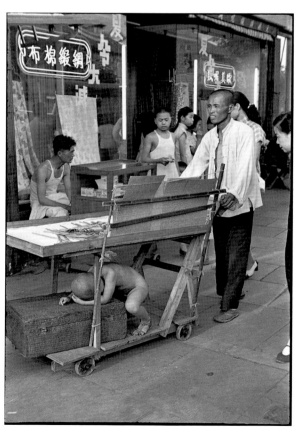

422 Shanghai, China, 1949

421 Hong Kong, 1949

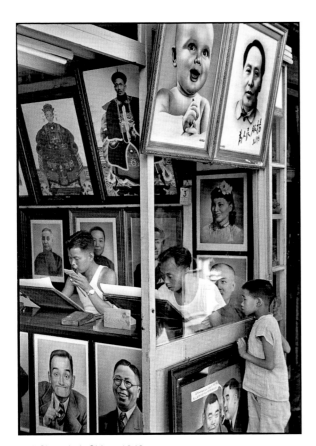

423 Shanghai, China, 1949

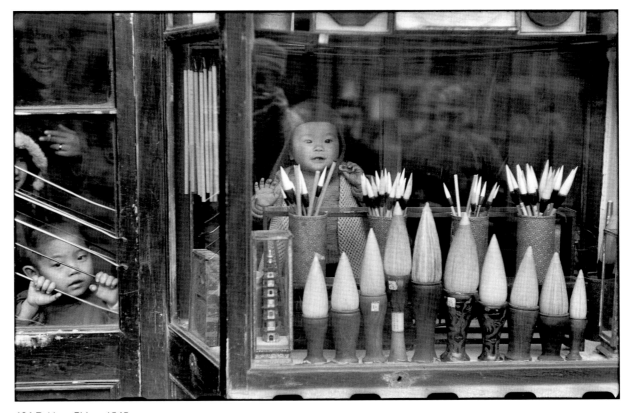

424 Peking, China, 1948

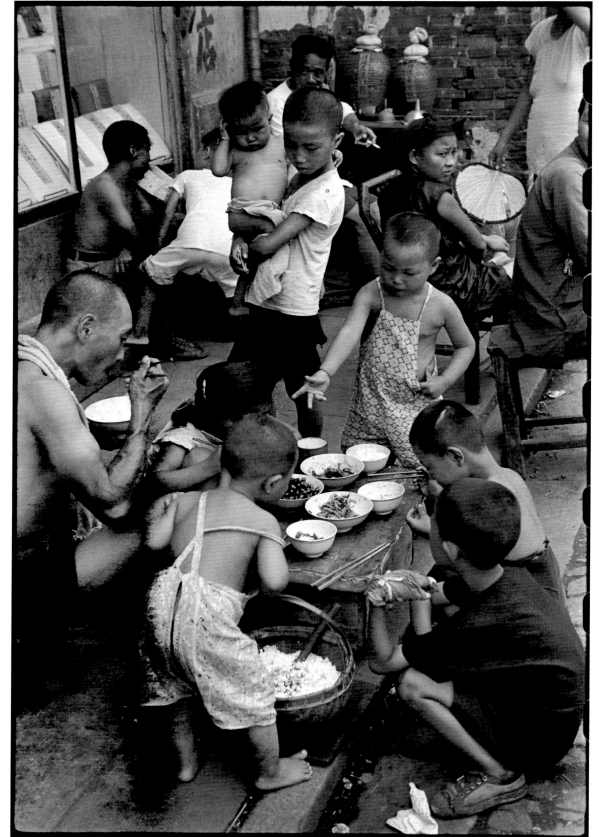

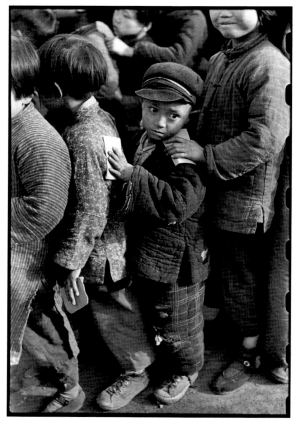

426 China, 1949

425 Shanghai, China, 1949

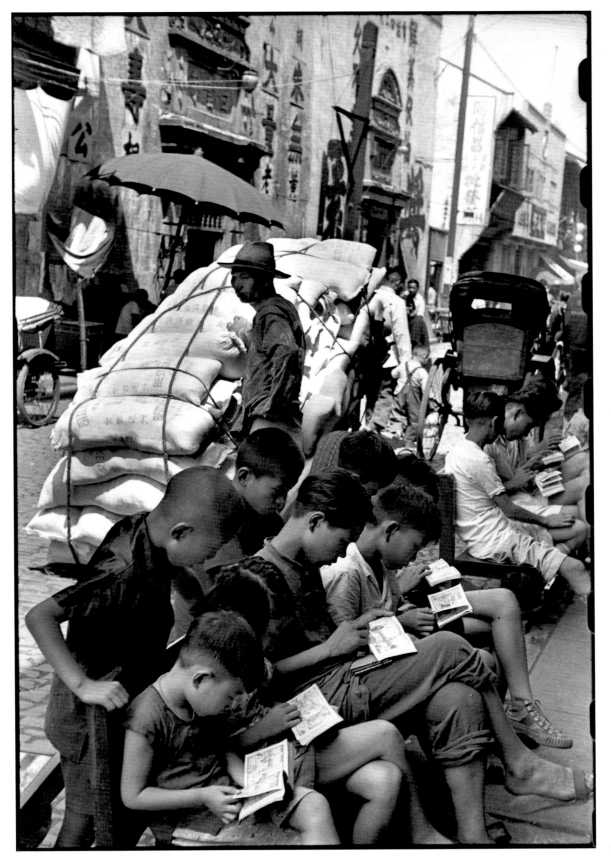

427 Shanghai, China, 1949

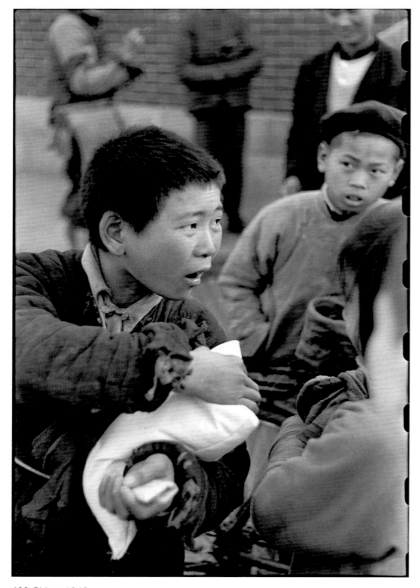

428 China, 1949

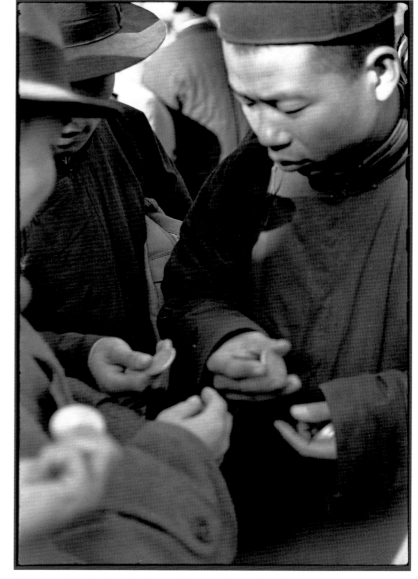

429 Speculators in the early days of Communism, Peking, China, 1948

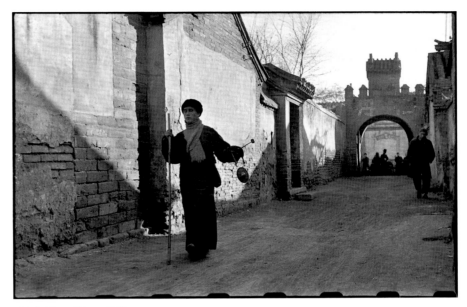

431 Peking, China, 1948

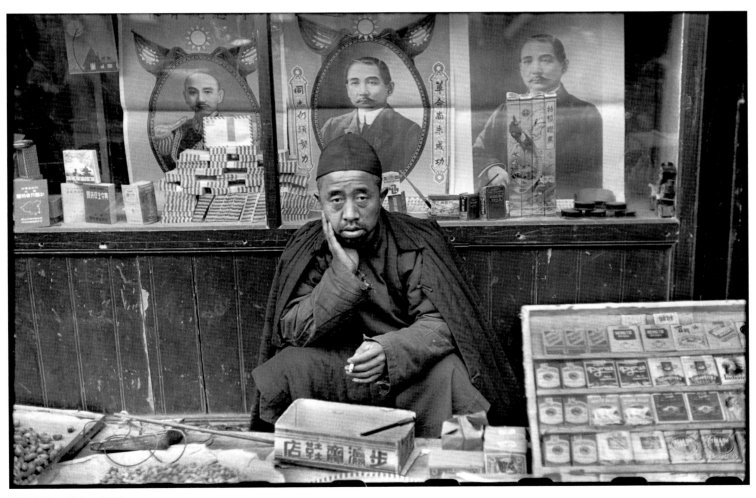

430 Peking, China, 1948

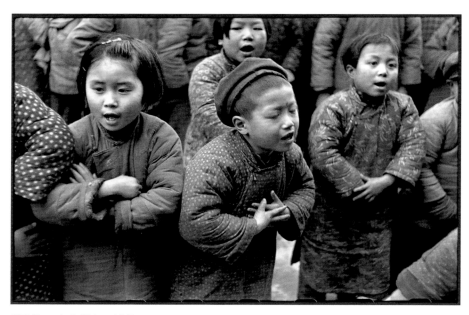

432 Shanghai, China, 1949

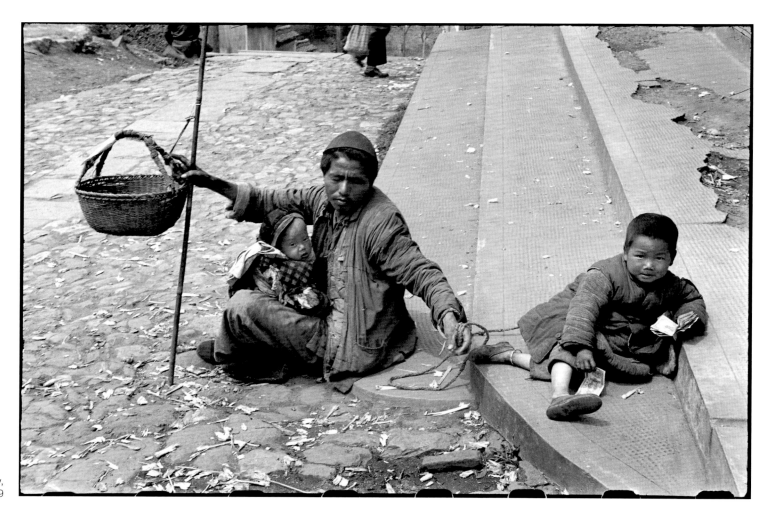

433 Hangchow,
China, 1949

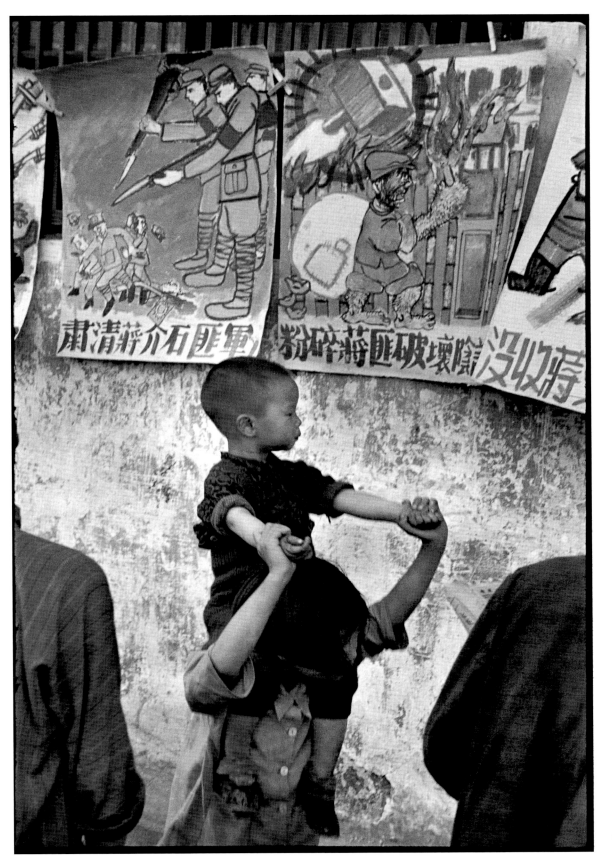

434 Nanking, China, 1949

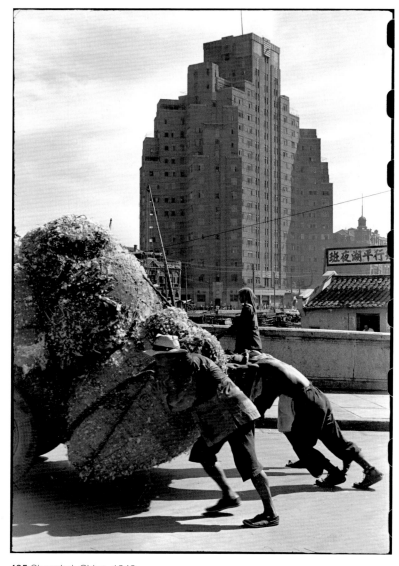

435 Shanghai, China, 1949

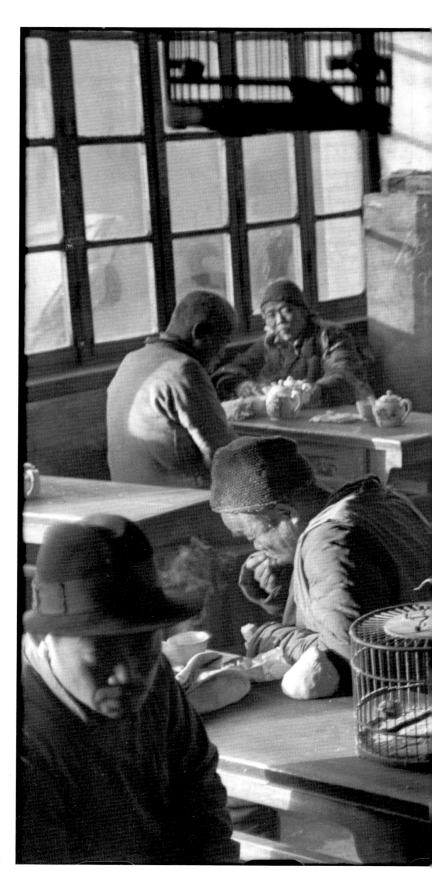

436 Tea house, Peking, China, 1948

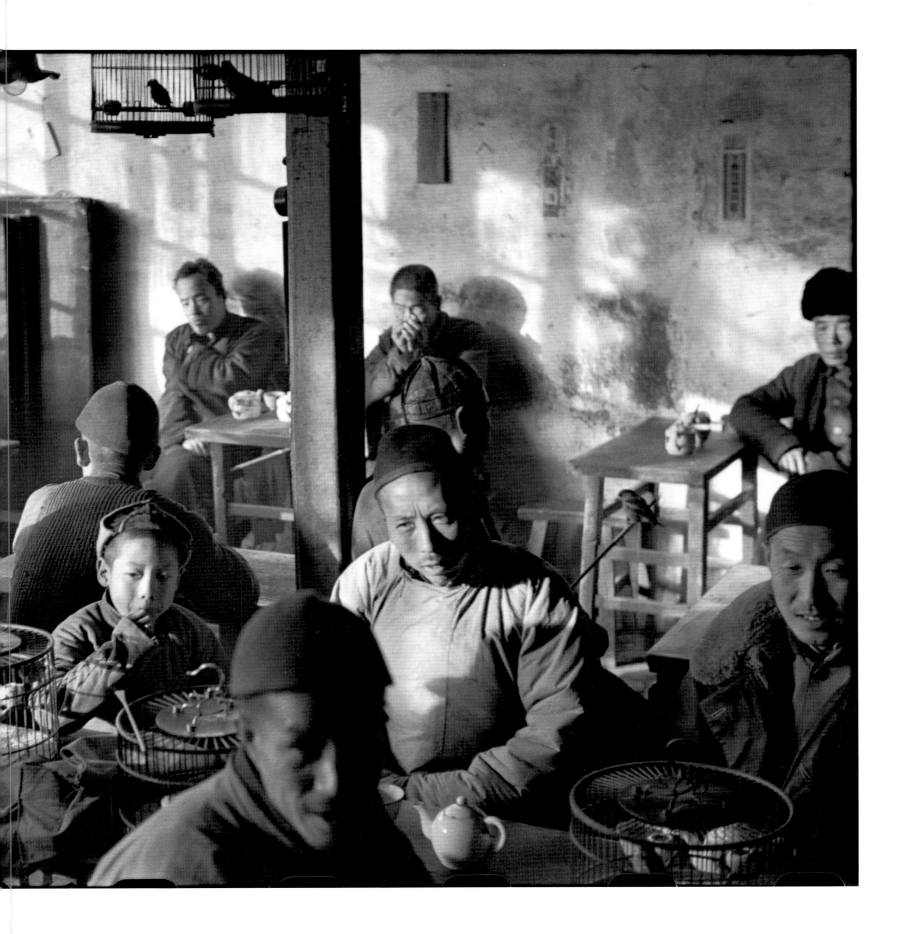

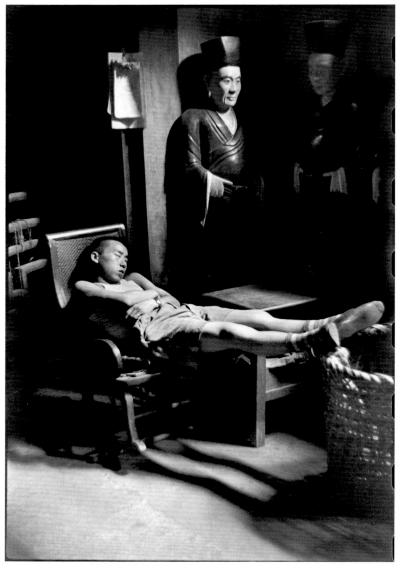

437 Guardian of the temple of Nan Tao, Shanghai, China, 1949

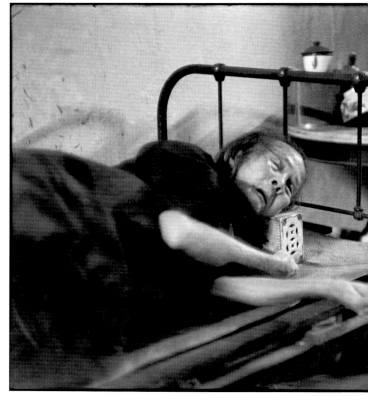

439 House of the dead, Singapore, 1949

438 House of the dead, Singapore, 1949

440 Liberation of Shanghai, China, 1949

441 News of the Chinese revolution, Hong Kong, 1949

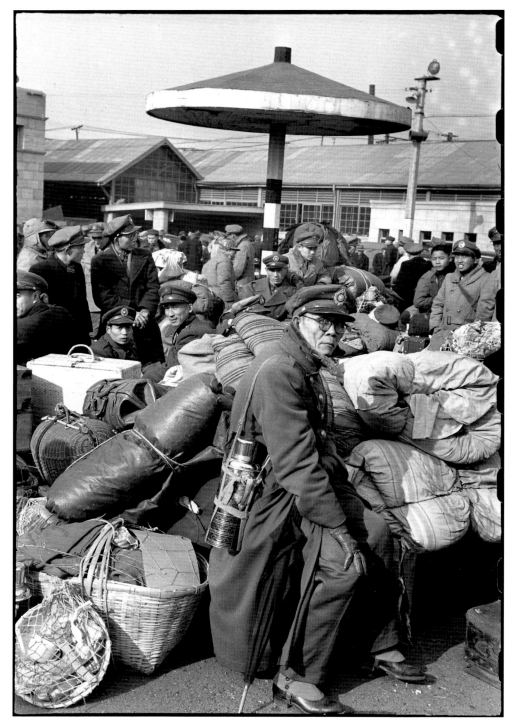

443 Departing Kuomintang officer, Shanghai, China, 1948

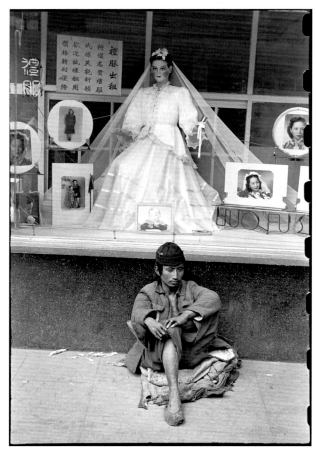

442 Hangchow, China, 1949

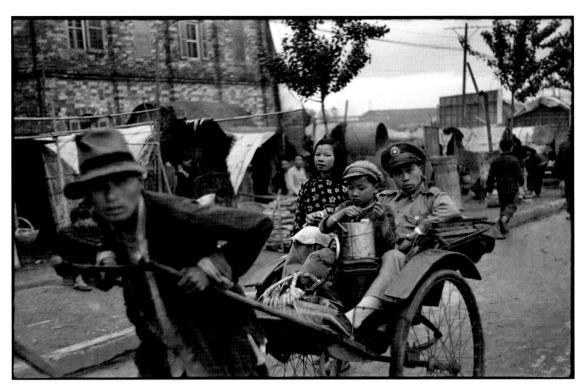

445 Fleeing the arrival of the Communists, Nanking, China, 1949

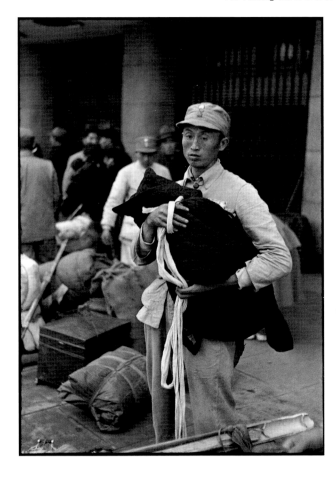

444 Nanking, China, 1949

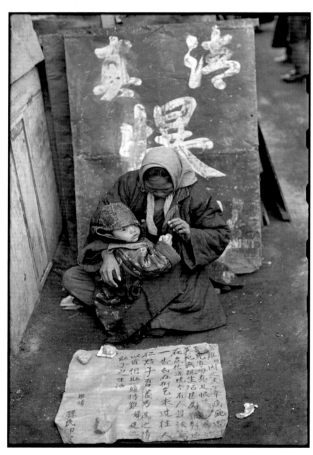

446 Peking, China, 1949

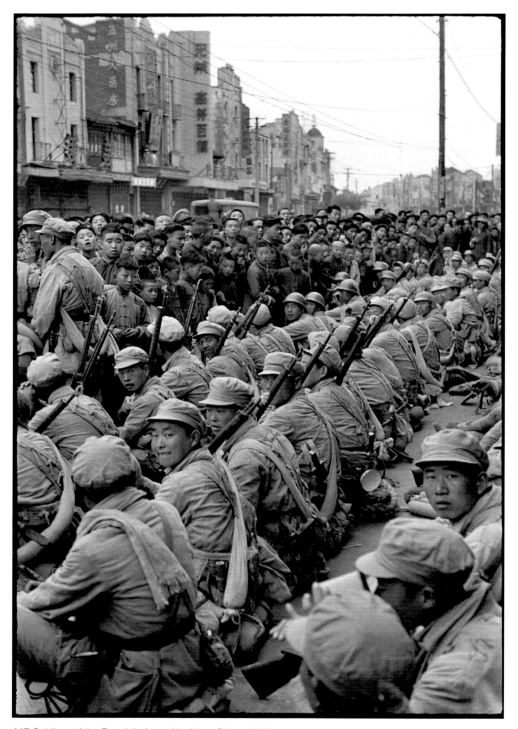

447 Soldiers of the People's Army, Nanking, China, 1949

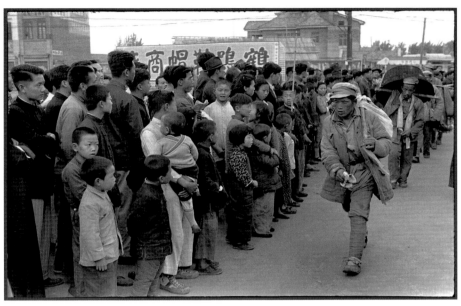

449 Arrival of soldiers of the People's Army, Nanking, China, 1949

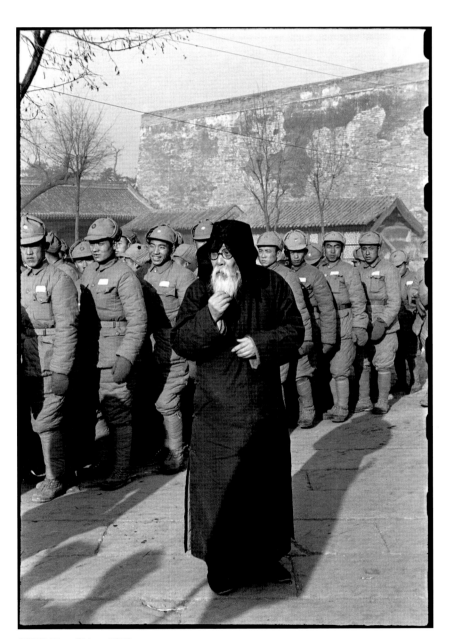

448 Peking, China, 1949

307

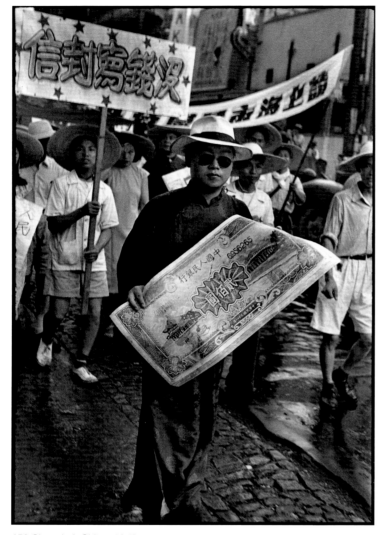

450 Shanghai, China, 1949

451 Shanghai, China, 1949

452 Shanghai, China, 1949

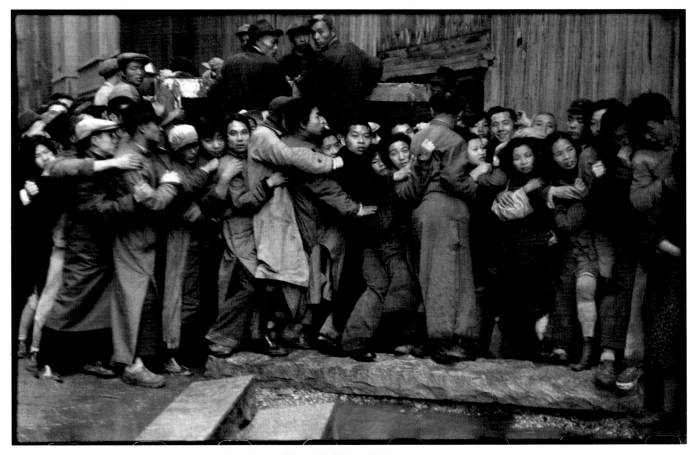

454 Distribution of gold in the last days of the Kuomintang, Shanghai, China, 1949

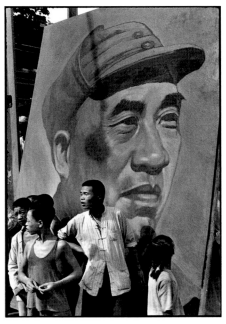

453 Portrait of General Chu-Teh, Shanghai, China, 1949

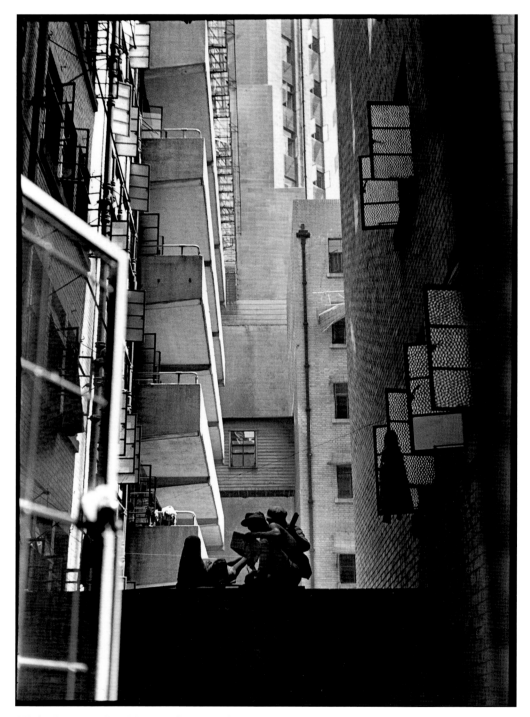

456 Soldiers of the People's Army, Shanghai, China, 1949

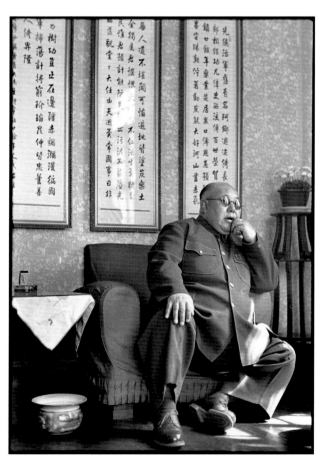

455 General Ma Hung-Kuei, Nanking, China, 1949

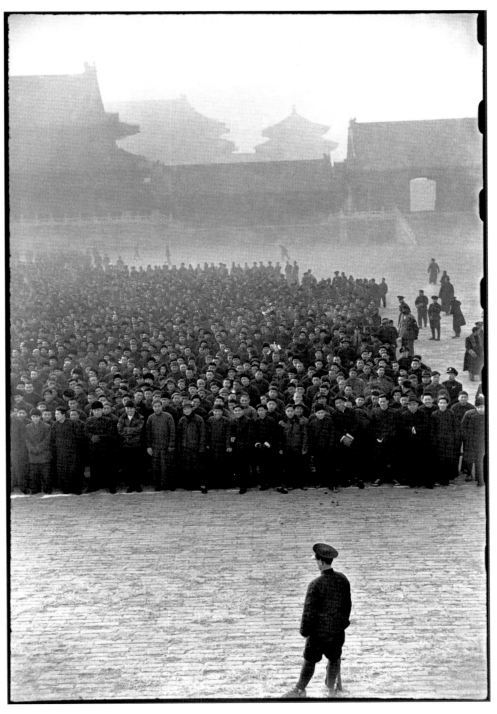

457 Kuomintang forces, Peking, China, 1948

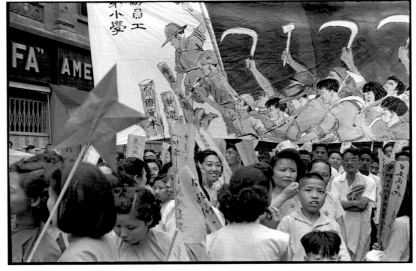

458 Shanghai, China, 1949

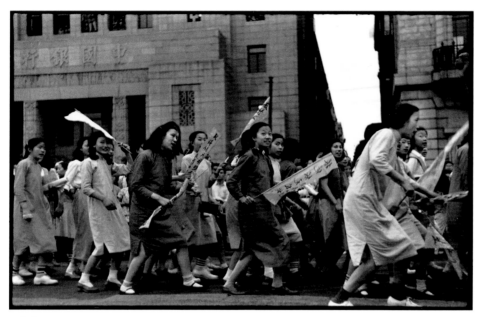

459 Students demonstrating against the black market, Shanghai, China, 1949

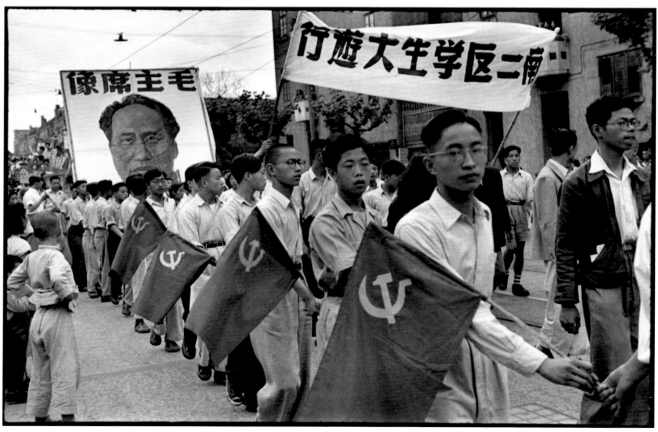

460 Shanghai, China, 1949

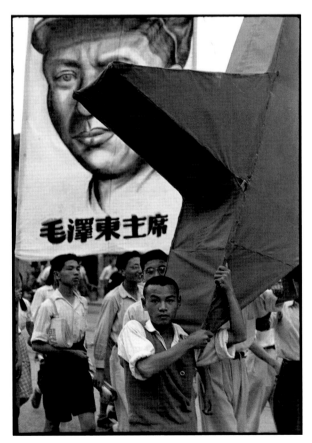

461 Celebrations for the Communist takeover of Shanghai, China, 1949

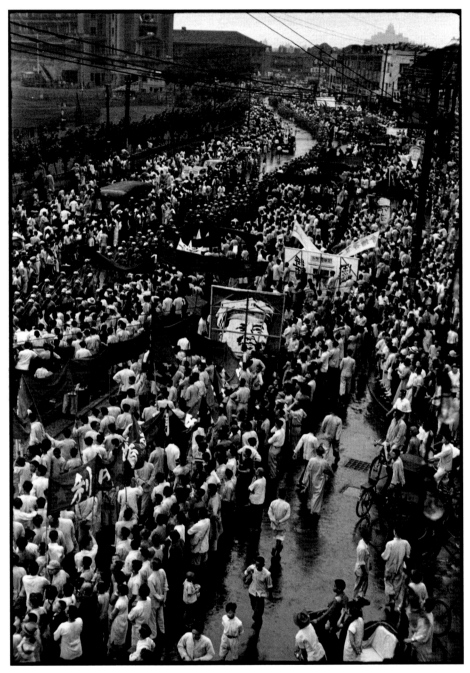

462 Nanking Road, a trade union procession marches up the road as the People's Army marches down it, Shanghai, China, 1949

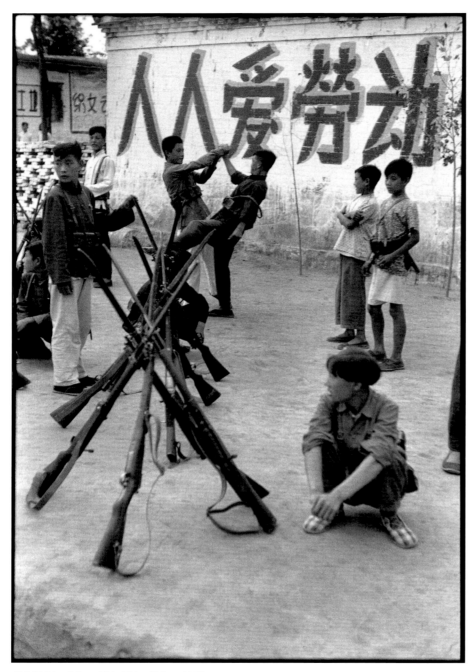

463 Child soldiers, Shiu Shin, China, 1958

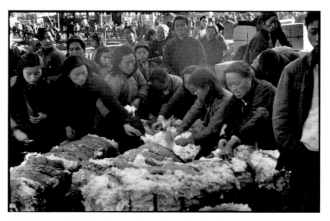

464 Beggars helping themselves to cotton to keep warm, Shanghai, China, 1949

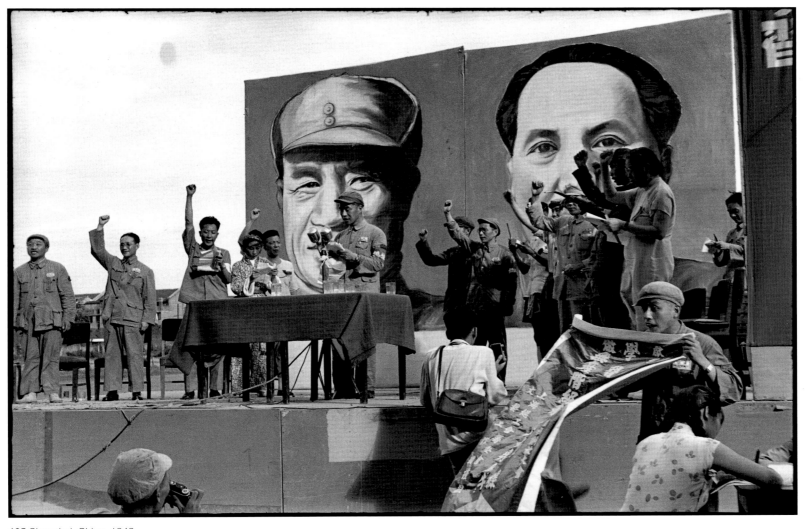

465 Shanghai, China, 1949

466 Shanghai, China, 1949

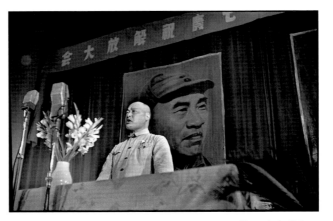

467 General Chen-Yi, associate of Mao Tse-tung, Shanghai, China, 1949

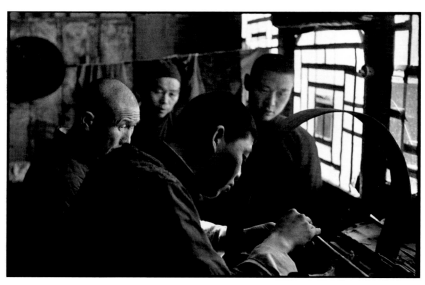

468 Polishing jade, Peking, China, 1948

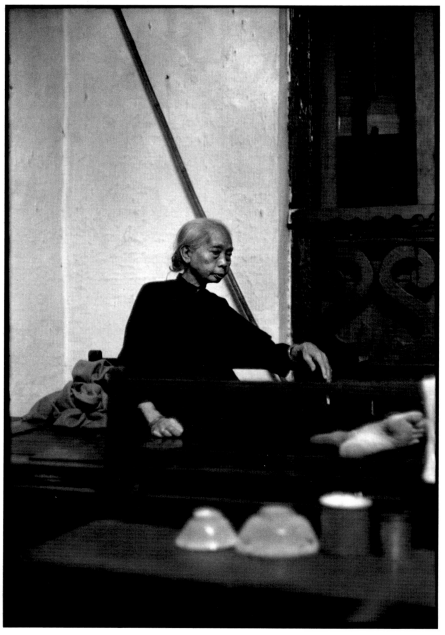

469 House of the dead, Singapore, 1949

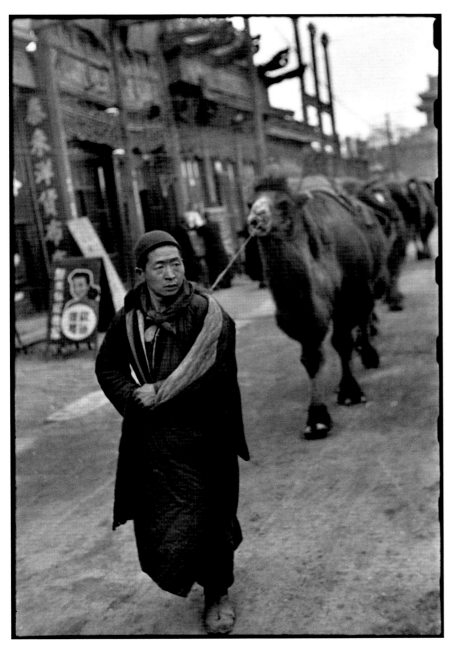

470 Peking, China, 1948

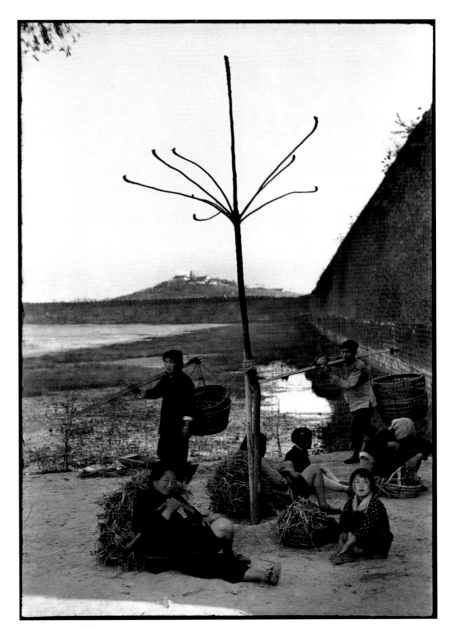

471 Nanking, China, 1949

317

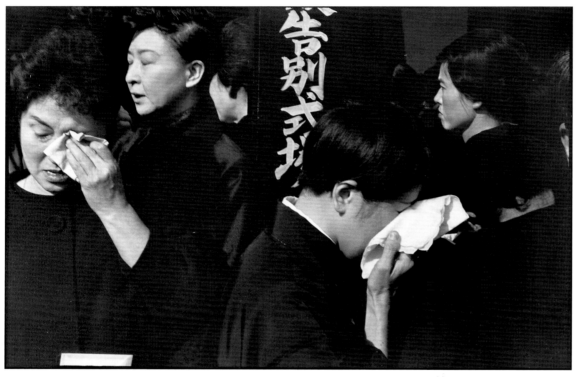

472 Shinto burial ceremony for the Kabuki actor Danjuro, Tokyo, Japan, 1965

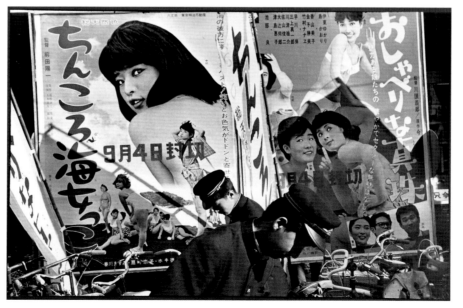

473 Hokkaido, Japan, 1965

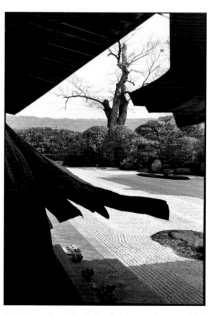

474 Temple of Daitoku-ji, Kyoto, Japan, 1965

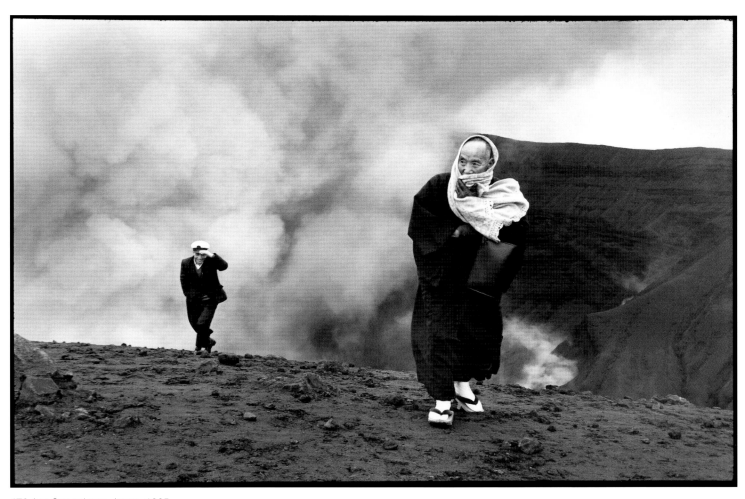

476 Aso San volcano Japan, 1965

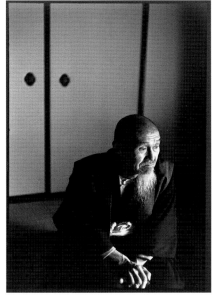

475 Buddhist monk, Kyoto, Japan, 1965

477 Fake Leica made of wood and cardboard, constructed by Saul Steinberg and presented to Henri Cartier-Bresson

478 Fake diploma drawn up by Saul Steinberg, authorizing Henri Cartier-Bresson to pursue a career as a photographer

'Photography is an immediate action; drawing a meditation.'
Henri Cartier-Bresson

A Passion for Drawing Jean Leymarie *Former Director of the French Academy in Rome*

It was nearly thirty years ago that Henri Cartier-Bresson resolved to devote himself more or less exclusively to drawing. He has pursued that course with increasing tenacity ever since, although without ever quite abandoning his legendary Leica. I have been lucky enough to share part of the adventure with him, being often at his side as he consults the variety of sketchbooks he employs for drawing models and motifs from life, and sometimes helping him select the best pieces for exhibition or publication.

The personal traits and particular talents that have brought him worldwide fame as a reporter are well known. There is no true photographer who does not have an artistic foundation behind him, who does not have the eye and the rhythms of a painter. The introduction he wrote in 1952 for his first wonderful album of photographs, which is like a charter of his craft, opens with the revealing declaration: 'I have always had a passion for painting. As a child I would paint every Thursday and Sunday, and on the other days I dreamed about it.' His father, a successful entrepreneur, was a reasonably gifted amateur, but the person he regarded as his 'spiritual father' in this domain was his uncle Louis, a professional painter and winner of the Prix de Rome. It was during the Christmas holidays in 1913, when he was just five years old, that he visited his studio at Fontenelle in Brie. He responded to its magical atmosphere, and saw for the first time the small landscapes done *in situ* in various parts of France and Italy, or in a nearby park, many examples of which he still possesses today, their delicate simplicity and sensitivity as appealing to him now as they were then. His uncle died in the war in 1915 and it was a friend called Jean Cottenet who introduced him to painting at the age of twelve during the school holidays. As an adolescent he used to paint during the summers spent at the family home in Normandy, and was also made welcome, along with his cousin, the archaeologist Louis Le Breton, by his country neighbour Jacques-Emile Blanche, who watched him paint in his garden, encouraged him, and later offered him his professional and personal friendship. Still intact are two small pictures on cardboard of 1924 that are striking for their chromatic richness. His literary curiosity was as intense as his sense of colour, and, with the complicity of his school supervisor, he read the modern novelists and poets at a very early age. He visited the Louvre and private art galleries, met Max Jacob and Elie Faure and became friendly with Max Ernst and René Crevel.

In 1927, when Kertész was photographing studios in Montparnasse, he became a pupil in the atelier of André Lhote, a well regarded theoretician and teacher. Fearful at first of his systematic approach, he learned to his benefit that art is governed by internal geometry and the harmonious relationship of the parts. Two paintings from 1928, a studio interior and a double portrait, are Purist compositions in a Surrealist vein. He was fascinated by Surrealism and, while he rejected the movement's doctrines and aesthetics, he was to be lastingly influenced by its call to intuition, surprise and a sense of wonderment, as well as its willingness to rebel against all forms of oppression, something that chimed well with his libertarian leanings. By nature brusque and highly strung, temperamentally inclined to sudden break-ups and changes of heart, in 1930 he shook off Western and bourgeois conventions and escaped to Africa to make a fresh start, carrying the works of Conrad and Rimbaud in his pockets. In the Ivory Coast he earned a living as a game hunter, before turning himself into a hunter of images instead, exploiting exactly the same ability to stalk his prey, the same accuracy of shot. Illness forced him to return. He scoured Central Europe, explored the hidden areas of Italy and Spain, spent a period in Mexico, a primitive country that he found invigorating, and then moved on to New York, where he spent all his time in Harlem. Right from the outset, from his earliest beginnings in photography, his style was there, intact, partly because his eye was instinctively attuned to the golden section, and partly because the hunt for pictures was for him a way of life, his personal way of seeing, discovering and apprehending the world. Back in Paris in 1936, the quality of his observation did not change, but it was expressed in the different visual medium of film, while working as Jean Renoir's assistant and directing documentaries himself on the Spanish Civil War.

After his escape from prisoner of war camp in 1943, he considered returning to painting, even though it would have meant abandoning an established professional career. But in the end it was the pressure of events and his own taste for adventure, as well as the need to record the planet's upheavals with, as he said 'a faster tool than a paintbrush', that carried the day. His working trips took him to every continent, often at critical moments in history, and in particular to places all over Asia, whose many upheavals he has recorded, and where he came under the influence of Buddhism, not so much as a religion or philosophy but as a principle of harmony. In the course of these expeditions he also expanded his artistic horizons, visiting monuments and museums, while focusing as far as his photographic enterprises were concerned on human events and spectacles. On the occasions he returned to France, he stayed in touch with the major contemporary artists who had become his friends, and of whom he had been commissioned to take photographic portraits in their domestic surroundings. In 1955, he got the ecology bug and became

very conscious of the accelerating pace of mechanization that was destroying the environment and the patterns of human behaviour. His photographs acquired an increasingly lyrical and contemplative cast as they moved away from social contexts to concentrate on landscapes and open spaces that were still free of industrial contamination. In 1966, while still allowing Magnum Photos to manage his archives, he retired from active participation in the cooperative agency he had co-founded in 1947. He felt that television and advertising, and commercial considerations in general, were affecting the integrity of his profession. 'We are obliged to recognize,' he declared in 1968, 'that there is an abyss separating the economic requirements of our consumer society from the needs of those who bear witness to our times.' In 1970, by then in his sixties, he married Martine Franck, the daughter of collectors and a fine young photographer better adapted than he to the new conditions. To her, it would seem, he handed on the baton, passing on his message of respect for the external world and for human values. He went back to drawing for his own enjoyment.

In 1973 he decided to take the plunge, to the astonishment of most of his friends, and put away the camera that had made his reputation to return to his first vocation. He was encouraged in this by the publisher Tériade, the far-sighted mentor whose advice he sought and accepted. He also received Jean Renoir's blessing and, a year later, the enthusiastic approval of his old friend Saul Steinberg, whose graphic genius he so admired. His change of direction did not in fact represent an abrupt break with the past as he had always regarded his mode of photography as resembling a sketchbook, and what he called *shooting photographs* as *accelerated drawing*. Photography takes place in an instant. Drawing is developed over a period, and it is characterized by things like individual handling and a personal style of script, which are absent in the mechanical transmission of a mental image. Cartier-Bresson challenges the hierarchy and refuses to blur the lines between these two parallel activities, whose particular natures he sums up as follows: 'Photography is an immediate action; drawing a meditation.'

He rejected oil painting, which required the grinding of pigments, as being too slow and complicated for his impetuous nature. His preference has been for tempera, a quick and intimate medium with a matt surface, which he uses with great delicacy and restraint. For the most part he has concentrated on black-and-white drawings, using hard lead pencils and graphite crayons, sometimes charcoal and Italian stone, the close grain of which lends itself especially well to the modelling of volumes; he has also made occasional use of silverpoint. His pen-and-Indian-ink drawings, rapidly executed without revisions, are characterized by their authoritative sweep and calligraphic accents. He does not incline towards the bold contours favoured by Matisse and Picasso, which, by enclosing the form, imply its ideal state, but rather, in the manner of his

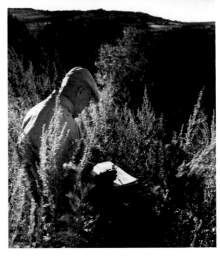

479 Henri Cartier-Bresson drawing in Provence, 1990, photo John Mullin, D.R.

preferred intermediaries Bonnard and Giacometti, proceeds by means of a series of open lines or hatchings that never enclose what they seek to suggest. In the same way that he restricted himself to documentary films, incapable of creating fiction, he pronounced himself incapable of drawing from memory or the imagination, instead keeping strictly to drawing from the motif, observational drawing. Realism in painting may be said, according to some authorities at least, to have reached its culmination with Jan van Eyck and Dürer, its supreme exponents, and then to have resurfaced in the modern era with Degas and the single-minded Cézanne, who made it his goal to 'penetrate what one has in front of oneself', with no form of intellectual or emotional diversion. The photograph is from the very outset enclosed within a fixed frame. Observational drawing, on the other hand, has no predetermined location, no fixed coordinates, it remains of necessity empirical, seeking to find itself and defining itself as it goes along by means of successive approximations, offering itself to the active blank space of the paper, which is the recipient of form, the generator of light, and of light in combination with form.

Whatever his talents and previous experience, Henri Cartier-Bresson had to go back to basics, working patiently and persistently, under the critical but helpful eyes of such experienced draughtsmen as his friends Sam Szafran and Georg Eisler. He began with meticulous topographical urban views, framed by the uprights of a window. For months he held back, to practise his scales, as he said himself, but also because the subject was so overwhelming. He would scrupulously transcribe the skeletons of dinosaurs in the Muséum d'Histoire Naturelle, which has a fantastic collection of prehistoric reconstructions. He also made numerous copies, a discipline that used to be common practice in all studios, and remains today the very best form of self-education. His favourite subjects were Ingres and Delacroix, Vincent van Gogh, Dürer and Brueghel, Rubens, Zurburan and Goya. Among his most attractive copies is one after Géricault's *Madwoman* plunged in mental anguish, and another after Tintoretto's *Self-portrait* done in his old age, which that indefatigable copyist Giacometti thought the finest head in the Louvre, because of its density of bone structure and profundity of expression.

Leaving aside the copies, which are indicative of his personal tastes, the drawings and temperas of Henri Cartier-Bresson fall into the traditional categories of landscapes and portraits, still-lifes and nudes. His still-lifes, although finely executed, are few in number because he is less interested in inert domestic objects than in the animation of the human face or the living natural world. They are pictures of game, bunches of flowers, attractive arrangements of fruits and vegetables, among them artichokes with their fleshy bracts. With the exception of one or two ironic allusions, the self-portrait is entirely absent from his 'extrovert' photographic oeuvre because the

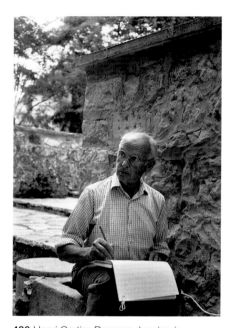

480 Henri Cartier-Bresson drawing in Provence, 1979, photo Martine Franck, Magnum

conditions of his work imposed anonymity. 'The observer,' Baudelaire notes of the draughtsman and reporter Constantin Guys, 'is a *prince* who goes everywhere incognito.' His 'introvert' graphic oeuvre on the other hand is studded with self-portraits, not out of any narcissism, but as a way of imposing a kind of structure, creating a series of landmarks in time. Of all the genres, portraiture is perhaps the ideal form of observational drawing. When Cartier-Bresson indulges his taste for making studies of his friends, many of whom are writers and artists, he aims for an identity that goes beyond mere resemblance. He shows their heads and shoulders against a neutral background, often just the head on its own, like an entity encapsulating a whole range of reactions, some curious geological specimen with sparkling eyes. Sometimes he drew his closest friends in full-length portraits within an interior. Almost all these portraits are executed in hard lead pencil, the exception being the graceful line-drawings in silverpoint of his wife Martine and daughter Mélanie. To embark on a portrait, he said, reflecting his oriental leanings, 'the draughtsman needs inner silence'.

Aside from two or three exceptional works of sublime quality, he never did nude photography, because of a sort of modesty, because the speed of capturing the image seemed to him like a violation; the genre was far better suited to drawing, which employed a different approach, 'without indiscretion'. He has used a number of models, white- and dark-skinned, allowing them free access to his studio. They adopt whatever pose they choose, so that they are unselfconscious as he observes them. For those who still regard the female body as sacred, possessed of a cosmic power to delight whatever the ravages of time, it will always be the supreme symbol of beauty, the perfect embodiment of form. As a motif it is both the most attractive choice and the riskiest, because the least distortion in the relationship between the individual parts or of the parts within the whole will destroy the harmony of the proportions. Cartier-Bresson is a great admirer of Titian, Rubens and Bonnard, the pre-eminent exponents of the female nude, and also, for the naturalness and variety of his poses, Degas, the inventor of the modern nude in a polyvalent space. As an adolescent he had been fascinated by Seurat's *Poseuses*, formerly at the Galerie Barbazanges before their departure for the Barnes Foundation, but his nudes were never anything like these thin, frontal figures, these Giacometti-like 'vertical' nudes. His bodies, with their expansive curves, are seated in an armchair, or more often than not stretched out on the floor, reclining on rich fabrics in the Venetian manner, viewed from every conceivable angle, from the front, the side, the back or upside down, in the full glory of their tactile magnificence. He has agonized over the problem he has with drawing hands and feet, which he always covers up when his nudes become women sleeping, but he relishes with a Baudelairian delight the revelation of

the swelling forms of breast and belly, the curve of the hips. To preserve the living beating heart of the body, he has said, you have to 'know when to stop, not to keep working at it'.

More than half Henri Cartier-Bresson's drawings and temperas are landscapes, urban or rural scenes done *in situ* all over Europe, in India and the United States. For these he uses lightweight portable equipment, little more than a shooting stick and a drawing board on the knees to hold a sketchbook. He is most at home with the 'atmospheric' landscape that is typical of Chinese art, which enables him to control his fundamental impetuosity by adopting the rhythm of the elements, the phases of the light. His Paris home is on the top floor of a building in the Rue de Rivoli which overlooks the Tuileries and its surrounding monuments. In the nineteenth century the apartment immediately below was occupied by that discriminating patron of the arts, Victor Choquet, who collected Delacroix and was painted with affectionate respect by Cézanne and Renoir. It was in Choquet's apartment that Monet and Pissarro stationed themselves to paint the classical gardens that Cartier-Bresson contemplates every day from exactly the same angle, which he too loves to draw at different seasons and times of day, capturing the miraculous harmony of water, stone and plants under changing skies. He has observed and recorded all the recent metamorphoses of this historic area of Paris that abuts the Louvre.

481 In Gjon Mili's office at *Life* magazine, New York, 1979, photo Martine Franck, Magnum

He loves to walk about the city, and is a frequent admirer of the flowerbeds in the Jardin des Plantes, with its view over the trees to distant bell towers and domes; he lingers in the busy central squares of Carrousel, Châtelet and Saint-Michel; he visits out-of-the-way places beloved of the Surrealists like the Canal Saint-Martin, as well as the boulevards lined with their serried ranks of Haussmann's severe buildings. Sometimes he ventures into interiors such as the Beaubourg Library, or the Gare d'Orsay before it became a museum, noting down the metal structures in a manner reminiscent of Piranesi. For trees, bare or in leaf, whether the dense masses of the countryside or the delicate groves of the town all aquiver, he has a particular affection. In New York, it is through a screen of foliage that he pictures the beetling skyscrapers.

In the summer, and increasingly now at other times as well, he withdraws to his isolated house in Alpes-de-Haute-Provence, which is at the centre of a large conservation area. Every day he strikes out into this wonderful landscape in search of suitable motifs, mindful of Corot's advice to sit in the right place, not too close, not too distant. He loves drawing hilltops with their narrow access roads, huddles of houses with towers rising above them, old villages perched on crags, Gordes, Vachères, Reillanne. I have followed in his footsteps on some of these expeditions, seen the precise spot where he likes to take up his position on the edge of the abyss of the Canyon d'Oppedette, the changing colours of its limestone strata shining out from among the shrubs and

brushwood. He used to visit his old friend Balthus, a fine draughtsman whose appreciation of his drawings gave him encouragement. In the area around Gstaad he adds to his repertory of mountain studies, austere views of jagged peaks etched on empty space. Berne and the old Swiss towns, Venice, which he adores, the banks of the Loire and the shores of the Cotentin Peninsula are among his other sources of inspiration.

What defines an artist is the strength and determination of his commitment. For Henri Cartier-Bresson drawing is an urgent and vital necessity, a perpetual challenge that is unappeased by the numerous exhibitions he allows to take place in private and public galleries. By a process of some sort of oriental osmosis, he has become the figure of the old man who is passionate about drawing, whose creative fervour actually increases with age, who holds up to us the example of his energy, his innocent ability to wonder at the world's splendour.

Jean Leymarie is the former Director of the French Academy in Rome

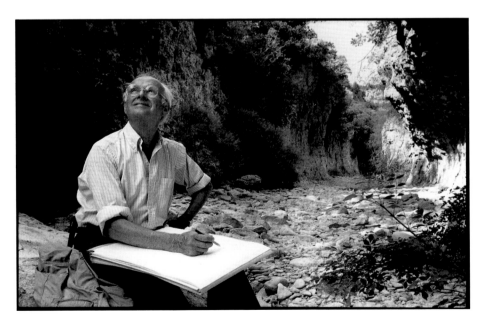

482 In the Canyon d'Oppedette, Provence, 1979, photo Martine Franck, Magnum

483 André Lhote's studio, 1927. Oil on canvas, 54 × 44 cm (21¼ × 17⅜ in.), Private collection, Paris

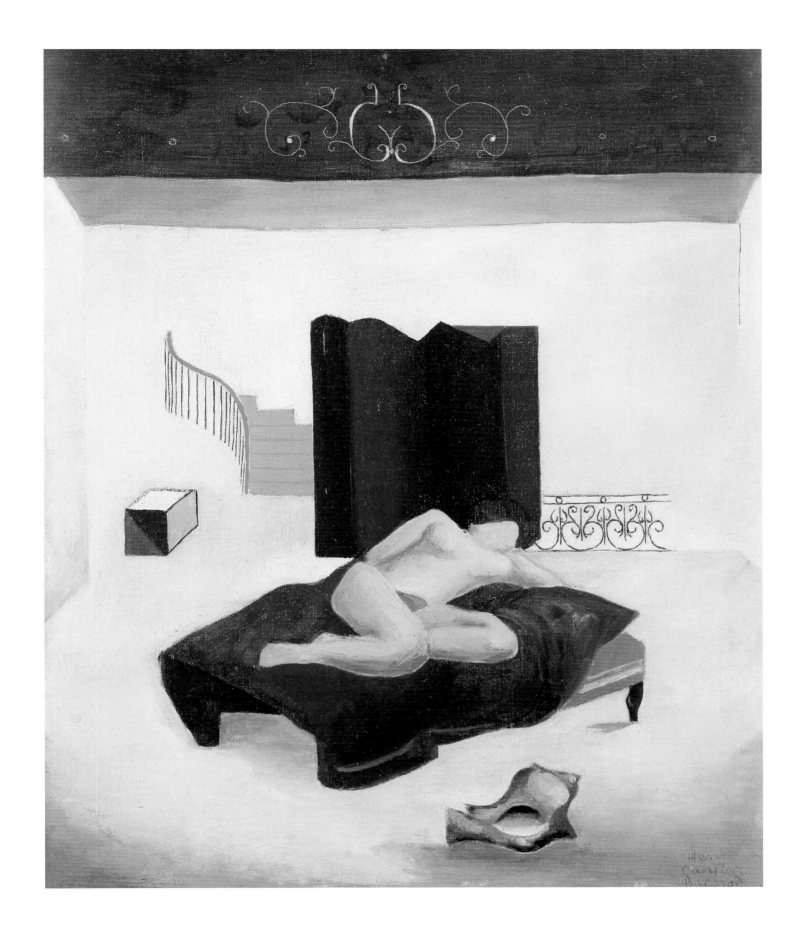

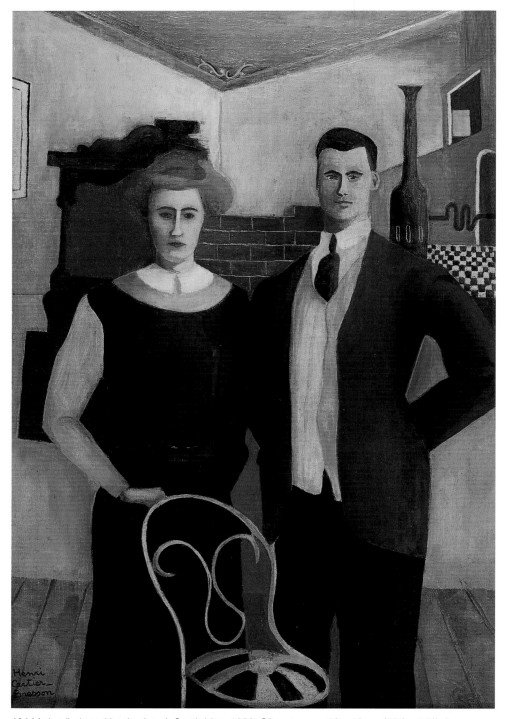

484 My landlady and her husband, Cambridge, 1928. Oil on canvas, 50 × 40 cm (19⅝ × 15¾ in.), Private collection, Paris

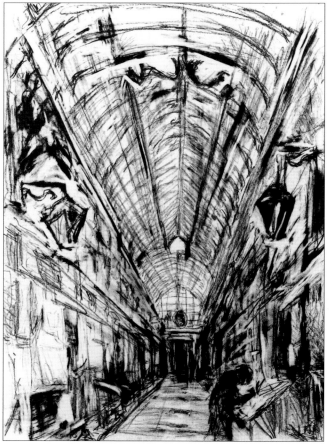

485 Passage, Paris, 1993. Lithograph for Louis Aragon's 'Paysans de Paris', 49 × 35.6 cm (19¼ × 14 in.), Limited edition, New York

486 Muséum d'Histoire Naturelle, Paris, 1975. Pencil drawing, 38 × 48 cm (15 × 18⅞ in.). Musée National d'Art Moderne, Centre Georges-Pompidou, Paris

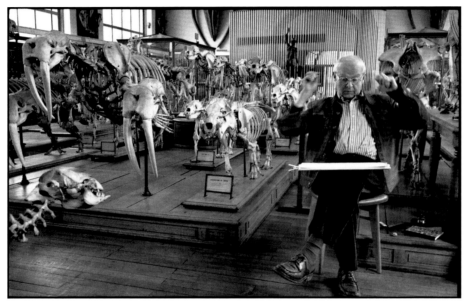

487 Henri Cartier-Bresson, Muséum d'Histoire Naturelle, Paris, 1976.
Photo Martine Franck, Magnum

488 Muséum d'Histoire Naturelle, Paris, 1975. Pencil on paper, 39.3 × 48.5 cm (15½ × 19 in.), Private collection, Paris

H.CR.12.15

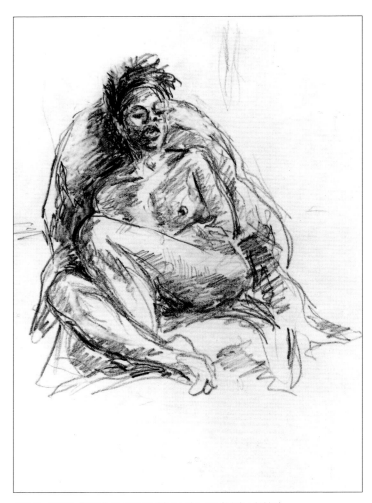

489 K., 1989. Pencil on paper, 29.5 × 21 cm (11½ × 8¼ in.),
Private collection, Paris

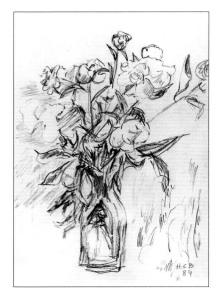

490 Flowers, 1984. Pencil on paper,
21 × 13.5 cm (8¼ × 5¼ in.),
Private collection, Paris

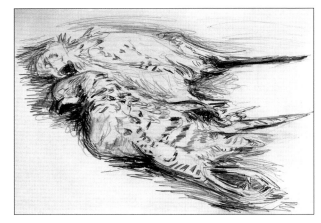

492 Pheasants, 1974. Pencil on paper, 23.5 × 31.7 cm
(9¼ × 12½ in.), Peter Bunnell collection, Princeton

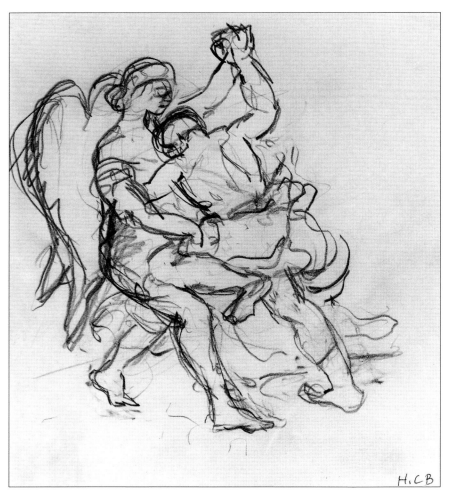

491 Jacob Wrestling with the Angel, after Delacroix, 1987. Pencil on paper, 22.8 × 17.4 cm
(9 × 6⅞ in.), Private collection, Paris

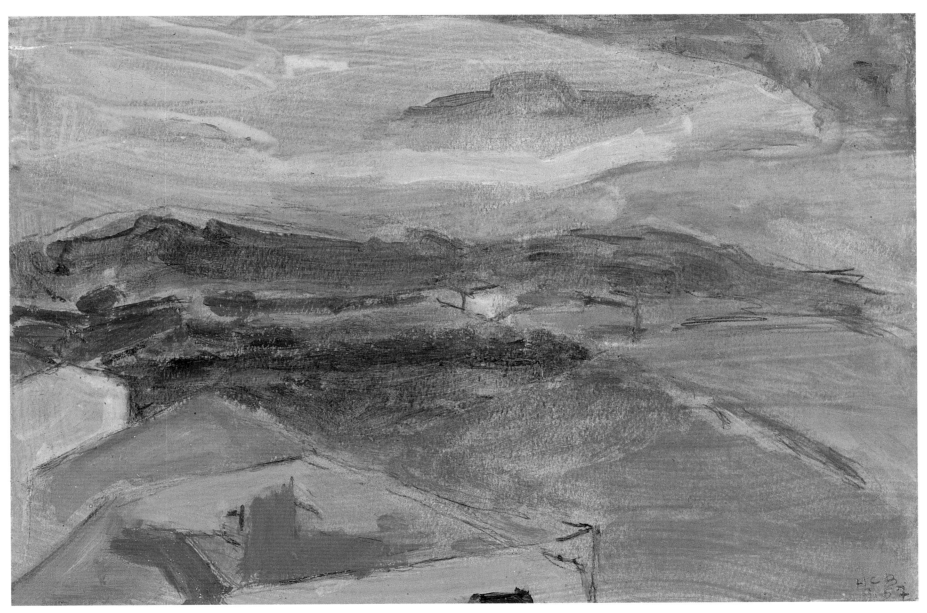

493 Cannes, 1967. Tempera, 18 × 26.5 cm (7⅛ × 10½ in.), Private collection, Paris

496 M. C-B, 1973. Ink on paper, 15 × 25.5 cm (5⅞ × 10 in.), Private collection, Paris

494 Self-portrait, 1987. Pencil on paper, 20.5 × 14.8 cm (8⅛ × 5¾ in.), Private collection, Paris

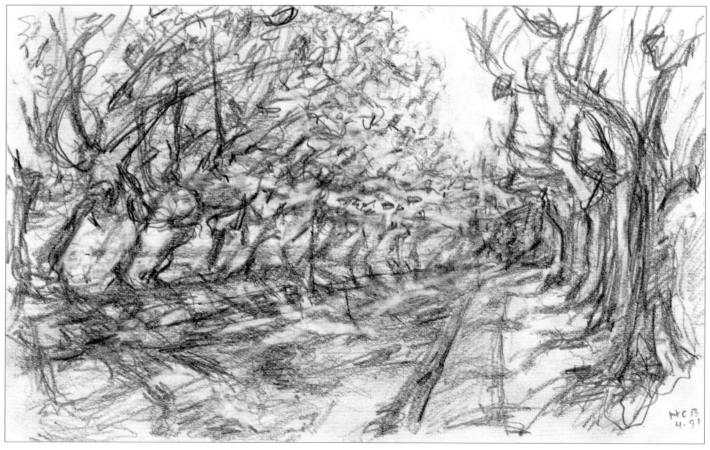

495 Isle-sur-la-Sorgue, 1991. Pencil on paper, 16 × 24 cm (6¼ × 9½ in.), Private collection, Paris

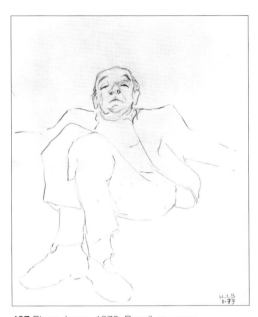

497 Pierre Josse, 1979. Pencil on paper,
30.5 × 24 cm (12 × 9½ in.), Private collection, Paris

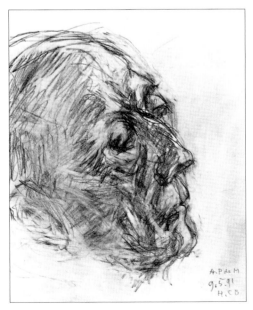

498 André Pieyre de Mandiargues, 1991.
Pencil on paper, 23 × 17 cm (9 × 6¾ in.),
Private collection, Paris

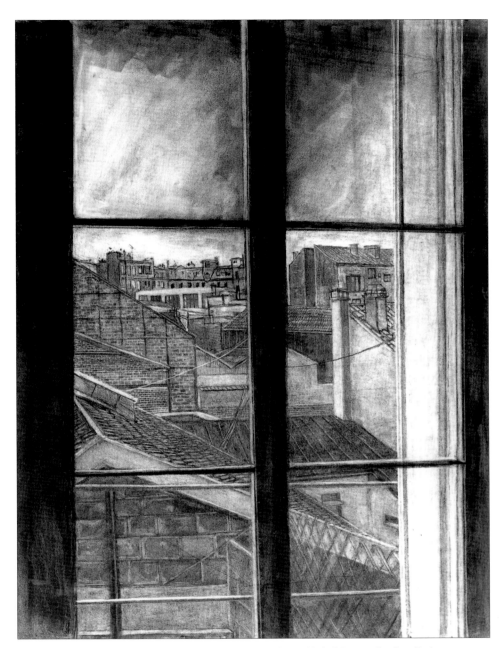

499 Malakoff, 1979. Charcoal on paper, 75 × 58 cm (29½ × 22⅞ in.), Private collection, Paris

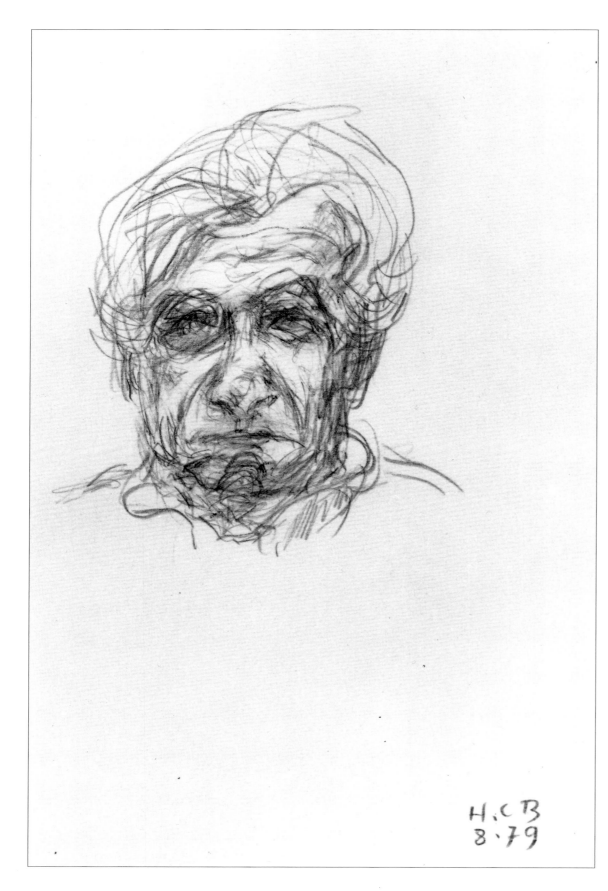

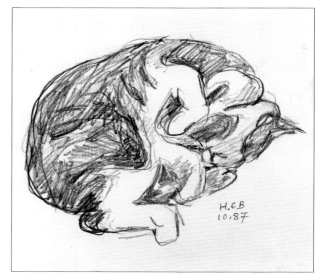

501 Ulysses the cat, 1987. Pencil on paper, 14.9 × 20.5 cm
(5¾ × 8⅛ in.), Private collection, Paris

500 Yves Bonnefoy, 1979. Pencil on paper, 24 × 14.5 cm (9½ × 5⅝ in.),
Musée National d'Art Moderne, Centre Georges-Pompidou, Paris

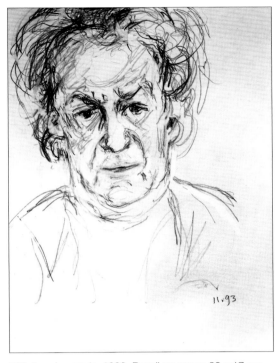

503 Jean Leymarie, 1993. Pencil on paper, 23 × 17 cm
(9 × 6¾ in.), Private collection, Paris

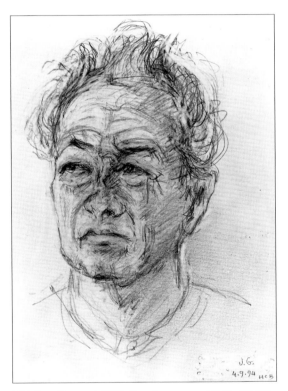

504 Jean Genoud, 1994. Pencil on paper, 28.7 × 20 cm
(11¼ × 7⅞ in.), Private collection, Paris

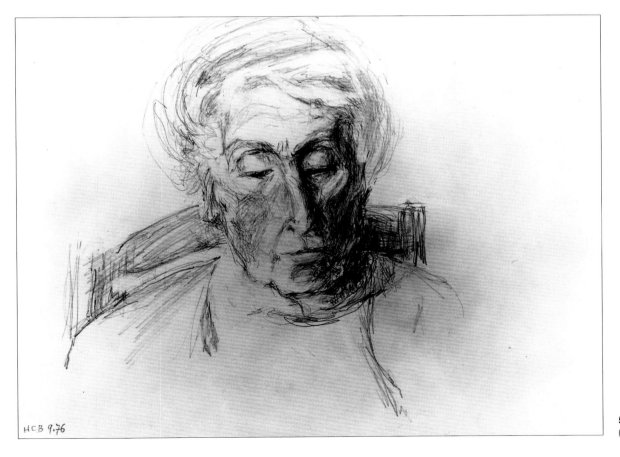

HCB 9.76

502 Ruta Sadoul, 1976. Pencil on paper, 23 × 31.5 cm
(9 × 12⅜ in.), Private collection, Paris

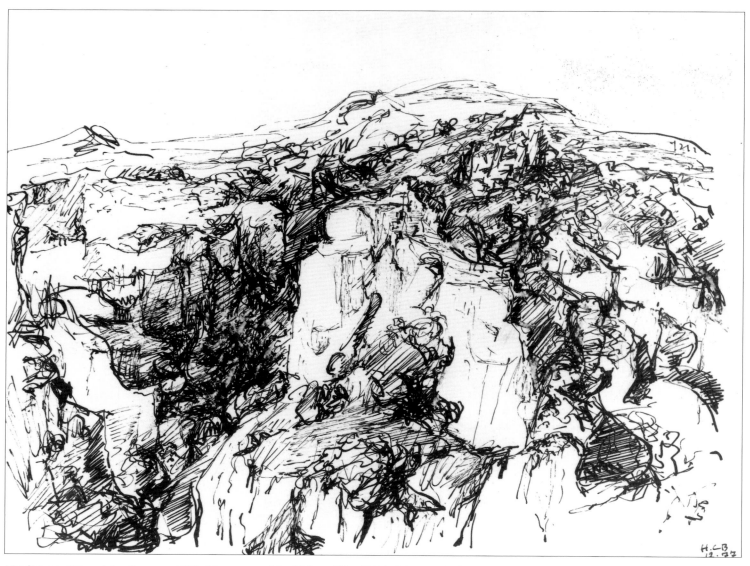

505 Canyon d'Oppedette, Provence, 1977. Ink on paper, 24 × 30.5 cm (9½ × 12 in.), Private collection, Paris

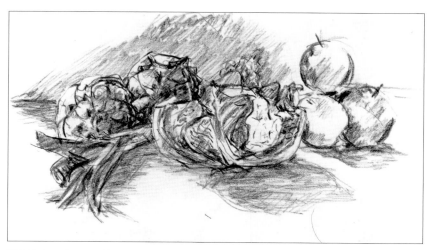

506 Fruit and vegetables, 1980. Pencil on paper, 12.5 × 21.5 cm (4⅞ × 8½ in.),
Private collection, Paris

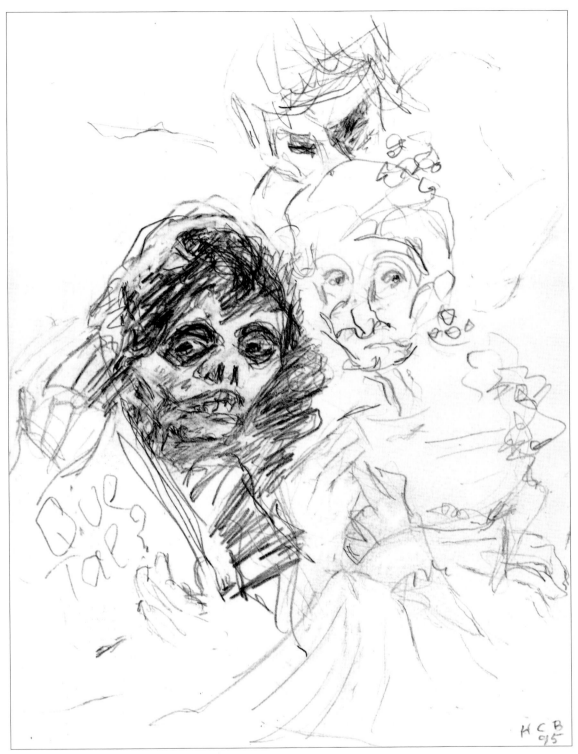

507 Copy after 'The Old Women' by Goya, detail, 1995. Pencil on paper, 20.5 × 15 cm (8⅛ × 5⅞ in.),
Private collection, Paris

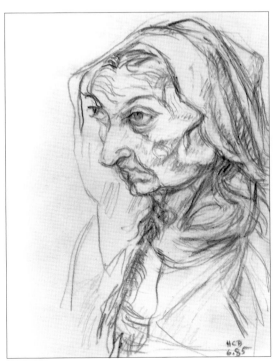

508 Copy after 'Portrait of the Artist's Mother' by Dürer,
1985. Pencil on paper, 20.4 × 14.9 cm (8 × 5¾ in.),
Private collection, Paris

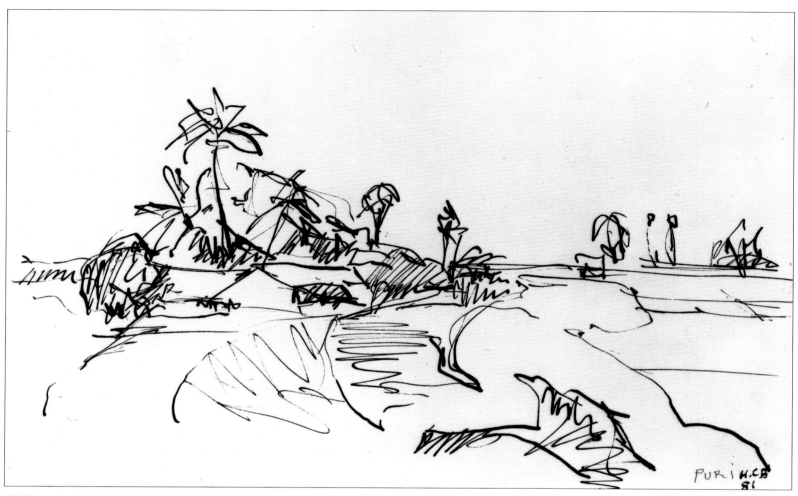

509 Orissa, India, 1981. Ink on paper, 12 × 24 cm (4¾ × 9½ in.), Private collection, Paris

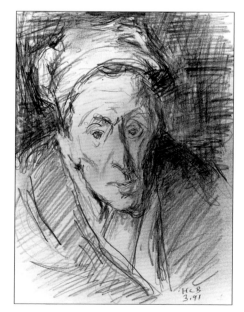

510 Copy after Géricault, 1991. Pencil on paper, 20.6 × 15 cm (8⅛ × 5⅞ in.). Private collection, Paris

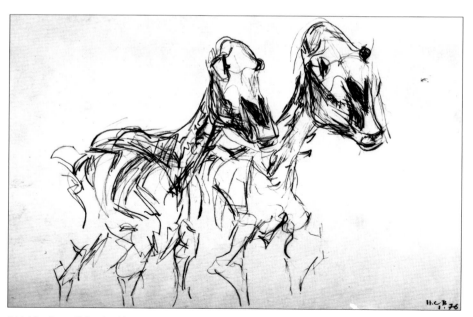

511 Muséum d'Histoire Naturelle, Paris, 1976. Black stone on paper, 23.5 × 31.5 cm (9¼ × 12⅜ in.), Private collection, Paris

512 C.E.,1984. Pencil on paper, 25.2 × 19.8 cm (9⅞ × 7¾ in.),
Blumenfeld collection, San Francisco

513 Newcastle upon Tyne, 1978. Ink on paper, 20.5 × 13.5 cm
(8⅛ × 5¼ in.), Private collection, Paris

514 Tériade, 1982. Pencil on paper, 31.7 × 23.8 cm (12½ × 9⅜ in.), Private collection, Paris

515 La Madeleine, 1978. Black stone on paper, 18 × 11 cm (7⅛ × 4⅜ in.), Private collection, Paris

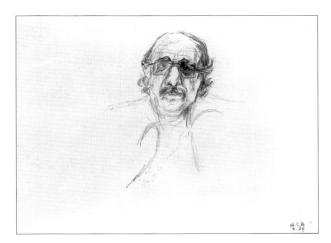

516 Sam Tata, 1976. Pencil on paper, 23.5 × 31.7 cm (9¼ × 12½ in.), Private collection, Paris

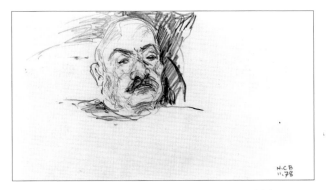

517 Romeo Martinez, 1978. Pencil on paper, 17.7 × 21.6 cm (7 × 8½ in.), Private collection, Paris

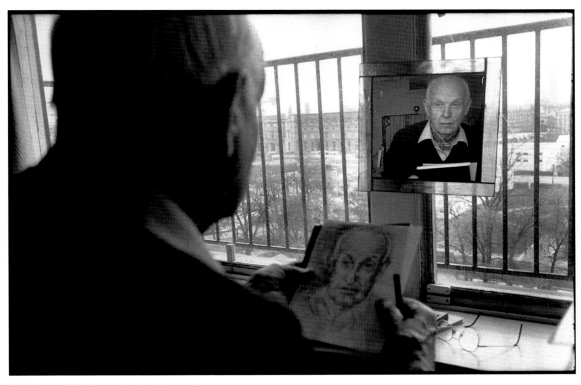

519 Paris, 1992. Photo Martine Franck, Magnum

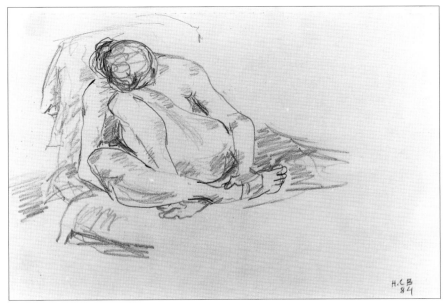

518 Nude, 1984. Pencil on paper, 20.5 × 29.5 cm (8⅛ × 11½ in.), Private collection, Paris

Film-making: Another Way of Seeing Serge Toubiana *Cahiers du Cinéma*

Henri Cartier-Bresson has made no more than a handful of films, nothing that could be said to constitute an oeuvre in the proper sense of the word. Yet, sporadic though his activity may have been, it represents an essential element in his close and enduring relationship with the camera and the image. Cartier-Bresson certainly never viewed the cinema as a vocation, or as an all-consuming activity like photography or, later on, drawing. But there were two or three periods in his life when it represented a genuine alternative for him, a different way of *seeing the world* and recording its events.

There are a number of films with which he was involved, at intervals, between 1936 and the end of the sixties.

In 1936, when he returned to Paris after a few months in New York, having spent a year in Mexico in 1934, Henri Cartier-Bresson decided he wanted to make films. He was not yet thirty. Initially he approached Luis Buñuel in the hope of becoming his assistant, but he said no. Cartier-Bresson then went to see Jean Renoir, whom he admired, and gave him a book of his photographs. Renoir did not hesitate and took on the young photographer as one of his assistants. Cartier-Bresson has preserved this unique document ever since, as a sort of talisman, as it was this book that opened the doors of the cinema to him. He became a full member of Renoir's team.

In 1936, Renoir was preparing to direct a film commissioned by the Communist Party, *La Vie est à nous* (The People of France). Its purpose was to boost the morale of the Popular Front. Cartier-Bresson assisted Jean Renoir, working alongside Jacques Becker, Marc Maurette, Maurice Lime, Jacques B. Brunius and Pierre Unik. Most of these were Communists, but not Renoir or Cartier-Bresson, then only fellow travellers. André Zwoboda and Jean-Paul Le Chanois were Jean Renoir's co-directors. The film was a collaborative venture, combining professional actors (Gaston Modot, Madeleine Sologne, Charles Blavette, Roger Blin, Julien Bertheau) with leading members of the Communist Party (Marcel Cachin, Maurice Thorez, Jacques Duclos and Paul Vaillant-Couturier, who was co-author of the script with Renoir). Later in 1936, Cartier-Bresson was again taken on by Jean Renoir as assistant director on *Une partie de campagne* (A Day in the Country) adapted from a Guy de Maupassant short story, and featuring Sylvia Bataille. The film was shot

520 Jean Renoir, frame from a film. Bifi collection, 1936

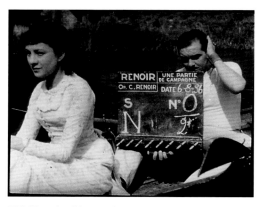

521 Shooting *Une partie de campagne,* Jean Renoir, photo D.R., Bifi collection, 1936

not far from Marlotte, Renoir's house at Sologne. Cartier-Bresson worked alongside Jacques Becker (who became one of his closest friends), Jacques B. Brunius, Claude Heymann, Yves Allégret and an unknown Italian called Luchino Visconti, who was in charge of the costumes. Cartier-Bresson made a fleeting appearance in *Une partie de campagne* dressed as a young priest. He appears standing next to the writer Georges Bataille. The two men, both wearing black, look in amazement at the lovely Sylvia Bataille, whose white dress flies up as she sails though the air on a swing. 'We were a group of friends, and it was like spending some sort of happy holiday on the banks of a beautiful river,' Renoir was later to declare. The film was shot during the summer of 1936. Bad weather and a variety of production problems caused shooting to be suspended, and Renoir abandoned the film. *Une partie de campagne* was not finally released until May 1946. In 1939 Cartier-Bresson worked as Renoir's assistant for the last time, on *La Règle du jeu* (The Rules of the Game), in which he made another brief appearance, this time as an English kitchen hand. The scene in question is the famous sequence at the servants' table in the château owned by La Chesnaye (the character played by Marcel Dalio). In a series of classic exchanges, Cartier-Bresson says two things – 'Voulez-vous me donner "le" moutarde' and 'Où il y a de la gêne, il n'y a pas de *pleasure*' – both in an excruciating English accent.

522 Shooting *Une partie de campagne,* left to right: Pierre Lestringuez, Henri Cartier-Bresson (centre, as a young priest), and Georges Bataille, 1936, photo Eli Lotar, D.R.

Between 1936 and 1939, the fate of nations trembled in the balance. Europe was living through a gathering storm, obliged to put behind it the euphoria of the Popular Front in France, and the victory of the Republicans in the elections to the Spanish legislature of February 1936, and confronting instead the outbreak of the Spanish Civil War, and the growing threat of German and Italian Fascism. Henri Cartier-Bresson launched himself into the political arena as a film-maker. If he was to witness events for himself, he needed to be on the front line, in Spain. He shot his first film in 1937, *Victoire de la vie* (Return to Life, 1938), listing himself in the credits as Henri Cartier. He made the film at the behest of the Centrale Sanitaire Internationale. The CSI had its headquarters in Paris, but there were branches in several European countries and in America. This was the time of mobilization, when people were being urged to go and fight for the Republican

523 Jacques Becker, Sylvia Bataille and Henri Cartier-Bresson in *Une partie de campagne* by Jean Renoir, 1936, photo Eli Lotar. D.R., courtesy of Galerie Françoise Paviot

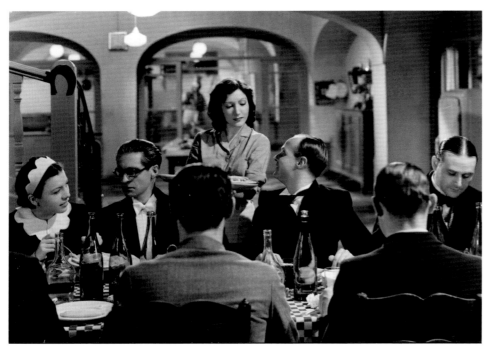

524 *La Règle du jeu* by Jean Renoir, scene at the servants' table, Henri Cartier-Bresson seen in back view, right, 1939, photo D.R.

525 Frame from the film *La Règle du jeu* by Jean Renoir, 1939, Bifi collection

cause. Funds needed to be raised to care for the sick and wounded. The opening shots of *Victoire de la vie* are of children playing in the streets of Madrid. They are luminous images, joyful almost, pacific in tone, recognizably in the style of Cartier-Bresson's photographs. Each shot is exuberant, beautifully composed, and with a sense of life captured in the raw. But the capital was living through desperate times. The city is shown desolate and in ruins. Queues of men, women and children wait for a little food in order to survive. The commentary by Pierre Unik is sombre: 'Madrid the martyr continues to live with the sound of gunfire.' The intention of the film was to demonstrate, with the aid of graphics and images, the strenuous efforts that had been made by Republican Spain to reduce the rate of infant mortality by opening childcare centres. In just a few years the mortality rate had fallen from 203 per 1000, in 1931 (the year the monarchy fell), to 63 per 1000, in September 1937. A succession of simple images – pregnant women in a dispensary, children being cared for, doctors and nurses at work – was intended to demonstrate how effective the policies of the Republican left had been. But that was not enough. The effort needed to be maintained in a time of civil war as the enemy bombs rained down: Cartier-Bresson filmed a factory which manufactured rolls of cotton for use by nurses and the sick. Inhabitants and the soldiers fighting on the front line also needed feeding: he filmed peasants farming, olive-picking, the harvest. *Victoire de la vie* was made to serve a just and legitimate cause to the best of its ability, and it did not hesitate to pull out all the stops in doing so. Hence the detail of the images, their almost palpable force. Hence the lyrical quality of the montage and the commentary, the better to convince the viewer of the efforts that needed to be made, and the aid that was required as Spain struggled for survival and freedom. There is an obvious debt to the Soviet documentary realism of the period. In all his shots, Cartier-Bresson emphasizes the geometry of straight lines and horizons, taking immense care with the framing and composition of the images. That is typical of the style of his films, which are characterized by their discipline, restraint and unostentatious elegance. With every shot it is apparent that the director knows how to keep just the right distance from the action, coming up close to the people he is filming, taking risks when up on the front line tracking the stretcher-bearers busy saving the wounded, lingering on faces or injured bodies.

There is a pervasive gentleness, a palpable sense of humanity, always watchful, always alert. It is clear that it is Spain itself that is wounded. A neighbour and a friend, the country must be healed, must be saved, and the film will do everything it can for this noble cause. Each shot makes that intention clear, sober in the extreme, yet imbued with a lyrical and poetic spirit. In one unforgettable scene a legless cripple drags himself to his bed in the hospital and a doctor helps him put on his splints. The man walks hesitatingly, a cigarette between his fingers, like an automaton. But he stays upright, dignified. The image is painful, but it is the metaphor of the film: if your purpose is to care and cure, you must be prepared to show the full horror.

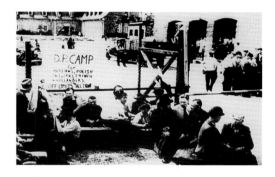

Henri Cartier-Bresson spent several months in Spain during the years of civil war. He made the decision to take no photographs while he was there but to concentrate exclusively on films. These would be his personal testimony. Later, he regretted not taking photographs, like his friend Robert Capa. Presumably he underestimated the time and energy required to make a film. He made his second film *L'Espagne vivra* under the name of Cartier. The commentary was written by Georges Sadoul, film historian and critic, a militant Communist and former member of the Surrealist group. He was also at the time Cartier-Bresson's brother-in-law. The film was commissioned by the Secours Populaire de France et des Colonies, an organization that worked closely with the Communist Party, collecting money, foodstuffs and clothes for the Spanish Republicans to support them in their struggle against Franco's rebel troops. In contrast to *Victoire de la vie*, the commentary (spoken by a female voice) played a central role. Its militant rhetoric dictated the rhythms of the film. The ultra-fast montage, with lots of short shots, was expressly designed to illustrate the points made by the propagandist commentary. The truthfulness of the individual images was subordinated to the wider truth of the militant discourse. The purpose was to provide concrete, tangible, physical, and of course political proof that a Fascist plot was brewing in Europe. This was at the time when the Western governments, meeting in London in August 1936, adopted the proposition put forward by Léon Blum's Socialist government and determined on a policy of non-intervention in Spain. With the aid of maps and pictures, the film set out to demonstrate the very real danger that Franco's rebel troops, supported by their German and Italian allies, would succeed in overthrowing the legitimate Spanish government. In the middle of the film, an astonishing sequence documents the interrogation of an Italian prisoner of war, in which details of the military alliance between Mussolini and Franco are revealed. In this, the only scene in the film to use synchronized sound, the existence of a Fascist conspiracy is described in the prisoner's own words: not only does the major part of the Spanish rebel troops' war equipment

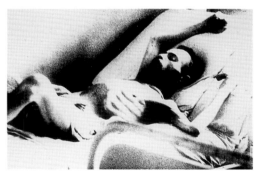

526, 527, 528 Frames from Henri Cartier-Bresson's film *Le Retour*, 1945, Bifi collection

come from Germany and Italy, so too do the military instructors. *L'Espagne vivra* is a politically motivated film, intended to foil the international conspiracy that threatened not only Republican Spain but the Western democracies as well. The last ten minutes of the film were devoted to demonstrating the active support provided for the Spanish Republicans by the Secours Populaire, who organized milk collections for the children, and arranged for money, foodstuffs and clothes to be brought to Spain by lorry and boat. Solidarity was the keynote. The role of the International Brigade was scarcely mentioned, although it was at just this time, in October 1937, that these democratic opponents of Fascism were leaving Spain – acting in good faith, deceived by the terms of the London agreement – even as tens of thousands of Italian soldiers continued to fight alongside Franco's troops.

529 Shooting the film *Southern Exposures*, left to right: Henri Cartier-Bresson, Walter Dombrow and Jimmy Murphy, 1970, photo Martine Franck, Magnum

In 1945, Cartier-Bresson returned to the cinema, directing a film on the liberation of prisoners of war in Germany and their slow and painful readjustment to freedom and normality. This was *Le Retour* (The Return). The subject matter was close to his heart as he was himself a former prisoner of war, number KG 845, held for over two years in a German prison camp, or *Stalag*, before escaping at the third attempt. The film was produced by Norma Ratner and the US Office of War Information, and was made in collaboration with officers of the American army and French ex-prisoners of war. Aided by cameramen from the film section of the American army, Cartier-Bresson assumed overall charge of photography, ably assisted by Captain G. Krimsky and Lieutenant Richard Banks. The shots at the end of the film were directed in Paris at the Gare d'Orsay by Claude Renoir, the film-maker's nephew. The commentary was written by Claude Roy, the music was by Robert Lannoy, performed under the direction of Roger Désormières. *Le Retour* is without doubt the film in which Cartier-Bresson invested the most of himself: his experiences as a prisoner of war make themselves felt in every single shot and scene. The prisoners' predicament is described in great detail. The film starts with archive footage of prisoners working in German camps. This is followed by images of the fighting, seen from the point of view of the Allies. There are then shots of captured German soldiers. Victory is celebrated, the camps are liberated, the crowds hail the forces of liberation. A splendid high-angle tracking shot, taken from the top of a jeep, sweeps across the crowd of delirious prisoners as they clap the

530 Walter Dombrow and Henri Cartier-Bresson during the shooting of *Southern Exposures*, 1970, photo Martine Franck, Magnum

soldiers on the back in gratitude. What is so striking about *Le Retour* is its power to get inside its subject matter. In contrast to *L'Espagne vivra*, the commentary does not dictate the meaning of the images; here it is the images themselves that touch us, bold, intense, sometimes almost intolerable: cadaverous figures of the living dead, hollow faces, skeletal bodies, the beseeching, bewildered looks of men who seem not to have the strength or will to learn how to live again. Many no longer have the strength even to walk, still less haul themselves onto the American army lorries. The film makes plain their distress, their abject mental and physical condition. Then comes the slow and difficult process of readjustment. There are some particularly powerful scenes, such as when, in Dachau, a freed prisoner recognizes his former jailer and torturer and, unable to contain his hatred, strikes him in the face; or when the defeated German soldiers make a pile of all the keys belonging to the liberated camps. Even in victory, death continues to do its work. The sick need immediate care, typhus and cholera have to be combated. Men, women and children queue up to be disinfected with DDT powder. Vigilance is required to identify Gestapo agents and torturers passing themselves off as ordinary prisoners. The military police take charge and winkle out a couple of traitors, whose long faces speak volumes. A group of women are being cross-examined: one, dressed from head to toe in black, recognizes the woman who betrayed her to the Gestapo; unable to help herself, she hits her full in the face. Cartier-Bresson also took a photograph of this scene which is virtually identical to the filmed shot in respect of focal length and composition. The power both of the photograph, regarded as one of the high points of Cartier-Bresson's oeuvre, and of the cinema shot, derives in large measure from the unposed quality of the scene, which looks like an accident of the real world. With the unflinching filming of a punch, with an image that is a snapshot of reality, photography and film come together within a single focus.

531 Henri Cartier-Bresson and Jean Boffety, *Impressions of California*, 1969, photo D.R.

Le Retour tells the story of the long months during which millions of men from all over Europe clog the roads of Germany, crossing rivers, walking for miles as they try to regain their homeland. The massive exodus actually impedes the advance of the Allied troops. Some sort of administration is needed to impose order, and temporary centres of reclassification and repatriation are set up. The prisoners elect their delegates by nationality, interpreters are brought in, and a chain of command is established. Eventually the railwaymen get the trains back in service. They are, as the commentary says, 'trains of joy'. Repatriation is effected by every means possible. Between 10 April and 20 May 1945, the Americans organize a massive airlift. But people have to be patient before they can climb into a plane, often for the first time in their lives, and fly back to their native lands. There are wonderful aerial views of Paris, first Notre-Dame, then the Eiffel Tower. The scenes at the Gare d'Orsay are extraordinary: everyone is searching for someone, hoping to be

reunited with a loved one. Their expressions reveal their hopes and fears. People cry, hug one another, they are overcome with joy, and everyone says 'Never again!'.

In 1969, Henri Cartier-Bresson directed two documentaries for the American TV company CBS News. These were *Impressions of California* and *Southern Exposures*. This time there was no voiceover or commentary. Shot using synchronized sound and in colour, each film lasted approximately 23 minutes. Christine Ockrent was working at the time for CBS News, and she did the preliminary research. *Impressions of California* and *Southern Exposures* are travel diaries, filmed essays that achieve their effects through montage and the intrinsic power of the individual shots and scenes. Cartier-Bresson made extensive use of close-ups of people's faces, and he allowed the camera to zoom in and linger over their bodies as well; the screen is filled with movement, singing, dancing, gesticulation, and at one point figures in a state of trance. In these mosaic-like pieces, his intention was to paint a picture of the America of the late sixties, when the Vietnam War was at its height: *Impressions of California* has footage of a huge anti-war demonstration. This was also the era of the bitter struggles of the black minorities to achieve their civil rights: the black pastor in *Southern Exposures* preaches a sermon about the assassinations of Martin Luther King and Robert Kennedy. America was a deeply divided country at this time. On the one hand there was economic prosperity and well-being (California); on the other hand there was apartheid, poverty and racism, and blacks were denied their legitimate rights (the Southern States). Cartier-Bresson allowed his eye to roam freely, and often ironically, over such folksy elements of American life as its choral societies, the drilling of drum majorettes, charity committees, religious rituals, the cult of sport, and psychotherapy sessions.

At the beginning of *Southern Exposures*, blues music accompanies images of the South in and around Maryland. A short tracking shot reveals the poor housing in which black families eke out a meagre existence; a few close-ups on the faces suffice to convey the tone of the film, which is more poetic than realist. What is striking is the speed with which Cartier-Bresson inhabits a landscape and isolates its key points. In just a few shots from real life, he manages, through a series of impressionistic touches, to describe a whole human condition, homing in on areas of tension and conflict. There is nothing in the least bit touristy about these two American films. They are the work of an inspired traveller, someone who is free of all preconceptions, and who has the ability to capture the decisive moment, or moment of truth, the ability to capture the twists and turns of events as they rise to a climax. There are two scenes in particular that are pure cinema. In *Impressions of California*, there is the extraordinary psychotherapy session in which we see a couple

532 Henri Cartier-Bresson, *Southern Exposures*, 1970, photo Martine Franck, Magnum

fighting, watched by the therapist who urges them on. The man and woman roll on the ground, now one has the upper hand, now the other. After a while the man is red in the face, incapable of continuing; he starts to cry, his wife holds his hands, comforts him and addresses him tenderly. Hostility melts away in a moment of hysteria, and the language of love is restored. There is also the scene at the end of *Southern Exposures* which shows a group of women being worked up into a trance-like state by an obese preacher who has them in the palm of his hand. In such mystic rituals, people are transported out of themselves. Cartier-Bresson films these moments of great intensity without the slightest hint of voyeurism. He concentrates on what is happening, disappearing behind the camera and allowing each scene to build to its climax. His purpose is not to pass judgment but to bear witness. There could scarcely be a better definition of film.

We may say in conclusion that Henri Cartier-Bresson made his few films because he wanted to experience the real world by means other than photography. Film is a cocktail of montage and movement, and it is from this heady mixture that the rhythm and significance of shots and images derive. As in his photographic work, Cartier-Bresson demonstrates an extraordinary compositional sense. Exploiting light and shade, manipulating perspective, his eye seems always on the lookout for the clarity that accompanies the moment of truth.

Serge Toubiana is a film critic with *Cahiers du Cinéma*

533 Henri Cartier-Bresson, *Southern Exposures,* 1970, photo Martine Franck, Magnum

FILMOGRAPHY

Henri Cartier-Bresson was second assistant director to Jean Renoir in 1936 for *La vie est à nous* and *Une partie de campagne,* and in 1939 for *La Règle du jeu.*

Films directed by Henri Cartier-Bresson

1937. *Victoire de la vie.* Documentary on the hospitals of Republican Spain. Director: Henri Cartier, with Herbert Kline. Produced by the Centrale Sanitaire Internationale. Photography: Jacques Lemare. Music: Charles Kœchlin. Commentary: Pierre Unik. Editing: Laura Sejour. Graphics: Griffoul. Running time: 49 minutes. Black and white.

1938. *L'Espagne vivra.* Documentary on the Spanish Civil War and the post-war period. Director: Henri Cartier-Bresson. Produced by the Secours Populaire de France et des Colonies. Editing: Ibéria. Graphics: Griffoul. Commentary: Georges Sadoul. Musical arrangement: J.-C. Simon. Spanish songs recorded by Le Chant du monde. Distributed by Les Films Populaires. This film has been restored by the French Ministry of Culture and the film archives of the Centre National du Cinema. Running time: 43 minutes and 32 seconds. Black and white.

1944-1945. *Le Retour.* Documentary on prisoners of war and detainees. Production: U.S. Army Signal Corps, Captain G. Krimsky and Office of War Information (OWI), Norma Ratner. Technical advisor: Henri Cartier-Bresson (Stalag VC), with the assistance of Lieutenant Richard Banks. Commentary: Claude Roy (Stalag Etain). Music: Robert Lannoy; (Stalag XIII B), orchestrated by Roger Désormières. Scenes filmed at the Gare d'Orsay: Henri Cartier-Bresson, assisted by Claude Renoir. Running time: 32 minutes and 37 seconds. Black and white.

1969-1970. *Impressions of California.* Director: Henri Cartier-Bresson. Producer: William McCure for CBS News. Production: Peter Callam, John Mayer, Judy Osgood. Executive producer: Burton Benjamin. Research: Christine Ockrent. Photography: Jean Boffety and Henri Cartier-Bresson. Sound: Michael Lax. Editing: Jules Laventhol. Running time: 23 minutes and 20 seconds. Colour.

1969-1970. *Southern Exposures.* Director: Henri Cartier-Bresson. Producer: William McCure for CBS News. Production: Jimmy Murphy, Ross Williams, Martine Franck and John Hockenberry. Executive producer: Burton Benjamin. Research: Christine Ockrent. Photography: Walter Dombrow and Henri Cartier-Bresson. Editing: Peter Callam. Sound: Harry Gianneschi. Running time: 22 minutes and 25 seconds. Colour.

Films compiled from photographs by Henri Cartier-Bresson

1956. *A travers le monde avec Henri Cartier-Bresson.* Directed by Jean-Marie Drot and Henri Cartier-Bresson. Running time: 21 minutes. Black and white.

1963. *Midlands at Play and at Work.* Produced by ABC Television, London. Running time: 19 minutes. Black and white.

1963-65. Five fifteen-minute films on Germany for the Süddeutscher Rundfunk, Munich.

1967. *Flagrants délits.* Directed by Robert Delpire. Original score by Diego Masson. Delpire production, Paris. Running time: 22 minutes. Black and white.

1969. *Le Québec vu par Cartier-Bresson/Quebec as seen by Cartier-Bresson.* Directed by Wolff Kœnig. Produced by the Canadian Film Board. Running time: 10 minutes. Black and white.

1970. *Images de France.* Film by Liliane de Kermadec for the ORTF Unité Trois Production.

1991. *Contre l'oubli : Lettre à Mamadou Bâ, Mauritanie.* Short film directed by Martine Franck for Amnesty International. Editing : Roger Ikhlef. Running time : 3 minutes. Black and white.

1992. *Henri Cartier-Bresson dessins et photos.* Director : Anick Alexandre. Short film produced by FR3 Dijon, commentary by the artist. Running time : 2 minutes and 33 seconds. Colour.

1997. *L'Araignée d'amour,* from the series '100 photos du siècle', broadcast by Arte. Produced by Capa Télévision. Running time : 6 minutes and 15 seconds. Colour.

Films about Henri Cartier-Bresson

N. D. *Henri Cartier-Bresson.* Directed by Gjon Mili. Running time : 2 minutes and 44 seconds. Black and white.

N.D. *Primo Piano.* Directed by Carlo Tuzii in collaboration with Romeo Martinez. Running time : 52 minutes. Black and white.

1962. *L'Aventure moderne : Henri Cartier-Bresson.* Directed by Roger Kahane. Broadcast by Jean Bardin and Bernard Hubrenne. Production : ORTF Running time : 29 minutes. Black and white.

1994. *H.C.B. Point d'interrogation ?* A film directed by Sarah Moon. Take Five Production. French and English version. Running time : 38 minutes. Black and white.

1994. *Contacts : Henri Cartier-Bresson.* Film compiled from photographs, Robert Delpire, Centre National de la Photographie, Paris. Production : KS Vision. Running time : 15 minutes. Colour.

1997. *La Conversation.* Interview with Laure Adler, France. Prodution : France 3. Running time : 64 minutes. Colour.

1998. *Pen, Brush and Camera.* Directed by Patricia Wheatley. Production : BBC. Running time : 50 minutes. Colour.

1999. Interview with Charlie Rose for the series '60 minutes'. Production : CBS. Running time : 55 minutes. Colour.

1999. *Le XXᵉ siècle a vécu avec la photographie : conversation avec Henri Cartier-Bresson.* Produced by NHK (cycle ETV Culture TV). Running time : 60 minutes. In Japanese. Colour.

2001. *Henri Cartier-Bresson : L'amour tout court,* from the series 'Profils'. Directed by Raphaël O'Byrne. Produced by Film à Lou. Broadcast by Arte. Running time : 70 minutes. Colour.

2003. *Henri Cartier-Bresson Biographie d'un regard.* A film by Heinz Bütler with Robert Delpire, Elliot Erwitt, Isabelle Huppert, Josef Koudelka, Arthur Miller and Ferdinando Scianna. Co-production : Fondation Henri Cartier-Bresson and NZZ Neue Zurcher Zeitung. Colour.

Audio production

Henri Cartier-Bresson : Le bon plaisir. FNAC/France Culture, Paris.

Left: Frames from the film *Victoire de la vie*
This page: Frames from the film *Le Retour*

The Public Eye: Shows and Exhibitions

Philippe Arbaïzar *Bibliothèque Nationale de France*

An exhibition is an ephemeral event. When it is over all that remains is a catalogue, a list of exhibits, a few memories. The essential is lost. Yet Cartier-Bresson regarded it as the best way of presenting his work to the public; while magazines could guarantee the wide distribution of his photographs, there were always strings attached, and books could not provide the scope the artist required. With a personal show, on the other hand, the artist was a free agent and it was there that his work was judged. Henri Cartier-Bresson always took great pains with his exhibitions, and it was often while working on them that he would refine his work. Three great moments stand out in the history of his one-man shows, each associated with a particular personality. It all began with the owner of a New York gallery, Julien Levy, and then with Beaumont Newhall who masterminded the exhibition at MOMA. Twice the initiative came from the US, but in the post-war period it was Robert Delpire in France who curated the great exhibitions that travelled the world and brought Cartier-Bresson international fame.

A crucial encounter: Julien Levy

Prompted by artistic curiosity, the young Cartier-Bresson immersed himself in the artistic scene of the late twenties, meeting Louis Aragon, René Crevel, Max Ernst and the poet and publisher Harry Crosby, an American living in France. It was at Crosby's home that Cartier-Bresson first got to know Julien Levy, a connoisseur of the arts whose enthusiasm for Surrealism matched his own. His gratitude to his two American friends was enduring, and many years later he was to say he owed his fame to them.[1]

The Julien Levy Gallery

Back in New York, Julien Levy opened a gallery in 1931. There he introduced Max Ernst to the public in 1932, Salvador Dali in 1933… and Henri Cartier-Bresson. In putting on an exhibition of his work, he was not only giving a young photographer his chance, but was also distancing himself from the dynasty of artists promoted by Stieglitz and his gallery 291. Although the great age of Stieglitz was over, his influence lived on. His aesthetic and gallery were reference

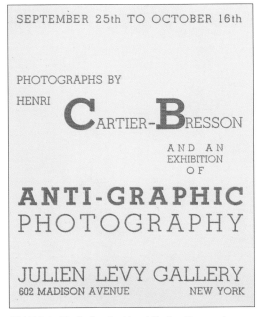

SEPTEMBER 25th TO OCTOBER 16th

PHOTOGRAPHS BY

HENRI **CARTIER-BRESSON**

AND AN
EXHIBITION
OF

ANTI-GRAPHIC
PHOTOGRAPHY

JULIEN LEVY GALLERY
602 MADISON AVENUE NEW YORK

534 Printed invitation for Henri Cartier-Bresson's first exhibition at the Julien Levy Gallery, New York, 1933

535 Envelope addressed to Henri Cartier-Bresson in Spain enclosing the invitation from the Julien Levy Gallery in New York, 1933

536 Invitation to the joint exhibition at the Julien Levy Gallery, New York, 1935

points which could not be ignored, so much so that Cartier-Bresson dubbed Stieglitz 'the father of us all'.[2]

Stieglitz was meticulous in his presentation of photography, for which he used lighting designed originally for graphic art. The colour of the walls toned perfectly with the values of the silver prints. The gallery's programme did not concentrate exclusively on photography but included other arts as well. Julien Levy also alternated photography with other art forms, the paintings of Massimo Campigli following on the heels of the gallery's inaugural exhibition of American photography. And in early 1932, an exhibition of Surrealist art brought together paintings, drawings and photographs. Contemporary documents indicate that the works were displayed according to much the same principles as at the gallery 291. Bare walls set off the framed photographs, which were presented separately, as individual works in their own right. There could be no mistaking the gallery's artistic orientation.

What is an 'anti-graphic' exhibition?

On 25 September 1933 Cartier-Bresson's exhibition opened for one month. In the thirties New York was beginning to demonstrate its ability to attract new talent. By entitling his exhibition 'Photographs by Henri Cartier-Bresson : Anti-graphic Photography', Julien Levy was effectively making a manifesto statement, which was expanded upon in the text of the printed invitation. Under the pseudonym of Peter Lloyd, Levy stressed Cartier-Bresson's originality. Given that the photographer himself was averse to theoretical pronouncements, the public needed to be primed in advance so they would not misinterpret his work. As a way of illustrating what Cartier-Bresson was about, Levy compared him to Chaplin, who had always filmed his movies in a very plain style. Compared with what Hollywood was producing at the time, this style seemed inferior; but then, the soft light that suited Garbo's beauty would not have been right for the comic figure of Charlie Chaplin. In the same way, people were not to be misled into comparing Cartier-Bresson with the great 'S's of American photography, Stieglitz, Sheeler and Strand, with their polished style. Julien Levy reinforced his point by including a section devoted to agency photos, snapshots and run-of-the-mill prints, even if their beauty was only a result of chance.[3] What they all had in common was the sheer power of the raw document. All were ambiguous, ambivalent, anti-plastic, and *anti-graphic*.

Having previously exhibited Stieglitz, Strand and Weston, now, with Cartier-Bresson, Julien Levy was promoting a completely different creative ethos. A new chapter was opening in a history henceforth dominated by the formalist aesthetic of Stieglitz, Sheeler and Strand. The combination of everyday images with artistic creations had already been done by *Film und Foto*,

and a few years before that by Kirstein in an exhibition staged by the Harvard Society for Contemporary Art. But the documentary content, the ordinary scenes of everyday life captured by Henri Cartier-Bresson were disturbing to an audience more accustomed to the perfection of Stieglitz or Strand and their abstract tendencies. Julien Levy's anti-graphism was something very different, much more in the documentary tradition of Abbot, Atget and Evans. Cartier-Bresson, however, retained his originality by working exclusively in small formats. His technique was very different from the more studied approach associated with large formats, where the composition was plotted in advance. Henri Cartier-Bresson improvised, incorporating the effects of chance and accident as he went along. He belonged to another world altogether.

Madrid and Mexico

A few weeks after his New York exhibition, Cartier-Bresson had a show in Madrid at the Ateneo club. A photograph in a contemporary newspaper (*Ahora*, 29 November 1933) shows the young photographer with his prints in the background securely framed and mounted under glass. It is likely that this Madrid show, which pronounced itself 'anti-graphic', was the work of Julien Levy, although there is no actual proof the same prints were used. Again in 'anti-graphic' mode, Cartier-Bresson featured in an exhibition in Mexico with Manuel Alvarez Bravo. That was before Alvarez Bravo met André Breton, when he was still photographing scenes of everyday life in Mexico, such as the child urinating in a basin. The two photographers shared the same crudity of approach. Both knew how to juxtapose warring elements. Cartier-Bresson's classicism and the rigour of his composition were not to be acknowledged until later, when the content of his work became less confrontational. The exhibition held in New York from 23 April to 7 May 1935 at Julien Levy's gallery completed this cycle, bringing together works by Alvarez Bravo, Cartier-Bresson and Walker Evans.

Meanwhile in Paris

Although he was absent from Paris for a long time, Cartier-Bresson remained in touch with his contacts there. Charles Peignot's journal *Photographie* published a number of his prints. Thanks to Louis Aragon, he also worked for the magazines *Ce soir* and *Regards*, an engagement that connected him with the exhibition 'Documents sur la vie sociale' staged by the Association of Revolutionary Writers and Artists at the Galerie de la Pléiade in 1935.[4] The following year, the same gallery showed one of his Mexican reportages, alongside photographs of Russia by Rosie Ney and Spain by Eli Lotar.

537 Invitation to the exhibition at the Palacio de Bellas Artes in Mexico, with Manuel Alvarez Bravo, 1935

538 Henri Cartier-Bresson standing in front of a display of his photographs at the Ateneo Club in Madrid, 1933, photo D.R.

539, 540 Scrap Book, compiled for the 'posthumous' exhibition at MOMA in 1947, cover and inside pages

As well as pursuing this more social and militant strand of his work, Cartier-Bresson also worked for Tériade and featured in the first issue of *Verve* (1937). This was a world much more in tune with the options available to Julien Levy on the other side of the Atlantic. Cartier-Bresson occupied a curious position, hovering between art and documentary, and between two continents: in New York he exhibited in a major gallery, while in Paris he featured in shows mounted by politically committed groups. By maintaining his direction, he was able to guarantee his freedom and to develop a new form of photographic art.

The posthumous exhibition

Henri Cartier-Bresson was caught up in the horrors of war. Having no news of him, people in the United States believed he was dead. On the strength of this rumour, Nancy Newhall came up with the idea of organizing an exhibition at the Museum of Modern Art in New York to pay homage to the French photographer who had featured in the retrospective staged by her husband at MOMA in 1937. While trying to trace prints owned by Cartier-Bresson's friends, Nancy Newhall learned the truth: Cartier-Bresson was alive, but held prisoner in Germany. For the time being, the best option was to put the whole idea into cold storage; the presence of photographs by Cartier-Bresson in the left-wing press, and the nature of the artist's views, suggested that discretion was required. Nancy Newhall therefore waited until the war was over to make contact with Henri Cartier-Bresson and tell him of her plans. Once again fortune smiled on the French photographer from the other side of the Atlantic. In 1945, Beaumont Newhall was released from the army and was able to start work on the new exhibition.

A review of the complete works

Originally the exhibition was to be made up exclusively of existing prints, but as soon as Cartier-Bresson learned what was planned, he threw himself into the project wholeheartedly and began to search through his old contact sheets. He also wanted his new photographs to be included, and at once set about making a selection to send to Beaumont Newhall. In a France that was beset by shortages, he had to ask for paper to make some small prints. These 9 × 12 cm (3½ × 4¾ in) exposures he arranged in a thick album with a stout leather cover. This Scrap Book (as it was titled on the cover) formed the basis for the show.

Beaumont Newhall, for his part, had hit a few snags, notably a delay in scheduling the exhibition and making a space available. He had to remind his superiors that Cartier-Bresson's work was just as important as Weston's or Strand's. He went so far as to predict that Cartier-Bresson's

ideas would change the face of American photography.[5] The Scrap Book contained some 150 to 200 pictures; a large exhibition space was needed to show not only the off-the-cuff portraits of Bonnard, Matisse and others, but also the photographs originally exhibited by Julien Levy in the thirties, which, according to Cartier-Bresson, formed 'a whole with the recent ones'.[6] A lot had happened since the thirties, a whole world had collapsed and a new era had begun, but it was important to show the link between the two periods.

Mounting an exhibition

By 1946, the exhibition had been scheduled. Cartier-Bresson was due to start printing the proofs, but lack of paper and the distances involved made this task difficult, so the decision was taken to transfer all the preparations for the exhibition to New York. Henri Cartier-Bresson was thus freed of a task he had never really enjoyed. It was also decided not to use any of the existing proofs, but to make new ones, under Henri's overall control.[7]

Gradually the formula evolved that was to set the standard for the future: the exhibition was an original creation, complete in its own right, and was an opportunity to revisit Cartier-Bresson's oeuvre, not merely an assembly of the proofs already in existence.

Design and layout

The exhibition opened on 4 February 1947. It consisted of 163 photographs, divided into 18 sections that corresponded to the different reportages, arranged in no particular chronological order. Headings indicated the broad themes: Spain, France, Mexico, Italy, San Gennaro, New Orleans, Sunday on the Banks of the Marne, Brooklyn, Bonnard at Le Cannet, Matisse in Vence, Pablo Picasso, Georges Rouault, Wine Growers, the Coronation of George VI in London, Hyde Park…. But the images extended beyond their individual themes. Black or white panels were used to group the pictures together and impose a pattern on the visual display. Written information was kept to a minimum. The museum had supplied brief titles, and an introduction explained that the photos were, above all, personal testimonies. For the man who made them, the mind, the heart, the eye, and the hand counted for more than the camera. The pictures were conceived in the fraction of a second it took him to shoot them with his small-format camera. His innate instinct for composition derived from his experience as a painter.

The exhibition was clearly laid out and skilfully designed, but according to very different principles from those that governed the original show by Julien Levy. Here there were no frames and no glass. The prints were simply mounted and then attached to panels. The idea was to

541, 542 Inside pages of the Scrap Book

avoid anything at all precious. The aim was rather for natural progressions between the images, and an overall harmony between the various different formats.

Coming after the Walker Evans show as it did, the exhibition was highly significant, marking MOMA's recognition of a great photographer. Lincoln Kirstein could not hide his enthusiasm for such a thought-provoking body of work, of such great documentary and human value. The occasion was also significant in that it was during the preparations for the show that Cartier-Bresson devised the formula that suited him best, which he was to develop further with the aid of colleagues.

Encounters

Henri Cartier-Bresson never concealed his lack of enthusiasm for working in the darkroom, so he was happy to find in Pierre Gassmann the future interpreter of his images. He could now devote himself exclusively to the actual process of taking photographs – and by now Magnum Photos was bringing him in a lot of work. Another friend who was to play a decisive role in his life was Robert Delpire. To him Cartier-Bresson entrusted all his publishing projects of any substance, as well as the organization of all his future exhibitions, with the exception of those at MOMA.

The Pavillon de Marsan exhibition

In his introduction to this exhibition, Henri Cartier-Bresson offered some important insights into his approach to the presentation of his photographs. The exhibition gave him the opportunity to update his selection of works, as he had done with the Scrap Book, while the sequence of images chosen needed to recreate the artistic, political and human emotions in play at the time the photographs were taken. The panels were designed to ensure the sequences remained as he had envisaged them, wherever the exhibition was subsequently staged.

In *Photo-Ciné Magazine* (December 1955), Lucien Lorelle contributed a detailed description of the exhibition in just a few lines: 'The prints... are of very fine quality, relying on an overall tonality a half-tone down from the dark black we are accustomed to with glossy paper. The proofs are stuck to a piece of card a few millimetres thick, the edges left raw. The card that forms the relief is itself stuck to a light grey panel of 1.5 to 2 metres. Each panel benefits from a layout that is deceptively simple, but which the careful observer can see has been subtly contrived.'

The exhibition lined up 375 photos, more than double the number (163) in the Beaumont Newhall show. The quantity was justified on the grounds that '*it is through accumulation that chance is forced to operate*:[8] a great profusion of images and not just a few successes ought to bear the stamp

543 Pierre Gassmann and Henri Cartier-Bresson at a picture hanging, 1967, photo D.R.

of the man and so serve to illustrate a particular cast of mind'. In this way, the exhibition took on the appearance of a vast fresco.

The construction of the oeuvre

Henri Cartier-Bresson's cosmopolitanism may have been one reason why his exhibitions travelled all over the world. That was a major enterprise in itself: travel arrangements had to be coordinated and the fabric of the exhibition had to be maintained; Cartier-Bresson would ensure the presentation was perfect, and he made any necessary revisions, as when the exhibition at the Pavillon de Marsan was redesigned for IBM and he delved into his back catalogue to make modifications, replacing a portrait of Bonnard, for example, with one of R. H. Oppenheimer. The show became the place where the work was constructed. The exhibition at the Pavillon de Marsan ran until 1960, and with several other major exhibitions following on its heels, Henri Cartier-Bresson developed into a veritable ambassador for French culture.

544 Pierre Gassmann and Henri Cartier-Bresson at a picture hanging, 1967, photo D.R.

A second exhibition at MOMA in 1968

Over the years MOMA had remained faithful to Cartier-Bresson, and in 1968 John Szarkowski put on a show of his most recent work. Reverting to the pre-war formula, the proofs were mounted and framed under glass. The selection incorporated works from the museum's own collections. A limited retrospective of 26 pictures taken between 1929 and 1950 accompanied the more recent portraits and landscapes. Some years later, Peter Galassi was to adopt the same approach for his study of Cartier-Bresson's early photographs, laying special emphasis on the differences between the works of the thirties and those of the post-war period.

Exhibiting drawings, reviewing the archives

In 1975 Henri Cartier-Bresson showed his drawings in public for the first time. By now he was casual about the whole business of photography. Pierre de Fenoyl, who had seen the sheer volume of work Cartier-Bresson faced at Magnum Photos, suspected his attitude was the result of the pressure of his obligations.[9]

With his new emphasis on drawing, Cartier-Bresson inaugurated a whole new cycle of exhibitions. Meanwhile, the exhibitions of photographs continued to do the rounds. They were the work of Delpire, and were often linked to the publication of a book. The photographer and his editor have enjoyed a long working relationship based on mutual trust: the former choosing the pictures and the latter deciding how they would be displayed and which formats would be used.

Delpire respected the spirit of the work. His exhibitions did not follow chronological order, nor were they organized by theme or by geography. He concentrated rather on the style and the images, an approach that gradually began to prevail over the documentary interpretation originally favoured by Julien Levy. In *Le Monde* of 30 October 1980, Hervé Guibert paid homage to Robert Delpire's work, stressing 'the dynamic intelligence' of the hanging. He would set up an interplay between the images, so that a narrative began to emerge as you moved from one to the other; as stories began and ended, so the century's past was brought to life. Old contact sheets produced a host of new prints to add to the 150 to 200 works that constituted the essential core of his oeuvre, a figure that had remained relatively stable since the seventies. But the boundaries of this vast body of work remain fluid, the precise selection having varied over the years. High time, one might think, for a definitive catalogue.

From the very first exhibition at Julien Levy's gallery to the most recent, nothing has changed as regards Cartier-Bresson's fundamental belief that a photograph exists in the moment it is taken. It is there in just that fraction of a second. Exhibitions, newspapers, and books subsequently give life to the negative image, but a Cartier-Bresson photograph does not rely for its existence on its physical manifestation, any more than a novel relies for its existence on the paper on which it is printed. While a photograph is given substance in an exhibition, it also possesses a spiritual dimension that liberates it from its material form. The passage of time militates in any case against any such classical ideal, as the different editions of the prints retain the traces not only of their individual evolution and aspirations but also of collective influences. Exhibitions that once seemed to be ephemeral constructs become precious documents in the history of photography. All the proofs have to be preserved as evidence. Once the works have been exhibited and the creative process is complete, then comes the time for them to be catalogued and for an inventory of all the proofs to be made. Henri Cartier-Bresson used to make long lists of the photographs that constituted the core of his oeuvre; now new lists are being drawn up to describe it in its entirety.

545 André Malraux, Minister of Culture, opening the Cartier-Bresson exhibition at the Musée des Arts Décoratifs, Paris, 1966, photo René Burri, Magnum

546 'Hommage à Henri Cartier-Bresson', exhibition at the Palais de Tokyo, Paris, 1988, photo Bernard Baudin, D.R.

Philippe Arbaïzar is a Curator at the Bibliothèque Nationale de France

547 Exhibition 'Hommage à Henri Cartier-Bresson', Palais de Tokyo, Paris, 1988, photo Bernard Baudin, D.R.

1. *Le Monde*, 30 October 1980.
2. Interview with Norman in the *New York Post*, 26 August 1946, in which Cartier-Bresson expresses his admiration for Steichen, Evans and Weston.
3. As we shall see below, Henri Cartier-Bresson regarded the exhibiting of a large number of photographs as a way of demonstrating that his success owed nothing to chance, it being repeated too often.
4. Artists appearing in this exhibition: Y. Allégret, J.-A. Boiffard, P. Boucher, Brassaï, Y. Chevalier, Chim, J. Heartfield, A. Kertész, G. Krull, P. Lemare, R. Livet, E. Lotar, E. Makovska, Man Ray, J. Moral, Papillon, R. Parry, W. Ronis, H. Tracol, R. Zuber.
5. According to a note written by Beaumont Newhall in the archives of the Fondation Henri Cartier-Bresson.
6. Letter from Cartier-Bresson to Beaumont Newhall (21 January 1946) in the archives of the Fondation Henri Cartier-Bresson.
7. The enlargements were made by Ilse Northman of Leco Photo Service, with the exception of six large prints made by John Bacco of Lenscraft Studios.
8. My emphasis.
9 Interview with Anne Baldassari in *Cahiers de la photographie* n°18, 1986, special issue on Henri Cartier-Bresson, pp. 77–82.

'Memory, memory, what do you want of me?'
Verlaine

'Who knows but someday this, too, will be remembered with pleasure!'
Virgil

548 Henri Cartier-Bresson with his granddaughter Natasha and a portrait of his mother, 2002. Photo Martine Franck, Magnum

549 The Le Verdier grandparents, centre, with members of the family

551 Henri's parents Marthe and André Cartier-Bresson

550 Marthe Cartier-Bresson and her children Henri, left, and Denise, right, 1910

553 Marthe Cartier-Bresson with Henri, Jacqueline and Denise, 1912

552 Henri and his parents at the family home in Fontenelle, 1909

555 Chanteloup, Seine-et-Marne, France, 1915

556 One of Henri's first portraits of his sister Nicole, 1931

554 Chanteloup, Henri (right) with his sisters Denise and Jacqueline and brother Claude, c. 1922

557 Henri Cartier-Bresson, c. 1914

558 Henri, in the foreground, with his camera

559 *c.* 1920

560 1924

561 Ecole Fénelon, Paris 1918–1919, Henri Cartier-Bresson, in the foreground to the right of the teacher

562 Henri Cartier-Bresson, in the foreground to the right of the priest

563 1924

564 Henri Cartier-Bresson, in the foreground, far right

565 Henri Cartier-Bresson, back row, far right, Ecole Fénelon, Paris, 1923–24

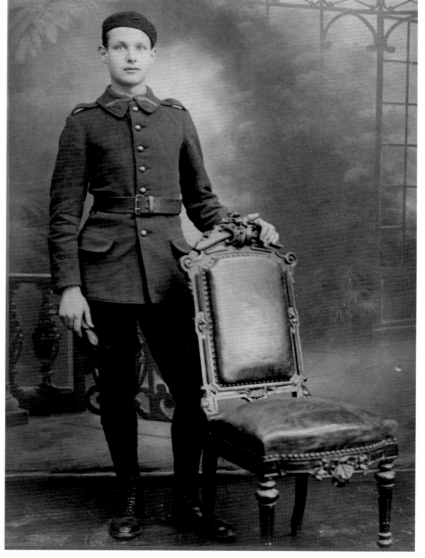

566 Corporal Cartier-Bresson, doing his military service, 1926

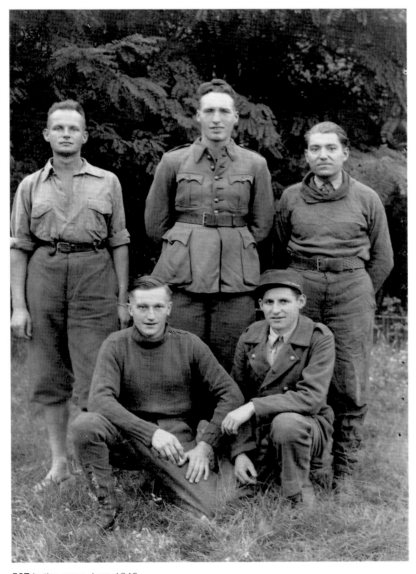

567 In the army, June 1940

568 In the army, June 1940

569 Henri Cartier-Bresson as a prisoner in a German camp, 1943

570 Henri Cartier-Bresson in the foreground, far left, doing his military service at Le Bourget, 1926

572 Henri, far left, 1940

571 Henri as a German prisoner, far right, June 1940

573 New York, 1935, photo Beaumont Newhall, D.R.

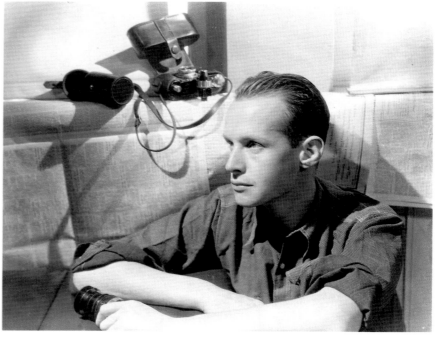

574 New York, 1935, photo George Hoyningen-Huene, D.R.

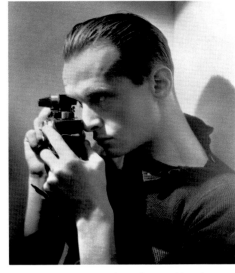

577 New York, 1935, photo George Hoyningen-Huene, D.R.

576 Photo Dimitri Kessel, D.R.

575 New York, 1935, photo George Platt Lynes, D.R.

578 Henri and his first wife, Ratna Mohini, in China, 1949, taken with Henri Cartier-Bresson's camera, D.R.

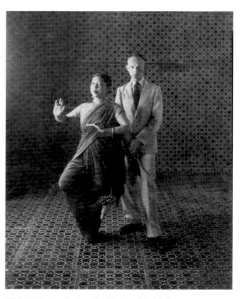

580 With his first wife, Ratna Mohini, New York, 1946, photo Irving Penn, courtesy of Condé Nast Inc.

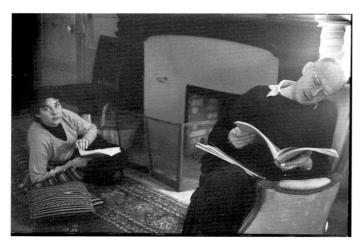

579 With his sister Nicole in Paris, 1959, taken with Henri Cartier-Bresson's camera, D.R.

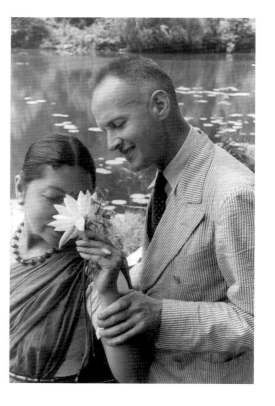

581 With Ratna Mohini, New York, 1946, photo Edward Steichen, taken with Henri Cartier-Bresson's camera, D.R.

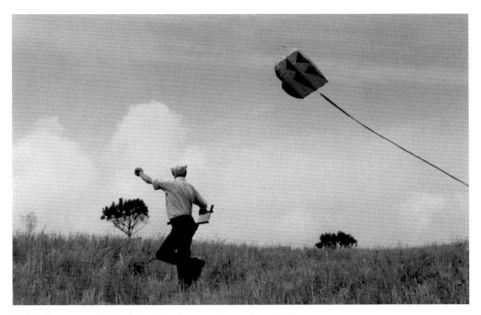

583 In Provence, 1987, photo John Loengard, courtesy of *Life*

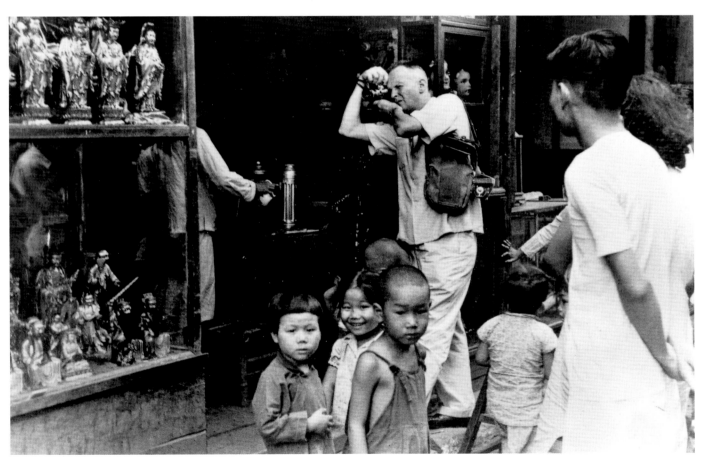

582 China, 1949, photo Sam Tata, D.R.

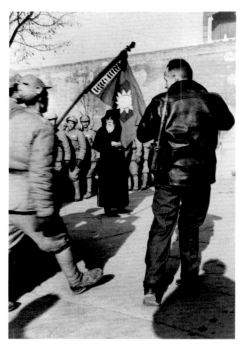

584 Last days of the Kuomintang, Shanghai, 1949, photo D.R.

587 Paris, 1961, photo Dan Budnik, D.R.

588 Cuba, 1963, photo René Burri, Magnum

585 Henri Cartier-Bresson with Rosellina Bischof-Burri, 1956, photo René Burri, Magnum

586 Henri Cartier-Bresson with Ferdinando Scianna in Bagheria, Sicily, 1986, photo Martine Franck, Magnum

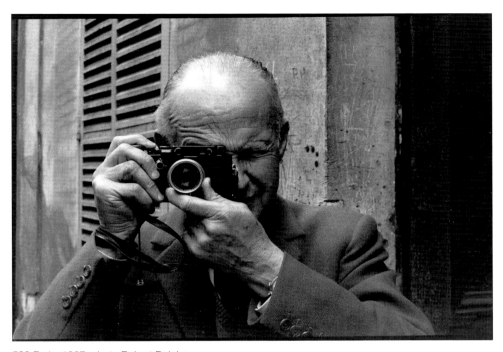

589 Paris, 1967, photo Robert Delpire

591 Moscow, 1973, photo D.R.

590 Rimini, Italy, 1984, photo Martine Franck, Magnum

592 Left to right: David Seymour 'Chim', Robert Capa, Werner Bischof, Paris, *c.*1947, photo D.R.

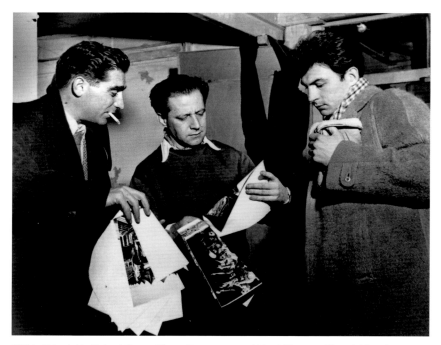

593 Left to right: Robert Capa, Pierre Gassmann and Ernst Haas, at Pictorial Service, Paris, *c.* 1950, photo D.R.

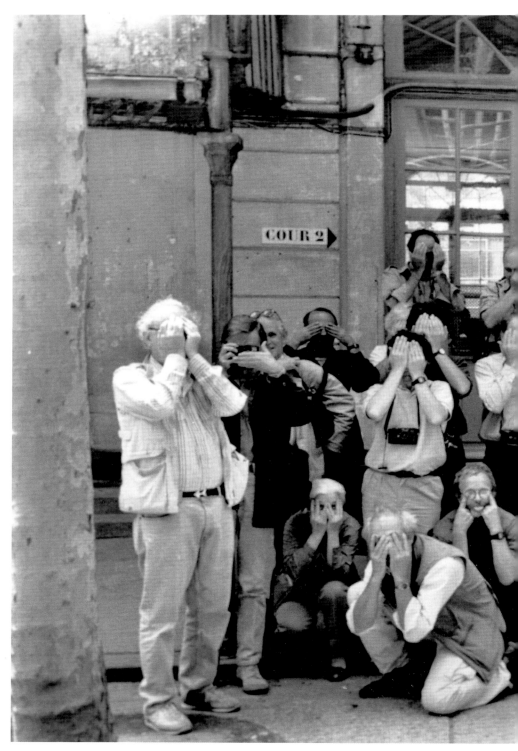

594 Annual Magnum get-together at the Lycée Fénelon, Paris, 1988, photo Elliott Erwitt, Magnum

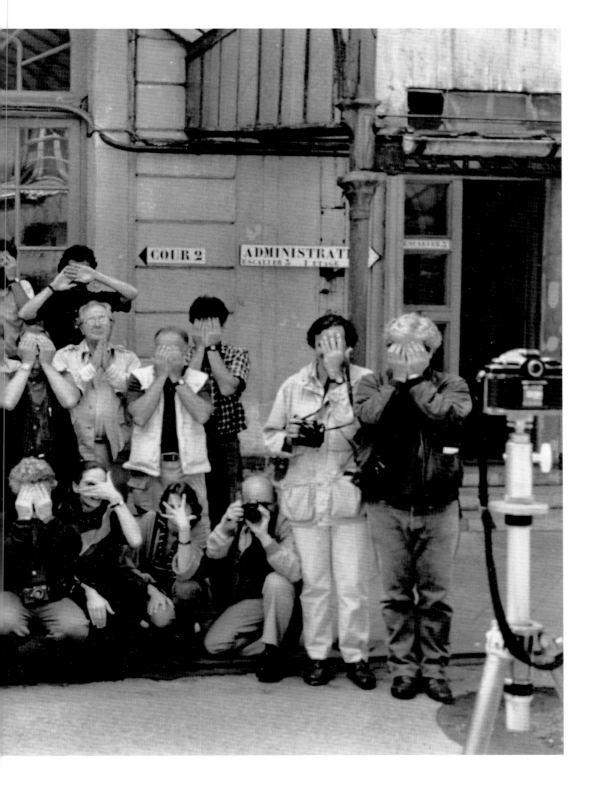

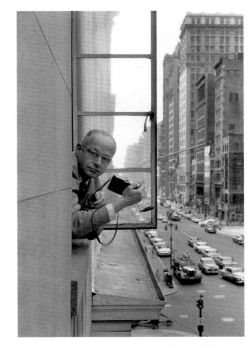

596 Henri Cartier-Bresson, New York, 1959,
photo René Burri, Magnum

595 David Seymour 'Chim' and Robert Capa, 1952, photo Henri Cartier-Bresson

600 Henri Cartier-Bresson and his daughter Mélanie, France, 1974, photo Martine Franck, Magnum

598 At Jacques-Henri Lartigue's in Paris, left to right: Robert Delpire, Jeanloup Sieff, Sarah Moon, Jacques Henri Lartigue, Martine Franck and Henri Cartier-Bresson, J.H. Lartigue collection/Ministry of Culture-AAJHL

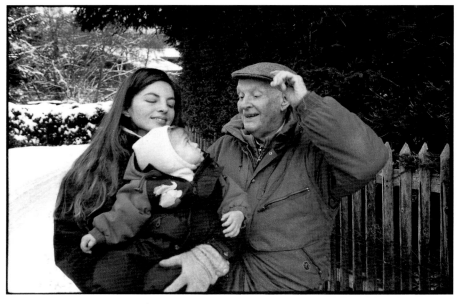

599 Henri with his daughter Mélanie and granddaughter Natasha, Switzerland, 2001, photo Martine Franck, Magnum

597 With the Dalai Lama in the Dordogne, 1991, photo Martine Franck, Magnum

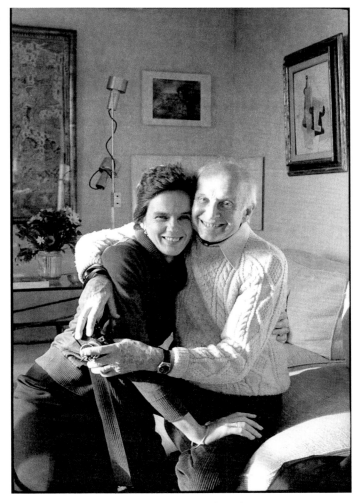

601 With Martine Franck, 1980, photo André Kertész, taken with Martine Franck's camera, D.R.

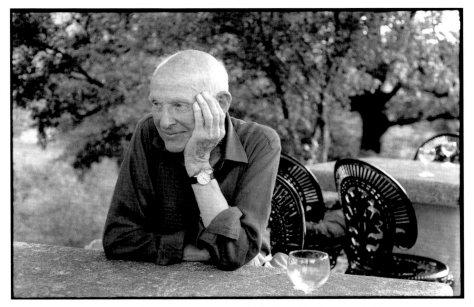

603 The Combe de Lourmarin, Vaucluse, France, 1996, photo Martine Franck, Magnum

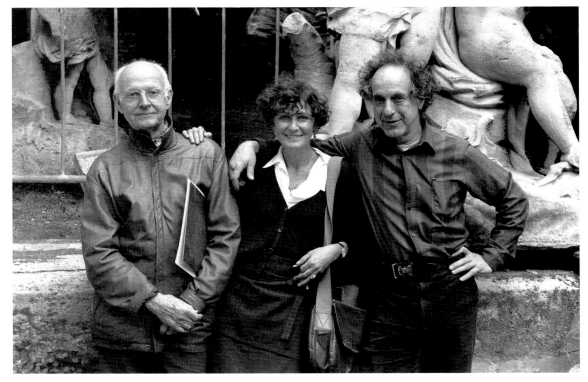

602 With Sarah Moon and Robert Frank, Paris, 1982, photo Robert Delpire

Henri Cartier-Bresson: Master of Photographic Reportage

Claude Cookman *Indiana University, Bloomington*

The idea of making a photographic reportage, that is to say, of telling a story in a sequence of pictures, was something which never entered my head at that time [the early 1930s]. *I began to understand more about it later, as a result of looking at the work of my colleagues and at the illustrated magazines. In fact, it was only in the process of working for them that I eventually learned – bit by bit – how to make a reportage with a camera, how to make a picture story.*[1]

Henri Cartier-Bresson

Rashomon, the Japanese film classic by Akira Kurosawa, relates the story of a nobleman and his wife, who are accosted by a bandit while travelling in medieval Japan. The bandit and the wife have sex. The nobleman is killed. But what do these two acts mean? Kurosawa retells this story from the perspectives of the bandit, the wife, the slain nobleman, whose story is channelled through a medium, and a woodcutter, who witnesses the incident. Each perspective casts doubt on previous tellings. Is the nobleman slain in a fair fight, does he die a coward, or does he commit suicide? Is the wife raped, or does she welcome the bandit's sexual bravado? Does she urge the bandit to kill her husband, or does she grieve at his death? In the end, the viewer is left with an unsettling message that has become the orthodoxy of our postmodern age – truth is relative to one's point of view.

The life and work of Henri Cartier-Bresson offer a non-fiction parallel to *Rashomon*. For more than forty years, from the early 1930s to the mid-1970s, he produced a body of work unrivalled in twentieth-century photography. Regarded by the French as a national treasure, mentioned as a touchstone in almost every article in the popular photographic press, emulated by legions of photographers, Cartier-Bresson has delighted and informed millions with his photographs. Still, in the wake of near universal admiration, questions remain. What does his oeuvre mean? What was he doing when he produced it? Which photographs deserve to be considered as part of his oeuvre and which should be discounted? The answers and the meanings that accompany them depend on one's point of view.

Perspectives on Cartier-Bresson's vast and complex production are even more diverse than those in Kurosawa's film. Critics and commentators have argued that he was a Surrealist, a classicist, a humanist, a cruel observer who wielded his camera with 'a touch of sadism', a man with

a tragic vision, an elitist who distanced himself from his subjects, an aesthete who never saw beyond visual superficialities, a lyricist, a romantic, a realist. The only point most writers agree on is that Cartier-Bresson was a photographic artist.

What is lost in this range of perspectives is the fact that Cartier-Bresson produced his oeuvre while practising the craft of photojournalism. From the early 1930s, he actively sought to publish his reportages in illustrated magazines. He felt compelled to witness the major events and people of his era and to communicate what he witnessed to mass audiences. While he loved geometric composition, he also used his camera to expose the plight of the unemployed and homeless. While his spirit embraced Surrealism's intuition and rebellion, his working method was photographic realism. While his exhibitions and books present him as a photographer of single images, his actual unit of work was the reportage, a series of related images that combine to tell a story.

The bibliography at the end of this catalogue lists more than five hundred published reportages by Cartier-Bresson. This essay weighs those reportages, not merely as published in magazines, but also as revealed in his contact sheets, captions, and manuscripts at Magnum Photos' Paris bureau. Just as a preparatory drawing reveals much about an artist's finished painting, these materials tell us much about Cartier-Bresson's methods and intentions.

In the early 1930s Cartier-Bresson created a new aesthetic in photography that he later termed 'the decisive moment'. It comprises two elements: first, the photograph must contain significant content, typically, instances of the human condition; second, this content must be arranged in a rigorous composition. Form, line, texture, tonality, contrast, and geometric composition carry an importance equal to, but also inextricable from, the content. In the preface to his 1952 book *The Decisive Moment*, he defined decisive-moment photography as 'the simultaneous recognition in a fraction of a second of the significance of an event as well as of a precise organization of forms'.[2]

As the word 'moment' implies, shutter timing is crucial, but Cartier-Bresson practised a more rigorous aesthetic than merely clicking the shutter at a narrative climax. He sought equilibrium and geometry. 'Inside movement there is one moment at which the elements in motion are in balance,' he wrote. 'Photography must seize upon this moment and hold immobile the equilibrium of it.' Geometry was essential. 'If the shutter was released at the decisive moment,' he continued, 'you have instinctively fixed a geometric pattern without which the photograph would have been both formless and lifeless.'[3]

In 1932, Cartier-Bresson discovered the 35mm Leica camera, which he called the

'extension of my eye'. With it, he created this mode of photographic expression and elevated it to a level unmatched by countless imitators. In the process he demonstrated to the world the potential of the small hand-to-eye camera to capture spontaneity and to make pictures remarkable for their revelatory content and formal excellence. He made hundreds of these pictures, images so palpable that they pull the viewer into their space, images so visually compelling that the viewer can look at them again and again, finding fresh rewards each time. Almost all were produced in the practice of photojournalism.

Cartier-Bresson's own perspective on his work is split. In the early 1950s, he enthusiastically embraced photojournalism. Since the mid-1970s, he has disowned photojournalism and minimized the importance of photography in his life. In a 1973 interview he called himself 'a very bad reporter and photojournalist'.[4] In a 1974 interview he declared, 'Photography no longer interests me.'[5] In 1990, he insisted vehemently that he had never been a photojournalist and had never produced reportages: 'They want to put clothes on me that don't fit me.'[6]

Notwithstanding the large number of his reportages published in mass-circulation magazines, he insists that he was engaged in a private pursuit that had nothing to do with journalism except on the most superficial level. In different contexts he describes his activity as experiencing the world, keeping a visual diary, using a mechanical sketchbook, and engaging in Zen encounters that united him with his subjects. He calls his camera 'only a tool for instant drawing'.[7] He insists that the fused act of seeing, composing, and clicking the shutter is paramount, while the photographs that result are uninteresting by-products. 'I adore taking a photo. Once it is taken, for me, the pleasure is finished, terminated.'[8]

He acknowledges his ties with the picture magazines. 'I am extremely grateful to *Life, Harper's Bazaar, Holiday*, etc., who set me free and paid for my upkeep and generous salary,' he wrote in 1994.[9] And again: '[I was] not ashamed to deal with magazines to communicate with the average person.' Beyond that, however, he insists that it was simply not important that he photographed on assignment; reported on events, countries, and individuals; selected, sequenced, and captioned his pictures for editors; and encouraged his agents to market his work to mass-circulation magazines to the maximum extent possible. He made his living at it, but his real interests were 'poetry, novels, drawing, painting, … music, and friends'.

Cartier-Bresson's denials from the 1970s to the present contrast sharply with the commitment to photojournalism expressed in his 1952 preface to *The Decisive Moment*. Based on his experiences working with *Vu, Regards, Harper's Bazaar, Life, Paris Match*, and others, he described the world of magazine photojournalism, including the ethics and working methods of

photojournalists; their product, the picture story; the editors and designers who shape that product's presentation; and the audience that consumes it. He called himself a photo-reporter: 'We photo-reporters are people who supply information to a world in a hurry.'[10] He identified himself as a member of a trade: 'Our trade of photo-reporting has been in existence only about thirty years.' He said that he did not understand reportage when he began photographing, but over the years by learning from colleagues and by studying the picture magazines he 'eventually learned – bit by bit – how to make a reportage with a camera, how to make a picture-story'. A decade later he still spoke of himself as a photojournalist interested in witnessing and communicating the world's events: 'The important thing about our relations with the press is that it provides us with the possibility of being in close contact with life's events. What is most satisfying for a photographer is not recognition, success and so forth. It's communication: what you say can mean something to other people, can be of a certain importance.'[11]

In *The Decisive Moment*, Cartier-Bresson said the ideal is to tell a story in a single image, 'one unique picture whose composition possesses such vigor and richness and whose content so radiates outward from it that this single picture is a whole story in itself'.[12] Unfortunately, 'this rarely happens. The elements … are often scattered either in terms of space or time.' This problem necessitates and justifies the picture story. 'If it is possible to make pictures of the "core" as well as the struck-off sparks of the subject, this is the picture story.' The elements, 'dispersed throughout several photographs', are reunited on the magazine page by editors and designers to complete the story. There is no standard method, but the photojournalist must be involved with his subject at the deepest personal level: 'The picture-story involves a joint operation of the brain, the eye and the heart.' Is the result art? Cartier-Bresson preferred to call himself an artisan: 'It is to the illustrated magazines that we, as artisans, deliver raw material.'

A few biographical points help to understand Cartier-Bresson's work better. He was the eldest son of an *haute bourgeoisie* family that accumulated great wealth in the French textile industry. He refused to work in his father's business, choosing instead to align himself with the political left. He never joined the Communist Party, but during the 1930s when Fascism was threatening Europe, he was engaged on the left. He participated in such organizations as the Association of Revolutionary Writers and Artists (*Association des Ecrivains et Artistes Révolutionnaires*, AEAR), and he served as assistant director to Jean Renoir on *La Vie est à nous*, a propaganda film that helped elect the Popular Front – a coalition of the Communist, Socialist, and Radical parties – in 1936.

Cartier-Bresson's association with the left was typical of many young artists and intellectuals as Fascism threatened Europe between the wars. He saw his choice as inevitable. 'Hitler was at

our backs,' he said. 'We were all on the left. There is nothing to be ashamed of. Nothing to be proud of.'[13] His leftist sympathies, his anti-Fascism, his opposition to French capitalism, his revolt against the established order are more than biographical footnotes. They establish a serious element in his nature. His politics help explain the socially conscious photographs he took in the 1930s and continued taking throughout his career. They constitute one more aspect of his complex nature.

Having rejected his father's business, Cartier-Bresson set out to make his living by selling his photographs. His first published reportage appeared in the French illustrated magazine *Vu* in late 1933. Correspondence with an editor at *Life* magazine in 1934 demonstrates that he was intent on earning his living by selling his pictures for publication. After travelling to Mexico City and New York City, he returned to Paris and worked for the Communist daily newspaper *Ce Soir* and its companion magazine *Regards* from 1936 to the end of the decade. Taken prisoner at the beginning of World War II, he escaped and joined the French Resistance. Working as a photojournalist, he documented the liberation of Paris in August 1944 and covered the allied forces as they liberated concentration camps and pressed on toward victory in Germany.

Beginning in the mid-1940s his intentions as a photojournalist on assignment for magazines show clearly in his contact sheets. He worked fluid situations with great thoroughness, photographing not just for the 'one single photograph' but for story-telling sequences. In most cases, these reportages follow the conventions of the magazine picture story by including general views that establish a setting, portraits that characterize the principal protagonists, action pictures that suggest conflict or a plot, and close-ups that show symbolic details. With the exception of a small number of personal pictures of family members and friends, almost his entire body of work, comprising more than fifteen thousand rolls of black-and-white film and an unknown number of colour rolls, was photographed on assignment from magazine editors, or on self-assignment with the expectation of selling the resulting pictures to such editors. Without this patronage, it is difficult to conceive of Cartier-Bresson's producing many of the single images for which he is famous. The illustrated magazines financed his world travels and helped him gain entry to cover events and make portraits of notable people. They also provided an audience for his work.

Cartier-Bresson's reportages fall into three broad categories: news, ethnography, and portraiture. Numerous examples could be cited for each category, but a few must suffice. While he covered many news events, his two greatest news reportages are the funeral of Gandhi in 1948 and the student rebellion in Paris of May 1968. As an amateur ethnographer, he has described the social, economic, and cultural dimensions of people living in countries as disparate as China, England, India, Mexico, Turkey, and the United States. His most important reportage in this

category was his 1954 visit to the Soviet Union. While single portraits have always been an important part of his work, in the early 1960s he produced an extended series of portraiture essays on such subjects as Leonard Bernstein, Alberto Giacometti, Julie Harris, Robert Kennedy, and Arthur Miller.

It is inevitable that an oeuvre as large and multivalent as Cartier-Bresson's would generate divergent interpretations. Because his photographs have existed in two distinct and antithetical domains – art museums and mass-circulation magazines – the interpretations are all the more oppositional. His contact sheets, captions, manuscripts, correspondence, and the original presentation of his work in illustrated magazines reveal a body of work very different from the received picture. In contrast to the presentation of his photographs as single images, the evidence shows that most of them originated in reportages – purposeful, coherent sequences of photographs intended to narrate a story or convey a point of view. While his photographs are re-presented in books and exhibitions as photographic art, they were originally taken on assignment for the post-war illustrated magazine industry. Contrary to the impression that Cartier-Bresson wandered the streets of the world discovering his photographs through a serendipitous conjunction of intuition and luck, the evidence at Magnum Photos shows he researched, planned, and positioned himself to take advantage of major events, and then worked extremely hard to photograph them with great thoroughness. While Cartier-Bresson shows a preference for decontextualizing his photographs, the historical contexts behind his work enrich personal interpretation and formal appreciation.

What makes Cartier-Bresson's photography so rich, but also so susceptible to contradictory interpretations, is that it combines both formal qualities and accessible content to a degree that few of his contemporaries achieved. His ability to capture remarkable geometric compositions, to juxtapose forms, to arrange lines, to harmonize tonalities – in short, his mastery of the 35mm camera's plastic possibilities – set a rigorous standard of formalism. Nonetheless, his pictures went beyond formalism to embrace content, primarily the human condition, often filtered through his leftist politics.

In his 1955 book *The Europeans*, Cartier-Bresson characterized the role of the photographic reporter by saying, 'I was there and this is how life appeared to me at that moment.'[14] His statement encompasses the essence of photojournalism. Anticipating a significant event, he got himself into position, photographed the event with thoroughness, edited his film, added text and captions, and then, through the picture magazines, communicated what he witnessed to a mass audience. Although he has rejected this interpretation of his enterprise, the evidence at Magnum Photos demonstrates that almost all of his work began as journalistic reportages for picture magazines. From

these reportages, he selected his best single images to present as art in books and museum exhibitions. Without the photojournalism, however, there would have been little photographic art.

Claude Cookman is Associate Professor, School of Journalism, Indiana University, Bloomington

1. Henri Cartier-Bresson, *The Decisive Moment*, New York: Simon and Schuster, 1952, n.p.

2. Ibid.

3. Ibid.

4. *The Decisive Moment Narrated by Henri Cartier-Bresson*, New York: Scholastic Magazines, Inc. and the International Fund for Concerned Photography, 1973, frame 38.

5. Yves Bourde, 'Nul ne peut entrer ici s'il n'est pas géomètre: un entretien avec Henri Cartier-Bresson', *Le Monde* (Paris), 5 September 1974, p.13.

6. Author's conversation with Cartier-Bresson, 24 April 1990.

7. Annotated manuscript in the author's archives.

8. Alain Desvergnes, 'HCB a la question: À Arles, le discret Cartier-Bresson a bien voulu parler de la photo', *Photo* n°144, September 1979, p.98.

9. All quotes in this paragraph from an annotated manuscript in the author's archives.

10. This and the following two quotes from *The Decisive Moment* (1952).

11. *Creative Camera* (London), March 1969, p.92. The statement was made in July 1962.

12. All quotes in this paragraph from *The Decisive Moment*, (1952).

13. Author's conversation with Cartier-Bresson, 3 March 1990.

14. Henri Cartier-Bresson. *The Europeans*, New York: Simon and Schuster 1955, n.p.

I would like to thank the periodical *Journalism History* for permission to reproduce extracts from the article 'Compelled to Witness : The Social Realism of Henri Cartier-Bresson', Spring 1998, and the magazine *History of Photography* (http: www.tandf.co.uk/journals/tf/03087298.html) for permission to reproduce extracts from 'Gandhi's Funeral by Margaret Bourke White and Henri Cartier-Bresson', vol. 22 n°2, Summer 1998.

Chronology and Bibliography compiled by Claude Cookman and Tamara Corm for the Fondation Henri Cartier-Bresson.

This bibliography has been compiled largely thanks to the archives of the Fondation Henri Cartier-Bresson.
In order for it to be as complete as possible, other sources – public or private collections – have been consulted.
This compilation makes possible the presentation of all the appearances of Henri Cartier-Bresson's work in the international press.
Works whose covers reproduce photographs by Henri Cartier-Bresson are mentioned.
Since the town of origin was not always known for periodicals, it was decided to give the country of publication.
In some rare cases, in the absence of full information, the country of publication has been inferred from the language used in the article cited.
For more information on the date and place of publication of exhibition catalogues,
the reader may refer to the chronological list of exhibitions.

CHRONOLOGY

1908 Conceived in January in Palermo, Sicily. Born 22 August at Chanteloup, Seine-et-Marne. Educated at the Lycée Condorcet, Paris. No formal higher education.

1923 Develops a passionate interest in painting and aspects of Surrealism.

1927–28 Studies painting under André Lhote.

1931 Spends one year in the Ivory Coast, where he takes his first photographs. Back in Europe, concentrates on photography. Travels in Europe with André Pieyre de Mandiargues and Leonor Fini.

1933 Exhibits at the Julien Levy Gallery, New York. His photographs are subsequently shown at the Ateneo Club in Madrid. Also published by Charles Peignot in *Arts et Métiers Graphiques*.

1934 Spends a year in Mexico with an ethnographic expedition. Exhibits with Manuel Alvarez Bravo at the Palacio de Bellas Artes de Mexico in 1935.

1935 Spends some time in the USA, where he takes his first photographs of New York and first experiments with film, with Paul Strand.

1936 Works as second assistant to Jean Renoir on *Une partie de campagne* (A Day in the Country).

1937 Directs a documentary on the hospitals of Republican Spain, *Victoire de la vie* (Return to Life), also a documentary for the Secours Populaire, *L'Espagne vivra*. Louis Aragon provides him with an introduction to *Regards*, where he publishes a number of photographic reportages, including coverage of the coronation of George VI.

1939 Joins Jacques Becker and André Zvoboda as an assistant on Jean Renoir's *La Règle du jeu* (The Rules of the Game).

1940 Taken prisoner by the Germans, escapes at his third attempt in February 1943.

1943 Works for MNPGD, a secret organization set up to help prisoners and escapees.

1944–45 For Editions Braun, takes a series of photographic portraits of writers and artists (Matisse, Picasso, Braque, Bonnard, Claudel, Rouault etc). Working as part of a team, photographs the Liberation of Paris. Directs *Le Retour* (The Return), a documentary on the repatriation of prisoners of war and detainees.

1946 Spends over a year in the USA working on the so-called 'posthumous' exhibition of his work, proposed by the Museum of Modern Art in New York at a time when he was believed to have died in the war. Travels in the USA with John Malcolm Brinnin.

1947 With Robert Capa, David Seymour (Chim), William Vandivert and George Rodger founds the cooperative agency Magnum Photos.

1948–50 In the Far East for three years, in India for the death of Gandhi, China for the last six months of the Kuomintang and the first six months of the People's Republic, and in Indonesia for independence.

1952–53 Back in Europe.

1952 His first book, *Images à la sauvette*, cover by Matisse, is published by Tériade.

1954 Publication by Robert Delpire of his book on Balinese theatre, *Les danses à Bali*, with a text by Antonin Artaud, marking the beginning of a long collaboration with Delpire. He is the first photographer to be allowed into the USSR during the period of détente.

1955 First exhibition in France at the Pavillon de Marsan in the Louvre, which subsequently travels all over the world. Tériade publishes *Les Européens*, cover by Miró.

1958–59 Returns to China for three months for the tenth anniversary of the People's Republic of China.

1963 Returns to Mexico for the first time in thirty years, staying for four months. *Life Magazine* sends him to Cuba.

1965 Spends several months travelling in Japan.

1966 Returns to India. Terminates his active working relationship with Magnum Photos, although the agency distribution retains his archives. As before, his photographs are printed by Pictorial Service.

1967 Commissioned by IBM to create 'Man and Machine'.

1969–70 Spends a year travelling around France for *Reader's Digest* and publishes a book, *Vive la France*, to accompany the exhibition 'En France' staged at the Grand Palais in 1970. In the USA directs two documentaries for CBS News.

1972 Returns to the USSR.

1975 First exhibition of drawings at the Carlton Gallery, New York. Concentrates on drawing but continues to practise portrait and landscape photography.

1980 Returns to India.

1981 Grand Prix National de la Photographie presented by the Minister of Culture in Paris.

1986 In Palermo, presented with the Novecento prize by Jorge Luis Borges' widow.

1987 The Museum of Modern Art, New York, stages the exhibition of photographs 'Henri Cartier-Bresson : The Early Work'.

1988 The Centre National de la Photographie celebrates his eightieth birthday.

2000 With his wife Martine Franck and daughter Mélanie, makes plans to set up the Fondation Henri Cartier-Bresson, to provide a permanent home for his collected works as well as an exhibition space open to other artists.

2002 The Fondation Henri Cartier-Bresson wins state-approved status.

2003 Inauguration of the Fondation Henri Cartier-Bresson. Retrospective exhibition 'HCB de qui s'agit-il?' at the Bibliothèque Nationale de France.

BOOKS AND EXHIBITION CATALOGUES

1947. *The Photographs of Henri Cartier-Bresson.* Text by Lincoln Kirstein and Beaumont Newhall. New York: Museum of Modern Art.

1948. *Beautiful Jaipur.* Text by Max J. Olivier. Jaipur: Information Bureau, Government of Jaipur.

1952. *Images à la sauvette.* Devised and published by Tériade. Text by Henri Cartier-Bresson. Paris: Verve. [Paper cut-out by Henri Matisse on the cover.]
The Decisive Moment. Text by Henri Cartier-Bresson. New York: Simon & Schuster. [US edition of *Images à la sauvette.* Title chosen by the publisher Dick Simon.]

1954. *Les danses à Bali.* Text by Antonin Artaud and Béryl de Zoete. Collection Huit. Paris: Delpire éditeur.
Swiss-German edition: *Bali: Tanz und Theater.* Text by Antonin Artaud. Olten: Roven, 1960. [Larger format.]
D'une Chine à l'autre. Text by Jean-Paul Sartre. Paris: Delpire éditeur.
German edition: *China Gestern und Heute.* Text by Henri Cartier-Bresson. Düsseldorf: Karl Rauch Verlag, 1955.
UK edition: *China in Transition.* London: Thames & Hudson, 1956.
US edition: *From One China to Another.* Text by Han Suyin. New York: Universe, 1956.
Italian edition: *Da una Cina all'altra.* Milan: Artimport, 1956.

1955. *Les Européens.* Devised and published by Tériade. Text by Henri Cartier-Bresson. Paris: Verve.
US edition: *The Europeans.* New York: Simon & Schuster.
Moscou, vu par Henri Cartier-Bresson. Text by Henri Cartier-Bresson. Paris: Delpire éditeur.
Italian edition: *Mosca.* Milan: Artimport.
UK edition: *People of Moscow.* London: Thames & Hudson.
US edition: *The People of Moscow.* New York: Simon & Schuster.
German edition: *Menschen in Moskau.* Düsseldorf: Karl Rauch Verlag.
Swiss-German edition: *Menschen in Moskau.* Lucerne: Karl Rauch Verlag.

1956. *Henri Cartier-Bresson Photographien 1930–1955.* Zurich: Kunstgewerbemuseum. [Exhibition catalogue.]

1957. *Henri Cartier-Bresson: The Decisive Moment: Photographs 1930–1957.* New York: American

Federation of Arts/French Cultural Services. [Exhibition catalogue.]
Henri Cartier-Bresson Photoworks Exhibition. Tokyo/Osaka: Takashimaya. [Exhibition catalogue.]

1958. *Henri Cartier-Bresson: Fotografie.* Text by Anna Fárová. Prague: Státní nakladatelství krásné literatury, hudly um ění.
Slovak edition: *Henri Cartier-Bresson: Fotografie.* Bratislava: Slovenské vydavateľstvo krásnej literatúry, 1959.

1960. *The Decisive Moment.* New York: IBM Gallery. [Exhibition catalogue.]
1960 Annual, Banker's Trust Company. New York: Banker's Trust Co. [Annual report.]

1963. *Het Beslissende Moment.* Amsterdam: Stedelijk Museum. [Exhibition catalogue.]
Photographies de Henri Cartier-Bresson. Text by Henri Cartier-Bresson. Paris: Delpire éditeur.
UK edition: *Photographs by Henri Cartier-Bresson.* London: Jonathan Cape.
US edition: *Photographs by Henri Cartier-Bresson.* Text by Lincoln Kirstein and Beaumont Newhall. New York: Grossman.
Swiss-German edition: *Henri Cartier-Bresson: Meister-Aufnahmen.* Zurich: Fretz & Wasmuth.
Japanese edition: *Photographs by Henri Cartier-Bresson.* Tokyo: Asahi Shimbun.
Java Bali. Text by Clara Malraux. Collection l'Atlas des Voyages. Lausanne: Rencontres.
Rome. Text by Paul Chaulot. Collection l'Atlas des Voyages. Lausanne: Rencontres.
China as photographed by Henri Cartier-Bresson. Preface by Henri Cartier-Bresson and afterword by Barbara Brakeley Miller. New York: Bantam.
Photographs by Henri Cartier-Bresson. Washington, DC: Phillips Collection. [Exhibition catalogue.]

1966. *Henri Cartier-Bresson: Exhibition of Photographs after the Decisive Moment.* Tokyo: Asahi Shimbun. [Exhibition catalogue.]
Photographs by Henri Cartier-Bresson. Text by Henri Cartier-Bresson, Claude Roy and Ryoichi Kojima. Tokyo: Asahi Shimbun. [Exhibition catalogue.]

1967. *Henri Cartier-Bresson.* Text by Claude Roy and Ryoichi Kojima. Milan: French Embassy/ Centro Francese de Studi di Milano/Popular Photography Italiana. [Exhibition catalogue.]
Henri Cartier-Bresson. Text by Henri Cartier-Bresson, Claude Roy and Helmut May. Cologne: Kunsthalle Köln. [Exhibition catalogue.]

1968. *Flagrants délits, Photographies de Henri Cartier-Bresson.* Text by Henri Cartier-Bresson.

Paris: Delpire éditeur.
German edition: *Meine Welt von Henri Cartier-Bresson.* Lucerne and Frankfurt: Bücher.
US edition: *The World of Henri Cartier-Bresson.* New York: Viking Press.
Impressions de Turquie: Henri Cartier-Bresson. Text by Alain Robbe-Grillet. Paris: Bureau de Tourisme et d'Information de Turquie. [Exhibition catalogue.]

1969. *Les Français.* Text by François Nourissier. Lausanne: Rencontre.
Man and Machine. IBM World Trade Corporation. New York: Viking Press.
French edition: *L'Homme et la machine.* Text by Etiemble. Paris: Chêne/IBM World Trade Corp.
UK edition: *Man and Machine.* IBM World Trade Corp. London: Thames & Hudson.
German edition: *Mensch und Maschine.* IBM World Trade Corp.
Spanish edition: *El hombre y la maquina.* IBM World Trade Corp.
Italian edition: *L'Uomo e la macchina.* IBM World Trade Corp.
The Mandate of Heaven: Photos by Henri Cartier-Bresson. Ed. John F. Melby. London: n.p.
Turquie. Text by Claude Duthuit. Lausanne: Rencontre.

1970. *Vive la France.* Text by François Nourissier. Paris: Robert Laffont, Reader's Digest Selection.
UK edition: *Cartier-Bresson's France.* Text by François Nourissier. London: Thames & Hudson.
US edition: *Cartier-Bresson's France.* Text by François Nourissier. New York: Viking Press.
German edition: *Frankreich.* Lucerne and Frankfurt: Bücher.
Henri Cartier-Bresson: En France. Text by François Nourissier. Paris: Galeries Nationales d'Expositions du Grand Palais. [Exhibition catalogue.]

1971. *Henri Cartier-Bresson.* Buenos Aires: Centro de Arte y Communicación.

1972. *The Face of Asia.* Introduction by Robert Shaplen. New York: John Weatherhill and Orientations Ltd, Hong Kong.
French edition: *Visage d'Asie.* Paris: Chêne.

1973. *The Decisive Moment.* Narration by Henri Cartier-Bresson. New York: Scholastic Magazines, Inc. and the International Fund for Concerned Photography. [Audio-visual production.]
A propos de l'URSS. Text by Henri Cartier-Bresson. Paris: Chêne.
UK edition: *About Russia.*

London: Thames & Hudson.
German edition: *Sowjetunion, photographische Notizen von Henri Cartier-Bresson.* Lucerne and Frankfurt: Bücher.
US edition: *About Russia.*
New York: Viking Press, 1974.

1974. *Vive la France.* Text by Henri Cartier-Bresson. Tokyo. [Exhibition catalogue.]

1975. *Henri Cartier-Bresson: Drawings.* Text by Julien Levy. New York: Carlton Gallery. [Exhibition catalogue.]
Henri Cartier-Bresson: Zeichnungen. Text by Manuel Gasser. Zurich: Galerie Bischofberger. [Exhibition catalogue.]

1976. *Henri Cartier-Bresson.* Text by Henri Cartier-Bresson. History of Photography Series. Millerton, New York: Aperture. [Managing editor Robert Delpire.]
French edition: *Henri Cartier-Bresson.* Collection Histoire de la Photographie. Paris: Nouvel Observateur/Delpire.
UK edition: *Henri Cartier-Bresson.* London: Gordon Fraser Gallery.
Japanese edition: *Henri Cartier-Bresson.* Tokyo: Quick Fox.
German edition: *Henri Cartier-Bresson.* Munich: Rogner und Bernhard, 1978. [Revised US version (1987) and Italian version (1988).]
Henri Cartier-Bresson: dessins. Forcalquier: Galerie Lucien Henry. [Exhibition catalogue.]
Selected Photographs by Henri Cartier-Bresson. Text by Laxmi P. Sihare. New Delhi: National Gallery of Modern Art. [Exhibition catalogue.]

1977. *Henri Cartier-Bresson: 70 photographies.* Text by Yves Bourde. Marseilles: Ecole d'Art et d'Architecture de Marseille-Luminy. [Exhibition catalogue.]

1978. *Henri Cartier-Bresson.* Text by Sir Ernst Gombrich. London: Victoria & Albert Museum. [Exhibition catalogue.]
Henri Cartier-Bresson, His Archive of 390 Photographs from the Victoria and Albert Museum. Text by Ernst Gombrich. Edinburgh: Scottish Arts Council. [Exhibition catalogue.]
Henri Cartier-Bresson. Text by Henri Cartier-Bresson and Ferdinando Scianna. Collection Photo-Galerie. Udine, Italy: Art & Udine, 1978.

1979. *Henri Cartier-Bresson.* Tokyo: Pacific Press Service, 1979. [Archive of 392 photographs.]
Henri Cartier-Bresson: Photographe. Text by Yves

Bonnefoy. Paris: Delpire éditeur. [Currently in its 10th edition. Revised in 1992.]
US edition: *Henri Cartier-Bresson: Photographer.* Boston: New York Graphic Society.
UK edition: *Henri Cartier-Bresson: Photographer.* London: Thames & Hudson.
Japanese edition: *Henri Cartier-Bresson: Photographer.* Tokyo: Pacific Press Service.
German edition: *Das Fotografen – Porträt.* Lucerne: Karl Rauch Verlag, 1980.
Henri Cartier-Bresson: Photographer. New York: International Center of Photography. [Exhibition catalogue.]

1980. *Images du Pays Franc: Cartier-Bresson.* Lille: Le Pays Franc, Région Nord-Pas-de-Calais. [Exhibition catalogue.]

1981. *Henri Cartier-Bresson: Dessins, 1973–1981.* Preface by Bernadette Contensou. Text by James Lord and André Berne-Joffroy. Paris: Musée d'Art Moderne de la Ville de Paris. [Exhibition catalogue.]

1982. *Henri Cartier-Bresson.* Text by Jean Clair. Paris: Fondation Nationale de la Photographie. [Photo Poche 1st edition; currently in its 11th edition.]
US edition: *Henri Cartier-Bresson.* Text by Michael Brenson. New York: Pantheon, 1985.
UK edition: *Henri Cartier-Bresson.* Text by Michael Brenson. London: Thames & Hudson, 1985.
Italian edition: *Henri Cartier-Bresson.* Text by Jean Clair. Rome: Contrasto, 2000.
Henri Cartier-Bresson: Dibujos 1973–1981. Text by James Lord. Mexico City: Museo de Arte Moderno/Instituto Nacional de Bellas Artes. [Exhibition catalogue.]
L'Imaginaire d'après nature. Paris: Michel Chandeigne and Robert Delpire. [Limited edition of 30 copies.]
Scanno di Henri Cartier-Bresson. Text by Carlo Bertelli. Scanno: Biblioteca Comunale di Scanno. [Exhibition catalogue.]

1983. *Henri Cartier-Bresson: Ritratti: 1928–1982.* Text by André Pieyre de Mandiargues and Ferdinando Scianna. I Grandi Fotografie Series. Milan: Gruppo Editoriale Fabbri.
German edition: *Henri Cartier-Bresson: Das Fotografenportrait.* Lucerne: Karl Rauch Verlag.
UK edition: *Henri Cartier-Bresson: Portraits.* London: William Collins Sons, 1984.
Spanish edition: *Henri Cartier-Bresson Retratos: 1928–1982.* Barcelona: Ediciones Orbis, 1984.
Henri Cartier-Bresson: Teckningar (1973–1981). Text by Christian Dumon. Stockholm: Franska Institutet. [Exhibition catalogue.]

L'Imaginaire d'après nature: disegni, dipinti, fotografie, documentari Henri Cartier-Bresson. Text by Henri Cartier-Bresson, James Lord, Giuliana Scimé and Lamberto Vitali. Milan: Padiglione d'Arte Contemporanea. [Exhibition catalogue.]

1984. *Henri Cartier-Bresson.* Toulouse: Galerie Municipale du Château d'Eau. [Exhibition catalogue.]
Henri Cartier-Bresson: Carnet de notes sur le Mexique. Text by Juan Rulfo. Paris: Centre Culturel du Mexique. [Exhibition catalogue.]
Henri Cartier-Bresson: Drawings and Painting. Text by David Elliott, Julien Levy and André Berne-Joffroy. Oxford: Museum of Modern Art. [Exhibition catalogue.]
Henri Cartier-Bresson: Paris à vue d'œil. Text by André Pieyre de Mandiargues and Véra Feyder. Paris: Paris Audiovisuel and the Association des Amis du Musée Carnavalet. [Exhibition catalogue.]
Photographs by Henri Cartier-Bresson from Mexico, 1934 and 1963. Text by Amy Conger. Corpus Christi: Art Museum of South Texas. [Exhibition catalogue.]

1985. *Henri Cartier-Bresson.* Seoul: KBS, 1985. [Exhibition catalogue.]
Henri Cartier-Bresson: dessins et tempéras. Text by Michael Brenson, André Berne-Joffroy and James Lord. Athens: Institut Français d'Athènes. [Exhibition catalogue.]
Henri Cartier-Bresson en Inde. Text by Satyajit Ray and Yves Véquaud. Collection Photo Copies. Paris: Centre National de la Photographie. [Exhibition catalogue.]
Henri Cartier-Bresson: Photoportraits. Text by André Pieyre de Mandiargues. Paris: Gallimard.
UK and US editions: *Henri Cartier-Bresson: Photoportraits.* New York & London: Thames & Hudson.
German edition: *Photoportraits.* Munich: Schirmer/Mosel.
Henri Cartier-Bresson: Zeichnungen. Text by Dieter Schrage. Salzburg: Rupertinum and Museum Moderner Kunst, Palais Lichtenstein, Vienna. [Exhibition catalogue.]

1986. *Henri Cartier-Bresson: fotografo.* Text by Jose Maria Salvador, Susana Benko, Paolo Gasparini and Henri Cartier-Bresson. Caracas: Museo de Bellas Artes. [Exhibition catalogue.]
Henri Cartier-Bresson: Photophien. Text by Jean Clair and Henri Cartier-Bresson. Berlin: Centre Culturel Français. [Exhibition catalogue.]
Henri Cartier-Bresson: Zeichnung und Fotografie. Text by Roland Scotti, Thomas Schirmböck

and Friedrich W. Kasten. Mannheim: Mannheimer Kunstverein. [Exhibition catalogue.]
L'Uomo e la macchina: Henri Cartier-Bresson. Text by Leonardo Sciascia and Giuliana Scimé. Agrigente: Centro Culturale Editoriale Pier Paolo Pasolini. [Exhibition catalogue.]

1987. *Henri Cartier-Bresson.* Masters of Photography Series. Revised edition. New York: Aperture.
Henri Cartier-Bresson: The Early Work. Text by Peter Galassi. New York: Museum of Modern Art.
French edition: *Henri Cartier-Bresson: premières photos: de l'objectif hasardeux au hasard objectif.* Paris: Arthaud, 1991.
Henri Cartier-Bresson in India. London: Thames & Hudson.
US edition: *Henri Cartier-Bresson in India.* New York: Thames & Hudson.
Indian edition: *Henri Cartier-Bresson in India.* Ahmedabad: Mapin Publishing Co.
Henri Cartier-Bresson: Drawings and Paintings. Introduction by Arnold Herstand. New York: Arnold Herstand & Company. [Exhibition catalogue.]

1988. *Henri Cartier-Bresson en la India.* Bilbao: Caja de Ahorros Municipal de Bilbao. [Exhibition catalogue.]
Paris vu par Atget et Henri Cartier-Bresson. Preface by Noriyoshi Sawamoto. Tokyo: Tokyo Metropolitan Teien Art Museum. [Exhibition catalogue.]

1989. *Trait pour trait.* Text by Jean Clair and John Russell. Paris: Arthaud.
UK edition: *Line by Line.* London: Thames & Hudson.
German edition: *Zeichnungen.* Munich: Schirmer/Mosel.
Henri Cartier-Bresson. Tokyo: Pacific Press Service. [Exhibition catalogue in two volumes: photographs with accompanying text by his friends; catalogue of his drawings and gouaches.]
L'Autre Chine. Introduction by Robert Guillain. Collection Photo Notes. Paris: Centre National de la Photographie.

1990. *La Lucania di Henri Cartier-Bresson.* Text by Rocco Mazzarone and Giuseppe Appella. Rome: Edizioni della Cometa.

1991. *Alberto Giacometti photographié par Henri Cartier-Bresson.* Text by Henri Cartier-Bresson and Louis Clayeux. Milan: Franco Sciardelli.
L'Amérique furtivement: Photographies Henri Cartier-Bresson: USA 1935–1975. Text by Gilles Mora. Paris: Seuil.

UK edition: *America in Passing.* London: Thames & Hudson.
US edition: *America in Passing.* Boston: Little, Brown and Co.
German edition: *Henri Cartier-Bresson: Amerika Photo-Skizzen.* Munich: Schirmer/Mosel.
Italian edition: *America Furtivamente.* Milan: Federico Motta Editore.
Portuguese edition: *América Furtivamente.* Porto: Afrontamento.

1992. *Henri Cartier-Bresson: Photographe.* 7th revised edition. Text by Yves Bonnefoy. Paris: Delpire éditeur.
US edition: *Henri Cartier-Bresson: Photographer.* Boston: Bulfinch.
German edition: *Die Photographien.* Munich: Schirmer/Mosel.
Italian edition: *Henri Cartier-Bresson Fotografo.* Florence: Alinari.

1994. *Paris à vue d'œil.* Text by Véra Feyder and André Pieyre de Mandiargues. Paris: Seuil.
UK edition: *A propos de Paris.* London: Thames & Hudson.
US edition: *A propos de Paris.* Boston: Bulfinch.
German edition: *A propos de Paris.* Munich: Schirmer/Mosel.
Japanese edition: *A propos de Paris.* Tokyo.
Henri Cartier-Bresson: Double Regard. Text by Jean Leymarie. Amiens: Le Nyctalope.
UK edition: *Henri Cartier-Bresson: Double Regard.* Amiens: Le Nyctalope.

1995. *André Breton: Roi Soleil.* Text by Henri Cartier-Bresson and Gérard Macé. Saint-Clément: Fata Morgana.
Carnets mexicains 1934–1964. Text by Carlos Fuentes. Paris: Hazan.
Italian edition: *Henri Cartier-Bresson Messico 1934–1964.* Milan: Federico Motta Editore.
UK edition: *Mexican Notebooks 1934–1964.* London: Thames & Hudson.
L'Art sans Art d'Henri Cartier-Bresson. Text by Jean-Pierre Montier. Paris: Flammarion.
UK edition: *Henri Cartier-Bresson and the Artless Art.* London: Thames & Hudson, 1996.
US edition: *Henri Cartier-Bresson and the Artless Art.* Boston: Bulfinch, 1996.
German edition: *Henri Cartier-Bresson: Seine Kunst – Sein Leben.* Munich: Schirmer/Mosel, 1996.
Italian edition: *Henri Cartier-Bresson Lo Zen e la Fotografia.* Milan: Leonardo Arte, 1996.

1996. *L'Imaginaire d'après nature.* Preface by Gérard Macé. Text by Henri Cartier-Bresson.

Saint-Clément: Fata Morgana. [Anthology of writings by Henri Cartier-Bresson.]
German edition: *Auf der Suche Nach dem Rechten Augenblick.* Text by Gérard Macé and Henri Cartier-Bresson. Munich: Christian Pixis.
Greek edition: *L'Imaginaire d'après nature.* Athens: Agra, 1998.
US edition: *The Mind's Eye.* New York: Aperture, 1999.
Special editions: *L'Imaginaire d'après nature.* Saint-Clément: Fata Morgana, 1996. [Limited edition of 30 copies, with an original photograph of Henri Cartier-Bresson by Martine Franck.]
The Mind's Eye. New York: Aperture, 2000. [Special edition.]
Henri Cartier-Bresson: Pen, Brush, and Cameras. Text by Evan M. Maurer, Carroll T. Hartwell and Michael Brenson. Minneapolis: Minneapolis Institute of Arts. [Exhibition catalogue.]
Henri Cartier-Bresson: Drawings, 1970–1996. Introduction by James Lord. London: Berggruen & Zevi Limited. [Exhibition catalogue.]
Vowels. Text by Arthur Rimbaud. New York: The Limited Editions Club.

1997. *Henri Cartier-Bresson.* Kyoto: Kahitsukan/Kyoto Museum of Contemporary Art. [Exhibition catalogue.]
Henri Cartier-Bresson: Dessins 1974–1997. Text by Jean Leymarie. Paris: Galerie Claude Bernard. [Exhibition catalogue.]
Des Européens. Text by Jean Clair. Paris: Maison Européenne de la Photographie. [Exhibition catalogue.]
Des Européens. Text by Jean Clair. Paris: Seuil.
UK edition: *Europeans.* London: Thames & Hudson, 1998.
US edition: *Europeans.* Boston: Bulfinch, 1998.
German edition: *Europäer.* Munich: Schirmer/Mosel, 1998.
Italian edition: *Gli Europei.* Rome: Peliti Associati, 1998.
Portuguese edition: *Europeus.* Belém: Centro Cultural de Belém, 2001.

1998. *Henri Cartier-Bresson: Photographien und Zeichnungen.* Introduction by Ernst Beyeler. Text by John Berger. Basel: Galerie Beyeler. [Exhibition catalogue.]
Henri Cartier-Bresson: Neue Zeichnungen/Dessins Récents. Text by Guido Magnaguagno. Bern: Benteli Verlag/Kunsthaus Zürich.
Tête à tête. Introduction by E. H. Gombrich. London: Thames & Hudson.
French edition: *Tête à tête.* Paris: Gallimard.

German edition: *Tête à tête*.
Munich: Schirmer/Mosel.
US edition: *Tête à tête*.
Boston: Bulfinch.
Italian edition: *Tête à tête*.
Milan: Leonardo Arte, 1999.
Brazilian edition: *Tête à tête*.
São Paulo: Schwarcz, 1999.

1999. *Henri Cartier-Bresson Disegni e Acquarelli*.
Text by Guido Magnaguagno. Florence: Alinari.
Henri Cartier-Bresson. L'œuvre photographique.
Text by Gilles Mora and Henri Cartier-Bresson.
Paris: Collection Actualité des Arts Plastiques,
Centre de Documentation Pédagogique, Special
edition 1.
Henri Cartier-Bresson Landscape. Tokyo: Magnum
Photos.
Omaggio a Henri Cartier-Bresson. Preface by
Ferdinando Scianna. Florence: Alinari.

2000. *Henri Cartier-Bresson: Vers un autre futur: un
regard libertaire*. Text by Michel Bakounine. Paris:
Nautilus. [Exhibition catalogue.]

2001. *Paysages*. Text by Erik Orsenna and Gérard
Macé. Paris: Delpire éditeur.
US edition: *City and Landscapes*.
Boston: Bulfinch/Little, Brown & Co.
UK edition: *Landscape/Townscape*.
London: Thames & Hudson.
Italian edition: *Paesaggi*. Rome: Contrasto.
German edition: *Landschaften und Städte*.
Munich: Schirmer/Mosel.
Illuminations. Text by Arthur Rimbaud.
Verona: Gibralfaro & E.C.M.

2002. *Henri Cartier-Bresson: Indonésie, 1949*. Text
by Hervé Ladsous, Dr Mukhlis Paeni, Ong Hok
Ham, Sitor Situmorang and Kunang Helmi-Picard.
Jakarta: Centre Culturel Français. [Exhibition
catalogue.]

PORTFOLIOS

1992. *L'Aimée au lotus sanglant*. Text by Lokenath
Bhattacharya. Saint-Clément: Fata Morgana.
Comme aller loin, dans les pierres. Text by Yves
Bonnefoy. Lithographs by Henri Cartier-Bresson.
Crest: La Sétérée/Jacques Clerc.

1994. *Physiologie du rêve*: André Pieyre de
Mandiargues. Text by Gérard Macé. Saint-
Clément: Fata Morgana.
Le Paysan de Paris. Text by Louis Aragon and
Henri Cartier-Bresson. New York: The Limited
Editions Club.

1996. *Vowels*. Text by Arthur Rimbaud.
New York: The Limited Editions Club.

1997 *Three Poems from Les Fleurs du Mal*.
Text by Charles Baudelaire and Jean Leymarie.
New York: The Limited Editions Club.

MAGAZINE AND NEWSPAPER REPORTAGES

1932. 'Photo 1932'. Text by André Beucler. *Photographie*, France (1932).

1933. *Crapouillot*, France, (Apr. 1933), cover.
Crapouillot, (Aug. 1933), cover.
'L'Espagne Parle'. Text by George Rotvand. *Vu*, n° 296, France, (15 Nov. 1933), pp. 1713–1714.
'L'Espagne Parle II – Elections'. Text by George Rotvand. *Vu*, n° 297 (22 Nov. 1933), pp. 1741–1742.
'L'Espagne Parle III – Au Seuil de l'avenir'. Text by George Rotvand. *Vu*, n° 298 (29 Nov. 1933), pp. 1774–1775.
'Photo 1933–1934'. *France*, n° 4, France (1933), n.p.

1935. 'La Belleza de lo imprevisto'. Text by Fernando Leal. *El Nacional*, Mexico, (17 Mar. 1935), n.p.
'On Yorkville's Streets'. *New Theatre*, n° 2, USA (Sept. 1935), p. 9.

1937. 'Coronation, ceux qui regardent… reportage photographique d'Henri Cartier'. *Regards*, n° 175, France (20 May 1937), pp. 6–7.
'Es Lebe der König! Straßenbild aus London am Kronungstage Georgs VI'. *Zürcher Illustrierte*, Switzerland (21 May 1937), cover.
'Cotton club, ou vitalité noire'. Text by Louis Capace. *Regards*, n° 181 (1 July 1937), p. 12.
'Cavaliers et taureaux. Haripeo Mexicain'. *Regards*, n° 197 (21 Oct. 1937), pp. 12–13.
'Chevelures.' *Verve*, n° 1, France (Dec. 1937), p. 19.
'La Psychologie de l'Art.' Text by André Malraux. *Verve*, n° 1 (Dec. 1937), pp. 41–63.

1938. 'Noces et banquets'. Text by Yves Bonnat. *Regards*, n° 225, France (5 May 1938), pp. 12–13.
'Jeux enfantins dans les jardins de Paris'. *Regards*, n° 228 (26 May 1938), pp. 12–13.
'Dans la Loire, une île de loisirs: Amboise ville du passé au seuil de l'avenir'. Text by Paul Tillard. *Regards*, n° 230 (9 June 1938), pp. 12–13.
'Sous les grands arbres du Valois à Ermenonville où Gérard dansait avec Sylvie, les chevaliers de l'arc perpétuent une ancienne tradition'. Text by Georges Sadoul. *Regards*, n° 233, (30 June 1938), pp. 12–13.
'Et vive l'eau vive!' Text by Yves Bonnat. *Regards*, n° 234 (7 July 1938), pp. 12–13.
'Camping de fortune aux portes de la ville'. Text by Georges Sadoul. *Regards*, n° 237 (28 July 1938), pp. 4–5.
'L'accueil de la France aux souverains anglais'. *Regards*, n° 237 (28 July 1938), pp. 11–13.
'Tout le confort de la ville, banlieues de toile'. Text by Georges Sadoul. *Regards*, n° 242, (1 Sept. 1938), p. 16.

1944. 'Les Troupes de montagne françaises patrouillent dans la neige, à la frontière de l'Andorre'. *Voir*, n° 18, France (Dec. 1944), back cover.
'Sur la Seine passe le pont des Arts'. Text by René Leplat. *Cadran*, n° 5, France (1944), pp. 30–31.

1945. 'Vergt: petite capitale du Maquis'. *Voir*, n° 22, France (Feb. 1945), n.p.
'American Red Cross – Western Front'. *Harper's Bazaar*, n° 2799, USA (Mar. 1945), pp. 74–77.
'Above the crowd in Paris'. *Harper's Bazaar*, n° 2800 (Apr. 1945), pp. 98–99.
'Lines from Paris'. *Harper's Bazaar*, n° 2800 (Apr. 1945), pp. 100–103.
'Dearest, I love you'. Text by Victoria Chapelle. *Harper's Bazaar*, n° 2801 (May 1945), p. 56.
'England: On the Land'. *Harper's Bazaar*, n° 2803 (July 1945), pp. 24–27.
'England: Free Speech in Hyde Park'. *Harper's Bazaar*, n° 2803 (July 1945), pp. 32–34.
'England: Cyril Connolly'. *Harper's Bazaar*, n° 2803 (July 1945), p. 35.
'Les livres: autour de Claudel'. Text by André Rousseaux. *France Illustration*, France, (13 Oct. 1945), p. 47.
'Le Retour'. Text by François de Roux. *France Illustration* (20 Oct. 1945), pp. 69–70.
'Le Retour'. Text by Claude Roy. *Portofolio II: An International Quarterly* [Black Sun Press], USA (Dec. 1945), p. 6.

1946. 'A child in a bottleneck'. *Harper's Bazaar*, n° 2810, USA (Feb. 1946), pp. 154–155.
'The Musicians'. Text by Gerald Kersh. *Harper's Bazaar*, n° 2811 (Mar. 1946), pp. 194–195, 254.
'Behind the Crime'. *Harper's Bazaar*, n° 2811 (Mar. 1946), pp. 200–201.
'At the Schiaparelli Collection Spring 1946'. *Harper's Bazaar*, n° 2813 (May 1946), p. 125.
'Paris working girl 1946'. *Harper's Bazaar*, n° 2814 (June 1946), p. 56.
'France resurgent: science and religion'. *Harper's Bazaar*, n° 2814 (June 1946), p. 58.
'The naive life of Adam and Eve'. *Harper's Bazaar*, n° 2815 (July 1946), pp. 88–89.
'Paris designers are artisans'. *Harper's Bazaar*, n° 2815 (July 1946), p. 127.
'Alfred Stieglitz'. *Harper's Bazaar*, n° 2816 (Aug. 1946), pp. 169–171.
'L'anniversaire de la libération de Paris'. *France Illustration*, France (24 Aug. 1946), p. 171.
'Brooklyn Bridge'. Text by Alfred Kazin. *Harper's Bazaar*, n° 2817 (Sept. 1946), p. 204.
'Rouault'. *Harper's Bazaar*, n° 2817 (Sept. 1946), p. 215.
'Anxious women'. *Harper's Bazaar*, n° 2818, (Oct. 1946), pp. 202–205.
'Notes on N.O.'. Text by Truman Capote. *Harper's Bazaar*, n° 2818 (Oct. 1946), pp. 268–271.
'Americans in Paris'. *Harper's Bazaar*, n° 2818, (Oct. 1946), pp. 276–277.
'The headless hawk'. Text by Truman Capote. *Harper's Bazaar*, n° 2819 (Nov. 1946), p. 254.
'The year of the ballet'. *Harper's Bazaar*, n° 2819 (Nov. 1946), p. 262.

1947. 'Portraits: "Romantics", "Rapt", "Stieglitz", "Siesta"', *New York Times Magazine*, USA (2 Feb. 1947), n.p.
'Moves in the game of peace'. *Harper's Bazaar*, USA (Feb. 1947), pp. 180–183.
'Henri Cartier-Bresson: Photographer'. *Harper's Bazaar* (Feb. 1947), pp. 196–197.
'They speak as if he still lives on'. Text by Meyer Berger. *New York Times Magazine* (13 Apr. 1947), pp. 8–9 and cover.
'The faces of New York'. *This Week Magazine* [Supplement of the *New York Herald Tribune*] USA (27 Apr. 1947), pp. 10–11.
'Above the Crowd… Joan Miró and Corrado Cagli'. *Harper's Bazaar* (June 1947), p. 104.
'Young Visitors from Europe: Nicole Cartier-Bresson, Daniel Milhaud, Claire Nicolas'. *Junior Bazaar* USA (June 1947), p. 73.
'Highway cyclorama'. *Harper's Bazaar*, (Sept. 1947), p. 208.
'The American scene'. *New York Times Magazine* (5 Oct. 1947), p. 22.
'Faces of America'. *New York Times Magazine* (12 Oct. 1947), pp. 20–21.
'Signs of America'. *New York Times Magazine* (26 Oct. 1947), p. 20.
'A visit to William Faulkner in Mississippi'. Text by John Malcolm Brinnin. *Harper's Bazaar* (Nov. 1947), pp. 202–206, 302.
'Alfred Stieglitz'. Text by Nancy Newhall. *Formes et Couleurs*, n° 6, France (1947), n.p.
'Climat du Blues'. Text by Ian Lang. *Formes et Couleurs*, n° 6 (1947), n.p.
'La Découverte de l'Amérique'. Text by Alexandre Astruc. *Formes et Couleurs*, n° 6 (1947) n.p.
'Jeunes auteurs américains'. Text by Newton Arvin. *Formes et Couleurs*, n° 6 (1947), n.p.

1948. 'Kashmir – Report on a Coveted Valley'. Text by Michael James. *New York Times Magazine*, USA (10 Feb. 1948), pp. 10–11, 42.
'Le Mahatma Gandhi apôtre de la non-violence'. Text by Roger Céré. *France Illustration*, France (14 Feb. 1948), pp. 159–160.
'Gandhi joins the Hindu immortals.' *Life*, USA (16 Feb. 1948), pp. 21–29.
'The last days of Gandhi: all the drama, all the

horror that swept a shocked India is photographed and described by Henri Cartier-Bresson'. *Illustrated*, UK (21 Feb. 1948), pp. 7–11.
'India's DPs'. *New York Times Magazine*, (22 Feb. 1948), pp. 8–9.
'Gandhis Leichenbegängnis'. *Sie und Er*, Switzerland (27 Feb. 1948), p. 5.
'Gandhi joins the Hindu immortals'. *Life* [International edition] (1 Mar. 1948), pp. 7–17.
'Frank Lloyd Wright', *Harper's Bazaar*, USA (Mar. 1948), p. 200.
'Civil war in fair Kashmir'. *Illustrated* (13 Mar. 1948), pp. 5–8.
'Sacred rivers receive Gandhi's ashes'. *Life* (15 Mar. 1948), pp. 76–78.
'Sorrow in India'. *Harper's Bazaar*, (Apr. 1948), pp. 163–169.
'Wenn ein maharadchu geburtstag hat…'. *Sie und Er* (30 Apr. 1948), pp.16–17 and cover.
'The Racing Maharaja'. *Illustrated* (22 May 1948), pp. 5–7.
'A maharaja celebrates his birthday'. *Harper's Bazaar* (May 1948), pp. 134–137.
'Maharaja's birthday'. *Life* (May 1948), pp. 40–41.
'Travelling Companions'. Text by Newton Arvin. *Harper's Bazaar* (June 1948), pp. 76–77, 128.
'The World's Queerest State'. Text by Edgar Snow. *Saturday Evening Post*, USA (17 July 1948), pp. 24–25, 120–122.
'Paradies auf Streitobjekt Bajonetten: Kaschmir'. *Illustrierte Berliner Zeitschrift*, n° 20, Germany (29 July 1948), pp. 2–3.
'The Fourth'. *Harper's Bazaar* (July 1948), p. 41.
'Three of the Plain People'. *Harper's Bazaar* (July 1948), p. 42.
'Dilemma of a despot'. *Illustrated* (28 Aug. 1948), pp. 5–8.
'Baroda fête les 40 ans de son prince'. Text by James de Coquet. *Figaro Illustré*, France, (Aug. 1948), p. 105.
'The American scene'. *Illustrated* (30 Oct. 1948), pp. 14–21.
'War without a front'. *Illustrated* (6 Nov. 1948), pp. 14–21.
'Kashmir: Uneasy Crossroads'. *New York Times Magazine*, (Nov. 1948), pp. 10–11.
'Politik am Himalaja'. *Heute*, Germany (Nov. 1948), pp. 16–17.
'The New India Keeps her Ancient Customs of Romance and Terror'. *Sunday Mirror Magazine*, UK (11 Dec. 1948), pp. 16–17.
'India's city of destiny'. Text by Robert Jackson. *Illustrated* (11 Dec. 1948) pp. 7–11.
'Le plus fastueux des maharajas abandonne son palais hindou pour un cottage anglais'. *Point de Vue: Images du Monde*, France (16 Dec. 1948), pp. 2–5.
'India's own Congress. It faces a crucial year with

a new constitution'. *Now* (25 Dec. 1948), pp. 5–6.
'Wohin treibt Burmas Schicksal?' *Sie und Er*, (1948) p. 3.
'Dreikampf um Kaschmir'. *Schweizer Illustrierte Zeitung*, Switzerland (1948), pp. 6–7.

1949. 'A last look at Peiping'. *Life*, USA (3 Jan. 1949), pp. 13–21.
'Chinese gold rush: Red advance brings Shanghai panic'. *Life* (17 Jan. 1949), pp. 20–21.
'Shanghai'. Text by Til Salg. *Se*, n° 3, Sweden (18 Jan. 1949), n.p.
'Shanghai auf der Flucht'. *Schweizer Illustrierte Zeitung*, n° 3, Switzerland (19 Jan. 1949), cover.
'The city of despair'. *Illustrated*, UK (22 Jan. 1949) p. 7.
'Panick in Shanghai'. *Der Spiegel*, Germany (22 Jan. 1949), p. 3.
'Last hours of Peiping'. Text by W. M. Towler. *Illustrated* (29 Jan. 1949), pp. 18–22.
'Derniers jours de Pékin'. *Samedi Soir*, France (29 Jan. 1949), p. 1.
'A Last Look at Peiping'. *Life* [International edition] (31 Jan. 1949), pp. 50–59.
'La tragédie chinoise: panique à Shanghai'. *Le Soir Illustré*, France (2 Feb. 1949), p. 12.
'Imaginez la déroute de la Chine…'. Text by Gérard Deville. *Noir et Blanc*, France (2 Feb. 1949), pp. 72–73.
'Panik I Shanghai'. Text by Henri Cartier-Bresson. *Se*, n° 6, (3 Feb. 1949), p. 4.
'Dernières images de Pékin assiégé; reportage photographique exclusif de Henri Cartier-Bresson pour Regards'. *Regards*, France (4 Feb. 1949), pp. 5–7.
'This Kiss Could Kill'. *Illustrated* (5 Feb. 1949), pp. 22–23.
'En sista halsning fran Peiping'. *Se*, n° 8 (17 Feb. 1949), pp. 7–9.
'Uneasy road to Mandalay'. *Illustrated* (19 Feb. 1949), pp. 19–22.
'Eunuchs of Peiping'. Text by James Burke. *Life* (21 Feb. 1949), pp. 17–18, 20, 23.
'Kysset, der er en leg med doden…' *Billed-Bladet*, Netherlands (22 Feb. 1949), pp. 12–13.
'Changing Burma'. *New York Times Magazine*, USA (20 Mar. 1949), cover.
'Panique à Shanghai, ruée vers le riz, ruée vers l'or'. *Paris Match*, n° 1, France (29 Mar. 1949), pp. 2–3.
'Hong Kong struggle for existence.' *New York Times Magazine* (17 Apr. 1949), p. 11 and cover.
'Britain's family meets'. *Illustrated* (23 Apr. 1949), p. 7.
'Doden far et kyss'. *Aktuell*, Norway, (Easter 1949), n.p.
'China prays for peace'. Text by Peter Hume. *Illustrated* (7 May 1949), pp. 7–13.

'Akbars land'. *Vändi* (7 May 1949), p. 15.
'Fact Invades India's Fabled Land: Princely treasures, Maharaja of Baroda'. Text by Robert Trumbull. *New York Times Magazine* (8 May 1949), pp. 12–13.
'The looting of Nanking: Chinese pillage their own capital on eve of capture by Communists'. *Life* (9 May 1949), pp. 35–38.
'Auszug aus Nanking'. *Heute*, Germany (11 May 1949), p. 4.
'Chine. La Ferveur de 30 000 pèlerins a préservé le "paradis de Ling Ying"'. *Point de Vue: Images du Monde*, France (12 May 1949), pp. 14–17.
'Nanking: zero hour'. *Illustrated* (14 May 1949), pp. 7–11.
'Chine: Une armée en pousse-pousse, traîné par des coolies, fuit et pille'. *Samedi Soir* (14 May 1949), p. 9.
'China in confusion: Refugees seek passage across the Yangtze'. *New York Times* (15 May 1949), p. 11.
'Kinas hovedstad kapitulerer'. *Billed-Bladet*, (24 May 1949), pp.19–22.
'Sportsmanship in reverse: targets for the killjoys'. *Illustrated* (4 June 1949), p. 28.
'Reno'. *Illustrated* (4 June 1949), n.p.
'Chaos in Asia'. Text by Max Ways. *Life* (6 June 1949), pp. 114–124.
'Jaipur den lyserøele by'. *Billed-Bladet* (21 June 1949), n.p.
'Les Communistes à Shanghai'. *Paris Match* (16 July 1949), pp. 11–14.
'Chinese communist troops are shown after capture of a nationalist city'. *New York Times* (7 Aug. 1949), n.p.
'Behind the Red Bamboo Curtain'. *Illustrated* (13 Aug. 1949).
'Bebop not wanted. Burmese dancers battle to preserve their own culture'. *Illustrated* (20 Aug. 1949), pp. 16–17.
'China door een rode Bril. Het rode leger in opmars'. *Kroniek van de Week*, n° 48, Netherlands (27 Aug. 1949), pp. 2–4.
'China raumt auf'. *Berliner Illustrierte*, Germany (4 Oct. 1949), pp. 4–5.
'3 x Amerikanische Gesichter – Zeugnisse der Amerikanischen Vielfaltigkeit'. Text by William U. Sinclair. *Schweizerische Allgemeine* (15 Oct. 1949), cover, photos inside n.p.
'Report on Communist Shanghai'. Text by Robert Doyle. *Life* (17 Oct. 1949), pp. 129–142.
'Jawaharlal Nehru: From India, a leader for Asia, a friend for the West'. *Business Week*, USA (22 Oct. 1949), cover.
'China'. *Quick*, Germany (23 Oct. 1949), pp. 7–9.
'Shanghai'. *Point de Vue: Images du Monde* (3 Nov. 1949), pp. 14–19.
'Inside Red Shanghai: Photographed by Henri

Cartier-Bresson'. *Illustrated* (5 Nov. 1949), pp. 26–33.
'Report on Communist Shanghai'. *Life* [International edition] (7 Nov. 1949), pp. 48–59.
'The heart of Hongkong'. *Illustrated* (12 Nov. 1949), pp. 9–17.
'Siste melding fra Shanghai'. *Aktuell* (12 Nov. 1949), n.p.
'Shanghai: erster unzensierter Bildbericht'. *SZ im Bild* (19 Nov. 1949), p. 1.
'Honkongs Hjerte'. *Billed-Bladet* (22 Nov. 1949), p. 8.
'Hong Kong investi. Dernières photos'. Text by Henri Cartier-Bresson. *Paris Match* (26 Nov. 1949), pp. 25–29.
'Tight little isle off Communist China'. *New York Times Magazine* (4 Dec. 1949), p. 10.
'Dans la Pagode au toit d'or, les hommes donnent à manger aux dieux'. *Point de Vue: Images du Monde* (8 Dec. 1949), pp. 14–17.
'Im Glanz der goldenen Pagode'. *Badische Illustrierte*, Germany (15 Dec. 1949), pp. 15–17.
'L'an I de la République Populaire Chinoise'. *Regards* (30 Dec. 1949), p. 7.
'Vaarwel Shanghai'. *De Week in beeld* (Dec. 1949), p. 21.
'Shanghai'. *Point de Vue: Images du Monde* (1949), p. 14.
'Panikk i Shanghai'. *Aktuell* (n.d.), p. 21.
'Editorial: Much more Communist than Chinese'. *New York Times Magazine* (1949), pp. 7, 29.
'Chinesen beten um den Frieden'. *Sie und Er* (1949), pp. 4–5.
'I Peiping afgores Kinas skaebne', *Billed-Bladet*, n° 12 (1949), n.p.
'Shanghai Woos the Chinese Reds'. Text by Darrell Berrigan. *Saturday Evening Post*, UK (1949), pp. 34–35.
'Paris Diary'. *New York Times Magazine* (1949), pp. 38–39.

1950. 'Communist Challenge in Asia'. *New York Times*, USA (22 Jan. 1950), pp.12–13, 50–51 and cover.
'Een Nieuwe Staat Werd Geboren. Ir Soekarno beedigd als eerste president van de Republiek Indonesia Serikat'. *Panorama* (3 Feb. 1950), p. 18.
'The new nation of Indonesia: 14 pages of pictures by Henri Cartier-Bresson'. *Life*, USA (13 Feb. 1950), p. 41 and cover.
'Et Folk blir Fritt'. Text by Eilert Eriksen. *Aktuell*, Norway (18 Feb. 1950), pp. 18–21, 25.
'The New Nation Indonesia: Fabulous Indies change owners'. *Life* [International edition] (27 Feb. 1950), n.p.
'La vérité sur la Chine communiste'. *Réalités*, France, USA (Feb. 1950), pp. 12–21.
'The East in ferment: a camera record'. *New York Times Magazine* (5 Mar. 1950), pp. 8–9.

'Where death is the host'. *Illustrated*, UK (18 Mar. 1950), pp. 22–24.
'Beauty around the world: Burma'. Text by Henri Cartier-Bresson. *Modern Photography*, USA (Mar. 1950), p. 47.
'Hindoefeest in Singapore'. *Panorama* (14 Apr. 1950), n.p.
'Bali, paradis terrestre, a trouvé le secret du bonheur de vivre'. *Point de Vue: Images du Monde*, France (27 Apr. 1950), pp. 4–9.
'Bali: er stadig tropernes paradis'. *Billed-Bladet*, Netherlands (2 May 1950), n.p.
'Die Bewohner von Singapur gehen ins Hotel, um zu sterben'. *Sie und Er*, Switzerland (5 May 1950), pp. 8–9.
'Interlude in Bali, the dancing island'. Text by Patrick O'Donovan. *Illustrated* (6 May 1950), pp. 24–27 and cover.
'Tanz auf Bali'. *Heute*, Germany (21 June 1950), pp. 29–31 and cover.
'Zo leeft Amerika'. *Panorama* (14 July 1950), p. 5.
'Which way will India turn?' Text by Lionel Fielden. *New York Times Magazine* (16 July 1950), pp. 14–15, 35.
'The dark, bright world of Faulkner'. Text by Harry Sylvester. *New York Times Book Review* (20 Aug. 1950), p. 1.
'I saw a God die'. Text by Darrell Berrigan. *Saturday Evening Post*, UK (26 Aug. 1950), pp. 28–29, 108–110.
'Dee "lebende Gott"; nur viermal im Jahr zeigt sich Sri Auro-bindo den Pilgern'. *Heute* (8 Nov. 1950), pp. 20–21.
'Die heilige man van Pondicherry'. *Panorama* (1 Dec. 1950), pp. 19–21.
'Funérailles d'une riche Chinoise à Peiping'. *Le Patriote Illustré*, France (12 Dec. 1950), p. 1452.
'The Shah weds a commoner'. *Illustrated* (30 Dec. 1950), pp. 32–35.
'Im Zauberland des Maharadschas von Baroda'. *DKI*, Denmark (Dec. 1950), n.p.

1951. 'Eternity greets a god'. *Illustrated*, UK (6 Jan. 1951), pp. 27–29.
'Oil in the desert of paradise'. *Illustrated*, UK (26 Jan. 1951), p. 22.
'Hahen af Iran gifter sig igen'. *Billed-Bladet*, Netherlands (6 Feb. 1951), n.p.
'Ich bin ein arbeitender König'. *Heute*, Germany (14 Feb. 1951), p. 6.
'In meiner Suche: Persien'. *Heute*, (21 Feb. 1951), p. 17.
'The Last days of Hong Kong'. Text by William L. Worden. *Saturday Evening Post*, UK (24 Feb. 1951), pp. 28–29, 115.
'The enormous miracle Jean Anouilh'. Text by Nancy Wilson Ross. *Harper's Bazaar*, USA

(Feb. 1951), p. 136.
'Climb to the Clouds'. *Illustrated* (10 Mar. 1951), pp. 22–24.
'In Ancient and Troubled Iran'. *New York Times Magazine*, USA (18 Mar. 1951), cover.
'Le Cachemire, pomme de discorde entre l'Inde et le Pakistan'. *Le Patriote Illustré*, France (22 Apr. 1951), p. 456.
'Forty miles from heaven'. *Illustrated* (28 Apr. 1951), pp. 22–24.
'Figures in a salon'. *Harper's Bazaar* (Apr. 1951), pp. 114–115.
'Madame Vincent Auriol'. *Harper's Bazaar* (Apr. 1951), p. 133.
'Report from Egypt, the sands of uncertainty'. *Illustrated* (5 May 1951), pp. 28–31.
'The steps of St Paul's: a photographic essay by Henri Cartier-Bresson'. Text by John Prebble. *Illustrated* (5 May 1951), pp. 9–16.
'In search of London – 1'. Text by H. V. Morton. *Illustrated* (12 May 1951), pp. 11–25.
'In search of London – 2: the city has two faces'. Text by H. V. Morton. *Illustrated* (19 May 1951), pp. 12–15, 35.
'In search of London – 3: after office hours'. Text by H. V. Morton. *Illustrated* (26 May 1951), pp. 33–36, 45.
'Un reporter… Henri Cartier-Bresson'. Text by Daniel Masclet. *Photo*, France (May 1951), pp. 28–33.
'All-star cast for a sultan'. *Illustrated* (2 June 1951), p. 26.
'Behind the face of Persia'. *Illustrated* (9 June 1951), pp. 12–15.
'Gateway to trouble'. *Illustrated* (23 June 1951), pp. 29–31, 37.
'Thebes in Egypt'. *Harper's Bazaar* (June 1951), pp. 54–55.
'Faucons du Khyber'. Text by Henri Cartier-Bresson. *Point de Vue: Images du Monde*, France (12 July 1951), pp. 10–13.
'The magic of Paris'. Text by H. E. Bates. *Illustrated* (14 July 1951), pp. 11–15.
'Berlin's Two Memorials. Europe's Strangest City'. Text by Willi Frischauer. *Illustrated* (8 Sept. 1951), pp. 11–15.
'The Matisse chapel'. *Harper's Bazaar* (Sept.1951), pp. 232–237.
'C'est parce qu'ils haïssent l'Anglais... qu'ils acclament Nahas Pacha'. *Paris Presse l'Intransigeant*, France (19 Oct. 1951), n.p.
'Brennpunkt Kairo'. *Illustrierte Merkur*, n° 10, Germany (27 Oct. 1951), cover.
'La Maison du muscle à Téhéran'. *Neuf*, France (Oct. 1951), pp. 46–48.
'They ask the gods to smile'. *Illustrated* (17 Nov. 1951), p. 28.

'Persik Marknad 1951'. *Veck Journalem*, (19 Nov. 1951), pp. 24–25.
'Of time and the Nile'. *Harper's Bazaar* (Nov. 1951), pp. 126–127.
'Portfolio from portfolio'. *ASMP News*, USA (Dec. 1951), p. 12.
'Cartier-Bresson in The Orient'. Text by Lincoln Kirstein. *Portfolio. The Annual of the Graphic Arts*, USA (1951), n.p.
'HCB, le chasseur d'hommes au Leica'. Text by Madeleine Charmet-Ochsé. *Le Leicaiste* [French edition] (1951), n.p.

1952. 'Ces pèlerins faméliques attirent la clémence du dieu de la destruction'. *Point de Vue : Images du Monde*, France (3 Jan. 1952), pp. 16–19.
'Guérilla ou guerre en Malaisie?'. *France Magazine*, France (6 Jan. 1952), p. 8.
'Jerusalem, Bagdad. People of Troubled Iran'. *New York Times*, USA (Jan. 1952), pp. 9, 12–13.
'Astronomical architecture'. *Harper's Bazaar*, USA (Feb. 1952), pp. 172–173.
'Britons Gather to Bid Farewell to a King'. *Life*, USA (Feb. 1952), pp. 22–29.
'Portrait of Mrs. Augustus John'. *Harper's Bazaar* (Feb. 1952), p. 171.
'Portrait of Mrs. McCloy Berlin'. *Harper's Bazaar* (Feb. 1952), n.p.
'Artist who lives a legend'. Text by John Davenport. *Illustrated* (8 Mar. 1952), pp. 22–24, 38.
'Britons mourn a king and hail a new queen.' *Life* [International edition] (10 Mar. 1952), pp. 14–15.
'The Roman Hunt'. Text by Harvey Ladew. *Harper's Bazaar* (Mar. 1952), pp. 158–161.
'Gebst uns Land'. *Telebild* (18 Apr. 1952), pp. 5–8.
'Hier verliefs Adam de Erde'. *Weltbild*, Germany (Apr. 1952), p. 14.
'Kathakali'. *Zondagsvriend* (31 July 1952), p. 2.
'Festival in Manhattan'. *Park East*, USA (July 1952), pp. 54–57.
'Même aux Indes des saints vont en enfer...' *Noir et Blanc*, France (20 Aug. 1952), pp. 538–539.
'A tribute to Val Mulkerns'. Text by Frank O'Connor. *Harper's Bazaar* (Aug. 1952), pp. 110–111.
'Tériade, the man who invented Verve'. *Harper's Bazaar* (Aug. 1952), pp. 112–113.
'French Actors – The Lover and the Mime'. *Harper's Bazaar* (Aug. 1952), p. 131.
'Behind the Headlines of the Middle East'. Text by Elisabet Monroe. *New York Times Magazine* (14 Sept. 1952), p. 9.
'Derby Day at the Curragh'. *Harper's Bazaar* (Sept. 1952), pp. 234–239.
'Vertueuse Erin'. *Réalités*, France (Sept. 1952), pp. 44–53.
'Directors Meeting (John Huston)'. *Harper's Bazaar* (Sept. 1952), p. 156.

'La Permanence du Cirque'. *Neuf*, n° 7, France (Sept. 1952), pp. 13, 19.
'Egypte. Porteuse d'eau'. *La Route des Scouts de France* (Sept.–Oct. 1952), cover.
'Après vingt ans de voyages autour du monde Cartier-Bresson le grand poète de la photographie présente ses chefs-d'œuvre'. *Paris Match*, France (11–18 Oct. 1952), pp. 34–39.
'The Right Moment: Work of Cartier-Bresson is Lesson in Timing'. Text by Jacob Deschin. *New York Times* (18 Oct. 1952), n.p.
'Indonesia'. Text by Leone Lombardi. *L'Illustrazione Italiana*, Italy (Oct. 1952), pp. 32–39.
'Intruder on tiptoe'. *Harper's Bazaar* (Oct. 1952), pp. 164–169.
'The de Filippos'. *Harper's Bazaar* (Oct. 1952), p. 199.
'In der Entscheidensekunde'. *Illustrierter Merkur*, Germany (1 Nov. 1952), cover.
'Ein Tag des jungen Arztes. Dem unveröffentlichten Schulsband seiner Jungendgeschichte'. Text by Hans Carossa. *SZ im Bild* (1 Nov. 1952), p. 2.
'HCB Grootmeester der fotographie'. *Panorama* (12 Dec. 1952), n.p.
'Christmas in Scanno'. *Harper's Bazaar* (Dec. 1952), pp. 78–81.
'Il Natale a Scanno'. Text by Massimo Leij. *L'Illustrazione Italiana* (Dec. 1952), pp. 32–35.
'Iosten stiger solen opp'. Text by Raymond Cartier. *Aktuell*, Norway (1952), pp. 22–28, 44.
'Die Gitarre als Stierkampfwaffe'. *Die Woche*, Switzerland (1952), pp. 27–28.

1953. 'The independent cockney'. *Picture Post*, UK (10 Jan. 1953), pp. 25–27.
'Mit den Augen eines Meister – Fotografen: Indien'. *Frankfurter Illustrierte*, Germany (14 Feb. 1953), pp. 6–7.
'Images de l'Inde'. *Ere Nouvelle*, France (Feb. 1953), p. 15 and cover.
'Dior day in Paris'. *Picture Post* (7 Mar. 1953), pp. 18–19.
'Paris überrascht'. *Revue*, Germany (7 Mar. 1953), cover.
'The island of Ischia'. *Harper's Bazaar*, USA (Mar. 1953), pp. 146–147.
'Carlyle Brown of Ischia'. *Harper's Bazaar* (Mar. 1953), p. 148.
'Fiery French drama critic'. *Harper's Bazaar* (Mar. 1953), p. 160.
'Paris! City of types: a portfolio of photographs by Cartier-Bresson'. *Holiday*, USA (Apr. 1953), pp. 48–51.
'Paris! City of Fine Food'. Text by Silas Spitzer. *Holiday* (Apr. 1953), pp. 54–59.
'Paris! City of Children'. Text by Ruth McKenny.

Holiday (Apr. 1953), pp. 62–71.
'Fiesta at Pamplona'. *Harper's Bazaar* (May 1953), p. 105.
'Before coronets'. *Harper's Bazaar* (June 1953), pp. 67–69.
'The dignity of silence: Francisco Borès'. *Harper's Bazaar* (June 1953), p. 82.
'Everything goes on in the Piazza'. *Life*, USA (20 July 1953), pp. 71–79.
'Portfolio: Roman Piazza'. *Life* (July 1953), n.p. [Off-print.]
'Zank um das Bergland Kaschmir'. *Die Woche*, Switzerland (28 Sept.–4 Oct. 1953), pp. 6–7.
'Germany today: butter and guns?' *Picture Post* (21 Nov. 1953), pp. 14–17.
'Het Voorjaarsoffensief van Dior'. *Panorama* 14 (1953), pp. 12–14.

1954. 'The face of Europe, a picture portfolio by Henri Cartier-Bresson.' *Holiday*, n° 15, USA (Jan. 1954), pp. 32–53.
'The World's Finest Food'. *Holiday*, n° 15 (Jan. 1954), pp. 62–63.
'Favorite Tours'. *Holiday*, n° 15 (Jan. 1954), pp. 64–69.
'Europe Amused'. *Holiday*, n° 15 (Jan. 1954), pp. 98–110.
'The mountain castles of Austria'. *Harper's Bazaar*, USA (Jan. 1954), p. 97.
'Notes de voyage en Chine'. *Photo Monde*, n° 31, France (Jan. 1954), pp. 15–32.
'Le reportage de Vercors sur la Chine'. *L'Express*, France (6 Feb. 1954), p. 1.
'Lucania, the land where Christ stopped short'. *World*, UK (Feb. 1954), pp. 28–31.
'The New York of West Germany'. *Fortune*, USA (Apr. 1954), pp. 122–125.
'Der Moment der Entscheidung'. Text by Henri Cartier-Bresson. *Camera*, n° 4 (Apr. 1954), pp. 140–151.
'Italien. Land der deutschen Sehnsucht Zwei Millionen reisen 1954 über den Brenner'. *Munchner Illustrierte*, Germany (29 May 1954), pp. 8–11.
'Spain'. Text by V. S. Pritchett. *Holiday* (May 1954), pp. 34–47.
'Pages from a Greek sketchbook'. Text by Peter Brook. *Harper's Bazaar* (June 1954), pp. 76–76, 117.
'Vijf jaar geleden viel het dock over de chinese burgeroorlog'. *Zondagsvriend*, Belgium (3 July 1954), p. 16.
'Pamplona: fiesta of the bull'. *Photography*, UK (July 1954), p. 25.
'Wedding Procession in Provence'. *Harper's Bazaar* (July 1954), pp. 60–63.
'Henri Laurens, a personal tribute by Tériade'. *Harper's Bazaar* (Aug. 1954), pp. 114–115.

'Viaggio in Italia'. *L'Illustrazione Italiana*, Italy (Aug. 1954), pp. 28–32.
'Auf dem Pferderücken zum Traualtar'. *Ihre Freundin*, n° 21, Germany (7 Oct. 1954), pp. 30–31.
'Die Stiere sind los!' *IBZ*, n° 26 (1954), p. 6.
'Land der Sehnsucht. Allen Umstanden zum trotz wurde Italien wieder das für ungezahlte Menschen. Die es nach Romantik durstet'. *Schweizer Illustrierte Zeitung*, Switzerland (1954), pp. 32–33.
'Die liquidierte Fliege'. *Kristall*, Germany (1954), pp. 3–5.

1955. 'Jedes Foto eine Welt'. *Ihre Freundin*, Germany (1 Jan. 1955), pp. 4–5.
'The people of Russia (part I)'. *Life*, USA (17 Jan. 1955), p. 15.
'Annonce du reportage de Henri Cartier-Bresson sur la Russie'. *Paris Match*, n° 304, France (22 Jan. 1955), pp. 14–15.
'A camera in Russia–1: the face of the people of Moscow'. *Picture Post*, UK (29 Jan. 1955), pp. 10–15.
'Un témoignage sans précédent, le peuple russe, 24 pages photos de Cartier-Bresson'. *Paris Match*, n° 305 (29 Jan.–5 Feb. 1955), pp. 44–67.
'Als erste Zeitung deutscher Sprache bringen wir Cartier-Bresson's Bild bericht: das Gesicht des sowjetburgers Menschen in Moskau'. *Schweizer Illustrierte Zeitung*, Switzerland (31 Jan. 1955), pp. 42–43.
'The people of Russia (part II)'. *Life* (31 Jan. 1955), pp. 83–91.
'A camera in Russia–2: the children of town and steppe'. *Picture Post* (5 Feb. 1955), pp. 30–34.
'The people of Russia (part II)' *Life* [International edition] (7 Feb. 1955), pp. 11–26.
'Le peuple russe, deuxième partie'. *Paris Match*, n° 306 (5–12 Feb. 1955), pp. 46–63.
'A camera in Russia-3: a fashion show in Moscow'. *Picture Post* (12 Feb. 1955), pp. 30–34.
'A camera in Russia-4: does this spell the end of leisure in Russia?' *Picture Post* (19 Feb. 1955), pp. 47–50.
'Folket i sovjet'. *Se*, Sweden (18– 24 Feb. 1955), pp. 10–21 and cover.
'Ich sprach mit Chruschtschew'. Text by M. MacDuffie. *Der Stern*, Germany (20 Feb. 1955), pp. 4–11.
'Menschen in Moskau'. *Der Stern* (20 Feb. 1955), pp. 9–15 and cover.
'Modeschau in Moskau. Aus dem photographischen Reisetagebuch HCB: "Das Gesicht des Sowjetburgers"'. *Schweizer Illustrierte Zeitung*, (21 Feb. 1955), pp. 20–21.
'La mode à Moscou'. *Point de Vue: Images du Monde*, France (24 Feb. 1955), pp. 22–25 and cover.

'De Russen, zoals zij zijn'. *Zondagsvriend*, n° 8, Belgium (24 Feb. 1955), pp 2–7 and cover.
'Folket i "sovjet"'. *Se* (25 Feb.–3 Mar. 1955), pp. 10–21.
'La tribune des lecteurs de Paris Match: Cartier-Bresson fait sensation'. *Paris Match* (26 Feb.–5 Mar. 1955), p. 7.
'Passaporte per l'URSS. Ecco la Russia di Malenkov Tutto naturale per l'uomo Sovietico'. Text by Henri Cartier-Bresson and Enrico Emanuelli. *Epoca*, Italy (27 Feb. 1955), pp. 22–27.
'Menschen in Moskau, teil II, des grossen Bildberichtes von Henri Cartier-Bresson'. *Der Stern* (27 Feb. 1955), pp. 9–11.
'De Russen zoals zij zijn'. *Zondagsvriend*, n° 9 (3 Mar. 1955), pp. 22–27.
'Resa i ryssland'. *Se* (4–10 Mar. 1955), pp. 16–25.
'Volk van rusland, gezien door het oog van Henri Cartier-Bresson'. *De Katholieke Illustratie*, Belgium (5 Mar. 1955), pp. 434–445 and cover.
'Menschen in Moskau, teil III des Bildberichts von Henri Cartier-Bresson'. *Der Stern* (6 Mar. 1955), pp. 7–11.
'Passaporto per l'URSS: Da Leningrado all'Uzbekistan'. *Epoca*, (6 Mar. 1955), pp. 50–61.
'Aus H. Cartier-Bresson photographischem Reisebuch: das Gesicht des Sowjetbürgers, Sie bauen das neue Moskau'. *Schweizer Illustrierte Zeitung*, (7 Mar. 1955), pp. 10–11.
'De Russen zoal's zij zijn 3'. *Zondagsvriend* (10 Mar. 1955), pp. 10–15.
'Rysk rekreation'. *Se* (11–17 Mar. 1955), pp. 22–29.
'Mensen in Moskou'. *De Katholieke Illustratie* (12 Mar. 1955), pp. 507–511.
'Teil IV des Bildberichts von Henri Cartier-Bresson, Moskau auf Urlaub'. *Der Stern* (13 Mar. 1955), pp. 7–13.
'Aus Cartier-Bresson russischem Bilderbuch: das Gesicht des Sowjetbürgers, die Generation der Gottgläubigen'. *Schweizer Illustrierte Zeitung*, (14 Mar. 1955), pp. 32–33.
'De Russen zoals zij zijn 4'. *Zondagsvriend*, n° 11 (17 Mar. 1955), pp. 10–15 and cover.
'De russiche mens bij arbeid en outspanning'. *De Katholieke Illustratie* (19 Mar. 1955), pp. 552–559 and cover.
'Die Reise nach Leningrad'. *Der Stern* (20 Mar. 1955), pp. 6–9.
'De Russen zoal's zij zijn 4'. *Zondagsvriend* (24 Mar. 1955), pp. 10–15.
'Sport in de Sovjet-Unie'. *De Katholieke Illustratie* (26 Mar. 1955), pp. 600–607.
'Ein Blick in die Stalinwerke'. *Schweizer Illustrierte Zeitung* (28 Mar. 1955), pp. 14–15.
'Moscou: l'attrait des magasins'. *Nouveau Femina*, France (Mar. 1955), pp. 56, 58–63.
'The Russians – photographed by Henri Cartier-

Bresson'. *Harper's Bazaar*, USA (Mar. 1955), pp. 150–153.
'God leeft nog in Rusland'. *De Katholieke Illustratie* (2 Apr. 1955), pp. 626–633.
'La Cina di Mao'. *Epoca* (3 Apr. 1955), pp. 41–53.
'Aus Cartier-Bresson' photographischem Tagebuch: die Kolchosebauern von Taraszowka'. *Schweizer Illustrierte Zeitung* (11 Apr. 1955), pp. 10–11.
'Winkelen in Moskou'. *De Katholieke Illustratie* (16 Apr. 1955), pp. 726–731.
'Czaar Peter opende een venster op Europa'. *De Katholieke Illustratie* (23 Apr. 1955), pp. 789–791.
'The partridge country'. *Harper's Bazaar* (Apr. 1955), pp. 170–175, 205, 213.
'Het verleden leeft voort...' *De Katholieke Illustratie* (14 May 1955), pp. 918–920.
'Op de grens van Europa en Azie...' *De Katholieke Illustratie* (21 May 1955), pp. 984–986.
'The Paris Scene'. *Harper's Bazaar* (June 1955), p. 68.
'A "royal show" in Russia'. *Picture Post* (9 July 1955), pp. 29–32.
'La Bacchu-Ber'. *Prestige Français et Mondanités*, France (July 1955), pp. 30–34.
'Med kamera i sovjet, Aktuell móter sovjet-folket; storbyen moskva – et verdensrikes myldrende sentrum'. *Aktuell*, Norway (27 Aug. 1955), pp. 16–21.
'Cartier-Bresson med kamera i sovjet 2, barn og ungdom – lek og fritid'. *Aktuell* (3 Sept. 1955), pp. 4–7.
'Cartier-Bresson med kamera i sovjet 3, storbedrift, kóer, metro og museum i moskva'. *Aktuell* (10 Sept. 1955), pp. 18–21.
'What Sport Means to Russia'. *Picture Post* (10 Sept. 1955), pp. 33–36.
'Cartier-Bresson med kamera i sovjet 4, sportsparade moskva'. *Aktuell* (17 Sept. 1955), n.p.
'Cartier-Bresson med kamera i sovjet 5, sportsparade moskva'. *Aktuell* (24 Sept. 1955), pp. 4–7.
'Cartier-Bresson med kamera i sovjet 6, hamnebyen leningrad'. *Aktuell* (1 Oct. 1955), pp. 20–23.
'Russian curtain raisers'. *New York Herald Tribune*, USA (25 Oct. 1955), n.p.
'The little shows of Paris'. *New York Herald Tribune* (28 Oct. 1955), n.p.
'La vision instantanée de Henri Cartier-Bresson'. Text by Beaumont Newhall. *Camera*, Switzerland (Oct. 1955), pp. 456–460 and cover.
'Lenin – tomater'. *Aktuell* (5 Nov. 1955), pp. 20–23.
'L'URSS telle que nous l'avons vue...' Text by Danielle Darrieux and Roger Marse. *L'Humanité*, France (6 Nov. 1955), pp. 1–9.
'Les femmes ne sont pas encore libres!' Text by Françoise Giroud. *L'Express*, France (25 Nov. 1955), pp. 8–9.

'Henri Cartier-Bresson: Témoin et poète de notre temps'. Text by Madeleine Ochsé. *Le Leicaiste* [French edition] (Nov. 1955), pp. 5–9 and cover.
'Espagne 1955'. Text by Jean Montiel. *Horizons*, France (Nov. 1955), p. 33.
'The Façade in Focus: "The People of Moscow"'. Text by Harry Schwartz. *New York Times Book Review*, USA (25 Dec. 1955), p. 10.
'Raymond Cartier nous câble de Hong-Kong et montre à travers propagande et barbelé le farouche visage de la Chine Rouge'. Text by Raymond Cartier. *Paris Match*, n° 309 (1955), pp. 16–21.

1956. 'L'épiphanie en Italie, depuis deux mille ans, Befana court après les rois mages!' *Pour Tous*, Switzerland (3 Jan. 1956), n.p.
'La France vue au microscope'. Text by Béatrice Beck. *L'Express*, France (24 Jan. 1956), p. 8.
'Jean-Paul Sartre en Chine, ou les cynismes d'un mandarin'. *Demain*, France (Jan. 1956), n.p.
'Portugal'. Text by V.S. Pritchett. *Holiday*, USA (Jan. 1956), pp. 26–34, 80.
'Vienna is Vienna again.' *Harper's Bazaar*, USA (Jan. 1956), pp. 89–93.
'Le gourou m'a dit "Dieu est en vous"'. *Réalités*, France (Feb. 1956), pp. 58–65.
'Portugal'. *Harper's Bazaar* (Feb. 1956), pp. 26–34, 80.
'Is it safe to get sick in London?' Text by Richard Gordon. *Holiday* (Apr. 1956), p. 26.
'London… magnificent… muddled… mad… fascinating'. Text by V.S. Pritchett. *Holiday* (Apr. 1956), pp. 36–40.
'London's Best Dining'. Text by Ian Fleming. *Holiday* (Apr. 1956), pp. 40–44.
'London's Minor Royalty'. Text by H. F. Ellis. *Holiday* (Apr. 1956), pp. 48–51.
'John Christie of Glyndebourne'. Text by Peter Heyworth. *Harper's Bazaar* (June 1956), pp. 94, 114–115.
'La Seine'. Text by Pierre Joffroy. *Paris Match*, n° 379 (14 July 1956), pp. 34–45.
'Zu den Photographien von Henri Cartier-Bresson'. Text by Manuel Gasser. *Werk* (July 1956), pp. 226–231.
'… und Heiterkeit im Blick; die Welt lyrisch'. *Berliner Illustrierte*, Germany (25 Aug. 1956), pp. 6–8.
'Här presentera's "virkdebs bäste fitigraf" – Se haus bilder på mittusppslaget! Bresson plåtar alla – vill vara anonymn'. Text by Carl-Olaf Lång. *Expressen*, Finland (12 Sept. 1956), p.4.
'Henri Cartier-Bresson, bildberättar i expressen om sverige! Valmöte eller är det kanske "söndagsskola?"' *Expressen* (12 Sept. 1956), pp. 14–15.
'Henri Cartier-Bresson debut-titar på Sverige, Norrland'. *Expressen* (23 Sept. 1956), pp. 10–11.

'Henri Cartier-Bresson debut-titar på Sverige, Stockholm'. *Expressen* (25 Sept. 1956), p. 10.
'Henri Cartier-Bresson debut-titar på Sverige, Göteborg'. *Expressen* (26 Sept. 1956), p. 10.
'Henri Cartier-Bresson debut-titar på Sverige, Norrland'. *Expressen* (27 Sept. 1956), p. 9.
'Henri Cartier-Bresson debut-titar på Sverige, Mästerfotografen "strövar runt, träffar folk i norr och i" söder, ett halvdussin bilder berättar'. *Expressen* (6 Oct. 1956), pp. 16–17.
'Die Seine. Die entthronte Konigin Frankreichs'. Text by Paula Wehr. *Radio Osterreich*, Austria (6 Oct. 1956), pp. 34–35.
'Tre occhiate a Mosca di un grande fotografo'. *Corriere d'Informazione*, Italy (10–11 Oct. 1956), p. 9.
'Croisière en URSS'. Text by Maurice Ricord. *La Revue des Voyages*, n° 20, France (1956), n.p.
'The Rhine; a storied river helps to revive the economy of western Europe'. Text by Ferdinand Kuhn. *The Lamp*, vol. 38, n° 4, USA (Winter 1956), pp. 9–16 and cover.
'De Seine van bron tot monding'. *Zondagsvriend*, Belgium (1956), pp. 12–17.
'Kardinal Wyszynski in triomf teruggekeerd. Polen bleef trow a an zijn geloot'. *Zondagsvriend* (1956), pp. 17–23.

1957. 'La Pologne se réveille: le témoignage photographique d'Henri Cartier-Bresson'. *Paris Match*, n° 404, France (5 Jan. 1957), pp. 14–25.
'Warsaw: Russia comes to terms'. *Picture Post*, UK (7 Jan. 1957), pp. 8–9.
'New Trials for the "Traitors"'. *Picture Post* (7 Jan. 1957), pp. 10–11.
'Pamplona'. *The Sketch*, UK (16 Jan. 1957), p. 63.
'Polen väljer frihet'. *Se*, Sweden (18 Jan. 1957), p. 8.
'Poland's youth debates'. *New York Times Magazine*, USA (20 Jan. 1957), pp. 12–13 and cover.
'Polen zwischen Hoffnung und Enttäuschung'. *Schweizer Illustrierte Zeitung*, Switzerland (21 Jan. 1957), pp. 2–3.
'De tva makterna: gud och Gomulka'. *Se* (Jan. 1957), pp. 17–21.
'Kirke og stat-idyllen i Polen'. *Aktuell*, Norway (2 Feb. 1957), pp. 13–15.
'Polen glaubt an "seine zukunft"'. *Hören und Sehen*, Germany (10–16 Feb. 1957), pp. 2–3.
'Eindrücke in Polen'. Text by Philipp Wiebet. *Aufwärts*, Germany (15 Feb. 1957), pp. 9–10.
'Arlette Rémy, die kleine Ballettratte'. *Sie und Er*, Switzerland (4 Apr. 1957), pp. 29–31.
'Home folks are right there as Nebraska's laws are made; the legislature faces the people'. *Life*, USA (15 Apr. 1957), pp. 40–47.
'A Perceptive Frenchman's camera records U.S. Democracy at Work. The Legislature faces the

people'. *Life* [International edition] (May 1957), pp. 16–23.
'Het Klein Wereldrijk. Zo'n Kleine Rat'. *De Katholieke Illustratie*, Belgium (6 July 1957), pp. 2–4 and cover.
'One city one game'. *Sports Illustrated*, USA (8 July 1957), pp. 15–25.
'Pilgrims of the USA visiting their capital'. *Life* (8 July 1957), pp. 76–83.
'The Magnificent Rhine'. *Pageant* (Sept. 1957), pp. 26–35.
'La crise vécue dans l'intimité par un grand photographe: Cartier-Bresson, l'épisode Pinay'. Text by Jean Farrau. *Paris Match* (26 Oct. 1957), pp. 42–49.
'La storia economica dell'URSS'. *Cultura Moderna*, Italy (Nov. 1957), pp. 2–4 and cover.

1958. 'Two great resorts – a candid look: Miami, Palm Beach are poles apart'. *Life*, USA (20 Jan. 1958), pp. 87–94.
'De Wereld van het kind Arlette'. *Zondagsvriend*, n° 6, Belgium (6 Feb. 1958), pp. 8–11.
'One hundred years after the miracle'. *Sunday Graphic*, UK (16 Feb. 1958), pp. 12–13.
'Two great resorts – a candid look: A Frenchman contrasts Miami, Palm Beach'. *Life* [International edition] (17 Feb. 1958), pp. 57–63.
'Hundert Jahre Lourdes'. *Sie und Er*, Switzerland (20 Feb. 1958), p. 28.
'Karneval in Köln'. *Du*, Switzerland (Feb. 1958), pp. 8–11.
'Lourdes: Année 100'. Text by Robert Serrou and Pierre Vals. *Point de Vue: Images du Monde*, France (Feb. 1958), pp. 66–75.
'Lourdes'. *Settimo Giorno*, Italy (6 Mar. 1958), pp. 27–35.
'Hofball in Brussel'. *Sie und Er* (Apr. 1958), pp. 45–47.
'Il Re malinconica ha scelto la più timida?' *Epoca*, Italy (27 Apr. 1958), p. 28 and cover.
'Young women of Russia'. Text by Julia Edwards. *Mademoiselle*, USA (Apr. 1958), pp. 132–135.
'Leopold und Liliane kamen in den Saal… und die Musik brach ab'. *Weltbild*, Germany (1 May 1958), p. 3.
'Het bal van de eeuw'. *Panorama*, n° 18 (3 May 1958), pp. 24–26.
'Zesduizend gasten voor de Koning. Hofbal in Brussel na vijfentwintig jaar'. *De Katholieke Illustratie*, n° 18, Belgium (3 May 1958), pp. 22–28.
'Brussels Ball'. *Der Stern*, Germany (3 May 1958), p. 10.
'De koning danste een slow'. *Libelle*, Germany (10 May 1958), pp. 88–92.
'Où en sont les Américains'. Text by Raymond Cartier. *Paris Match*, France (10 May 1958), pp. 34–46.
'Voor enkele uren herleefde een sprookje'. *Beatrijs*,

n° 19, Belgium (10 May 1958), pp. 24–27.
'Les Américains vus par Henri Cartier-Bresson'. *Paris Match*, (17 May 1958), pp. 40–49.
'Un promeneur dans l'exposition Cartier-Bresson'. *Paris Match* (May–Oct. 1958), pp. 54–66. [Special edition on the exhibition 'Bruxelles 54'.]
'L'Obbiettivo di Cartier-Bresson puntato sugli Stati Uniti: I "teen" americani'. Text by Henri Cartier-Bresson. *Epoca* (5 June 1958), pp. 16–23.
'La Seine: das Leben eines Stromes'. *Du*, vol. 18, n° 6 (June 1958), pp. 3–52 and cover.
'Wallfahrt nach Lourdes'. Text by Vilma Sturm. *Frankfurter Allgemeine Bilder und Zeiten*, Germany (5 July 1958), n.p.
'Houston – photographs by Henri Cartier-Bresson'. *Intercom*, USA (Aug. 1958), p. 4.
'The Communist mold'. *Real*, [UK edition] (Sept. 1958), pp. 11–37.
'Americano ma non tranquillo'. *Epoca*, n° 418 (5 Oct. 1958), n.p.
'Edelsteine werden versteigert: vier Photos aus New York von Henri Cartier-Bresson'. *Du* (Nov. 1958), pp. 26–30.
'Pie XII'. *Point de Vue: Images du Monde* (1958), n.p.
'Henri Cartier-Bresson'. *Photography*, UK (1958), pp. 28–33.

1959. 'Les Chinois, an X de leur révolution'. *Paris Match*, n° 508, France (3 Jan. 1959), pp. 22–39.
'Il termitaio cinese'. Text by Raymond Cartier. *Epoca*, Italy (4 Jan. 1959), pp. 64–75 and cover.
'Red China Bid for a future: Young and old join in "The Great Leap Forward"'. *Life*, USA (5 Jan. 1959), pp. 44–61 and cover.
'Red China revisited: chapter one: Henri Cartier-Bresson: first impressions'. *The Queen*, UK (6 Jan. 1959), pp. 32–43 and cover.
'Henri Cartier-Bresson'. Text by Peggy Delius. *Amateur Photography*, UK (7 Jan. 1959), pp. 2–7.
'Les Chinois, an X de leur révolution: (part 2)'. *Paris Match*, n° 509 (10 Jan. 1959), p. 38.
'Unser großer Dokumentar – Bericht Hinter dem Bambusvorhang von Rotchina'. *Bunte Deutsche Illustrierte*, Germany (17 Jan. 1959), pp. 4–7.
'Le Piramidi di Mao'. Text by Raymond Cartier. *Epoca* (18 Jan. 1959), pp. 64–75.
'China's thirst for power: Red China revisited: chapter two'. *The Queen* (20 Jan. 1959), pp. 27–37.
'Images des USA, Washington by Cartier-Bresson'. *Informations et Documents*, France (1 Feb. 1959), p. 36.
'China's drive for self-improvement: Red China revisited: chapter three'. *The Queen* (3 Feb. 1959), pp. 36–45.
'Pietro Nenni, vu par Henri Cartier-Bresson'. *L'Express*, France (26 Feb. 1959), pp. 6–13 and cover.
'Peking tadelt… inkorrekte Denklinie: Die

Volkskommunin waren ubereilt. Mao muß zurückpfeifen…'. *Bunte Deutsche Illustrierte* (Feb. 1959), pp. 8–11.
'L' entretien des 3 à Londres'. *L'Express* (5 Mar. 1959), pp. 9–13.
'Rotchina – das Grösstevolk in Waffen'. *Bunte Deutsche Illustrierte* (7 Mar. 1959), pp. 8–11.
'New York: les grandes cités – IX'. Text by Art Buchwald. *Jours de France*, France (28 Mar. 1959), p. 47.
'William Faulkner'. *Lilliput*, Germany (Mar. 1959), p. 26.
'The deciding eye'. *Lilliput* (Mar. 1959), p. 40.
'When the steppe is green, wrestle!' *Sports Illustrated*, USA (6 Apr. 1959), p. 20.
'Red China report: part 1'. *Pix*, Australia (11 Apr. 1959), pp. 19–24.
'Malraux et la grandeur'. Text by J.-J. Servan-Schreiber. *L'Express* (16 Apr. 1959), p. 5.
'China's drive for self improvement. Red China report: part 2: a swift change from old to new'. *Pix* (18 Apr. 1959), pp. 16–21.
'Henri Cartier-Bresson photographs Queen Charlotte's Ball'. *The Queen* (26 May 1959), pp. 41–45.
'Begegnung mit der Chinesin'. Text by Pater Franz Eichinger. *Sie und Er*, Switzerland (28 May 1959), pp. 9–11.
'Vijf jaar gelden viel het doek over de Chinese Burgeroolog'. *Zondagsvriend*, Belgium (3 July 1959), pp. 16–19.
'The sky's the limit: New York'. Text by Art Buchwald. *The Queen* (7 July 1959), pp. 18–19.
'USA réveille-toi'. Text by Michel Drancourt. *Réalités*, France (July 1959), pp. 28–39.
'Praline beriebtet über die schönsten Städte der Welt New York'. Text by Art Buchwald. *Praline* (5 Aug. 1959), pp. 36–42.
'L'infernale eredita del pittore Bonnard.' *Epoca*, (9 Aug. 1959), pp. 58–61.
'Frankreich-Heute'. Text by Armin Mohler. *Madame* (Oct. 1959), pp. 104–112.
'Menschen in New York'. Text by Art Buchwald. *Du*, Switzerland (Dec. 1959), pp. 72–81, 94.
'China in de smeltkroes. Wereldhaven Sjanghai onderging metamorfose'. *Zondagsvriend* (1959), pp. 20–24.
'China – das Land, das selbst Chruschtschew fürchtet'. *Sie und Er*, n° 12 (n. d.), p. 9.
'China will Industrie macht werden'. *Sie und Er*, n° 18 (n. d.), p. 13.

1960. 'Matisse in a Masterpiece: Speaking of Pictures'. *Life*, USA (25 Jan. 1960), pp. 8–9.
'The classical river of France: the Rhône'. Text by Lawrence Durrell. *Holiday*, USA (Jan. 1960), pp. 68–73, 115–121.

'One-Man Show: Henri Cartier-Bresson Photojournalist'. Text by Peter Pollack. *Leica Photography* [UK edition] (Jan. 1960), pp. 6–9.
'El Arte de H. Cartier-Bresson'. Text by C. Perez Gallego. *Cuadernos de Arte y Pensamiento*, n° 3, Spain (Feb. 1960), pp. 84–88.
'Henri Cartier-Bresson Revisited: A 14-Page Portfolio'. *35 mm Photography*, USA (Mar. 1960), pp. 122–134.
'L'Homme: L'éternel Don Juan'. *Marie France*, France (May 1960), p. 41.
'Garten Europas: Portugal'. *Praline*, Germany (21 June 1960), n.p.
'Les Paysans sont-ils condamnés à mort? Cartier-Bresson un drame inconnu en marge des routes nationales'. *Paris Match*, France (25 June 1960), pp. 52–65.
'Rome a Republican vigor'. Text by Aubrey Menen. *Holiday* (July 1960), pp. 66–73.
'Visita a 700 milioni di cinesi: il presente non è facile ma il passato è stato peggiore'. Text by Raffaello Uboldi. *Settimo Giorno*, Italy (4 Aug. 1960), pp. 26–28 and cover.
'People are talking about… Marilyn Monroe and Clark Gable'. *Vogue*, New York (15 Sept. 1960), p. 157.
'La prière du monde'. *Plaisir de France*, France (Special edition, Dec. 1960), p. 6.
'Où vous vous prosternez, vous trouverez Dieu'. *Plaisir de France* (Dec. 1960), pp. 9–16.
'To hear some masters of music at home'. Text by John Conly. *Vogue*, New York (Dec.1960), pp. 126–127.
'Henri Cartier-Bresson. Vision of America'. Text by Beaumont Newhall. *Art in America*, USA (1960), p. 79.
'The changing balance of power'. Text by Max Beloff. *Steel Review*, USA (1960), pp. 2–4.
'Le flâneur des deux rives'. *Asahi Camera*, n° 1, Japan (1960), p. 50.

1961. 'Naples.' *Holiday*, USA (Jan. 1961), pp. 62–69, 142–145.
'Why do people keep going back to Ireland?' *GO*, USA (Jan. 1961), pp. 42–44.
'The Disciplines of Henri Cartier-Bresson'. Text by Judith Holden. *Infinity*, USA (Feb. 1961), pp. 3–17 and cover.
'Touch of Greatness: Julie Harris: American actress extraordinary'. *The Queen*, UK (29 Mar. 1961), pp. 41–45.
'Max Ernst'. *Harper's Bazaar*, USA (Mar. 1961), pp. 132–133.
'People are talking about… Mr. and Mrs. Edward Steichen'. *Vogue*, New York (1 Apr. 1961), pp. 123–124 and cover.
'Touch of Greatness: The first American music

man Leonard Bernstein'. *The Queen*, (26 Apr. 1961), pp. 52–57.

'Porträtaufnahmen von Henri Cartier-Bresson'. *Du*, vol. 21, n° 4, Switzerland (Apr. 1961), pp. 1–40.

'Touch of Greatness: Arthur Miller'. *The Queen* (10 May 1961), pp. 90–97.

'Touch of Greatness: Papadimitriou'. *The Queen* (12 June 1961), pp. 100–105.

'Touch of Greatness: Hugh Cudlipp'. *The Queen* (21 June 1961), pp. 50–55.

'Touch of Greatness: Ballerina of fire and snow: Svetlana Beriosova'. *The Queen* (6 July 1961), pp. 54–59.

'Quel decisivo venticinquesimo di secondo'. Text by Yvonne Baby. *Il Giorno*, Italy (31 July 1961), n. p.

'Report from Mongolia'. *San Francisco Chronicle*, USA (31 July 1961), p. 1.

'The natural American'. *Holiday* (July 1961), pp. 34–47.

'Touch of Greatness: Jerome Robbins: American master of modern choreography'. *The Queen* (2 Aug. 1961), pp. 20–25.

'Daimler-Benz: Quality über Alles'. Text by Robert Sheehan. *Fortune*, USA (Aug. 1961), p. 86 and cover.

'De Gaulle: voyage "Suspense"'. *Paris Match*, France (30 Sept. 1961), pp. 47–51.

'Como ho visto la Francia'. *Settimo Giorno*, Italy (10 Oct. 1961), pp. 20–25.

'Touch of Greatness: Scotty Reston'. *The Queen* (11 Oct. 1961), pp. 96–101.

'Det Regmer ol i Munchen'. *Aktuell*, Norway (28 Oct. 1961), pp. 32–33.

'Chi Po-Shih and the sorcerer'. Text by Oscar Mandel. *Harper's Bazaar* (Dec. 1961), pp. 92–93.

'Journey in Greece'. Text by V.S. Pritchett. *Holiday* (Dec. 1961), pp. 66–83.

'Heute im Reich des Dschingis Kahn: Mongolei'. *Praline*, n° 21, Germany (1961), pp. 56–62.

Internationale Musik – Festwochen [Lucerne] (1961), p. 2.

1962. 'Audiences Everywhere'. *Show*, USA (Jan. 1962), pp. 42–49 and cover.

'Conversazione "sulle rive della Senna"'. Text by Pietro Bianchi. *Il Giorno*, Italy (6 Feb. 1962), pp. 63–69.

'Touch of Greatness: Alain Robbe-Grillet'. *The Queen*, UK (13 Feb. 1962), pp. 34–39.

'Prime mover of the Common Market: Jean Monnet'. *Vogue*, New York (1 Mar. 1962), p. 120.

'Cuando la paz "estalla" en Argelia'. Text by Santiago Nadal. *La Actualidad Española* (29 Mar. 1962), pp. 16–17.

'Charles the Great'. *The Queen*, (1 May 1962), pp. 23–25.

'Touch of Greatness: Giacometti'. *The Queen* (1 May 1962), pp. 26–31.

'Au rendez-vous des misères'. Text by Alain Hervé. *Réalités*, France (May 1962), p. 82.

'Touch of Greatness: The two worlds of Menotti'. *The Queen* (19 June 1962), pp. 29–33.

'The Maugham explosion'. *Vogue*, New York (June 1962), p. 118.

'Henri Cartier-Bresson: Americans at Play'. *Camera 35*, UK (June–July 1962), p. 18.

'Dam Tegen de Honger'. Text by Chris Van Gurp. *Panorama* (21 July 1962), pp. 22–27.

'Faulkner'. *Vogue* (July 1962), pp. 70–73, 114.

'Mrs. Paul Mellon's garden in Virginia'. *Vogue*, New York (July 1962), pp. 52–55.

'The well-loved river'. *Horizon*, USA (July 1962), pp. 52–55.

'Doctor Spock talks with mothers: the child with one parent'. *Ladies' Home Journal*, UK (Summer 1962), pp. 30–32.

'Yes, mother, there is a Dr Spock'. *Ladies' Home Journal* (Summer 1962), pp. 34–36.

'Touch of Greatness: Lord Ted: the man with a hot seat among the ashes'. Text by Brian Glanville. *The Queen* (7 Aug. 1962), pp. 24–27.

'Jean Monnet'. *Vogue*, New York (15 Aug. 1962), pp. 100–103.

'The brothers Penn'. *Vogue*, New York (1 Sept. 1962), p. 186.

'Eton'. *Vogue*, New York (1 Sept. 1962), pp. 214–217.

'Touch of Greatness: A man of charity'. *The Queen* (4 Sept. 1962), pp. 33–37.

'Stieglitz and Cartier-Bresson'. Text by Dorothy Norman. *Saturday Review*, UK (22 Sept. 1962), pp. 52–56.

'A routine day in a Paris police station'. *Réalités* (Sept. 1962), n.p.

'Papadimitriou'. *Vogue*, New York (1 Oct. 1962), pp. 166–169.

'Der Osten'. *Magnum* [German edition] (Oct. 1962), p. 111.

'Irving Berlin: key man in the making of "Mr. President", the new semi-political musical'. *Vogue*, New York (1 Nov. 1962), pp. 144–147.

'Andrew Wyeth'. Text by Allene Talmey. *Vogue*, New York (15 Nov. 1962), pp. 118–121, 160.

'The importance of being Eton'. Text by Robert Kee. *Sunday Times* [London] (25 Nov. 1962), pp. 3–6, 9 and cover.

'China sliter – ag sulter'. *Aktuell*, n° 19 (1962), pp. 10–11.

'Berlijn – gfespleten stad'. *Zie Volgende Blz* (1962), pp. 3–7.

1963. 'The new year: the bad good films'. Text by Penelope Gilliatt. *Vogue*, New York (1 Jan. 1963), pp. 124–125, 155.

'Bostonian unique – Miss Sears'. Text by Cleveland Amory. *Vogue*, New York (15 Feb. 1963), pp. 80–83.

'Eton'. *Vogue*, Paris (Feb. 1963), pp. 56–61.

'A famous photographer inspects Communism's western outpost: this is Castro's Cuba seen face to face'. *Life*, USA (15 Mar. 1963), pp. 28–41.

'How Fidel Castro was bearded in his lair'. Text by George P. Hunt. *Life* (15 Mar. 1963), p. 3 and cover.

'An island of pleasure gone adrift'. Text by Cartier-Bresson. *Life* (15 Mar. 1963), pp. 42–43 and cover.

'Mrs. Guest and Monsieur Boudin'. *Vogue*, New York (1 Apr. 1963), pp. 148–149, 159.

'People are talking about... Joy Adamson'. *Vogue*, New York (1 Apr. 1963), p. 101.

'A Cuba, Tra Castro e i Russi'. *Epoca*, Italy (14 Apr. 1963), pp. 28–37.

'Cuba in camera'. *Sunday Times Colour Magazine*, UK (14 Apr. 1963), pp. 2–15.

'En la Cuba de Castro. Un Fotografo famoso observa la avanzada roja en Occidente'. Text by Henri Cartier-Bresson. *Life* [Spanish edition] (15 Apr. 1963), pp. 4–17 and cover.

'The man-machines may talk first to Dr. Shannon'. Text by Brock Brower. *Vogue*, New York (15 Apr. 1963), pp. 88–89, 138.

'Sardinia, a unique island hovering between old-fashioned banditry and jets'. *Vogue*, New York (15 Apr. 1963), pp. 106–109.

'Die Russen haben tins im Stich gelassen'. *Der Stern*, Germany (21 Apr. 1963), pp. 16–29.

'L'Amico de tutte le mamme'. *Successo*, Italy (Apr. 1963), pp. 32–35.

'In Grillet'. *Adam*, USA (June 1963), pp. 49–51.

'Blackpool: the English fun-and-chips holiday town'. Text by Shelagh Delaney. *Vogue*, New York (June 1963), pp. 100–103, 144.

'Ten years of Castro: Cubans debate their future'. *IPS Contact Sheet*, n° 2, USA (17 July 1963), n.p.

'Viaggio nella Cina di Mao Tse-Tung L'Eresia in Campagna'. Text by Roy MacGregor-Hastie. *L'Europeo*, Italy (28 July 1963), pp. 40–46.

'Henri Cartier-Bresson: das stille Amerika'. *Magnum* [German edition] (Aug. 1963), p. 8.

'The Buddhist way'. *New York Times Magazine*, USA (1 Sept. 1963), pp. 1, II.

'People are talking about... Edmund Wilson'. *Vogue*, New York (1 Sept. 1963), pp. 198–200.

'Photographs by Cartier-Bresson'. Text by Ralph Hattersley. *Infinity*, USA (Oct. 1963), pp. 4–11.

'I cani si vedono solo allo zoo.' Text by François Dubreuil. *Epoca*, Italy (3 Nov. 1963), pp. 60–68.

'Il nostro uomo all'avana'. Text by Graham Greene. *L'Europeo* (3 Nov. 1963), pp. 16–27.

'Enquête au Texas'. Text by Pierre and Renée Gosset. *L'Express*, France (12 Dec. 1963), pp. 18–19.

'L'Uomo dell'attesa'. *L'Europeo* (13 Dec. 1963), p. 28.

'Cartier-Bresson's "Lovers"'. Text by Manuel Gasser. *Leica Photography* [UK edition] (1963), pp. 192–197.
'China y los dos emperadores'. *La Actualidad Española*, n° 585, Spain (1963), pp. 36–40.
'La Liberazione…'. *L'Europeo*, n° 15 (1963), n.p.

1964. 'Nureyev: "Surely this is genius"'. *Vogue*, New York (1 Mar. 1964), pp. 126–127.
'Cold War – Trauma or Challenge?' Text by Dr. Benjamin Spock. *IPS Contact Sheet*, n° 27, USA (16 Mar. 1964), n.p.
'Das Bild der Photographie'. *Du*, Switzerland (Mar. 1964), pp. 34–35, 39.
'People are talking about… President Charles de Gaulle of France'. *Vogue*, New York (15 Apr. 1964), pp. 86–87.
'Admiral, the great Morgan horse, ridden by the Marquise de St. Innocent in the Spanish hills above Barcelona'. *Vogue*, New York (June 1964), pp. 130–132.
'Spain – A country of gravity and grace – a unity of contrasts'. *Vogue*, New York (June 1964), pp. 122–129.
'La Marquise de Saint-Innocent et son cheval Admiral photographiés par Henri Cartier-Bresson'. *Vogue*, Paris (Aug. 1964), pp. 44–45.
'No power in France was ever more solid'. Text by François Nourissier. *Vogue*, New York (1 Sept. 1964), pp. 178–179.
'La Chine vue et racontée par Henri Cartier-Bresson'. *Vogue*, Paris (Sept. 1964), pp. 254–259.
'Brittany: dragon country'. Text by Eleanor Clark, *Vogue*, New York (15 Oct. 1964), pp. 144–147, 204.
'Power People. On the premise that influence is irresistible, we set out to pin point purveyors of power'. Text by James Cameron. *Vogue*, New York (15 Oct. 1964), pp. 83–88.
'Germany'. *Holiday*, USA (Oct. 1964), pp. 44–55.
'The secret people'. Text by V.S. Pritchett. *Holiday* (Oct. 1964), p. 44.
'Both sides of the wall'. Text by Laurens Van der Post. *Holiday* (Oct. 1964), pp. 74–77.
'Paris en parle'. *Vogue*, Paris (Nov. 1964), pp. 116–117.
'En avant-première de sa prochaine grande exposition, trois reportages qui sont trois moments de l'histoire contemporaine dévoilent la richesse humaine de cet artiste'. *Réalités*, France (Christmas 1964), pp. 116–121.
'Cinq portraits de Henri Cartier-Bresson'. Text by Manuel Gasser. *Leica Fotografie*, [French edition] (1964) n.p.
'Recent works by H. Cartier-Bresson'. *Asahi Camera*, n° 12, Japan (1964), pp. 44–51.
'Senator Kennedy – wollen Sie ins Weisse Haus?' *Sie und Er* (1964), p. 8.

1965. 'Georges Auric; a second fame: good food'. Text by Ninette Lyon. *Vogue*, New York (15 Jan. 1965), pp. 116–118.
'A great French photographer records the mood of London'. *Sunday Times*, UK (31 Jan. 1965), n.p.
'Winston Churchill: The Last Journey: January 30, 1965'. *Sunday Times Magazine* (7 Feb. 1965), n.p.
'Churchill entierro de una epoca; eran las once de la mañana…' *La Actualidad Española*, Spain (11 Feb. 1965), pp. 30–39.
'The great craftsmen of Paris'. Text by Violette Leduc. *Vogue*, New York (15 Mar. 1965), pp. 80–82, 152.
'Visitée en 1964 par 24000 Français, vue ici par Henri Cartier-Bresson, voici la Turquie de toujours'. *Vogue*, Paris (Mar. 1965), pp. 184–189.
'A Paris, leur vie, leurs travaux'. *Vogue*, Paris (May 1965), pp. 98–101.
'Cacoyannis, une gourmandise fidèle à la Grèce'. *Vogue*, Paris (May 1965), pp. 106–107, 126.
'La gloire à vingt ans'. Text by François-Régis Bastide. *Vogue*, Paris (May 1965), pp. 94–95.
'Pakistans Wetterwinkel'. *National Zeitung Basel*, n° 433, Switzerland (26 Sept. 1965), n.p.
'Yugoslavia'. Text by Arno Karlen. *Holiday*, USA (Nov. 1965), pp. 42–55.
'Somerset Maugham Al Filo de la Muerte'. *La Actualidad Española* (16 Dec. 1965), n.p.
'Sir Winston Churchill's funeral'. *Asahi Camera*, n° 4, Japan (1965), n.p.

1966. 'Le flâneur des deux rives'. *Asahi Camera*, n° 1, Japan (1966), p. 50.
'Wo wohnt Gott in Frankreich heute?' Text by George Stefan Troller. *Epoca*, [German edition] (Feb. 1966), pp. 58–64.
'Univers Match: L'Inde face au XXᵉ siècle'. *Paris Match*, n° 900, France (7 Sept. 1966), pp. 43–58.
'Encore at the Louvre: Henri Cartier-Bresson'. Text by Margaret R. Weiss. *Saturday Review* (26 Nov. 1966), pp. 24–31.
'Shoot'Men'. *Vogue*, London (Nov. 1966), n.p.

1967. 'People are talking about… Edmonde Charles-Roux and her prize novel, Oublier Palerme'. *Vogue*, New York (15 Jan. 1967), pp. 86–87.
'Edmonde Charles-Roux, prix Goncourt 1966, photographiée chez elle par Henri Cartier-Bresson'. Text by Robert Kanter. *Vogue*, Paris (Jan. 1967), pp. 78–80.
'Henri Cartier-Bresson's Japan'. *Look*, USA (7 Feb. 1967), pp. 28–33.
'Japan'. Text by William Plomer. *The Queen*, UK (26 Apr. 1967), pp. 54–59.
'Kanada mit de Gaulles Augen'. *Die Woche*, Switzerland (Aug. 1967), n.p.
'Die Schweiz gesehen von Henri Cartier-Bresson'.

Text by Peter Bichsel and Manuel Gasser. *Du*, vol. 27, n° 8, Switzerland (Aug. 1967), pp. 582–648 and cover.
'Canada Colonia o Nazione'. *Vie Nuove*, Italy (Sept. 1967), n.p.
'Adieu à Georges Sadoul'. *Les Lettres Françaises*, France (18 Oct. 1967), cover.
'L'Inde éternelle'. *Plaisir de France*, France (Nov. 1967), pp. 24–31.
'People of a proud land'. *Holiday*, USA (Dec. 1967), p. 66.
'Cartier-Bresson et la photographie'. Text by Robert d'Hooghe. *Leica Fotografie* [French edition] (1967), p. 105.

1968. 'Le Plus Grand Photographe du Monde a filmé une Journée de Gisèle Halimi'. *Convention*, France (Feb. 1968), p. 8.
'Power complex: six studies in diversity of power, photographed by Henri Cartier-Bresson'. *Vogue* (Feb. 1968), pp. 82–87.
'The action is everywhere the black man goes'. Text by Herbert Lottman. *New York Times Book Review*, USA (21 Apr. 1968), section VII, p. 6.
'Grand Nord'. *Vogue*, Paris (Apr. 1968), p. 114.
'Paul Morand'. *Vogue*, Paris (Apr. 1968), pp. 106–107.
'Henri Cartier-Bresson: Objectif Israël'. *Sciences et Voyages*, France (Apr. 1968), pp. 22–25.
'Jean Genet o bom ladrao'. *Manchete*, Brazil (11 May 1968), pp. 152–153.
'Henri Cartier-Bresson paysages'. *Arts et Techniques Graphiques* (3 June 1968), pp. 161–170.
'Israel'. *Asahi Camera*, n° 6, Japan (1968), pp. 63–78.
'Le Canada pour l'unité M. Trudeau victorieux'. Text by Louise Desels. *TV*, Switzerland (4 July 1968), pp. 24–25.
'The eternal faces', *Holiday*, USA (July 1968), pp. 56–61.
'Mexico'. *Holiday* (July 1968), p. 56.
'1929–1939 Ein Jahrzehnt im Spiegelseiner Photographen'. Text by Manuel Gasser. *Du*, Switzerland (July 1968), pp. 470–480, 517.
'People are talking about… Claude Lévi-Strauss'. *Vogue*, New York (1 Aug. 1968), pp. 100–101.
'En Turquie avec Henri Cartier-Bresson'. *Photo Cinéma Magazine*, France (Aug. 1968), pp. 282–284.
'Grand Matisse and his daily life'. *Asahi Camera*, n° 8, (Aug. 1968), pp. 7–13.
'Vielschichtiges Mexiko'. *Neue Zürcher Zeitung*, Switzerland (29 Sept. 1968), pp. 55–57.
'Dix portraits d'Henri Cartier-Bresson'. *Constellation*, France (Sept. 1968), pp. 141–151.
'De la "laudatio" pour Henri Cartier-Bresson, Paris Lauréat du Deutsche Gesellschaft für Photografie in 1967'. Text by Henri Cartier-Bresson. *Camera*, Switzerland (Oct. 1968), pp. 18–31.

1969. 'Adieu les Halles'. Text by Edmonde Charles-Roux. *Constellation*, France (Feb. 1969), pp. 142–153.

'The hope of all the world'. *Illustrated London News*, UK (22 Mar. 1969), p. 18.

'From trivial to universal'. Text by Edward Mullins. *Sunday Telegraph*, UK (23 Mar. 1969), p. 15.

'La machine et l'homme ou photogénie'. Text by Boris Rybak. *Combat pour La Connaissance*, France (9 May 1969), pp. 1–4.

'Cartier-Bresson: O homem que cria um mundo novo em uma fracao de Segundo. (Conversation)'. Text by Nei Sroulevich. *Fatos e Fotos*, Brazil (15 May 1969), pp. 60–67.

'Paris skulle utplanas – han tog bildema!' Text by Lars C.G. Ericsson. *Sondags Expressen*, Finland (24 Aug. 1969), p. 4.

'Die Befrersing Europas'. *Die Woche* (27 Aug. 1969), pp. 4–7.

'Free at last: France 1944 as Henri Cartier-Bresson saw it'. *Look*, USA (23 Sept. 1969), p. 58.

'Cartier-Bresson reporter de la libération'. *Photo*, France (Sept. 1969), pp. 3–19.

'Deux Sœurs'. *Camera*, Switzerland (Sept. 1969), pp. 11, 41.

'La Libération 1944–1945'. *Camera Mainichi*, Japan (Sept. 1969), pp. 74–114.

'Ces Images Inconnues de 44–45, elles expliquent les tragédies de l'épuration'. *L'Aurore*, France (16 Oct. 1969), pp. 1, 18.

'Paris takes its revenge'. *Sunday Times Magazine* [London] (16 Nov. 1969), p. 38.

1970. 'Henri Cartier-Bresson's Japan'. *Travel and Camera*, UK (Mar. 1970), pp. 36–43.

'Asi termino en Europa les segunda guerra mundial: un testimonia gráfico, inédito y exclusivo, de final de la guerra tomado por la cámara de Cartier-Bresson'. *La Actualidad Española*, Spain (14 May 1970), pp. 4–7.

'Comment vivent les Français'. Text by Maurice Roy. *L'Express*, France (12–18 Oct. 1970), pp. 78–85 and cover.

'Leaders from 80 Nations join in day long farewell to de Gaulle'. Text by Richard Eder. *New York Times*, USA (13 Nov. 1970), pp. 1, 12.

'Most Quebeckers, though proud of differences, want to be Canadians too'. Text by Jay Walz. *New York Times* (14 Nov. 1970), p. 11.

'Con III – A Source of Hope'. Text by Arthur Naftalin. *New York Times* (14 Nov. 1970), p. 29.

'Un aristocrate de la photo, Henri Cartier-Bresson regarde vivre les Français'. Text by Jean Bothorel. *Vie Catholique*, France (18–24 Nov. 1970), pp. 31–33.

'Mesdames vous êtes formidables'. *France Soir Magazine*, France (23 Nov. 1970), p. 16.

'De Gaulle: l'ultimo saluto. A Colombey insieme col generale'. Text by Indro Montanelli. *Domenica del Corriere*, Italy (24 Nov. 1970), p. 30.

'Le Pèlerinage à Colombey-les-Deux-Eglises (suite)'. *Point du Vue: Images du Monde*, France (27 Nov. 1970), pp. 10–11.

'Le Salon permanent de la Photo: Henri Cartier-Bresson'. Text by Albert Plécy. *Point de Vue: Images du Monde* (27 Nov. 1970), pp. 18–19.

'Une année de reportage, le portrait d'un pays: "Vive la France"'. *Photo*, France (Nov. 1970), p. 26.

'To the Basques it is their uniqueness that is on trial in Spain'. Text by Richard Eder. *New York Times* (10 Dec. 1970), pp. 1, 16.

'Espagne: le procès'. *L'Express* (14–20 Dec. 1970), p. 62 and cover.

'Les Femmes aux Etats Généraux vues par Cartier-Bresson'. *Elle*, France (21 Dec. 1970), p. 52.

'Burgos! Burgos!'. Text by Santiago Carillo. *France Nouvelle*, n° 1311, France (23 Dec. 1970), p. 12.

'Elas querem Fazer uma revolucao Francesa'. Text by Flavio Costa. *Manchete*, Brazil (Dec. 1970), pp. 64–68.

'Zbor baska u sjeni stratista'. *VUS*, Yugoslavia (Dec. 1970), p. 20.

'Henri Cartier-Bresson l'homme et la machine'. *Asahi Camera*, n° 3, Japan (1970), pp. 101–116.

1971. 'Beautés'. *Vogue*, Paris (Dec. 1970–Jan. 1971), pp. 96–105.

'Dans le Grand Palais de Cartier-Bresson'. Text by Robert Doisneau. *Journalistes, Reporters, Photographes et Cinéastes*, France (Jan. 1971), pp. 4–5.

'Comment vivent les Israéliens'. *L'Arche*, France (26 Feb.–25 Mar. 1971), pp. 51–55.

'My house is paper… glued with love'. Text by Françoise Mallet-Joris. *Vogue*, New York (15 Mar. 1971), pp. 82–83.

'The house that Calder built (in Touraine)'. Text by Shusha Guppy. *Vogue*, London (1 Apr. 1971), pp. 130–134, 153.

'My France'. Text by François Nourissier. *Observer Magazine*, UK (11 Apr. 1971), p. 5.

'Le Salon Permanent de la Photo. Le Prix Nadar'. Text by Albert Plécy. *Point de Vue: Images du Monde*, France (16 Apr. 1971), pp. 18–19.

'Mary McCarthy'. *Harper's Bazaar*, USA (June 1971), pp. 92–93.

'Agosto; 1944 parigi libera, un reportage mai pubblicato de Henri Cartier-Bresson'. *Epoca*, Italy (10 Sept. 1971), n.p.

'Nobel in Literature won by Neruda, Chilean poet'. Text by Henry Raymont. *New York Times*, USA (22 Oct. 1971), pp. 1, 34.

'Vive la France'. *Asahi Camera*, n° 3, Japan (1971), p. 77.

1972. 'Jeunes vus par Henri Cartier-Bresson'. *Panorama aujourd'hui: Le Journal des Chrétiens d'Aujourd'hui*, France (Jan. 1972), p. 22.

'Children and machines'. *Observer Magazine*, UK (26 Mar. 1972), pp. 32–33.

'Künstlerporträts von Henri Cartier-Bresson'. *Du*, Switzerland (Mar. 1972), pp. 206–226.

'La Lorraine attend Pompidou'. *L'Express*, France (Apr. 1972), pp. 43–53.

'Photographs by Henri Cartier-Bresson'. *Creative Camera*, Switzerland (Apr. 1972), p. 113.

'Cristobal Balenciaga 1895–1952'. Text by Violette Leduc. *Vogue*, New York (May 1972), pp. 136–137.

'Paris où est-ce, qui est-ce, et quoi?' Text by Henri Lefèbvre. *Politique*, France (29 June 1972), pp. 15–19 and cover.

'Inédit: Les "Erotiques" de Cartier-Bresson'. Text by Yves Bourde. *Photo*, n° 57, France (June 1972), pp. 74–81, 126.

'Cartier-Bresson sur les chemins de l'Asie'. *Photo* (1972), n.p.

'L'enfant et la machine'. *Photo* (Sept. 1972), p. 37.

1973. 'Lip, ça marche sans eux!' Text by Anouar Khaled. *Politique Hebdo*, France (28 June 1973), pp. 3–5 and cover.

'La vente chez Lip, un reportage de Henri Cartier-Bresson'. *L'Express*, France (2–8 July 1973), pp. 30–32.

'Wedding day by Cartier-Bresson'. *Sunday Times*, UK (18 Nov. 1973), p. 5.

'URSS 1973 par Henri Cartier-Bresson'. *L'Express* (19–25 Nov. 1973), p. 132.

'L'URSS de Cartier-Bresson'. *Photo*, n° 75, France (Dec. 1973), pp. 98–115.

'The Decisive Moment: Henri Cartier-Bresson'. *Scholastic Magazine*, USA (1973), pp. 72–83 and cover.

1974. 'A return visit after two decades, USSR by Cartier-Bresson'. *Photo World* (Apr. 1974), p. 80.

'The Decisive Moment: Henri Cartier-Bresson: Discussion and project ideas'. *Scholastic Magazine: Images of Man*, n° 2, USA (May 1974), p. 72 and cover.

'Zeichnungen und Malereien von Henri Cartier-Bresson'. Text by Manuel Gasser. *Du*, n° 399, Switzerland (May 1974), pp. 54–65.

'Henri Cartier-Bresson: La Basilicata'. Text by Rocco Mazzarone and Arnold Niederer. *Du*, vol. 34, n° 7 (July 1974), p. 6 and cover.

'A Taste of Russia'. Text by Henri Cartier-Bresson. *Observer*, UK (Aug. 1974), pp. 34–39.

'At last a photography museum'. Text by Gene Thornton. *New York Times*, USA (17 Nov. 1974), p. 38.

1975. 'Le Bonnard que vous n'avez jamais vu'. Text by Alain Delgrand. *Paris Match*, France

(26 July 1975), pp. 36–39.
'La photo c'était Paris'. *Photo*, France (Nov. 1975), p. 56.
'Henri Cartier-Bresson: about Russia'. *Camera Mainichi*, n° 3, Japan (1975), p. 23.

1976. 'Douze dessins de Henri Cartier-Bresson'. Text by Bruno Queysanne. *Arch*, n° 1, France (Apr. 1976), pp. 2–4.
'Sur les dessins de HCB'. *Arch*, n° 1 (Apr. 1976), pp. 15–16.
'With Liberty and… uh… uh…'. Text by Leonard Woodcock. *New York Times*, USA (1 May 1976), p. 23.
'Cartier-Bresson: Le Hasard Objectif'. Text by Gilles Plazy. *Les Nouvelles Littéraires*, France (8 July 1976), p. 17.
'Coup d'œil américain'. Text by Lincoln Kirstein and Allan Porter. *Camera*, vol. 55, n° 7, Switzerland (July 1976), pp. 3–46.
'Des trucs pour vos vacances, illustrés par Henri Cartier-Bresson'. *Photo*, n° 107, France (Aug. 1976), pp. 28–31.
'Cartier-Bresson por los caminos de Asia'. *Photo Español*, n° 14, Spain, p. 20.
'Coup d'œil Américain'. *Camera Mainichi*, n° 10, Japan (1976), pp. 69–83.
'CB: El Fotografo del Instante Decisivo'. *Photo Son*, n° 6, Spain (1976), pp. 20–33, 74.
'"Ese Querido Henri" Por Claude Roy'. Text by Claude Roy. *Photo Son*, n° 6 (1976), pp. 70–71.
'Henri Cartier-Bresson a rafagas'. *Photo Son*, n° 6 (1976), p. 72.
'HCB visto por Henri Cartier-Bresson'. *Photo Son*, n° 6 (1976), p. 73.

1977. 'Photo essay: Calder by Henri Cartier-Bresson'. *Bijutsu techo*, Japan (Feb. 1977), n.p.
'Le Nord vu par Henri Cartier-Bresson'. *L'Express*, France (30 May–5 June 1977), pp. 86–89.
'Henri Cartier-Bresson: le maître depuis quarante ans'. *Photo*, France (Aug. 1977), pp. 10–17, 75.
'Réflexions sur le portrait photographique'. Text by Jean Thibaudeau and Jean-François Chevrier. *Le Nouvel Observateur: Spécial Photo*, n° 2 special edition, France (Nov. 1977), pp. 30–39.

1978. 'Comme à vingt ans, Henri Cartier-Bresson'. *Photo*, France (May 1978), pp. 46–55.
'Henri Cartier-Bresson'. *Il Fotografo*, Italy (May 1978), pp. 82–88.
'La pyramide renversée'. Text by Danièle Sallenave. *Le Nouvel Observateur: Spécial Photo*, n° 3 special edition, France (June 1978), pp. 26–31.
'Selected works of HCB'. *Asahi Camera*, n° 6, Japan (June 1978), pp. 175–182.
'Während sie Ferien machen, müss ihre Kamera arbeiten'. *Photo* [German edition] (June 1978), pp. 44–48.
'La longue marche de Cartier-Bresson'. Text by André Fermigier. *Le Nouvel Observateur* (12 Oct. 1978), p. 38.
'Cartier-Bresson'. *U.S. Camera* (Autumn 1978), p. 18.
'Selected works of Henri Cartier-Bresson'. *Asahi Camera*, n° 6 (1978), pp. 175–182.

1979. 'Jeanne Moreau: elle a sacrifié son bonheur pour réussir son film'. Text by Philippe Bouvard. *Paris Match*, n° 1549, France (2 Feb. 1979), pp. 24–25.
'Comme un feu discret sous la cendre: quinze propositions de l'insolite en photographie'. Text by Danièle Sallenave. *Le Nouvel Observateur: Spécial Photo*, n° 5 special edition, France (Mar. 1979), pp. 6–11.
'Une aventure de Freddy la Bougeotte'. Text by Silvain Roumette. *Le Nouvel Observateur: Spécial Photo*, n° 5 special edition (Mar. 1979), pp. 12–15.
'Manuel Gasser 1909–1979'. *Du*, Switzerland (Oct. 1979), p. 1.
'Henri Cartier-Bresson de Paris'. Text by Gilles Neret. *Connaissance des Arts*, France (Dec. 1979), pp. 86–93.

1980. 'Master of the moment', *Quest/80* (Jan. 1980), p. 40.
'HCB: C'est sa photo de l'année'. *Photo* n° 150, France (Mar. 1980), p. 6.
'Marilyn ses photographies interdites'. *Photo*, n° 153, (June 1980), pp. 38–47, 114.
'Vive la Photo: Rencontre avec Henri Cartier-Bresson'. Text by Hervé Guibert. *Le Monde*, France (30 Oct. 1980), pp. 17–23.
'HCB: Musée d'Art moderne de la Ville de Paris: l'Exposition Capitale du Mois de la Photo'. *Photo*, n° 158, France (Nov. 1980), p. 52.

1981. 'In Grace with History'. Text by Sadnan Menon. *Indian Express*, India (7 Feb. 1981), p. 14.
'A la mémoire de Manuel Gasser'. Text by Henri Cartier-Bresson. *Du*, Switzerland (Mar. 1981), p. 77.
'Henri Cartier-Bresson'. Text by Carl-Adam Nycop. *Aktuell*, Norway (1981), pp. 41–45.

1982. 'Hortense Cartier-Bresson: A 24 ans le "singe savant" du piano affronte Paris'. Text by Robert Serrou. *Paris Match*, France (14 May 1982), pp. 72–73.
'Vorsicht Kamera'. Text by Peter Sager. *Zeit* (4 June 1982), pp. 8–18.
'Henri Cartier-Bresson'. Text by Gunter Metken. *Frankfurter Allgemeine Magazin*, Germany (6 Aug. 1982), pp. 6–12.
'Henri Cartier-Bresson'. Text by John Morris.

Exposure, vol. 20, n° 2, USA (second quarter 1982), pp. 16–17.
'Washington'. *Exposure*, vol. 20, n° 2 (second quarter 1982), pp. 26–27.

1983. 'Photographie, la tête, l'œil et le cœur. Henri Cartier-Bresson: une approche efficace et discrète'. *Illustré*, France (9 Feb. 1983), pp. 1–10.
'Henri Cartier-Bresson: Portraits d'Artistes'. *L'Hebdo*, France (24 Feb. 1983), pp. 36–37.
'Le Grand Révélateur'. Text by André Pieyre de Mandiargues. *Le Nouvel Observateur*, France (25 Feb. 1983), pp. 68–69.
'Gandhi, wo bist du?' Text by Ronald Sondergger. *Schweizer Illustrierte Zeitung*, Switzerland (11 Apr. 1983), pp. 32–37.
'L'ultima sera con Gandhi, mio nonno'. Text by Mino Guerrini. *Epoca*, Italy (22 Apr. 1983), pp. 32–37.
'Balanchine le chorégraphe immortel'. *Illustré* (18 May 1983), pp. 44–47.

1984. 'Henri Cartier-Bresson Viaggio in Italia'. Text by Giovanna Calvenzi. *Il Fotografo*, Italy (Feb.1984), pp. 54–61.
'Cartier-Bresson: photographer; a grand-master's work in Asia. Photographs from Magnum, Paris'. *Pacific: the Magazine for American Express Card Members* (July–Sept. 1984), pp. 8–16.
'Paris le 25 août 1944: Des photos derrière les vélos'. Text by Henri Cartier-Bresson. *Libération*, France (24–25 Aug. 1984), pp. 15–17.
'Teneré Istantanée'. *Photo*, Italy (Oct. 1984), pp. 102–107.
'Cartier-Bresson: Paris sans défaut'. *Clichés* (Nov. 1984), pp. 24–31.
'HCB. Photos et dessins accompagnés d'un Text by Julien Levy'. *Le Bucentaure*, n° 6–7 (fourth quarter 1984), France, pp. 29–50.
'Paris à vue d'œil'. Text by André Pieyre de Mandiargues. *Magazine Photo*, n° 57, France (Nov. 1984), pp. 104–113.

1985. 'Pierre Bonnard'. Text by Margit Hahnloser-Ingold. *Du*, Switzerland (Jan. 1985), pp. 22–53.
'Cartier-Bresson rue des Italiens'. *Le Monde Aujourd'hui*, France (17–18 Mar. 1985), pp. XII 198.
'Eye for an Image'. Text by Tom Hopkinson. *Sunday Telegraph Magazine*, UK (3 Nov. 1985), pp. 44–49.
'Cartier-Bresson: l'Œil du siècle'. Text by Jean-Dominique Bauby. *Paris Match*, France (8 Nov. 1985), pp. 3–5.
'Contre-Jours'. *L'Equipe Magazine*, France (16 Nov. 1985), pp. 56–59.
'Cartier-Bresson en Inde'. *Magazine Photo*, n° 67, France (Nov. 1985), pp. 46–51, 98.

1986. *Les Cahiers de la Photographie*, n° 18, France (Jan. 1986), issue entirely devoted to Henri Cartier-Bresson.
'Henri Cartier-Bresson'. pp. 5–159.
'L'Instant Décisif'. Text by Henri Cartier-Bresson. pp. 9–20.
'Meurtres dans un jardin français'. Text by Christian Phéline. pp. 21–34.
'A propos d'Henri Cartier-Bresson'. Text by Jean Kempf. pp. 35–48.
'Le Dessin d'HCB'. Text by Jean-Claude Lemagny. pp. 49–69.
'Henri Cartier-Bresson'. Text by Julien Levy. pp. 70–71.
'Le Grand Jeu'. Text by Gilles Mora. pp. 72–76.
'Pierre de Fenoyl: Entretien'. Text by Pierre de Fenoyl and Anne Baldassari. pp. 77–82.
'Esthétique du discontinu'. Text by Eric Bullot. pp. 83–87.
'Mais où est passé le chat de Steinberg?' Text by Patrick Roegiers. pp. 88–93.
'Le Temps d'une photographie'. Text by Jean Arrouye. pp. 94–99.
'Parcours d'une bibliographie'. Text by Gabriel Bauret. p. 100.
'Suite Espagnole n° 9. Hommage à Cartier-Bresson'. Text by Micheline Lo. pp. 107–109.
'Henri Cartier-Bresson: Une vision lyrique du monde'. Text by Ernst Haas. pp. 110–116.
'Henri Cartier-Bresson, Gilles Mora: Conversation'. Text by Gilles Mora. pp. 117–125.
'Entrevista con Henri Cartier-Bresson: Fotografare, che duro divertimento'. *Corriere della Sera*, Italy (9 Apr. 1986), p. 15.
'Nei suo disegni la chiave per capire le immagini'. Text by Carlo Bertelli. *Corriere della Sera* (9 Apr. 1986), p. 15.

1987. 'Artist's dialogue: Henri Cartier-Bresson. Drawing an old Passion'. Text by Michael Peppiat. *Architectural Digest*, USA (Jan. 1987), pp. 40–46.
'HCB Témoigne'. *Photo*, n° 233, France (Feb. 1987), pp. 88–89.
'HCB: Manifestazzioni studentsche'. *Photo*, Italy (Mar. 1987), pp. 74–75.
'Indien im Visier'. *Der Spiegel*, Germany (Apr. 1987), pp. 146–150.
'Henri Cartier-Bresson (Italian Portfolio)'. Text by Ferdinando Scianna. *Camera International*, Switzerland (Summer 1987), pp. 20–29.
'A Master with a double image. Cartier-Bresson: photojournalism or high art?' Text by Douglas Davis. *Newsweek*, USA (21 Sept. 1987), p. 53.
'Henri Cartier-Bresson Draughtsman and Photographer'. Text by Henri Cartier-Bresson. *Art International*, n° 1 (Autumn 1987), pp. 69–75.
'The most influential photographer alive today returns to his first love: painting, photographs and text'. Text by John Loengard. *Life*, USA (Dec. 1987), pp. 127–130.

1988. 'Protagonisti e idee: Henri Cartier-Bresson'. Text by Giorgio dal Bo. *Reflex*, Italy (July 1988), pp. 58–60.

1989. '150 ans de photographie de la première de Niépce à la dernière de HCB'. *Magazine Photo*, n° 100, France (Mar. 1989), pp. 42–43, 76–77.
'HCB: "J'ai toujours su que je serais peintre"'. Text by Pepita Dupont. *Paris Match*, France (23 Mar. 1989), p. 12.
'Autoritratto di un fotoreporter'. Text by Philippe Boegner. *La Repubblica*, Italy (25 Mar. 1989), pp. 13–15.
'Cartier-Bresson: Le Photographiste'. Text by Anne-Marie Morice. *Télérama*, n° 2047, France (5 Apr. 1989), pp. 14–15.
'Le réel épinglé de Cartier-Bresson'. Text by Marc Gantier. *Le Spectacle du Monde*, France (May 1989), pp. 64–67.
'Interview with Henri Cartier-Bresson'. Text by Amanda Hopkinson. *British Journal of Photography*, UK (26 Oct. 1989), pp. 12–19.
'Portfolio: Henri Cartier-Bresson'. Text by Dimitri Tzima. *Photographos*, n° 1, Greece (Dec. 1989), pp. 46–52.

1990. 'Balancing precision and movement'. Text by Jehanara Wasi. *The Times of India*, India (16 Apr. 1990), p. 12.
'Ritratto di un mito senza volto'. Text by Brunella Schisa. *Il Venerdi di Repubblica*, Italy (8 June 1990), pp. 124–129.
'Balthus dans son refuge, photographié par Henri Cartier-Bresson. Il possède une maison calme sur la montagne… et sait tellement de choses sur les jeunes filles'. Text by Jean Leymarie. *Paris Match*, France (15 Nov. 1990), pp. 106–115.

1991. 'La Fotografia es un beso muy calido Henri Cartier-Bresson Lo Imaginario, a partir de la natureleza'. Text by Alberto Anaut. *El Pais Semanal*, Spain (5–6 Jan. 1991), pp. 33–48 and cover.
'Bresson back on the button'. Text by Eammon McCabe. *Weekend Guardian*, UK (26–27 Jan. 1991), p. 10.
'A shot in the dark'. Text by Andrew Palmer. *Independent*, UK (14 Mar. 1991), p. 17.
'Legends: The secrets of their success: HCB'. *American Photo*, USA (July–Aug. 1991), p. 62.
'A World in his sights'. Text by Eric Ellis. *Sydney Morning Herald Magazine*, Australia (17 Aug. 1991), pp. 20–26.

'Bung Karno dan Indonesia di Kamera Bresson'. *Tempo*, Indonesia (17 Aug. 1991), pp. 49–50.
'Ia Merekam Pusi Kehidupan'. Text by Yudhi Soerjoatmodjo. *Tempo* (17 Aug. 1991), pp. 50–61.
'Dunia Hitam Putih Cartier-Bresson'. Text by Kunang Helmi. *Tempo* (17 Aug. 1991), pp. 62–64.
'Photographié par Henri Cartier-Bresson, le Dalaï-Lama nous reçoit au cœur du Périgord Noir, terre d'adoption du bouddhisme tibétain'. *Paris Match*, France (12 Sept. 1991), pp. 76–79.
'HCB: "Alle Americhe e ritorno"'. *Photo Italia*, n° 195, Italy (Sept. 1991), pp. 36–45.
'Cartier-Bresson's America'. Text by Bruce Bernard. *Independent Magazine*, UK (12 Oct. 1991), pp. 70–73.
'America por Cartier-Bresson'. Text by Maria Antolin Rato. *Revista El Sol*, Spain (20 Oct. 1991), pp. 20–27 and cover.
'America al Pasar'. Text by Arthur Miller. *Revista El Sol* (20 Oct. 1991), p. 28 and cover.
'Ver y Sentir'. Text by Henri Cartier-Bresson. *Revista El Sol* (20 Oct. 1991), p. 28 and cover.
'Les regards de peintre d'Henri Cartier-Bresson'. Text by Pepita Dupont. *Paris Match* (14 Nov. 1991), p. 3.
'L'Amérique d'un libertaire'. Text by Patrick Roegiers. *Le Monde*, France (21 Nov. 1991), pp. 20–21.
'Flaneur in Amerika: Henri Cartier-Bresson'. Text by Klaus Honnef. *Art*, Germany (Dec. 1991), pp. 80–83.

1992. 'El Paris de HCB'. Text by Henri Cartier-Bresson. *Vogue*, Madrid (Apr. 1992), pp. 146–151.
'Wiederbegegnung mit Albert Camus'. *Du*, Switzerland (June 1992), pp. 14–93.
'Paesaggi Francesi 1962–1969'. Text by Ferdinando Scianna. *Abitare*, n° 309, Italy (July–Aug. 1992), pp. 120–125.
'The Conscience of Time: The Art of Henri Cartier-Bresson'. Text by Szeto Lap. *Twenty-First Century*, n° 14, China (Dec. 1992), pp. 85–89.

1993. 'Matisse: La volupté de la vie'. Text by Henri Cartier-Bresson. *Télérama*, France (Feb. 1993), pp. 90–94.
'Henri Cartier-Bresson: From Photography to Painting: On the Art of Cartier-Bresson'. Text by Jean Leymarie. *Bostonia*, USA (Spring 1993), pp. 40–47 and cover.
'Observations on the Drawing of Henri Cartier-Bresson', 'Les années décisives: Henri Cartier-Bresson'. Text by Thibaut Saint-James. *Réponse Photo*, n° 15, France (June 1993), pp. 58–61.

1994. 'Les Egéries Russes: Lydia, lumière de Matisse'. Text by Gonzague Saint-Bris and Vladimir Fedoroski. *Paris Match*, France

(27 Jan. 1994), pp. 94–100.
'Henri Cartier-Bresson: Reportage'. Text by Henri Cartier-Bresson. *Photo*, n° 307, France (Jan.–Feb. 1994), pp. 16–17.
'Les Egéries Russes: Elsa, les yeux d'Aragon'. Text by Gonzague Saint-Bris and Vladimir Fedoroski. *Paris Match* (3 Feb. 1994), pp. 88–94.
'La métamorphose de William Faulkner'. Text by Christian Perrot. *Globe Hebdo*, France (16–22 Mar. 1994), pp. 36–38.
'Der Augen-Zeuge. Henri Cartier-Bresson'. Text by Irmgard Hochreither. *Der Stern*, Germany (7 Apr. 1994), pp. 60–74.
'Stated Meeting Report, Mathematics and Photography'. Text by David Travis. *Bulletin of the American Academy of Arts and Sciences*, vol. 47, n° 7, USA (Apr. 1994), pp. 23–45.
'La Vie Henri'. Text by John Berger. *Sunday Times Magazine*, UK (29 May 1994), pp. 38–47.
'Camera at work. Now at 86 the legendary Henri Cartier-Bresson has set aside his camera for a sketch book'. Text by Tala Skari. *Life*, USA (June 1994), pp. 30–34.
'Entretien avec Henri Cartier-Bresson'. Text by Michel Nuridsany. *Le Figaro*, France (26 July 1994), p. 14.
'Paris los Bulevares de la Libertad'. Text by Ernest Hemingway. *Blanco y Negro*, Spain (21 Aug. 1994), pp. 43–53.
'Paris nao Ardeu'. Text by Luis Almeida Martins. *Visao*, Portugal (25–31 Aug. 1994), pp. 41–49.
'Henri Cartier-Bresson'. Text by Manuel Gasser. *Photographers International*, n° 15 (Aug. 1994), pp. 68–77.
'50ᵉ anniversaire de la Libération de Paris'. Text by Jacques Thomas. *Notre Temps*, n° 296, France (Aug. 1994), pp. 68–77.
'Entretien avec Henri Cartier-Bresson'. Text by Pierre Assouline. *Lire*, France (Summer 1994), pp. 30–37.

1995. 'Un Cyclope nommé Cartier-Bresson'. Text by Jerome Charyn. *Libération Magazine*, France (21 Jan. 1995), pp. 76–79.
'Régularisations de propriétés'. *Les Annales de la Recherche Urbaine*, n° 66, France (Mar. 1995), cover.
'The Moment that counts: an interview with Henri Cartier-Bresson'. Text by Michel Nuridsany. *New York Times Book Review*, USA (2 Mar. 1995), pp. 17–18.
'Henri Cartier-Bresson sur les nouvelles générations de l'An 2000'. Text by Henri Cartier-Bresson and Eric Colmet-Daage. *Photo*, n° 320, France (May 1995), pp. 24–25.
'Lost in London, Found in Paris'. *Sunday Review* (Supplement of the *Independent*), UK (2 July 1995), pp. 10–13.

'With Henri Cartier-Bresson surrounded by his peers'. Text by Michael Kimmelman. *New York Times*, USA (20 Aug. 1995), pp. 1, 28.
'On Location with Henri Cartier-Bresson'. Text by John Berger. *Aperture*, n° 138, USA (Winter 1995), pp. 12–23.
'Cartier-Bresson'. Text by Henri Cartier-Bresson. *Matador*, Russia (1995), p. 80.
'Homage to Henri Cartier-Bresson'. *Lettre Internationale*, Germany (1995), pp. 4–47 and cover.
'Cartier-Bresson in Houston, 1957'. Text by Laurie Nelson. *City*, n° 33, USA (Autumn 1995–Winter 1996), pp. 27–31.

1996. 'Exposed: the Camera-shy photographer'. Text by Christian Tyler. *Financial Times*, UK (9–10 Mar. 1996), n.p.
'Fate of the Poorest'. Text by Jeremy Seabrook. *Resurgence*, n° 183 (Mar. 1996), pp. 21–27.
'Cartier-Bresson capta eternidade num instante'. Text by Sheila Leiner. *O Estado de São Paulo*, Brazil (15 June 1996), pp. 1, 4–5.

1997. 'Henri Cartier-Bresson. Photographs, Collages and Drawings. Dialogue with a Mute Interlocutor'. Text by Ilona Halberstadt. *Pix*, n° 2, UK (Jan. 1997), p. 5.
'Henri Cartier-Bresson: Interview'. Text by Olga Sviblova. *Matador*, Russia, n° 1 (Jan.–Feb. 1997), pp. 92–97.
'Inventaires'. Text by Pierre Assouline. *Lire*, France (Feb. 1997), p. 6.
'Europeos cuarenta anos de Union'. Text by Pepe Baeza. *La Vanguardia*, Spain (23 Mar. 1997), pp. 34–43 and cover.
'Quelques lettres pour Henri Cartier-Bresson'. Text by Brigitte Ollier. *L'Insensé*, n° 14, France (Spring 1997), p. 26.
'Henri Cartier-Bresson le photographe invisible'. Text by Jean-Jacques Naudet. *Paris Match*, France (3 Apr. 1997), p. 24.
'Henri Cartier-Bresson à la Maison européenne de la Photographie'. Text by Henri Cartier-Bresson. *Photo*, n° 338, France (Apr. 1997), pp. 60–69.
'Henri Cartier-Bresson: La mostra de anno alla Maison Europeene de la Photographie'. *Photo*, n° 6, Italy (May 1997), p. 52.
'Henri Cartier-Bresson'. Text by Isabelle Dillman de Jarnac. *Air France Magazine*, n° 2, France (June 1997), p. 96.
'Henri Cartier-Bresson sur Edouard Boubat'. Text by Henri Cartier-Bresson. *Photo* [Special edition devoted to Edouard Boubat], France (July–Aug. 1997), p. 66.
'Klasyk Fotoreportazu'. Text by Maria Kruckowska. *Magazyn Gazety*, Poland (14 Sept. 1997), p. 10 and cover.

'Collector's Issue-Master Series Number 2: Henri Cartier-Bresson'. *American Photo*, vol. 8, n° 5, USA (Sept.–Oct. 1997), issue devoted to Henri Cartier-Bresson.
'HCB and Me'. p. 30.
'Some Time with the Master'. pp. 47–52.
'HCB: The Decisive Moments'. Text by Carol Squiers. p. 47.
'In Europe and America: A Portfolio'. p. 54.
'HCB on Photography'. Text by Henri Cartier-Bresson. pp. 76–77.
'Critical Observations'. Text by John Szarkowski, John Loengard, Vicki Goldberg and Christian Caujolle. pp. 78–82.
'Collecting: I want my HCB'. Text by Peter Hay Halpert. p. 84.
'Bali au regard de Cartier-Bresson'. Text by André Coutin. *Geo*, n° 255, France (Nov. 1997), pp. 140–145.

1998. 'Perspective Master of "the moment"'. Text by Andrew Robinson. *The Times: Higher Education Supplement*, UK (13 Feb. 1998), p. 19.
'The Prints of Henri Cartier-Bresson'. Text by James Hyman. *Print Quarterly*, vol. 15, n° 1, UK (Mar. 1998), pp. 35–55.
'Il Grande occhio'. Text by Roberto Koch. *Ulisse 2000*, Italy (May 1998), pp. 76–87.
'Spécial Henri Cartier-Bresson'. *Photo*, n° 349, France (May 1998), issue entirely devoted to Henri Cartier-Bresson. 4 different covers.
'Henri Cartier-Bresson: Sa vie, son œuvre'. Text by Jean-Pierre Montier. pp. 4–10.
'Henri Cartier-Bresson'. Text by Eric Colmet-Daage. pp. 32–33.
'Londres célèbre un photographe français'. Text by Olivier Poivre d'Arvor. pp. 34–35.
'L'Orient: Chine, Indonésie, Inde, Japon'. Text by Henri Cartier-Bresson. pp. 36–55.
'Eros…' Text by André Pieyre de Mandiargues. pp. 56–61.
'L'Occident: URSS, Des Européens'. Text by Henri Cartier-Bresson. pp. 62–71.
'La Libération'. Text by Henri Cartier-Bresson. pp. 78–81.
'Dessin'. Text by Henri Cartier-Bresson. pp. 82–87.
'Amérique: Etats-Unis, Mexique, Cuba'. Text by Henri Cartier-Bresson. pp. 88–101.
'Tête à Tête'. Text by Henri Cartier-Bresson. pp. 102–105.
'Les Coulisses Henri Cartier-Bresson'. Text by Paul Khayat. pp. 106–108.
'La Presse'. Text by Roger Thérond. p. 109.
'Monsieur Henri Cartier-Bresson. L'Œil du siècle'. *L'Evénement du Jeudi*, France (21–27 May 1998), pp. 44–45.
'Les Images avant toute chose'. Text by Philippe

Gélas. *L'Evénement du Jeudi* (21–27 May 1998), pp. 46–48.
'Henri Cartier-Bresson: L'Instinct de l'instant'. Text by Marc Riboud. *L'Evénement du Jeudi* (21–27 May 1998), p. 49–50.
'Entrevista con Henri Cartier-Bresson. Un Instante tan pleno'. Text by Pierre Assouline. *La Nacion*, Argentina (9 Aug. 1998), pp. 1–3.
'Henri, eye of the age, makes it to 90 not out'. Text by Michael McDermott. *Sunday Independent*, UK (16 Aug. 1998), n.p.
'Un fotografo per un secolo'. Text by Guido Gerosa. *Corriere del Ticino*, Switzerland (21 Aug. 1998), p. 35.
'Henri Cartier-Bresson. Il a fêté ses 90 ans'. Text by François Nourissier. *VSD*, France (30 Aug. 1998), pp. 60–71.
'Henri Cartier-Bresson Festeggia i suo 90 anni'. *Photo*, n° 20, special edition on Henri Cartier-Bresson, Italy.
'Henri Cartier-Bresson Landschaften'. *Der Stern*, Germany (19 Nov. 1998), pp. 86–102.
'A Delicate Balance'. *Time* [Special edition: *Visions of Europe*], USA (Winter 1998–1999), p. 182.

1999. 'Henri Cartier-Bresson: Landschaften'. *Portfolio: Bibliothek de Fotografie Stern*, n° 13, Germany (1999), issue entirely devoted to Henri Cartier-Bresson.
'Der Klassiker/The Classic'. Text by Stefanie Rosenkranz. pp. 4–19.
'Das Leben auf frischer Tat ertrappen/Catching life in the act'. pp. 20–25.
'Landschaften/Landscapes'. p. 26.
'Intimate Lives'. Text by Philip Brookman. *Washington Post Magazine*, USA (19 Sept. 1999), pp. 8–16, 25–26 and cover.
'Henri Cartier-Bresson: Pour la Liberté de la Presse'. *Reporters sans frontières* (1999), pp. 1–78. [English, Spanish, Italian and German editions also available.]
'Cette mystérieuse flamme du regard'. Text by Robert Badinter. *Reporters sans frontières* (1999), n.p.
'Les yeux et les oreilles de l'Humanité'. Text by Wei Jingsheng. *Reporters sans frontières* (1999), p. 7.
'D'un certain mot'. Text by André Pieyre de Mandiargues. *Reporters sans frontières* (1999), p. 9.
'Cartier-Bresson: l'œil qui peint'. Text by Claudine Vernier-Palliez. *Paris Match*, France (11 Nov. 1999), n.p.
'Les contacts de Henri Cartier-Bresson'. *Photo*, n° 364 (Nov. 1999), p. 32.
'Un siècle de photographie: choix de Henri Cartier-Bresson'. Text by Henri Cartier-Bresson. *Photo*, n° 364 (Nov. 1999), p. 65.
'Zeugen des jarhunderts'. Text by Henri Cartier-Bresson. *Die Zeit*, Germany (29 Dec. 1999), pp. 14, 45.

2000. 'Giants of the 20th Century: Henri Cartier-Bresson'. *West Australian*, Australia (1 Jan. 2000), p. 15.
'At 91, Henri Cartier-Bresson still has an eye for "the decisive moment". In a rare interview, he shares his memories…' Text by Nicholas Glass. *Independent*, UK (15 Feb. 2000), p. 10.
'Svenskt 50 – tal genom Franske masteren Henri Cartier-Bresson sokare'. Text by Hasse Persson. *Foto*, Sweden (Mar. 2000), pp. 6–21.

2001. 'L'Uomo che cambio la fotografia'. *Il Venerdi di Repubblica*, Italy (26 Jan. 2001), pp. 102–107.
'Shooting Past 80'. Text by David Friend. *Vanity Fair*, USA (Jan. 2001), pp. 116–135.
'Jewels in the crown'. *Independent Magazine*, UK (Feb. 2001), pp. 8–9.
'Balthus la dernière touche'. Text by Jean-François Chaigneau and Alvaro Canovas. *Paris Match*, France (1 Mar. 2001), pp. 60–70.
'El ojo del siglo'. Text by Carla Faesler. *Gatopardo*, Mexico (Mar. 2001), pp. 136–144.
'Un Patron nommé Roger Thérond'. *Paris Match*, (5 July 2001), pp. 64–85.
'The Unknown Cartier-Bresson. Plain Dealer'. Text by Peter Lennon. *Guardian Weekend*, UK (11 Aug. 2001), pp. 18–25 and cover.
'Barcelone vue par l'Agence Magnum. L'Œil de Henri Cartier-Bresson'. *La Semaine du Roussillon*, France (30 Aug.–5 Sept. 2001), pp. 9–11.
'Man of the Perfect Moment'. Text by Martin Gayford. *Sunday Telegraph*, UK (4 Nov. 2001), p. 5.
'Anarchiste et orfèvre de l'instant présent'. Text by Martin Gayford. *Courrier International*, France (15–21 Nov. 2001), p. 14.
'A Master of the Art of looking'. Text by Paul Ryan. *Irish Times*, Irlande (22 Nov. 2001), p. 14.

2002. 'Cartier-Bresson, anguille frémissante'. Text by Michel Nurisdany. *Le Figaro*, France (9 July 2002), p. 21.
'Henri Cartier-Bresson' (in the series 'Chers parents'). Text by Annick Cojean. *Le Monde*, France (23 Aug. 2002), p. 8.
'Cartier-Bresson: Paris'. Text by George Raillard, *La Quinzaine Littéraire*, France (1–15 Sept. 2002), p. 18.

ARTICLES ON HENRI CARTIER-BRESSON

Accomando, C.H. 'The humane touch'.
Artweek (14 Jan. 1984), p. 11.

Arikha, Avigdor. 'Henri Cartier-Bresson'.
Peinture et Regard : Ecrits sur l'art 1965–1990.
Collection Savoir/Sur l'art. Paris: Hermann,
Editeurs des Sciences et des Arts, 1991, p. 222.

Assouline, Pierre. *Henri Cartier-Bresson : L'œil du siècle*.
Paris: Plon, 1999.

Henri Cartier-Bresson : L'œil du siècle. Collection
Folio, n° 3455. Paris: Gallimard, 2001.

The Audiences of Nine Magazines : a National Study.
New York: Cowles Magazines, 1955.

Baby, Yvonne. 'Henri Cartier-Bresson on the art of
photography'. *Harper's Magazine*, USA (Nov. 1961),
p. 72.

'Le dur plaisir de Henri Cartier-Bresson'.
L'Express, France (29 June 1961), p. 34.

Barnstone, Howard. *The Galveston That Was*.
Preface by James Johnson Sweeney. Photographs
by Henri Cartier-Bresson and Ezra Stoller.
New York: Macmillan, 1965.

Beaton, Cecil and Buckland, Gail. *The Magic Image*.
Boston: Little, Brown & Co., 1975.

Beceyro, Raul. *Henri Cartier-Bresson : Essai*.
Translation by D. Ferre. Collection l'encre et la
lumière. Paris: Créatis, 1980.

*Behind the Great Wall of China : Photographs from
1870 to the Present*. Ed. Cornell Capa. Text by
Weston J. Naef. New York: Metropolitan Museum
of Art, 1972.

Bertin, Celia. *Jean Renoir : A Life in Pictures*.
Translation by Mireille and Leonard Muellner.
Baltimore: Johns Hopkins University Press, 1991.

The Best of Life. New York: Time-Life Books, 1973.

Boegner, Philippe. 'Autoritratto di un foto reporter'.
La Repubblica Mercuno, Italy (25 Mar. 1989), p. 13.

'Document. La mémoire du siècle. Troisième
Entretien: Cartier-Bresson: "Photographier n'est
rien, regarder c'est tout!"'. *Le Figaro Magazine*,
France (25 Feb. 1989), p. 104.

'Books in Print: photoportraits'. *Camera
International*, Switzerland (Winter 1985), p. 8.

Boulanger, Pierre. '200 dessins du photographe
Henri Cartier-Bresson'. *Le Parisien*, France
(4 Mar. 1989), n.p.

Bourde, Yves. 'Nul ne peut entrer ici s'il n'est pas
géomètre: un entretien avec Henri Cartier-Bresson'.
Le Monde, France (5 Sept. 1974), p. 13.

'The camera as "optical, mechanical sketchbook":
Henri Cartier-Bresson talks to Yves Bourde'.
Guardian, UK (28 Sept. 1974), p. 14. [Translation of
the interview in *Le Monde*, 5 Sept. 1974.]

Brinnin, John Malcolm. *Sextet : T.S. Eliot
and Truman Capote and Others*. New York:
Delacorte Press/Seymour Lawrence, 1981.

'The World We See'. *New Republic*, vol. 127, n° 20,
USA (17 Nov. 1952), p. 26.

'Henri Cartier-Bresson: portrait of the artist, ca.
1947'. *Camera Arts* (Jan.–Feb. 1982), p. 14.

Brenson, Michael. 'Cartier-Bresson, objectif
dessin'. *Connaissance des Arts*, France (Aug. 1981),
p. 30.

Broecker, W.L. 'Henri Cartier-Bresson: an
exhibition, a book reviewed by W.L. Broecher'.
Infinity, USA (Sept. 1968), p. 22.

Buchsbaum, Jonathan. *Cinema Engagé : Film in the
Popular Front*. Chicago: University of Illinois
Press, 1988.

Butor, Michel. 'Henri Cartier-Bresson'. *Art*, n° 699
(Dec. 1958), n.p.

'Camera notes: latest Cartier-Bresson book of
photographs'. *New York Times*, USA (8 Jan.1956), n.p.

Capa, Robert and Seymour, David. *Front Populaire*.
Text by Georgette Elgey. Paris: Chine Magnum,
1976.

Capote, Truman. *Local Color*. Melbourne:
Heinemann, 1950.

Cartier-Bresson, Henri. 'Authentic photos'.
Newsweek, USA (6 Aug. 1979), p. 7.

'Du bon usage d'un appareil'. *Point de Vue : Images
du Monde*, France (4 Dec. 1952), p. 18.

'In my view'. *Creative Camera* (Apr. 1970), p. 106.

'La pyramide de tous les défis'. *Paris Match*,
France (18 Mar. 1988), p. 82.

'My friend Chim'. *Terre d'Images*, France
(Oct. 1966), p. 22.

'One man shows are best'. *Infinity*,
(Dec. 1959), p. 14.

'Reality has the last word'. *New York Times*
(8 July 1975), p. 31.

'Über das Photographieren'. *Du*, Switzerland
(June 1958), p. 53.

'Cartier-Bresson's approach to portraiture'.
Popular Photography, USA (Mar. 1954), p. 56.

'Cartier-Bresson's California'. *Variety*
(13 May 1970), n.p.

'Cartier-Bresson's choice'. *Penthouse Photo World*,
USA (June–July 1976), p. 80.

'Cartier-Bresson choisit ses Cartier-Bresson'.
Photo, France (Apr. 1975), p. 40.

'Cartier-Bresson et la photographie'. *Leica
Fotografie* [French edition], n° 3 (1967), p. 105.

'Cartier-Bresson exhibition in the Louvre'.

Leica Photography [UK edition] (Jan.–Feb. 1956), n.p.

'Cartier-Bresson, Henri'. *Current Biography*
(Mar. 1947), p. 11.

'Cartier-Bresson finds the decisive moment in
color'. *Modern Photography* (Feb. 1954), n.p.

'Cartier-Bresson: "La photographie est une
véritable écriture."' *Les Nouvelles Littéraires*,
France (5 Jan. 1956), n.p.

'Cartier-Bresson replies'. *Popular Photography*
(Feb. 1963), n.p.

'Cartier-Bresson's France'. *New York Post*,
USA (16 Feb. 1971), n.p.

Caujolle, Christian. 'Henri Cartier-Bresson
portraitiste'. *Libération*, France (10–11 Dec. 1983),
n.p.

'Magnum à la Polonaise'. *Libération* (Jan. 1983), n.p.

Chauvy, Laurence. 'Henri Cartier-Bresson, de la
photo au dessin'. *Journal de Genève*, Switzerland
(10 June 1989), n.p.

Clark, R. 'The sad fate of Henri Cartier-Bresson'.
British Journal of Photography, UK (30 May 1980),
p. 514.

Coleman, A. D. 'Cartier-Bresson: latent image'.
Village Voice, USA (18 July 1968), n.p.

'More than the decisive moment'.
New York Times (29 Mar. 1970), n.p.

Contemporary Photographers. Edited by George
Walsh. Text by Roger Thérond. New York: St.
Martin's Press, 1982.

'A conversation with Henri Cartier-Bresson'.
Ed. Byron Dobell. *Popular Photography*
(Sept. 1957), n.p.

Cookman, Claude. 'The Photographic Reportage
of Henri Cartier-Bresson, 1937–1973'. Doctoral thesis
in the History of Art. Supervised by Peter
C. Bunnell. Princeton University, June 1994.

'Henri Cartier-Bresson: Primary and Secondary
Bibliography'. *History of Photography*, vol. 19, n° 4,
USA (Winter 1995), p. 359.

'Compelled to Witness: The Social Realism
of Henri Cartier-Bresson'. *Journalism History*, USA
(Spring 1998), p. 3.

Daiches, Alan. 'Cartier-Bresson at the V & A'.
Art and Artists (Mar. 1969), p. 12.

Danto, Arthur C. *Encounters and Reflections*.
New York: Farrar, Straus & Giroux, 1991.

'Henri Cartier-Bresson'. *The Nation*, USA
(3 Oct. 1987), p. 346.

'Henri Cartier-Bresson'. *The Nation*
(13 Oct. 1987), p. 98.

Davis, Douglas. 'The magic of raw life: new
photography'. *Newsweek* (24 Apr. 1972), p. 46.

'A master with a double image; Cartier-Bresson: photojournalism or high art?' *Newsweek* (21 Sept. 1987), p. 78.

'A way of seeing'. *Newsweek* (3 Dec. 1979), p. 108.

'The decisive moment'. *Modern Photography* (Dec. 1952), p. 108.

'The Decisive Moment'. *U.S. Camera*, USA (Dec. 1952), p. 39.

Deschin, Jacob. 'Focusing on Europe: Cartier-Bresson produces a new volume on "The Europeans"'. *New York Times* (11 Dec. 1955), p. 27.

Delpire, Robert. 'Henri Cartier-Bresson'. *Du* (June 1958), p. 62.

Dentan, Yves. 'Les photographes témoins de leur temps: Trois maîtres de l'image'. *Réforme*, France (28 July 1956), p. 5.

'Un portrait d'Henri Cartier-Bresson: "photographier c'est comprendre la vie"'. *Réforme* (3 Dec. 1966).

Deschin, Jacob. 'A decade of work surveyed'. *New York Times* (30 June 1968), n.p.

'The right moment: work of Cartier-Bresson is lesson in timing'. *New York Times* (19 Oct. 1952), n.p.

'Les dessins d'Henri Cartier-Bresson'. *Le Quotidien de Paris*, France (15 Mar. 1989).

Desvergnes, Alain. 'Une interview de Henri Cartier-Bresson'. *Photo*, (Sept. 1979), p. 18.

Dister, Alain. 'Rencontre avec Henri Cartier-Bresson, paroles d'instantanés'. *Le Nouvel Observateur*, France (13–20 Sept. 1988), n.p.

Dobell, Byron. 'A conversation with Henri Cartier-Bresson'. *Popular Photography* (Sept. 1957), p. 130.

'Magnum: The first ten years...'. *Popular Photography*, vol. 4, n° 3 (Sept. 1957), n.p.

Dupont, Joan. 'A hunter who stalked his prey with a camera'. *New York Times* (27 Sept. 1987), p. 17.

Edkins, Diana. 'Henri Cartier-Bresson: a new kind of aesthetic – urgently of its time'. *Vogue*, New York (Sept. 1980), p. 308.

Edwards, Owen. 'Cartier-Bresson cooly obsessed with Humanity'. *Saturday Review* (10 Nov. 1979), p. 46.

Ellenzweig, Allen. 'Henri Cartier-Bresson at the ICP'. *Art in America*, USA (Jan. 1986), p. 131.

Elion, Katharine. 'Photographer takes portrait of capital'. *Washington Post and Times Herald*, USA (19 May 1957), p.18.

Esterow, Milton. 'Cartier-Bresson's Real Thing'. *Art News*, vol. 88, n° 6, USA (Summer 1989), p. 132.

'The Europeans: A New Book of Photographs by Henri Cartier-Bresson'. *Popular Photography* (Apr. 1956), n.p.

Evans, Harold. *Pictures on a Page*. New York: Holt, Rinehart & Winston, 1978.

Evans, Walker. 'Cartier-Bresson, a true man of the eye'. *New York Times Book Review* (19 Oct. 1952), p. 7.

'Eyes behind the camera, then and now'. *U.S. News and World Report* (9 Nov. 1987), p. 88.

'The face of Asia'. *Photo News Weekly* (12 July 1972), p. 7.

The Family of Man. New York: Simon & Schuster for the Museum of Modern Art, 1955.

Fermigier, André. 'La longue marche de Cartier-Bresson'. *Le Nouvel Observateur* (12–18 Oct. 1970), p. 38.

'First one-man photo show in Louvre: Cartier-Bresson exhibits 25 years of work'. *Life*, France (5 Dec. 1955), p. 32.

'Fleurir la statue de Cartier-Bresson ou la dynamiter?: Polémique sur la photographie'. Text by Robert Delpire, Jean-Michel Folon, Hauville, Guy Le Querrec and Marc Riboud. *Le Monde* (17 Oct. 1974), p. 18.

Foote, Nancy. 'Reviews: About Russia'. *Art in America* (Nov.–Dec. 1974), p. 57.

Forbes, Malcolm S. 'Henri Cartier-Bresson'. *Forbes*, USA (2 Mar. 1981), p. 22.

Franck, Martine. *Henri Cartier-Bresson par Martine Franck*. Text by Ferdinando Scianna. Milan: Franco Sciardelli, 1998.

Freund, Andreas. 'Cartier-Bresson captures the French'. *New York Times* (27 Oct. 1970), p. 52.

Frizot, Michel. 'Cartier-Bresson, le regard hors de soi'. *Beaux-Arts Magazine*, France (Feb. 1989), p. 68.

Galassi, Peter. 'An early Cartier-Bresson'. *MOMA*, New York (Winter 1975–1976), n.p.

'An early Cartier-Bresson'. *VSPA: Virginia Society for the Photographic Arts Newsletter*, n.d.

Gamon, M. 'Giving photographs'. *British Journal of Photography*, UK (20 Aug. 1976), p. 709.

Gantier, Marc. 'Le réel épinglé de Cartier-Bresson'. *Le Spectacle du Monde*, France (May 1989), p. 64.

Gasser, Manuel. 'Zeichnungen und Malereien von Henri Cartier-Bresson (dessins et peintures par Henri Cartier-Bresson)'. *Du*, (May 1974), p. 54.

'Cinq portraits de Henri Cartier-Bresson'. *Leica Fotografie* [French edition], n° 1 (1964), p. 12.

Gendel, Milton. 'Photography: Venice 79'. *Art News* (Sept. 1979), p. 156.

Gidal, Tim N. *Modern Photojournalism: Origin and Evolution, 1910–1933*. New York: Collier, 1972.

Girling, M. 'Interview: Ian Berry'. *British Journal of Photography* (27 Mar. 1981), p. 328.

Girod de l'Ain, Bertrand. 'Henri Cartier-Bresson au Grand Palais'. *Le Monde* (21 Oct. 1970), n.p.

'La photographie: Henri Cartier-Bresson'. *Le Monde* (9 Dec. 1966), p. 14.

Goldsmith, Arthur. 'Cartier-Bresson's people'. *Popular Photography* (Dec. 1985), p. 62.

'Good Man with a Camera'. *Harper's Magazine* (May 1947), p. 480.

'A new look at an old master'. *Popular Photography* (Nov. 1979), p. 100.

Gosling, Nigel. 'The genius of Cartier-Bresson'. *This Week's Magazine* [Supplement of the *Observer*], UK (16 Mar. 1969), p. 16.

'The world of Bresson'. *Observer Review* (6 Apr. 1969), n.p.

Gouvion Saint-Cyr, Agnès de, Lemagny, Jean-Claude and Sayag, Alain. *Art or Nature: 20th Century French Photography*. London: Trefoil, 1988.

'Le grand révélateur Henri Cartier-Bresson'. *Photo* (Nov. 1985), p. 74.

Great Photographic Essays from Life. Ed. Maitland Edey. Boston: Little, Brown & Co., 1978.

Greenberg, Clement. *The Collected Essays and Criticism, Vol. 2: 1945–1949*. Edited by John O'Brian. Chicago: University of Chicago Press, 1986.

Grundberg, Andy. 'Photojournalism: heroism meets esthetics', *New York Times* (26 Nov. 1989), p. 35.

'Two giants of modernism at opposite poles'. *New York Times* (13 Sept. 1987), section II, p. 47.

Guerrin, Michel. 'An interview with Henri Cartier-Bresson'. *Visual Anthropology*, n° 5, USA (1993), p. 331.

'La jouissance de l'œil'. *Le Monde* (21 Nov. 1991), p. 19.

'Henri Cartier-Bresson, le patron'. *Le Monde* (14 July 1994), n.p.

Guibert, Hervé. 'Les dessins d'Henri Cartier-Bresson: fragments d'une méditation'. *Le Monde* (4 June 1981), n.p.

'Cartier-Bresson: "Photoportraits" sans guillemets'. *Le Monde* (10 Oct. 1985), p. 19.

'L'envers de la médaille'. *Le Monde* (17 Dec. 1982), p. 31.

'Henri Cartier-Bresson de 1927 à 1980'. *Le Monde* (3 Dec. 1980), n.p.

'Un livre et une exposition d'Henri Cartier-Bresson'. *Le Monde* (5 Mar. 1980), p. 21.

'Vive la photo: rencontre avec Henri Cartier-Bresson'. *Le Monde* (30 Oct. 1980), n.p.

Haas, Ernst. 'Henri Cartier-Bresson: A Lyrical View of Life'. *Modern Photography*, vol. 35, n° 11 (Nov. 1971), p. 88.

Halsman, Philippe. 'The little human detail caught on a piece of film'. *New York Herald Tribune*, USA (16 Nov. 1952), p. 6.

'Henri Cartier-Bresson au Grand Palais: le dessin et la passion de la vie'. *Le Monde* (21 Oct. 1970), n.p.

'HCB inédit: le livre-testament de Cartier-Bresson: des surprises à chaque page'. *Photo* (Dec. 1979), p. 90.

'HCB vu par C-B'. *Photo* (Nov. 1974), p. 49.

'Henri Cartier-Bresson'. *Aperture*, USA (Autumn 1969), n.p.

'Henri Cartier-Bresson'. *British Journal of Photography* (18 Jan. 1957), n.p.

'Henri Cartier-Bresson côté dessin'. *Quotidien du Médecin*, France (10 Mar. 1989), n.p.

'Henri Cartier-Bresson et les images du delta du Mississippi'. *Le Monde* (4–5 Mar. 1973), p. 13.

'Henri Cartier-Bresson: "J'ai toujours su que je serais peintre"'. *Paris Match* (17 Mar. 1989), n.p.

'Henri Cartier-Bresson à la mémoire de Manuel Gasser'. *Du* (Dec. 1980), p. 27.

'Henri Cartier-Bresson'. *Photography* (Dec. 1955), p. 28.

'Henri Cartier-Bresson: photographer'. *New York Times* (9 Nov. 1979), p. C 1.

'Henri Cartier-Bresson: photoportraits'. *Modern Photography* (Mar. 1986), p. 39.

'Henri Cartier-Bresson: photoportraits'. *New Yorker*, USA (9 Dec. 1985), p. 18.

'Henri Cartier-Bresson'. *Popular Photography* (July 1958), p. 34.

'Henri Cartier-Bresson: recent photographs'. *Leica Photography* [UK edition], vol. 21, n° 2 (1968), p. 13.

'Henri Cartier-Bresson scampers in a view of two Hamlets'. *Evening Standard*, UK (14 Mar. 1969), p. 10.

'Henri Cartier-Bresson'. Text by D.H. Seylan in *Creative Camera International Year Book, 1975*. Eds. Colin Osman and Peter Turner. London: *Creative Camera*, 1975.

Hicks, Wilson. *Words and Pictures: An Introduction to Photojournalism*. New York: Harper & Brothers, 1952.

Hofstadter, Dan. 'Profiles: Stealing a march on the world – I'. *New Yorker*, vol. 65, n° 36, (23 Oct. 1989), p. 59.

'Profiles: Stealing a march on the world – II'. *New Yorker*, vol. 65, n° 37 (30 Oct. 1989), p. 49.

Temperaments: Artists Facing Their Work. New York: Knopf, 1992.

Holden, Judith. 'The disciplines of Henri Cartier-Bresson'. *Infinity* (Feb. 1961), p. 3.

'Hommage à un grand photographe: L'homme-œil entre au Louvre'. *Paris Match* (29 Oct. 1955), p. 62.

Hood, Robert E. 'The elusive Cartier-Bresson', *12 at War, Great Photographers Under Fire*. New York: G.P. Putnam's Sons, 1967.

Hopkinson, Tom. 'Henri Cartier-Bresson'. *Photography* (Jan. 1957), p. 22.

Horn, Miriam. 'Eyes behind the camera, then and now'. *U.S. News and World Report*, (9 Nov. 1987), p. 88. [Interviews with Henri Cartier-Bresson and Gilles Peress.]

Hughes, Jim. *W. Eugene Smith: Shadow and Substance, The Life and Work of an American Photographer*. New York: McGraw-Hill, 1989.

Hughes, Langston. *I Wonder As I Wander: An Autobiographical Journey*. New York: Hill & Wang, 1956.

'Fotografias, mas que fotografias'. *Todo*, Mexico (12 Mar. 1935), n.p.

'French photo traveler'. *Chicago Defender*, USA (22 Mar. 1947), n.p.

'The human world of Cartier-Bresson'. *New York Times Magazine* (3 Jan. 1960), p. 22.

Jensen, Peter M. 'The surrealist reality of Cartier-Bresson'. *Art World* (17 Nov.–15 Dec. 1979), n.p.

Joffroy, André Berne. 'Henri Cartier-Bresson: photographe et dessinateur'. *Gazette des Beaux-Arts*, USA (Dec. 1981), p. 233.

The Julien Levy Collection. New York: Witkin Gallery, 1977.

Kirstein, Lincoln. 'Artist with a camera'. *New York Times Magazine* (2 Feb. 1947), p. 12.

'Cartier-Bresson in the Orient: thirteen photographs', *Portfolio, The Annual of the Graphic Arts*. Cincinnati: Zebra Press, 1951.

'A great book of great photographers'. *Infinity* (Nov. 1952), p. 6.

'Metaphors of motion'. *Nation*, USA (15 Mar. 1971), p. 345.

'The scope of photography'. *Nation* (18 Apr. 1952), p. 347.

Kozloff, Max. 'Mercurial quietude: Cartier-Bresson and Lartigue'. *Art in America* (Jan.–Feb. 1972), p. 68.

Kramer, Hilton. 'Cartier-Bresson shows the pick of his photos'. *The New York Times* (9 Nov. 1979), n.p.

'Cartier-Bresson turns his focus to drawing'. *New York Times* (1 Mar. 1975), p. 20.

Lacayo, Richard. 'Drunk on a world served straight: MOMA brings out the surrealist in Cartier-Bresson'. *Time*, USA (12 Oct. 1987), p. 58.

Langer, Don. 'Camera talk'. *New York Post* (20 July 1968), n.p.

Larcher, David. 'A question of attitude. Henri Cartier-Bresson considers himself first and foremost a painter'. *Art News* (Dec. 1987), p. 11.

'The later works of Henri Cartier-Bresson'. *Creative Camera* (Sept. 1968), p. 302.

Lee Kyong Hong, 'Essai d'esthétique: L'instant dans l'image photographique selon la conception d'Henri Cartier-Bresson'. Doctoral thesis. Supervised by Olivier Revault d'Allonnes. Université de Paris I, Pantheon, Sorbonne, 1988.

Lemagny, Jean-Claude. 'Creative photography in Europe: a proposal for the classification of its contemporary tendencies'. *European Photography* (Jan.–Mar. 1980), p. 28.

Levy, Julien. 'Henri Cartier-Bresson'. *Le Bucentaure*, n° 6–7, France, p. 30.

Memoir of an Art Gallery. New York: Putnam, 1977.

Surrealism. New York: Black Sun, 1936.

London, John. 'Shy genius of the camera; he steals up on life'. *News Chronicle* (8 Jan. 1957), p. 3.

MacCarthy, Fiona. 'Always on the sidewalk'. *Arts Guardian*, UK (20 Mar. 1969), n.p.

McNay, Michael. 'Invisible eye'. *Arts Guardian* (20 Mar. 1969), p. 8.

Maddow, Ben. 'Surgeon, poet, provocateur'. *Photo League Bulletin*, USA (Apr. 1947), p. 2.

Manchester, William. *In Our Time: The World as Seen by Magnum Photographers*. Text by Jean Lacouture and Fred Ritchin. New York: American Federation of Arts and W.W. Norton & Co., 1989.

Mandiargues, André Pieyre de. *Le Désordre de la mémoire*. Paris: Gallimard, 1975.

'Henri Cartier-Bresson: le grand révélateur'. *Photo*, France (July–Aug. 1983), p. 56.

'Les victimes enchantées de Cartier-Bresson'. *L'Express* (18–24 Oct. 1985), pp. 177–178.

Manning, Jack. 'After the war was over: 168 masterpieces by Magnum photographers'. *New York Times Book Review* (26 Jan. 1986), p. 21.

'Masters of the Leica'. *Leica Photography* [UK edition] (Jan.–Feb. 1953), p. 4.

Matisse par Henri Cartier-Bresson. Introduction by Dominique Szymusiak. Le Cateau-Cambrésis, France: Musée Matisse, Musée Départemental, 1995.

'La meilleure photo de Cartier-Bresson, meilleur photographe du monde, ne figure pas dans "son album"'. *France Dimanche*, France (19 Oct. 1952), n.p.

Meltzer, Milton. 'Henri Cartier-Bresson: photoportraits'. *Library Journal* (15 Nov. 1985), p. 89.

'Memorable and beautiful: new Cartier-Bresson book shows work of a great photographer'. *Life* (13 Oct. 1952), p. 137.

Miller, Ralph. 'Photo show bows: Cartier-Bresson – modest great'. *New York World-Telegram and Sun*, USA (7 Jan. 1960), n.p.

Mohrt, Michel. 'Cartier-Bresson: Ce pays étrange'. *La Nouvelle Revue Française*, France (Jan. 1971), p. 124.

'MOMA show of photography revives old issue'. *New York Times* (6 May 1951), p. 15.

Montier, Jean-Pierre. 'Recherches sur l'esthétique photographique: à propos d'Henri Cartier-Bresson'. Doctoral thesis, Université d'Aix-en-Provence (1993), 3 volumes.

Munzi, Ulderico. 'Cartier-Bresson, la foto è stupro'. *Corriere della Sera*, Italy (2 June 1990), p. 5.

'Fotografia. Camera con vista: Io e la mia Leica in America': Le confessioni di monsieur Henri'. *Corriere della Sera* (2 Feb. 1992), p. 1.

Murray, Joan. 'Henri Cartier-Bresson: photographer'. *Artweek* (5 June 1982), p. 13.

Mydans, Carl. 'The invisible witness'. *New York Times Book Review* (21 July 1968), p. 6.

Nabokov, Nicholas. *Bagázh: Memoirs of a Russian Cosmopolitan*. New York: Atheneum, 1975.

Naggar, Carole. 'Du cœur à l'œil'. *Le Matin*, Switzerland (23 Jan. 1981), p. 19.

'Henri Cartier-Bresson, une exposition et un album racontent l'itinéraire visuel de l'un des grands témoins de ce temps'. *Le Matin* (12 Mar. 1980), n.p.

'New photography books'. *Modern Photography* (Dec. 1952), n.p.

Newhall, Beaumont. *Creative Camera* (May 1968), p. 150.

Focus: Memoirs of a Life in Photography. Boston: Little, Brown & Co., (1993).

'Henri Cartier-Bresson – vision of America'. *Art in America* (Autumn 1960), p. 79.

The History of Photography from 1839 to the Present. New York: Museum of Modern Art/Boston: Little, Brown & Co., (1982).

'La vision instantanée de Henri Cartier-Bresson'. *Camera*, vol. 34, n° 10 (Oct. 1955), p. 456 and cover.

Newhall, Beaumont and Newhall, Nancy. *Masters of Photography*. New York: George Braziller, 1958.

Photography 1839–1937. New York: Museum of Modern Art, 1937.

Photography: A Short Critical History. [Second edition.] New York: Museum of Modern Art, 1938.

Photography: Essays and Images. New York: Museum of Modern Art, 1980.

Norman, Dorothy. *The Hero: Myth, Image, Symbol*. New York: World Publishing & Co., 1969.

'Stieglitz and Cartier-Bresson'. *Saturday Review* (22 Sept. 1962), p. 52.

'A visitor falls in Love – with Hudson and East Rivers'. *New York Post* (26 Aug. 1946), n.p.

Nuridsany, Michel. 'Cartier-Bresson, anguille frémissante'. *Le Figaro*, France (9 July 2002), n.p.

'Cartier-Bresson: l'œil et le cœur'. *Le Figaro* (29 Feb. 1980), p. 32.

'Cartier-Bresson, un classicisme rayonnant'. *Le Figaro* (3 Dec. 1980), n.p.

'Cartier-Bresson portraitiste'. *Le Figaro* (14 Jan. 1984), n.p.

'Henri Cartier-Bresson l'incontournable'. *Le Figaro* (21 Nov. 1985), n.p.

'The moment that counts: an interview with Henri Cartier-Bresson'. *New York Review of Books* (2 Mar. 1995), pp. 17–18.

'150 ans de photographie'. *Photo* (Mar. 1989), p. 76.

'One-man show: Henri Cartier-Bresson'. *Leica Photography* [UK edition], vol. 13, n° 1 (1960), p. 4.

Paris/Magnum; photographs 1935–1981. Introduction by Inge Morath. Text by Irwin Shaw. Millerton, New York: Aperture, 1981.

'Paris photographer hunts baseball emotions of city'. *Milwaukee Journal*, USA (31 May 1957), n.p.

Perl, Jed. 'Photography and beyond'. *New Criterion*, USA (Dec. 1987), n.p.

A Personal View: Photography in the Collection of Paul F. Walter. Text by Peter Galassi. New York: Museum of Modern Art and New York Graphic Society, 1985.

Photographers on Photography. Edited by Nathan Lyons. Englewood Cliffs: Prentice-Hall/Rochester: George Eastman House, 1966.

'La Photographie, qu'est-ce que c'est?: Un entretien avec H. Cartier-Bresson'. *Témoignage Chrétien*, France (28 May 1954), p. 6.

'Photo-Journalistic Breakthrough'. *Infinity* (Mar. 1961), p. 3.

'Photographic Style'. *U.S. Camera* (Mar. 1961), p. 50.

Plécy, Albert. 'Gens d'images/Le salon permanent de la photo'. *Point de Vue: Images du Monde* (3 Feb. 1967), p. 19.

'Le salon permanent de la photo'. *Point de Vue: Images du Monde* (10 Feb. 1967), p. 18.

'Le salon permanent de la photo: Le Prix Nadar'. *Point de Vue: Images du Monde* (16 Apr. 1971), p. 18.

'Pour parler de la photo; Cartier-Bresson fuit les clichés'. *France Soir-Paris*, France (1 Apr. 1974), n.p.

Pradine, Jean. 'Henri Cartier-Bresson: "Photographier à longueur de journées est une façon de vivre."' *Libération* (23 Oct. 1952), p. 5.

Prescott, Orville. 'Books of the Times: Ways of Life Caught by Camera'. *New York Times* (16 Dec. 1955), n.p.

'Proust Questionnaire: Henri Cartier-Bresson'. *Vanity Fair*, USA (May 1998), p. 256.

Rayfield, Stanley. *How Life Gets the Story: Behind the Scenes in Photojournalism*. Garden City: Doubleday & Co., 1955.

Renoir, Jean. *Renoir on Renoir: Interviews, Essays, and Remarks*. Cambridge: Cambridge University Press, 1989.

The Resistance. Ed. Russell Miller. Alexandria: Time-Life Books, 1979.

Resnick, Mason. 'Henri Cartier-Bresson: The Early Work'. *Modern Photography* (Feb. 1988), p. 61.

Richard, Jacques. 'Cartier-Bresson parle: si souvent silencieux, le "pape" de la photographie sort de sa réserve'. *Le Figaro* (12 Mar. 1989), n.p.

Richard, Paul. 'Moments noticed: the classic photography of Henri Cartier-Bresson'. *Washington Post* (4 Apr. 1981), section B, p. 1.

'The Right Moment'. *New York Times* (19 Oct. 1952), section II, p. 15.

Robertson, Bryan. 'Authentic Cartier'. *Spectator*, UK (28 Mar. 1969), n.p.

Rodger, George. 'The beginnings of Magnum: random thoughts by a founder member'. *Creative Camera* (Mar. 1969), p. 96.

Roegiers, Patrick. 'L'Amérique d'un libertaire'. *Le Monde* (21 Nov. 1991), p. 21.

'Rencontre: Cartier-Bresson, gentleman-caméléon'. *Le Monde aujourd'hui* (16–17 Mar. 1986), p. 12.

'Mais où est donc passé le chat de Steinberg?'. *Les Cahiers de la Photographie*, n° 18, France (1986), n.p.

'Au musée d'Art moderne de New York, les jeunes années de Cartier-Bresson'. *Le Monde* (4 Oct. 1987), n.p.

Rosenblum, Naomi. *A World History of Photography*. New York: Abbeville Press, 1984.

Roth, Evelyn. 'Lasting, but not least: Marc Riboud steps out of Cartier-Bresson's enduring shadow'.

American Photographer, USA (Nov. 1989), p. 30.

Roy, Claude. 'Ce Cher Henri'. *Photo*, n° 86 (Nov. 1974), p. 66.

'Parler sans mots'. *Le Nouvel Observateur* (30 Dec. 1968–6 Jan. 1969), p. 28.

'La seconde de vérité'. *Lettres Françaises*, France (20 Nov. 1952), n.p.

'Le voleur d'étincelles'. *Le Nouvel Observateur* (17–23 Mar. 1980), p. 84.

Roy, Claude and Kojima, Ryoichi. 'Henri Cartier-Bresson'. *Popular Photography Italiana*, Italy (Oct. 1967), p. 1.

Sadoul, Georges. 'Victoire de la vie'. *Regards*, n° 234, France (1938), p. 18.

Salvesen, Christopher. 'Cartier-Bresson'. *Listener* (10 Apr. 1969), p. 508.

Schwalberg, Bob, Vestal, David and Korda, Michael. 'Cartier-Bresson today: three views'. *Popular Photography*, vol. 60, n° 5 (May 1967), p. 108.

Scianna, Ferdinando, 'In occasione del suo novantesimo compleanno HCB accetta di parlare di se: Guru dell'Istante Sospeso'. *Il sole 24 Ore*, Italy (6 Sept. 1998), p. 23.

'La photographie aussi est "cosa mentale"'. *La Quinzaine Littéraire*, France (1–15 Apr. 1980), p. 17.

'HCB: 255 ritratti'. *Photo* [Milan], n° 125 (Nov. 1985), p. 50.

Scully, Julia. 'In the 50's–when black-and-white photojournalists were king'. *Modern Photography* (Oct. 1985), p. 4.

'Seeing pictures'. *Modern Photography* (June 1970), p. 12.

Sealfon, Peggy. 'The eye of Cartier-Bresson'. *Horizon*, USA (Nov. 1979), p. 16.

Seed, Sheila Turner. 'Face to face II: Henri Cartier-Bresson interviewed by Sheila Turner Seed'. *Bulletin* [American Society of Magazine Photographers] (4 Oct. 1974), p. 7.

'Henri Cartier-Bresson: interview'. *Popular Photography* (May 1974), p. 108.

'7 masters'. *Life* (Autumn 1988; special edition: '150 years of photography'), p. 38.

Shahn, Ben. 'Henri Cartier-Bresson'. *Magazine of Art* (May 1947), p. 134.

Shirey, David L. 'Good fisherman'. *Newsweek* (22 July 1968), p. 78.

Siskind, Aaron. 'Silver Nitrate & Our Times'. *Saturday Review*, vol. 35, n° 51 (20 Dec. 1952), p. 14.

Soby, James Thrall. 'The art of poetic accident: the photographs of Cartier-Bresson and Helen Levitt'. *Minicam* (Mar. 1943), p. 28.

'A new vision in photography'. *Saturday Review* (5 Apr. 1947), n.p.

'Two contemporary photographers'. *Saturday Review* (5 Nov. 1955), p. 32,

Solier, René de. 'Cartier-Bresson, Brassaï et autres gens d'images'. *La Nouvelle Revue Française* (1 Mar. 1956), p. 543.

Sontag, Susan. 'La photographie à la recherche d'elle-même'. *Le Nouvel Observateur*, n° 1 special edition (June 1977), p. 6.

On Photography. New York: Farrar, Straus & Giroux, 1973.

'Speaking of pictures: Cartier-Bresson shows his eloquent camera work'. *Life* (3 Mar. 1947), p. 14.

Stevens, Nancy. 'In search of the invisible man'. *American Photographer* (Nov. 1979), p. 63.

Stuttaford, Genevieve. 'Henri Cartier-Bresson: photoportraits'. *Publishers Weekly* (27 Sept. 1985), p. 92.

Szarkowski, John. *Looking at Photographs: 100 Pictures from the Collection of the Museum of Modern Art*. New York: Museum of Modern Art, 1973.

Photography Until Now. New York: Museum of Modern Art, 1989.

Teller, Sanford M. 'Cartier-Bresson shows Leica pictures in new book'. *Camera News of West Germany* (Nov. 1963), n.p.

Terrasse, Michel. *Bonnard et Le Cannet*. Paris: Herscher, 1987.

Bonnard at Le Cannet. London: Thames & Hudson, 1988.

Thornton, Gene. 'Cartier: too much on the surface?' *New York Times* (24 Jan. 1971), section II, p. 25.

'Timeless moments'. *New York Post* (9 Sept. 1987), p. 27.

'Les Traits de Cartier-Bresson'. *La Croix l'Evénement*, France (7 Mar. 1989), p. 20.

Travis, David. *Photographs from the Julien Levy Collection, Starting with Atget*. Chicago: Art Institute of Chicago, 1976.

'L'univers noir et blanc d'Henri Cartier-Bresson'. *Photo*, France (Dec. 1968), p. 24.

'Velvet hand, hawk's eye'. *Newsweek* (20 Oct. 1952), p. 74.

'La vérité selon Cartier-Bresson'. *L'Express* (28 Oct.–3 Nov. 1968), p. 101.

Vestal, David. 'Cartier-Bresson: recent photographs'. *Popular Photography* (Oct. 1968), p. 115.

'Shows we've seen'. *Popular Photography* (Oct. 1968), n.p.

Weiss, Margaret. 'Cartier-Bresson's France'. *Saturday Review* (13 Feb. 1971), p. 46.

'Encore at the Louvre'. *Saturday Review* (26 Nov. 1966), n.p.

Welty, Eudora. 'Book review: About Russia'. *New York Times Book Review* (1 Dec. 1974), section VII, p. 4.

Westerbeck, Jr., Colin. 'Exhibition reviews'. *Artforum*, USA (Apr. 1980), p. 79.

Whelan, Richard. 'Cartier-Bresson: "For me photography is a physical pleasure"'. *Art News* (Nov. 1979), p. 120.

'Cartier-Bresson: "For me, photography is a physical pleasure"'. *Arts in Virginia* (1986), p. 24.

'Henri Cartier-Bresson: photographer'. *Art News* (Nov. 1979), p. 120.

'Henri Cartier-Bresson: Photographer'. *Arts In Virginia* (Winter 1980), p. 24.

White, Minor. 'Henri Cartier-Bresson: The Decisive Moment'. *Aperture*, n° 4 (1953), p. 41.

Witkin, Lee D. and London, Barbara. *The Photograph Collector's Guide*. Boston: New York Graphic Society, 1979.

'Who is Henri Cartier-Bresson?' *Amateur Photographer* (9 Oct. 1968), p. 8.

Williams, T. I. 'Cartier-Bresson at the V. & A'. *Photographic Journal* (May 1969), p. 218.

Winkfield, Trevor. 'Henri Cartier-Bresson: drawings'. *Art in America* (July–Aug.), p. 107.

Winokur, Ken. 'A challenge to Cartier-Bresson'. *Views: A New England Journal of Photography*, n° 3, USA (Spring 1980), p. 12.

Woodward, Richard B. 'Henri Cartier-Bresson'. *Art News* (Nov. 1987), p. 200.

'World of photography: Henri Cartier-Bresson'. *Photo 88*, n° 6 (1982), p. 2421.

World Photography. Ed. Bryn Campbell. Text by Ernst Haas. London: Hamlyn, 1981.

Wright, Helen. 'Cartier-Bresson's France'. *Popular Photography* (Feb. 1971), p. 92.

Wronecki, Daniel. *New York*. Paris: Nathan, 1949.

Yerxa, Fendall. 'Parisian gleans kernels of life in his pictures'. *New York Herald Tribune* (2 Feb. 1947), n.p.

Zannier, Italo. 'Henry [sic] Cartier-Bresson: l'immagine riferita'. *Popular Photography Italiana* (Apr. 1971), p. 39.

PHOTOGRAPHIC EXHIBITIONS

1933. (25 Sept.–16 Oct.) 'Photographs by Henri Cartier-Bresson: Anti-Graphic Photography', Julien Levy Gallery, New York, USA.
(Nov.) 'Photographs by Henri Cartier-Bresson', Club Ateneo, Madrid, Spain.

1935. (11–20 Mar.) 'Fotografias: Cartier-Bresson, Alvarez Bravo', Palacio de Bellas Artes: Galeria de Exposiciones, Mexico City, Mexico.
(23 Apr.–7 May) 'Photographs by Henri Cartier-Bresson, Walker Evans, Manuel Alvarez Bravo', Julien Levy Gallery, New York, USA.

1947. (5 Feb.–6 Apr.) 'The Photographs of Henri Cartier-Bresson', Museum of Modern Art, New York, USA.
Itinerary: Albright Art Gallery, Buffalo, USA (29 Oct.–19 Nov. 1948).

1948. (16–23 Feb.) 'Photographs by Henri Cartier-Bresson', Bombay Art Society's Salon, Bombay, India.

1952. (7 Feb.–4 Mar.) 'Photographs by Cartier-Bresson', Institute of Contemporary Arts, London, UK (First exhibition of Henri Cartier-Bresson in the UK).
(June–July) '215 Fotografie de Henri Cartier-Bresson', Strozzina di Firenze, Florence, Italy. Subsequently travelled to the Imperial Museum, Tokyo, Japan.

1953. (18 Jan.–1 Mar.) 'Great Documentary Photographer: Henri Cartier-Bresson', Art Institute of Chicago, Chicago, USA.

1955. (26 Oct.–30 Nov.) 'Henri Cartier-Bresson Photographies 1930–1955', Musée des Arts Décoratifs, Pavillon de Marsan, Paris, France. [358 photographs]
(This exhibition toured under different titles)
Itinerary: 'Images à la sauvette', Kunstgewerbemuseum Zürich, Zurich, Switzerland (22 Feb.–18 Mar. 1956).
'Photographien 1930–1955', Stadtisches Museum Leverkusen, Leverkusen, Germany (Mar.–15 Apr. 1956).
Kunstverein München, Munich, Germany (25 May–June 1956).
Bremer Kunsthalle, Bremen, Germany (8 July–5 Aug. 1956).
Staatliche Landesbildstelle Museum, Hamburg, Germany (Aug.–Sept. 1956).
'Mostra di fotografie di Henri Cartier-Bresson', Palazzo della Società per le Belli Arti, Milan, Italy (22 Sept.–16 Oct. 1956). Circolo della Provincia, Bologna, Italy (23 Oct.–Nov. 1956).
'Henri Cartier-Bresson: The Decisive Moment',
R.B.A. Gallery, London, UK (8–27 Jan. 1957).
'Henri Cartier-Bresson Photo Works Exhibition', Nihombashi Takashimaya, Tokyo, Japan (17 Apr.–5 May 1957). Namba Takashimaya, Osaka, Japan. (14 May 1957).
'The Decisive Moment 1930–1957' (1957–1960). The exhibition toured the USA under the administration of the American Federation of Arts & French Cultural Services.
'The Decisive Moment 1930–1957', M.H. de Young Memorial Museum, San Francisco, USA. (3 Nov.–1 Dec. 1957).
'The Decisive Moment Part 1, 1930–1957', IBM Gallery, New York, USA (4–23 Jan. 1960).
'The Decisive Moment Part 2, 1930–1957', IBM Gallery, New York, USA (1–21 Feb. 1960).
'Fotos van Henri Cartier-Bresson. Het Beslissende Moment', Stedelijk Museum, Amsterdam, Netherlands (5 Apr.–5 May 1963). [69 photographs. Small-scale version of the exhibition at the Pavillon de Marsan.]
'Henri Cartier-Bresson Fotokiallitasa', Kulturalis Kapcsolatok Intezete, Budapest, Hungary (3–18 Oct. 1964). [68 photographs. Probably a small-scale version of the exhibition at the Pavillon de Marsan.]

1964. (5 Apr.–5 May) 'Photographs by Cartier-Bresson', The Phillips Collection, Washington DC, USA. [Exhibition on loan from the *Vogue* archives.]

1966. (17 Apr.–5 May) 'After the Decisive Moment 1966–1967', Asahi Shimbun, Tokyo. Subsequently travelled in Japan.
(30 Nov. 1966–30 Jan. 1967) 'Photographies d'Henri Cartier-Bresson', Musée des Arts Décoratifs, Paris, France.
Itinerary: 'Henri Cartier-Bresson fotografias 1929–1967', Villa Comunale, Milan, Italy (2–30 Oct. 1967).
'Henri Cartier-Bresson Photographien von 1929–1967', Kunsthalle Köln, Cologne, Germany (22 Nov.–17 Dec. 1967) [200 photographs.]

1968. (10–31 May) 'Impressions de Turquie', Bureau de Tourisme et d'Informations de Turquie, Paris, France.
(24 June–2 Sept.) 'Cartier-Bresson: Recent Photographs', Museum of Modern Art, New York, USA. [151 photographs.]
Itinerary: 'Photographs by Henri Cartier-Bresson', Victoria & Albert Museum, London, UK (19 Mar.–27 Apr. 1969).
Graves Art Gallery, Sheffield, UK (14 June–13 July 1969).
City Art Gallery, York, UK (26 July–17 Aug. 1969).

City Art Gallery, Leeds, UK
(30 Aug.–21 Sept. 1969).
Towner Art Gallery, Eastbourne, UK
(4–26 Oct. 1969).
Museum of Modern Art, Oxford, UK
(8–30 Nov. 1969).
Museu de Arte Contemporanea da Universidade
de São Paulo, São Paulo, Brazil (14 May–4 June 1970).
(19 July–16 Aug.) 'Mensch und Maschine',
Stadthaus Zürich, Zurich, Switzerland.
Itinerary: Société IBM, Place Vendôme, Paris,
France (10–15 Apr. 1969).
IBM Gallery, New York, USA
(Mar.–4 Apr. 1970).
Centromilano IBM, Milan, Italy
(3 Dec. 1984–11 Jan. 1985).
Centro Culturale Editoriale, Agrigente, Sicily
(6 June–6 July 1986).
(14 Dec.–2 Sept.) 'Photographies de Henri Cartier-
Bresson', Palais des Beaux-Arts de Charleroi,
Charleroi, Belgium.

1969. (13–23 Nov.) 'Henri Cartier-Bresson',
Maison d'Art et de Loisir de Gelos, Gelos, France.

1970. (23 Apr.–30 May) 'Henri Cartier-Bresson
(Franta)', Institutul de Arhitectura, Bucharest,
Romania.
(21 Oct.–30 Nov.) 'Henri Cartier-Bresson:
En France', Galeries Nationales d'Expositions
du Grand Palais, Paris, France.
Itinerary: Metropolitan Toronto Library, Toronto,
Canada (1–31 Mar. 1978).

1971. (1–30 July) 'Henri Cartier-Bresson: En
France. Photos made from May 1968', Aspen
Institute for Humanistic Studies, Aspen, USA.

1974. (21 June–3 July) 'Vive La France', Japan.
(15 Nov. 1974–15 Feb. 1975) 'A propos de l'URSS
1953–1974 Henri Cartier-Bresson', International
Center of Photography, New York, USA. [Inaugural
exhibition of the ICP]

1975. (Mar.) 'Man in the Camera: photos from the
30's', Israel Museum, Jerusalem, Israel.

1976. (Feb.) 'L'Imaginaire d'après Nature', Galerie
Nouvel Observateur/Delpire, Paris, France.
Itinerary: Musée Réattu, Arles, France
(7 July–30 Sept. 1979).
(14 July–5 Aug.) 'Selected Photographs by Henri
Cartier-Bresson', The National Gallery of Modern
Art, New Delhi, India.
(23 Nov. 1976–8 Jan. 1977) 'Henri Cartier-Bresson',
Ecole d'Art et d'Architecture de Marseille,
Marseilles, France.

Itinerary: 'Henri Cartier-Bresson', Varmlands
Museum, Gothenburg, Sweden. (27 Feb.–13 Mar.
1977).
'Cartier-Bresson 40 anni di fotografia' and 'Images
du Pays Franc' Rotonda di Via Besana, Milan, Italy
(21 Mar.–23 Apr. 1978).

1977. (23 June–4 July) 'Images du Pays Franc',
Palais Rihour, Lille, France.
Itinerary: Brussels, London, Amsterdam (1977).
Salon de la Photo, Section culturelle, Paris, France
(5–13 Nov. 1977).
Maison de la région Nord-Pas-de-Calais, Paris,
France (2–28 July 1980).

1978. (4–21 Apr.) 'Cartier-Bresson: Archival
Collection', Osaka University of Arts, Osaka, Japan.
(19 Aug.–10 Sept.) 'Henri Cartier-Bresson:
his archive of 390 photos from the V & A', Fruit
Market Gallery, Edinburgh, UK.
Itinerary: Newcastle, UK
(Sept.–Oct.1978).
Hayward Gallery, London, UK
(11 Nov. 1978–7 Jan. 1979).
(8 Nov. 1979–6 Jan. 1980) 'Henri Cartier-Bresson
Photographer' (later called 'Retrospectiva'),
International Center of Photography, New York,
USA. [155 photographs.]
Itinerary: Art Institute of Chicago, Chicago, USA
(12 Feb.–23 Mar. 1980).
Carnegie Institute, Pittsburgh, USA
(17 Apr.–8 June 1980).
Virginia Museum of Fine Arts, Richmond, USA
(24 June–10 Aug. 1980).
Palacio de Bellas Artes, Mexico City, Mexico
(3 Sept.–12 Oct. 1980).
Seattle Art Museum, Seattle, USA
(19 Nov. 1980–4 Jan. 1981).
High Museum of Art, Atlanta, USA
(31 Jan.–15 Mar. 1981).
Corcoran Gallery of Art, Washington, DC, USA
(3 Apr.–17 May 1981).
Dallas Museum of Fine Arts, Dallas, USA
(3 June–12 July 1981).
Kunsthaus, Stiftung für die Photographie, Zurich,
Switzerland (20 June–23 Aug. 1981).
Philadelphia Museum of Art, Philadelphia, USA
(1 Aug.–4 Oct. 1981).
Museum des 20. Jahrhunderts, Vienna, Austria
(3 Sept.–18 Oct. 1981).
Indianapolis Museum of Art, Indianapolis, USA
(19 Oct.–1 Dec. 1981).
Stedelijk Museum, Amsterdam, Netherlands
(5 Nov. 1981–4 Jan. 1982).
Cleveland Museum of Art, Cleveland, USA
(16 Dec. 1981–24 Jan. 1982).
Palais des Beaux-Arts, Brussels, Belgium

(21 Jan.–7 Mar. 1982).
Museum of Fine Arts, Boston, USA
(16 Feb.–4 Apr. 1982).
Museum für Kunst und Gewerbe, Hamburg,
Germany (2 Apr.–16 May 1982).
San Francisco Museum of Modern Art,
San Francisco, USA (30 Apr.–13 June 1982).
Münchner Stadtmuseum, Fotomuseum, Munich,
Germany (4 June–9 Aug. 1982).
Nelson Gallery and Atkins Museum of Fine Arts,
Kansas City, USA (11 July–29 Aug. 1982).
Fundación Juan March, Madrid, Spain (1982).
Fondation Nationale de la Photographie, Lyons,
France (1982).
Fotografiska Museet, Stockholm, Sweden (1983).
Montreal Museum of Fine Arts, Montreal, Canada
(25 June–4 Sept. 1983).
Galerie des Arènes, Nîmes, France
(27 Apr.–20 May 1984).
Museu de Arte de São Paulo, São Paulo, Brazil
(14 Nov.–16 Dec. 1984).
Museo de Bellas Artes, Buenos Aires, Argentina
(7 Nov. 1985).
Museum of Modern Art, Cairo, Egypt
(Nov.–Dec. 1984).
Tata Theatre, Bombay, India (4–31 Jan. 1986),
subsequently travelled to Delhi and Calcutta.
Museo de Bellas Artes de Caracas, Caracas,
Venezuela (13 Feb.–30 Mar. 1986).
Sala de Armas de Ciudadela, Pampelune, Spain
(6–30 June 1986).
Kluuvin Galleria, Helsinki, Finland
(21 Aug.–14 Sept. 1986).
Centre Culturel Français, Berlin, Germany
(15 Dec. 1986–23 Jan. 1987).
Galerie der Hochschule für Grafik und Buchkunst,
Leipzig, Germany (20 Feb.–21 Mar. 1987).
Museum of Fine Arts, Peking, China
(26 Feb.–8 Mar. 1987).
Kunsthalle Rostock, Rostock, Germany
(22 Apr.–21 June 1987).
Palazzo della Ragione, Padua, Italy
(10 Mar.–17 Apr. 1988).
Galerie Stepànskà 35, Prague, Czech Republic
(18 Jan.–6 Mar. 1994).
Museo de Arte Contemporáneo de Monterrey,
Monterrey, Mexico (23 Apr.–27 June 1999).
Museo de Arte Moderno, Mexico City, Mexico
(15 July–26 Sept. 1999).
Artexpo, Bucharest, Romania
(8 Jan.–8 Feb. 2002).
Municipal Gallery of Sofia, Sofia, Bulgaria
(13 Feb.–15 Mar. 2002).
Ludwig Museum, Budapest, Hungary
(21 Mar.–26 May 2002).
Mimara Museum, Zagreb, Croatia
(31 May–30 June 2002).

House of Culture, Ljubljana, Slovenia
(4 July–28 Aug. 2002).
Paviljon Cvijeta Zuzoric, Belgrade, Serbia
(3–30 Sept. 2002).

1980. (25 Feb.–15 Mar.) 'Paysage avec les
Hommes: Henri Cartier-Bresson', Tokyo, Japan.
(28 Feb.–5 Apr.) 'Henri Cartier-Bresson
Photographie', Galerie Nouvel Observateur/
Delpire, Paris, France.
(12 Nov. 1980–11 Jan. 1981) 'Henri Cartier-Bresson:
300 photographies de 1927 à 1980', Musée d'Art
Moderne de la Ville de Paris, Paris, France.

1982. (7 Jan.–12 Feb.) 'Photographies et Caux
présente Henri Cartier-Bresson', La Maison
de la Culture du Havre, Le Havre, France.
(1 Feb.–30 Mar.) 'Henri Cartier-Bresson Portraits
de 1932–1982', Galerie Eric Franck, Geneva,
Switzerland.
(17 June–19 July) 'Scanno di Henri Cartier-Bresson',
Biblioteca Comunale di Scanno, Scanno, Italy.

1983. (8 Sept.–10 Oct.) 'L'Imaginaire d'après nature',
Padiglione d'Arte Contemporanea, Milan, Italy.
Itinerary: Il Università Degli Studi di Roma,
Rome, Italy (14 Nov.–3 Dec. 1983).
(16 Sept.–13 Nov.) 'Un demi-siècle de
Photographie', Musée des Arts Décoratifs de
Lausanne, Lausanne, Switzerland.
Itinerary: Fondation Pierre Gianadda, Martigny,
Switzerland (Dec. 1989–28 Jan. 1990).
'Henri Cartier-Bresson: disegni e foto', Villa
Medici, Rome, Italy (25 May–22 June 1990).
'Homage to Henri Cartier-Bresson: photos and
drawings', Museo Camon Aznar, Saragosse, Spain
(14 Jan.–12 Feb. 1993).
Kunsthaus Zürich, Zurich, Switzerland
(6 Sept.–29 Nov. 1998).
Palazzo Medici Riccardi, Florence, Italy
(1 Apr.–27 June 1999).
(24 Nov. 1983–28 Jan. 1984) 'Henri Cartier-
Bresson: Portraits de 1928–1982', Galerie Agathe
Gaillard, Paris, France.

1984. (22 Feb.-Mar.) 'Henri Cartier-Bresson',
Galerie Municipale du Château d'Eau, Toulouse,
France.
'Henri Cartier-Bresson: Drawings and Painting',
Museum of Modern Art, Oxford, UK.
(15 Mar.–28 Apr.) 'Henri Cartier-Bresson: Carnet
de Notes sur le Mexique', Centre Culturel du
Mexique, Paris, France.
(12 Oct.–25 Nov.) 'Photographs by Henri
Cartier-Bresson from Mexico, 1934 and 1963', Art
Museum of South Texas, Corpus Christi, USA.
Itinerary: Center for Creative Photography,
Tucson, USA (17 Jan.–14 Feb. 1985).

(5 Nov. 1984–6 Jan. 1985) 'Paris à Vue d'œil',
Musée Carnavalet, Paris, France.
Itinerary: Centre Culturel de l'Ambassade
de France, Prague, Czech Republic
(1–23 June 1988).
Instituto Francés de Madrid, Madrid, Spain
(7–30 Nov. 1990).
Deichtorhallen Hamburg, Hamburg, Germany
(4 Feb.–10 Apr. 1994).
Rupertinum, Salzburg, Austria
(11 May–16 July 1995).
Städtische Galerie, Iserlohn, Germany
(28 Nov. 1998–31 Jan. 1999).
Akureyri Art Museum, Reykjavik
(21 Apr.–3 June 2001).
Reykjavík Museum of Photography, Reykjavik,
Iceland (9 June–29 July 2001).
'Henri Cartier-Bresson Paryz', Centrum Kultury
Zamek, Galeria Fotografii 'pf', Poznan, Poland
(7–30 Apr. 2000).

1985. (23 Apr.–5 May) 'Henri Cartier-Bresson
photographs 1932–1976', Seoul Gallery, Seoul
Press Center, Seoul, Korea.
(23 Oct. 1985–13 Jan. 1986) 'Henri Cartier-Bresson
en Inde', Centre National de la Photographie,
Palais de Tokyo, Paris, France.
Itinerary: Musée de L'Elysée, Lausanne,
Switzerland (4 June–16 Aug. 1987).
International Center of Photography, New York,
USA (15 Jan.–28 Feb. 1988).
Aula de Cultura de la Caja Municipal de Bilbao,
Bilbao, Spain (26 May–10 June 1988).
Musée Municipal, Orange, France
(10 Sept. 1988).
National Gallery of Modern Art, New Delhi, India
(Nov. 1992).
Maison du Spectacle, Brussels, Belgium
(9 Mar.–24 Apr. 1994).
Galerie für Kunstphotographie, Zurich,
Switzerland (25 Mar.–19 June 1996).

1986. (17 Aug.–21 Sept.) 'Henri Cartier-Bresson:
Zeichnung und Fotografie', Mannheimer
Kunstverein, Mannheim, Germany.

1987. (July-Aug.) 'Henri Cartier-Bresson', Palais
des Congrès, Saint-Jean-de-Monts, France.
(9 Sept.–29 Nov.) 'Henri Cartier-Bresson: The
Early Work', Museum of Modern Art, New York,
USA. [90 photographs.]
Itinerary: 'Henri Cartier-Bresson: Das Frühwerk',
Folkwangmuseum, Essen, Germany
(17 Sept.–22 Oct. 1989).

1989. 'Henri Cartier-Bresson', Printemps Ginza,
Tokyo, Japan.

1991. 'Henri Cartier-Bresson', Osaka University of
Arts, Osaka, Japan.
(15 May–15 June) 'Henri Cartier Bresson', Galerie
Patrick Derom, Brussels, Belgium.
(19 Sept.–19 Oct.) 'Henri Cartier-Bresson:
American Photographs', James Danziger Gallery,
New York, USA.
(6–24 Oct.) 'Amériques' (part of Proyecto
Imagina), Claustro de Artes y Oficios, Almeria,
Spain.
(14 Nov. 1991–18 Jan. 1992). 'L'Amérique,
furtivement: 1935–1975', Fnac Etoile, Paris, France.
Itinerary: Galleria Credito Valtellinese, Milan,
Italy (5–28 Feb. 1992).
Château de Blérancourt, Musée National de
la Coopération Franco-Américaine, France
(31 Mar.–10 June 1996).
'Henri Cartier-Bresson in America, 1935–1975',
The Equitable Gallery, New York, USA
(19 Sept.–2 Nov. 1996).
Bruce Museum, Greenwich, Connecticut,
USA (26 July–14 Sept. 1997).

1992. 'Henri Cartier-Bresson: Fotografie',
Rocca di Sanvitale, Noceto, Italy.

1993. (7 Jan.–14 Feb.) 'Le Mexique', Espace
Image-Scène Nationale, Bayonne, France.
(9 Aug.–22 Oct.) 'Photographs by Henri Cartier-
Bresson', Gallery 2000, University of Florida,
Tallahassee, USA.

1994. (13 May–4 Sept.) 'Homage to Henri Cartier-
Bresson', International Center of Photography,
New York, USA.
(Sept.–1 Dec.) 'The work of Henri Cartier-Bresson',
Peter Fetterman Gallery, Santa Monica, USA.
(4–26 Oct.) 'Cartier-Bresson Part 1: France',
The Landmark Tower, Yokohama, Japan.
(28 Oct.–10 Nov.) 'Cartier-Bresson Part 2: Europe',
The Landmark Tower, Yokohama, Japan.
(14 Nov. 1994–29 Jan. 1995) 'Henri Cartier-Bresson
Primeres Fotografies i darrers dibuixos', Centro de
Cultura Contemporània de Barcelona, Barcelona,
Spain.
Itinerary: Pushkin Fine Arts Museum, Moscow,
Russia (1–31 May 1996).
Sala de San Benito, Valladolid, Spain
(13 Sept.–13 Oct. 1996).
Palazzo delle Esposizioni, Rome, Italy
(26 Sept.–8 Nov. 1998).

1995. (20 May–30 Oct.). 'Matisse par Henri
Cartier-Bresson', Musée Matisse, Le Cateau-
Cambrésis, France.
(8 Nov. 1995–22 Jan. 1996) 'Carnets Mexicains de
Henri Cartier-Bresson 1934–1964', Centre
National de la Photographie, Paris, France.

1996. (2 Mar.–12 May) 'Henri Cartier-Bresson: Pen, Brush and Cameras', Minneapolis Art Institute, Minneapolis, USA.
Itinerary: Montreal Museum of Fine Arts, Montreal, Canada (28 Aug.–2 Nov. 1997).

1997. (2 Mar.–22 June) 'Des Européens', La Maison Européenne de la Photographie, Paris, France.
Itinerary: Hayward Gallery, London, UK (4 Feb.–5 Apr. 1998).
Le Botanique, Brussels, Belgium (24 Apr.–14 June 1998).
Museo Della Fotografia Storica, Turin, Italy (3 Sept.–4 Oct. 1998).
Kunsthalle, Düsseldorf, Germany (18 Oct. 1998–3 Jan. 1999).
Louisiana Museum, Copenhagen, Denmark (20 Feb.–6 June 1999).
Darphane-i-Amire, Topkapi Sarayi, Istanbul, Turkey (3 Aug.–30 Sept. 1999).
Helsinki City Museum, Helsinki, Finland (12 Jan.–30 Apr. 2000).
Centro de Exposições de Centro Cultural, Belém, Portugal (18 Jan.–18 Mar. 2001).
Galerie am Tunnel, Luxembourg (15 Jan.–24 Feb. 2002).

1998. (19 Feb.–7 June) 'Henri Cartier-Bresson Portraits: Tête à Tête', National Portrait Gallery, London, UK.
Itinerary: Scottish National Gallery, Edinburgh, UK (13 Mar.–9 May 1999).
National Portrait Gallery, Washington, DC, USA (29 Oct. 1999–9 Jan. 2000).
Bendigo Art Gallery, Victoria, Australia (23 Mar.–13 May 2001).
National Portrait Gallery, Canberra, Australia (25 May–15 July 2001).
Cairns Regional Gallery, Cairns, Australia (1 Mar.–28 Apr. 2002).
(6 June–26 Sept.) 'Henri Cartier-Bresson: Photographien und Zeichnungen', Galerie Beyeler, Basel, Switzerland.
(29 Nov. 1998–12 Apr. 1999) 'Henri Cartier-Bresson: Elsewhere. Photographs from the Victoria and Albert Museum', Victoria & Albert Museum, London, UK.

1999. (1 July–31 Aug.) 'Cartier-Bresson: Known & Unknown', James Danziger Gallery, New York, USA.
(12 Aug.–16 Oct.) 'Henri Cartier-Bresson Photographs', Tel-Aviv Museum of Art, Tel-Aviv, Israel.
(12–17 Oct.) 'Landscape', Tokyo, Japan.
Itinerary: Images du Centre, Orleans, France (20 Sept.–10 Nov. 2002).

2000. (20 Jan.–26 Feb.) 'Henri Cartier-Bresson Photographies 1932–1999', Galerie Claude Bernard, Paris, France.
(22 Feb.–18 Mar.) 'Henri Cartier-Bresson Photographs', Galerie Frank & Schulte, Berlin, Germany.
(25 Mar.–25 June) 'Henri Cartier-Bresson: Fotografie & Disegni', Scuderie del Castello di Miramare, Trieste, Italy.
(25 Apr.–25 May) 'Henri Cartier-Bresson: Vers un Autre Futur: Un regard libertaire', Espace Louise-Michel, Paris, France.
Itinerary: Centre Espagnol, Perpignan, France (2–17 Sept. 2000)
(17 May) 'USSR 1950–1980', Manège, Moscow, Russia.

2001. (26 Jan.–18 Mar.) 'Henri Cartier-Bresson Fotografo: Paesaggi. Immagini e parole', Palazzo dell'Arengario, Milan, Italy.
(16 July–Aug.) 'Henri Cartier-Bresson', Centre d'Art Contemporain Boris-Bojnev, Forcalquier, France.
(14 Sept.–7 Oct.) 'Henri Cartier-Bresson: Immagini e paroli', Sala Civica 'Salvador Allende', Savignano sul Rubicone, Italy.
(19 Oct. 2001–13 Jan. 2002) 'Henri Cartier-Bresson paesaggi e opere commentate', Villa Impero, Bologna, Italy.

2002. (8 Jan.–8 Feb.) 'Henri Cartier-Bresson: Russia', Fondation BBK, Bilbao, Spain.
(8–26 Jan. 2002) 'Portraits d'écrivains: Photographies de Henri Cartier-Bresson', Médiathèque François-Mitterrand, Poitiers, France.
(1 Feb.–9 Mar.) 'Henri Cartier-Bresson: Erotic + - Surreal', Howard Greenberg Gallery, New York, USA.
(8 May–9 June) 'Indonésie 1949 par Henri Cartier-Bresson', Gedung Arsip Nasional, Jakarta, Indonesia.
Itinerary: Museum Negeri Sono Budoyo, Yogyakarta, Indonesia (11 June–6 July)
Agung Rai Museum of Art, Ubud, Bali (12 July–3 Aug.).
(14 June–1 Sept.) 'Sweden', Hasselblad Center, Gothenburg, Sweden.
(2 July–20 Sept.) 'Paris vu par Henri Cartier-Bresson', Galerie Claude Bernard, Paris, France.

DRAWINGS: BIBLIOGRAPHY AND MAIN EXHIBITIONS

1975. February: 'Drawings', First exhibition at the Carlton Gallery, New York, USA. Catalogue: preface by Julien Levy.
December: 'Zeichnungen', Galerie Bischofberger, Zurich, Switzerland. Catalogue: preface by Manuel Gasser.

1976. July: 'Dessins', Galerie Lucien Henry, Forcalquier, France. Catalogue.

1981. May: 'Dessins 1973–1981', Musée d'Art Moderne de la Ville de Paris, France. Catalogue: prefaces by James Lord and André Berne-Joffroy.

1982. February: 'Dibujos 1973–1981', Museo d'Arte Moderno de Mexico, Mexico.

1983. March: 'Teckningar 1973–1983', Institut Français de Stockholm, Sweden.
September: 'Dessins et Photographies', Galleria d'Arte Moderna and Padiglione Arte Contemporanea, Milan, Italy. Catalogue: prefaces by Lamberto Vitali and Giulana Scime.
November: 'Dessins et Photographies', Università Tor Vergata, Rome, Italy.

1984. June: 'Drawings and Paintings', Museum of Modern Art, Oxford, UK. Catalogue: preface by David Elliott.

1985. February: 'Zeichnungen', Salzburger Landessammlung Rupertinum, Salzburg, Austria.
April: 'Zeichnungen', Palais Lichtenstein, Vienna, Austria.
June: 'Zeichnungen', Galerie Annasäule, Innsbruck, Austria.
October: 'Dessins et Tempéras', Institut Français d'Athènes, Greece. Catalogue: preface by Michael Brenson.

1986. August: 'Dessins et Photographies', Mannheimer Kunstverein, Mannheim, Germany.

1987. September: 'Drawings and Paintings', Arnold Herstand Gallery, New York, USA.

1989. February: 'Dessins 1966–1989', Chapelle de l'Ecole des Beaux-Arts, Paris, France.
March: 'Dessins et Photographies', Printemps Ginza, Tokyo. Catalogue PPS, Tokyo.
December: 'Dessins et Photographies', Fondation Pierre Gianadda, Martigny, Switzerland.
Trait pour Trait, Paris: Arthaud. Text by John Russell and Jean Clair. [UK edition: *Line by Line*. London: Thames & Hudson. German edition also available.]

1990. May: 'Disegni e Fotografie', Villa Medici, Rome, Italy.

1991. January: 'Dessins et Photographies', Taipei Fine Arts Museum, Taiwan.
May: 'Dessins 1966–1990', Musée de Louvain-la-Neuve, Belgium.
October: 'Zeichnungen', Galerie Am Friedrichsplatz, Mannheim, Germany.

1992. September: 'Dessins et Photographies', Musée de Noyers, Noyers-sur-Serein, France. 'Henri Cartier-Bresson', Palazzo San Vitale, Parma, Italy.

1993. January: 'Dibujos y Fotografias', Centro de Exposiciones, Saragosse, Spain.
July: 'Dibujos y Fotografias', Centro de Exposiciones, Logrono, Spain.

1994. June: 'Photo Dessin-Dessin Photo', Arles, France. Catalogue, Actes-Sud. Text by Agnès de Gouvion Saint-Cyr.
November: 'Dessins et Premières photos', Centre de Cultura Contemporània, Casa de Caridad, Barcelona, Spain.
'*Henri Cartier-Bresson: Double regard*', Amiens: Le Nyctalope. Text by Jean Leymarie.

1995. March: 'Dessins et Hommage à Henri Cartier-Bresson', CRAC Valence, France.

1996. March: 'Henri Cartier-Bresson: Pen, Brush and Cameras', The Minneapolis Institute of Arts, Minneapolis, USA. Catalogue: text by Evan Maurer, T. Hartwell and M. Brenson.
March: 'Drawings', Berggruen and Zevi Gallery, London, UK. Catalogue: preface by James Lord.

1997. August: 'Henri Cartier-Bresson: plume, pinceau et pellicule', Montreal Museum of Fine Arts, Canada.
September: 'Henri Cartier-Bresson, dessins 1974–1997', Galerie Claude Bernard, Paris, France. Catalogue: text by Jean Leymarie.

1998. March: 'Line by Line', Royal College of Art, London.
September: 'Der Photograph als Zeichner', Kunsthaus, Zurich, Switzerland. Catalogue: Benteli, text by G. Magnaguagno.
September: 'Dessins-Photos', Galerie Beyeler, Basel, Switzerland. Catalogue: preface by John Berger.
'Henri Cartier-Bresson: Pen, Brush and Cameras', Museum of Contemporary Art, Kyoto, Japan.

1999. March: 'Disegni e Acquarelli', Palazzo Medici Riccardi, Florence, Italy. Catalogue: Alinari.
June: 'Dessins' (for the 48th Venice Biennale), Casino Venier, Venice, Italy.

2000. March: 'Fotografie & Disegni', Scuderie del Castello di Miramare, Trieste, Italy.

CAPTIONS FOR BOOK AND MAGAZINE COVERS

Page 33 : *The Photographs of Henri Cartier Bresson*. Catalogue of the so-called 'posthumous' exhibition at the Museum of Modern Art, New York, in 1947, text by Lincoln Kirstein and Beaumont Newhall.

Page 35 : *Crapouillot*. Paris, April 1933.

Page 36 : *Henri Cartier-Bresson : The Early Work*. Text by Peter Galassi, exhibition at the Museum of Modern Art, New York, 1987.

Page 60 : *Henri Cartier-Bresson : Photographe*. Text by Yves Bonnefoy. Delpire, Paris.

Page 68 : *Flagrants Délits*. Delpire, Paris, 1959.

Page 84 : *Regards*. Paris, 28 July 1938. Reportage by Henri Cartier-Bresson at the time of the visit of George VI to France.

Page 100 : *Les Européens*. Cover by Joan Miró. Tériade, Paris, 1955.

Page 109 : *Carnets Mexicains 1934–1964*. Text by Carlos Fuentes. Hazan, Paris, 1995.

Page 130 : *Portfolio Landschaften*. Published by *Stern*, Hamburg, 1998.

Page 137 : *L'Homme et la Machine*. Delpire, Paris, 1969.

Page 147 : *Life*, 'A Penetrating Look at The People of Russia'. New York, 17 January 1955.

Page 148 : *Katholieke Illustratie*, Belgian periodical in Flemish, 'Uit de Reportage: de Russische mens bij arbeid en onstpanning'. 19 March 1955.

Page 149 : *A propos de l'URSS, Photographies de Henri Cartier-Bresson*. Delpire, Paris, 1974. This book brings together the photographs taken by Henri Cartier-Bresson during his two journeys to the USSR in 1954 and 1972.

Page 151 : *Moscou vu par Henri Cartier-Bresson*. Delpire, Paris, 1955. This book presents the first important reportage on Moscow during the Cold War.

Page 156 : *Tête à Tête*. Introduction by E.H. Gombrich, Gallimard, Paris, 1998.

Page 162 : *Images à la sauvette*. Cover by Henri Matisse. Tériade, Paris, 1952. The first book by Henri Cartier-Bresson.

Page 205 : *Henri Cartier-Bresson : America in Passing*. Text by Gilles Mora, published by Bulfinch, USA, 1991.

Page 209 : *Camera*. Special edition on the USA, Lucerne, 1976.

Page 211 : *Illustrierter Merkur,* German periodical, 'Ein Cowboy trauert'. 1 November 1952.

Page 218 : *L'Amérique furtivement : Photographies Henri Cartier-Bresson : USA 1935–1975*. Text by Gilles Mora. Seuil, Paris, 1991

Page 251 : *Henri Cartier-Bresson en Inde*. Text by Yves Vequaud and Satyajit Ray. Centre National de la Photographie, Paris, 1985.

Page 270 : *Life*, 'The New Nation of Indonesia'. New York, 13 February, 1950.

Page 272 : *Heute,* 'Tanz auf Bali'. Munich, 21 June 1950.

Page 273 : *Les danses à Bali*. Text : 'Le Théâtre Balinais' by Antonin Artaud. Delpire, Paris, 1954.

Page 289 : *D'une Chine à l'autre*. Text by Jean-Paul Sartre. Delpire, Paris, 1954.

Page 314 : *New York Times Magazine,* 'Communist Challenge in Asia'. New York, 22 January 1950.

Page 381: Upper left, photographer's pass for the French Army. Lower right, press pass, Burma 1948.

Post scriptum

If my wife Martine Franck, with the support of our daughter Mélanie,
had not demonstrated the indomitable energy and willpower required
to create the Fondation HCB, this book would not exist.
I dedicate it to them with love and thanks.

Deepest thanks also go to: my devoted friend Robert Delpire
who has been making marvellous books for so many years, his team at Idéodis,
Caroline Bénichou, Michaël Derez, Katia Duchefdelaville, Agnès Gagnès,
Cécile Kambouchner, Léa, and Maud Moor.

Thanks also to Benoît Rivero.
The team at the Fondation HCB: Tamara Corm, Agnès Sire,
and my assistant Marie-Thérèse Dumas.

Magnum Photos, all my fellow photographers and Diane Auberger,
Micheline Fresne, Pascale Giffard, Marie-Pierre Giffey, Enrico Mocchi, Fabienne Muddu.

Pictorial Service, the three generations of the Gassmann family with whom I have enjoyed such a
long connection, Daniel Mordac, my printer, Marie-Pierre Bride, Régis Chalmel and the runners.

Many thanks to the Bibliothèque Nationale de France for the spontaneity
and enthusiasm of Jean-Pierre Angremy, Jean-Noël Jeanneney, Vivianne Cabannes,
Thierry Grillet and Anne Hélène Rigogne

And finally, Jean-Loup Champion and Gabriela Kaufmann at Editions Gallimard.

Henri Cartier-Bresson